Philip Hardie is a senior research fellow at Trinity College Cambridge and Honorary Professor of Latin at the University of Cambridge. His many books include *Virgil's Aeneid: Cosmos and Imperium*, *The Epic Successors of Virgil*, *Ovid's Poetics of Illusion*, *The Cambridge Companion to Ovid* and, edited with S. Gillespie, *The Cambridge Companion to Lucretius*.

'*The Last Trojan Hero* will become the primary resource for anyone interested in the reception of Virgil and his poetry, and it will serve as an excellent introduction to the topic for under-graduates and the general educated reader. But it is also a book I would recommend to anyone approaching Virgil for the first time. Hardie skilfully combines a sense of Virgil's place in ancient literary culture, a masterful overview of debates about the *Aeneid* in classical scholar-ship, and a panorama of poetic, artistic and political responses to the epic. Insightful readings are presented throughout, of texts from Ovid – Virgil's "earliest reader" – to Seamus Heaney. The *Aeneid*'s influence is traced through scatological travesty, the work of nation-building, and personal voices of protest or desire. The reader comes away from *The Last Trojan Hero* with a profound sense of how and why Virgil's poem *mattered* at different times and in different places. Hardie achieves a fine balance of encyclopedic scope and detailed reading, covering with a light touch an extraordinary breadth of material. His learning and interpretative sensi-bility brilliantly illuminate each text under discussion.'
– Ellen O'Gorman, Senior Lecturer in Classics, University of Bristol

'I enjoyed Philip Hardie's book immensely. It is not only a treasure trove of information about the ways Virgil's *Aeneid* has been read, but also a subtle and complex reading of the text itself, as well as a richly emotional engagement with western culture. Written by one of the most important living scholars of the *Aeneid* and its reception, this rich and resonant book will endlessly reward its readers, regardless of whether or not they are already familiar with Virgil's masterpiece.'
– Helen Lovatt, Associate Professor in Classics, University of Nottingham

'Fast-paced and learned, *The Last Trojan Hero* is a tour-de-force through the reception of Virgil's *Aeneid*. One of the world's most eminent Latinists has condensed a lifetime of research into a slim volume whose every page offers a dazzling wealth of ideas clearly expressed – a delight for the specialist and the uninitiated alike. Some adaptations are as well known as Dante's under-world and the Christian Virgil, some are surprises, such as Queen Elizabeth I in Dido's guise and the American Aeneas. Hardie ranges over German, Spanish, French, Italian, English and Portuguese as he collects nods to Virgil in art and literature from Europe, the Americas, Asia and Africa with a span from Ovid to Ursula Le Guin. More than a collection of references with rich visual documentation, Hardie offers a reading of the *Aeneid*, its heroes and heroines, its stance on foundation, empire, exile and passion through its variegated reception. His light touch and the simplicity of the presentation belie the depth of thought on display.'
– Michèle Lowrie, Professor of Classics and the College, University of Chicago

'In his new book Philip Hardie not only tells the story of Virgil's *Aeneid*, but also of a signifi-cant part of western culture. As one would expect from this author, it is a masterful selec-tion and presentation of the rich material at his command. Pursuing the reception of the central text (which is itself already an instance of reception), leads to intriguing insights into the development of literature, art, science and scholarship from antiquity to the present day. Hardie's unrivalled knowledge of Virgil and of later periods means that one learns as much about the *Aeneid* itself as about its later reception. A careful selection of relevant examples opens up a number of different perspectives and creates the framework for a comprehensive history of the legacy of this major epic. At the same time, this is such a well-written book that it will be accessible to all kinds of readers, specialist or not: it can enjoyably and rewardingly be read from cover to cover. Anyone interested in the history of epic will benefit from it and (re)discover new friends and old acquaintances.'
– Gesine Manuwald, Professor of Latin, University College London

THE LAST TROJAN HERO

A Cultural History of
Virgil's *Aeneid*

Philip Hardie

I.B. TAURIS

LONDON · NEW YORK

Paperback edition published in 2016 by
I.B.Tauris & Co. Ltd
London • New York
www.ibtauris.com

Hardback edition first published in 2014 by
I.B.Tauris & Co. Ltd

ISBN: 978 1 78453 483 7
eISBN: 978 0 85773 506 5

A full CIP record for this book is available from the British Library
A full CIP record is available from the Library of Congress

Library of Congress Catalog Card Number: available

Typeset in Adobe Caslon Pro by A. & D. Worthington, Newmarket, Suffolk
Printed and bound by CPI Group (UK) Ltd, Croydon, CR0 4YY

MIX
Paper from
responsible sources
FSC
www.fsc.org FSC® C013604

CONTENTS

ILLUSTRATIONS

PLATES

ACKNOWLEDGEMENTS

I am grateful to my editor Alex Wright for suggesting that I have a go at something that I would never have thought possible in the space of 90,000 words. I have enjoyed the challenge; I leave it to my readers to judge the success of my sketch of a vast topic. I am also grateful to David Rijser for inviting me to deliver the 2012 Amsterdam Vergil Lectures, based on the materials in this book, and to the stimulating audiences at those lectures.

1

INTRODUCTION

Virgil's Latin survives in unexpected places. The reverse of the American one-dollar bill displays three Latin phrases based on Virgilian quotations, on images of the Great Seal of the United States (designed by the Founding Fathers in 1782). *Nouus ordo saeclorum* 'a new order of ages' is adapted from Virgil's fourth *Eclogue* (line 5). *Annuit coeptis* '[God] looks favourably on our undertakings' is lightly adapted from a prayer to Jupiter in the mouth of Aeneas' son Ascanius at a critical moment in the Trojans' war in Italy in the *Aeneid* (9.625). *E pluribus unum* 'from many [colonies] one [nation]' is adapted from a pseudo-Virgilian poem, the *Moretum*, which describes how a rustic blends together the ingredients for a kind of garlic pesto, so that 'one colour emerges from many', *color est e pluribus unus* (*Moretum* 102). The motto of Oklahoma, *labor omnia uincit*, 'hard work overcomes all things', is the condition of the farmer's world in the *Georgics* (1.145). Further afield, the motto of the Brazilian state of Minas Gerais is *libertas quae sera tamen* 'liberty, which even if late', commemorating a late eighteenth-century liberation movement. It is an abbreviation of a line in the *Eclogues* in which a shepherd, formerly a slave, explains the reason why he went to Rome (*Ecl.* 1.27): *libertas, quae sera tamen respexit inertem* 'freedom, which, though late, nevertheless looked the way of an idle man'. The original context of the line is apposite for its Brazilian transplantation, since it is an example of Virgil's injection of contemporary social and political reality into the timeless pastoral world. Going still further afield, the motto of the Australian city of Melbourne is the Virgilian phrase *uires acquirit eundo* 'it gathers strength as it goes'. Here it is perhaps better not to remember that the original subject of these words is the monstrous personification of Rumour (*Fama*) in the *Aeneid* (4.175).

For most of the last two millennia Virgil's poetry, and in particular his epic the *Aeneid*, was a central monument in the literary and cultural landscape of Europe and, in more recent centuries, of those territories

around the world colonized by Europe, as the previous paragraph bears witness. The *Aeneid* was a core text in education, and, having entered the bloodstream of the educated elite, was the inspiration for countless new works of literature, as well as the visual arts and music. The influence of Virgil's epic was not limited to the literary and artistic. What might be called the Virgilian 'myth of history' has been evoked again and again in support of political programmes and manifestoes, mostly of nationalist and imperialist kinds.

In 1944 T.S. Eliot could still claim that Virgil was 'the classic of all Europe', in his presidential address to the newly founded Virgil Society, 'What is a Classic?'. 'Virgil acquires the centrality of the unique classic; he is at the centre of European civilization, in a position which no other poet can share or usurp.'[1] The Virgil Society had been set up in the dark days of World War II with the aim of 'unit[ing] all those who cherish the poetry of Virgil as the symbol of the cultural tradition of Western Europe'.[2] Eliot had his own agenda when it came to the matter of tradition and the classics, but his assertion of Virgil's continuing classic status was not absurd. Indeed the earlier part of the twentieth century had seen a reinvigorated attention to Virgil, and the bimillennium of Virgil's birth in 1930 had been enthusiastically celebrated on both sides of the Atlantic.[3] But well before the turn of the twenty-first century Virgil had comprehensively lost this status, largely as a result of the decline of Latin in schools, and partly as a result of a reaction against the ideologies of nation and empire with which the *Aeneid* is associated, and which have now become deeply unfashionable.

But if Virgil's poems enjoy a much reduced visibility in the modern world, their presence pervades the literature and art of the nineteen centuries and more during which Virgil was a central author. To write a comprehensive literary and cultural history of the reception of Virgil would be little less than to write a literary and cultural history of western Europe and its former overseas possessions. This short book can attempt only to give an overall sense of the history of Virgil's reception, together with a more detailed sampling of individual instances of that reception.

Its coverage is partial also in that it focuses on just one of Virgil's three canonical works, the last and most ambitious. The *Aeneid* was preceded by the *Eclogues*, Virgil's book of pastoral poetry in the line of the Hellenistic bucolic poetry of Theocritus, and the *Georgics*, composed in a tradition of Greek and Roman didactic poetry going back to the archaic poet Hesiod, a poem which uses the pretext of teaching the reader how to farm in order to raise much larger issues concerning man's place in the world. In

addition there is a collection of poems formerly attributed to the young Virgil, known as the *Appendix Vergiliana*. Modern scholars believe almost none of these to be by Virgil, but until the Renaissance they were generally regarded as authentic and they play their own part in the reception of Virgil.[4] The three major works, *Eclogues*, *Georgics* and *Aeneid*, form what in hindsight seems an almost pre-scripted progression in size, genre and subject-matter: from ten short, recherché poems about shepherds singing in the countryside, to a four-book poem about hard work on the farm, set within a much larger set of temporal and spatial frameworks, to the 12-book epic on the business of warfare and the foundation of cities. In the Middle Ages this tripartite career was given schematic representation in the 'Wheel of Virgil', which arranges the ascending analogies of the three poems in concentric circles.[5] The idea of a 'Virgilian career', working its way up from smaller literary exercises to the full-scale epic, was influential in later centuries, a challenge taken up, for example, by Edmund Spenser and John Milton.[6]

As well as forming a progression, the three Virgilian poems are also tightly connected by a dense network of self-allusion. For example, the *Eclogues* look forward to some of the major themes of the *Aeneid*: exile, the return of the Golden Age, the disastrous effects of love, apotheosis. The *Georgics* move on from the *Eclogues*, but also look back to them, and the epic *Aeneid* contains both pastoral and didactic passages. The three works can be thought of, in a sense, as 'one poetic space'.[7] A consequence of this for the reception of Virgil is that imitation of the *Aeneid* is often linked to imitation of the earlier works. In particular, allusion to the fourth *Eclogue*, whose political and cosmic vision could almost be read as a blueprint for the *Aeneid*, is often found together with allusion to Virgil's epic.

The *Aeneid* is a poem of very high quality, but that alone would not have assured it a central place in western culture. It achieved that position by being the particular kind of poem that it is, produced at a particular moment in history. It was written in the decade after the final victory of Octavian over Antony and Cleopatra at the battle of Actium in 31 BC (the ancient *Life of Virgil* by Aelius Donatus ascribes 11 years to the writing of the *Aeneid*, down to the death of Virgil in 19 BC).[8] In 27 BC Octavian took on the name Augustus. This was the decade that saw the institution of the principate and the passage from the Roman Republic to a *de facto* monarchy under Augustus, the first Roman emperor. At this moment of refoundation and transition Virgil created an epic poem that tells of a hero who flees from the destruction of his native city, Troy, and travels to Italy in order to found a new city. The hero, Aeneas, is also the ancestor of

the family (*gens*) into which Octavian was adopted by Julius Caesar, the *gens Iulia*, supposedly named after Iulus, the son of Aeneas (also known as Ascanius). Augustus was the first of the Julio-Claudian emperors, the line that came to a violent end with the death of Nero in AD 68. The city that Aeneas will found in Italy, after the end of the main narrative of the *Aeneid*, is Lavinium, from which his son Ascanius will found the city of Alba Longa, from which in the fullness of time Romulus will found Rome itself. While the action of the *Aeneid* is set in a remote legendary past, it constantly looks forward, through allusion and prophecy, to the foundation and history of the city of Rome, and to the person and rule of Augustus. Aeneas, forced by circumstance into the role of king of the Trojan refugees from Troy, is also trying out the role of Roman leader that Augustus was in the business of devising for himself in the years after Actium. Aeneas' journey to Italy, together with the whole history of Rome down to Augustus, is part of the plan of Jupiter or Fate, a way of claiming divine sanction for Augustus as the culmination of the historical process. The hero Aeneas has the added aura of being the son of the goddess Venus (and so grandson of Jupiter). On his death he will become a god, as will, in future centuries, Romulus, Julius Caesar and, in prospect from the point of view of Virgil's reader, Augustus.

No crude propaganda text, the *Aeneid* is yet deeply implicated in the construction of the principate. It quickly superseded what had been the national epic of the Romans, the *Annals* of Ennius (239–169 BC), which narrated Roman history from Romulus down to Ennius' own day. As the foundational epic of the Roman Empire the *Aeneid* becomes the central text for the five centuries of that empire's life, and then for later states and rulers which saw themselves as in some way successors of the Roman Empire.

The *Aeneid* asserts its canonical status in terms of literary-cultural, as well as political, history. It tells of the foundation of empire, and is itself imperialist in its literary ambition, which is no less than to establish itself as the Latin equivalent of the Homeric epics, the *Iliad* and the *Odyssey*. In antiquity Homer was viewed as the first and greatest of Greek poets, superhuman and almost divine, the fountainhead of all later Greek (and subsequently Roman) literature. Within its 12 books the *Aeneid* concentrates an almost unbelievably extensive and detailed imitation of the 48 books of the two Homeric epics.[9] Furthermore, as a logical consequence of the view that the Homeric poems contained the seeds of all later literature, the *Aeneid* contains allusions to a whole range of earlier authors and genres, both Greek and Roman, making it a consciously encyclopedic

epic. The ambition – and achievement – of the *Aeneid* is staggering: it is perhaps not surprising that Virgil is said to have written in a letter to Augustus that he must have been almost mad to undertake such an enormous task.[10]

The *Aeneid* thus completes an important stage in what is known as the 'Hellenization of Rome', the complex process whereby the militarily superior Rome negotiated its relationship with the cultural superiority of Greece. Homage to Homer and at the same time an imperialist appropriation of Greek cultural goods, the *Aeneid*, together with other Roman literature from the end of the Republic and the age of Augustus, by Cicero, Livy, Horace, Propertius, Tibullus, Ovid, goes to form a canon of Latin texts that can claim parity with the classics of Greek literature. One sign of the classic status of these Latin texts is that they become the central point of reference for later Roman authors. After Virgil Roman epic poets continue to allude to Homer, but the intertextual centre of gravity is always the *Aeneid*.[11] The history of imperial Roman epic, and of much post-antique epic in Latin and the vernaculars, is the history of responses to, and rewritings of, the *Aeneid*.

This is a book about the reception of the *Aeneid*, in other words the ways in which Virgil's epic has been commented on, critiqued, and imitated, a literary text that has inspired countless later writers and artists, including many of the greatest names in the western tradition, and a text that has also been enlisted in the service of politics and ideologies. But the story told in this book is part of a longer history stretching back before the composition of the *Aeneid*. The post-Virgilian reception of the *Aeneid* may be viewed as a continuation of the reception of pre-Virgilian literature, culture and history that is performed in the *Aeneid* itself, as Virgil uses the vast canvas of his epic to engage with previous Greco-Roman literary tradition as well as with wider military, political and cultural histories.

Modern criticism of Latin poetry has perhaps been overly obsessed with the hunt for 'metapoetics', the attempt to find commentary within texts on their own processes of poetic making, but it is hard not to see in the surface plot of the *Aeneid* reflections of the poem's own relationship to literary tradition, in images of transmission and translation, succession and inheritance. The overarching plot is the transfer of a people in the eastern Mediterranean to a new home in the west, in Italy, foreshadowing the later transfer of Greek literary and artistic goods from the eastern Mediterranean to Rome. More specifically, the journey from Troy to Rome reflects Virgil's own naturalization in Latin of the Greek epics of Homer. That was understood long before the twentieth century: in the

early sixteenth century Girolamo Vida, one of the most proficient of the many early modern imitators of Virgil who wrote in Latin, gives advice in his didactic poem on the *Art of Poetry* (1527) on the successful imitation of the ancient poets, and uses a number of images drawn from Virgil. These are practical examples of what it is that Vida is teaching, for very close verbal imitations of Virgil are put to work in quite different contexts. One of the images refers to the plot of the *Aeneid* as a whole: the successful imitator will put old material to new use (*Art of Poetry* 3.234–7), 'just as the Trojan hero [Aeneas] transferred the kingdom of Asia and the household gods of Troy to Latium, with auspices of better fortune, for all that, at the call of fate, unwillingly, Phoenician lady [Dido], he departed from your shore.' 'Transferred' is my translation of the Latin *transtulit*; the noun from the verb is *translatio*, one of whose meanings in classical Latin is indeed 'translation'. Vida is talking not about imitation across languages but about imitation in Latin of Virgil's Latin, but this is a useful reminder that translation (in our sense) is an important part of the reception of Virgil, important indeed for the wider literary history of the vernaculars into which the *Aeneid* has been translated.

There is more to be teased out of the lines quoted above from Vida: 'unwillingly, Phoenician lady, he departed from your shore' (*inuitus, Phoenissa, tuo de litore cessit*) is a light adaptation of the line in which Aeneas protests to the shade of Dido in the Underworld that he left the Carthaginian queen's shore unwillingly (*Aeneid* 6.460). The Virgilian line in turn is, notoriously, a light adaptation of a line in poem 66 of Catullus, the 'Lock of Berenice' (a model for Pope's *Rape of the Lock*), in which a lock of hair protests to its mistress, the queen of Egypt, that when it was cut off as a votive offering it had unwillingly left the queen's head (not shore). Vida inserts the line as a lesson in a multiple process of literary transference, or reception; he will not have known that the Catullan line in turn is (literally) a translation of a Greek original by the Alexandrian poet Callimachus.

Dreams, encounters in the Underworld, and the succession of sons to fathers are other Virgilian motifs that can be read as self-commentary on the *Aeneid*'s own relationship to its literary predecessors, and they are in turn used as images of their own literary ancestry by imitators of Virgil. John Dryden, in 'To the Memory of Mr. Oldham' (the poet John Oldham), alludes to the lament for the death of the younger Marcellus at the end of *Aeneid* 6: 'Once more, hail and farewell; farewell thou young, | But ah too short, Marcellus of our tongue.' But Dryden may succeed in reaching poetic maturity, where Oldham has failed. In his translation of the *Aeneid*

Dryden had discussed different interpretations of the lines at the end of *Aeneid* 6: "'Tis plain, that Virgil cannot mean the same Marcellus; but one of his descendants.' Dryden translates a difficult phrase in Aeneas' reaction to the vision of the younger Marcellus (*Aen.* 6.865 *quantum instar in ipso!*) as 'His son, or one of his illustrious name, | How like the former, and almost the same.' 'The beauty and propriety of the Virgilian allusion in "To the Memory of Mr. Oldham" derive from the gentle confidence that to Virgil, Dryden would be "one of his Descendants".' [12]

On the death of Virgil in 19 BC the *Aeneid* instantly became a school text.[13] A freedman of Cicero's friend Atticus is said to have been the first to lecture on Virgil in his school.[14] The rhetorician Quintilian in the late first century AD stipulated that schoolboys should begin their reading with Homer and Virgil, even if a more mature judgement is needed for appreciating their qualities; but for that there will be time, since they will be read more than once (*Education of the Orator* 1.8.5). The teacher himself would read out a poetic text, pointing out features of pronunciation, expression and prosody, in advance of the pupil's own reading. The satirist Juvenal, writing in the early second century AD, paints a picture of the badly paid schoolteacher, the *grammaticus*, literally 'grammarian', giving his lessons before dawn and having to endure the stench of the oil-lamps of his pupils, 'so that Horace is totally discoloured and the soot sticks to blackened Virgil' (*Satire* 7.226–7). Horace joins Virgil as a school-text.

This was a position that Virgil, together with a small number of other classical Latin authors, would maintain in grammar schools through the Middle Ages and Renaissance, and down to the twentieth century.[15] The texts were taught both to inculcate correct linguistic knowledge and to give moral lessons. As John Brinsley's teaching manual, *Ludus literarius* (1612), puts it, the boys should learn 'to make right use of the matter of their authors, besides the Latin [...] To help to furnish them with variety of the best moral matter, and with understanding wisdom and precepts of virtue, as they grow.' This kind of teaching reinforced a view of Virgil's texts as containing models of personal and social virtues that is very different from prevailing present-day ways of reading him.

As an authority for linguistic use, Virgil is also the most frequent source for illustrations in the ancient treatises on grammar. Domenico Comparetti, the great Italian scholar whose 1872 study of Virgil in later antiquity and the Middle Ages has not been supplanted, reckoned that 'if all the manuscripts of [Virgil] had been lost, it would be possible from the notices given us by the ancients of the Virgilian poems, and the passages

quoted from them by the grammarians alone, to reconstruct practically the whole of the *Bucolics*, the *Georgics*, and the *Aeneid*.[16]

Commentaries on Virgil started to be written soon after his death, beginning a tradition that continues down to the present day.[17] Of the two ancient commentaries on Virgil to survive complete, the more important is the massive commentary by Servius (late fourth/early fifth century AD) on all three of Virgil's poems.[18] As is generally the way of commentaries, Servius incorporates and builds on the commentaries of his predecessors, in particular that by the great scholar Aelius Donatus (earlier fourth century), the teacher of St Jerome and compiler of the most important of the ancient lives of Virgil. Servius' commentary was used throughout the Middle Ages and beyond; the first printed edition in Italy, in 1470, came only a year after the first printed edition of Virgil himself. Servius was followed by a number of Renaissance commentators; early modern editions of Virgil often print a number of commentaries together, in so-called 'Variorum' ('of various authors') editions. In these books a page typically displays a few lines of Virgil surrounded by a sea of commentary. The title-page of a 1499 Lyon edition of Virgil shows five commentators busy at their desks, with Servius, always the most important commentator, seated in the centre in the position of honour and writing at a larger desk.[19] The commentaries are an integral part of the reception of Virgil, not just the deposit of a separate scholiastic tradition: the point is made in the frontispiece painted by Simone Martini for the fourteenth-century manuscript of Virgil owned by Petrarch, whose own works engage in a profound dialogue with Virgil (Plate 1). In the painting Servius pulls aside a curtain to reveal Virgil in the act of composition. The other figures represent Virgil's three major works: beside Servius stands the armed Aeneas, hero of the *Aeneid*, while below a farmer pruning a vine symbolizes the *Georgics*, and a shepherd the *Eclogues*. One of the inscriptions reads: 'This is Servius, who recovers the mysteries of eloquent Virgil so they are revealed to leaders, shepherds and farmers.'

Servius is one of the interlocutors in the *Saturnalia* by Macrobius (early fifth century), learned and literary dialogues set during the Saturnalia of (?) AD 383. A central topic is the poetry of Virgil, who is praised as 'skilled in every discipline', and 'keen in his pursuit of elegance of expression'.[20] The discussions cover Virgil's oratorical skill, and his profound, and infallible, astronomical, philosophical and religious learning. The *Aeneid* is a sacred poem whose inmost shrine is to be opened up for the worship of the learned. This view of Virgil as an almost divine being and the encyclopedic repository of profound and universal wisdom mirrors an older view

of Homer as a godlike poet, the source of all literature and learning.

Macrobius' hero-worship of the Roman poet is also a reflection of the antiquarianizing nostalgia of the Roman elite in the last century of the western empire for their city's great and pagan past. But Virgil enjoyed star status already in his own lifetime, according to Tacitus who reports (*Dialogue on Orators* 13) that on the recitation of some of his verses in the theatre the audience all rose to their feet and paid homage (*uenerabatur*) to Virgil, who happened to be present, as if he were the Emperor Augustus (that other semi-divine human). The same verb is used in a letter by Pliny the Younger (3.7.8) of the veneration paid by the late first-century epic poet Silius Italicus (a faithful imitator of Virgil in his own epic) to the books, statues and pictures of Virgil, whose birthday (15 October) Silius celebrated more devoutly than his own, especially when he was in Naples, where he would visit Virgil's tomb (which he had bought) as if it were a temple. Virgil's (supposed) tomb, which survives in what is now a suburb of Naples, was the object of pilgrimage for centuries, and the subject of romantic paintings by Joseph Wright of Derby (Plate 2).[21]

Virgil's status as the incomparably great poet remained virtually unchallenged down to the seventeenth century. For Dante he is 'my master and my author' (*Inferno* 1.85). Julius Caesar Scaliger, author of one of the most influential works on poetics in the Renaissance, the *Poetices libri septem* (1561), says that 'Virgil should be our example, our rule, the beginning and the end' (*Poetices* 5.3). Like the relics of a saint, the materiality of the very words of Virgil is a part of their sacrosanctity, as is evident from two rather strange, to modern eyes, uses to which the text of Virgil has been put, the 'Virgilian lots' (*sortes Vergilianae*) and the *cento*.

The *sortes Vergilianae* is the practice of telling the future by opening a text of Virgil at random.[22] The same thing was done with Homer, and with that other sacred text, the Bible, as in Augustine's story (*Confessions* 8.29) of how on hearing the chant of *tolle, lege* 'pick up, read' in a children's game he was impelled to pick up the Bible and read the first passage he came across (Romans 13:13 f.), which told him to turn from the pleasures of the flesh to Christ. Evidence for the *sortes Vergilianae* in antiquity is confined to the unreliable late fourth-century *Historia Augusta*, which contains biographies of emperors of the second and third centuries AD. Here the *sortes* forecast to emperors or emperors-to-be the assumption or the loss of power, with most of the lines apparently hit upon by chance coming, not surprisingly, from the Parade of Heroes in the Underworld in *Aeneid* 6, the vision of the succession of the unborn souls of great Romans down to the time of Augustus. Verses on the final figure in that

parade, the prematurely dead younger Marcellus, crop up more than once as predictions of short-lived rule, an indication of how easily the lament for Augustus' young nephew, who was possibly being groomed for power when he died in 23 BC, could be taken as expressing a concern about the imperial succession – as it perhaps was already by Virgil's first Roman readers.

However, the *Historia Augusta* apart, the *sortes Vergilianae* seem essentially to be a Renaissance invention. The most famous English example is the story that during the English Civil War Charles I took the *sortes* in the Bodleian Library in Oxford, and hit upon the lines from Dido's curse in which she prays that if Aeneas is fated to reach Italy he should not live to enjoy his kingdom, but die before his time and lie unburied on the sand (*Aen.* 4.615–20). In Ben Jonson's play *Poetaster* (1601) Augustus appears as the first practitioner of the *sortes* when he asks Virgil to read from his *Aeneid* 'where first by chance | We here have turned thy book.' The passage chosen at random is that in *Aeneid* 4 describing the appearance of the monster Rumour after the union of Dido and Aeneas in the cave. The real-life fulfilment of the oracular text is instantaneous, with the entry of an informer, a purveyor of malicious rumour. In a comic example in Rabelais' *Tiers livre* (1536) Pantagruel and Panurge take the *sortes Vergilianae* in order to try and answer Panurge's question of whether to marry or not to marry. At the third taking of the lots they alight on *Aeneid* 11.782, 'she [the Amazonian warrior Camilla] raged with a woman's passion for booty and for spoil', which Pantagruel takes to mean that Panurge's wife will steal his goods and rob him. When Panurge does not agree, they turn to other methods of divination.

The *sortes Vergilianae* work by asking a fragment of Virgil's text to point to an event which was not included in the reference of that fragment in its original context. The cento (from the Greek *kentron* 'piece of patchwork') recombines a series of fragments of a text in order to produce another text meaning something different from the original. It is related to the literary pastiche, from Italian *pasticcio* 'pie containing a mixture of meat and pasta', a text cobbled together from bits and pieces from a variety of sources, usually to humorous effect. The cento is a stricter form, both because the fragments are taken from a single author and because the rules for the selection and combination are more rigorous: the unit of recombination is a half-line, a line, or a line and a half, rarely a longer segment. For an example of how this works in practice see the cento passage quoted below, p. 177. Most centos in Latin are patched out of fragments of Virgil, and the less numerous Greek examples are stitched together from fragments

of Homer. In other words, the cento is an act of homage to a canonical and almost sacred text, even if parodic, and it depends for its effect on its readers' deep familiarity with that text.[23]

Latin centos include the 'Nuptial Cento' (*Cento Nuptialis*) of the fourth-century Ausonius, a parodistic diversion of the words of Virgil to track the stages of a wedding (see below pp. 177–8), as well a number of centos on mythological subjects, including the late third-century *Medea* ascribed to a Hosidius Geta. In this extreme form of intertextuality allusive effects that reach deeper than the verbal surface cannot be ruled out: Geta draws heavily on Virgil's account of the abandoned Dido in constructing his tragedy on the subject of the abandoned and vengeful Medea, triggering the reader's recognition of Virgil's own extensive allusions to the story of Medea in his Dido narrative.

The cento is also a means of making Virgil speak the truths of Christianity. The first Christian cento, of the 350s or 360s AD, is by a woman, Faltonia Betitia Proba, who uses Virgilian language to retell Old and New Testament episodes from the Creation to the Crucifixion. Proba may have written her cento to get round a ban by the apostate emperor Julian on the teaching of pagan literature by Christians. The Christian cento is part of the wider phenomenon of the 'Christianization' of Virgil, in part to enlist the authority of the canonical Roman poet for Christian ends, and in part reflecting a belief that Virgil was in some sense a Christian before Christianity (see Chapter 6). The only surviving Homeric cento of any length is a biblical epic, and it was also composed by a woman, the Byzantine empress Eudocia (early fifth century). The Virgilian cento enjoyed a revival in the Renaissance, on subjects both sacred and erotic (for examples of each see below pp. 132, 178), and panegyrical, as in the late seventeenth-century cento panegyrics on the Hapsburg emperors Rudolf I and Rudolf II.

When Julius Caesar Scaliger said in his *Poetices* that in poetry Virgil was the beginning and end, he was passing a judgement in a long-standing debate as to the relative merits of Homer and Virgil. So long as post-antique western Europe, its Latin culture continuous with that of Roman antiquity, was to all intents and purposes Greekless, Virgil reigned supreme. But with the growing knowledge of Greek from the fifteenth century onwards the Homeric epics once more became available (as they had been to Virgil and educated Romans in classical antiquity), and a proper comparison of Homer and Virgil became possible, and indeed almost *de rigueur*, reviving a debate that goes back to Virgil's lifetime.[24] Even before the *Aeneid* was finished the elegist Propertius declared that 'something greater than the *Iliad* is being born' (Propertius

2.34.66). The rhetorician Quintilian tells how he asked his teacher who he thought came nearest to Homer. The reply was 'Virgil comes second, but he is nearer to the first than to the third' (*Education of the Orator* 10.1.86). Quintilian's own gloss on this judgement lays out some of the terms that will figure in later assessments of the relative qualities and virtues of the two: 'though we must yield to Homer's divine and immortal genius, there is more care and craftsmanship in Virgil, if only because he had to work harder at it; and maybe our poet's uniformly high level compensates for his inferiority to Homer's greatest passages.' Juvenal has a satirical picture of a blue-stocking at a party, pitting the two poets against each other and weighing Homer in one scale and Virgil in the other (*Satire* 6.434–7). Macrobius in the *Saturnalia* divides a long list of Homeric parallels in Virgil into three sections: passages in which Virgil improves on Homer, passages in which he equals his model, and passages in which he falls short.

We may find this kind of evaluative comparison of authors a distraction from more interesting forms of literary criticism, but it was deeply embedded in ancient ways of thinking about literature, and continued for centuries after. In the sixteenth and seventeenth centuries the palm usually went to Virgil, frequently with extravagant expressions of praise. Girolamo Vida ends his Latin didactic poem on the *Art of Poetry*, which might more accurately be labelled 'On the Art of Writing Poetry in the Manner of Virgil', with a full-scale hymn to his poetic god, calling on Virgil to 'pour your poetic ardour into our pure breasts', an equation of imitation and inspiration very far from Romantic ideas of originality. Homer was particularly found wanting in his lapses from literary decorum and in his repetitiousness – what we now identify as the formulaic manner of an oral tradition. Two of those who demurred from the prevailing 'Maronolatry' ('idolization of Virgil'; Maro is the last name of Publius Vergilius Maro) were both great translators, and deserve a hearing because of their very close engagement with the ancient texts. George Chapman (1559?–1634), translator of both the *Iliad* and the *Odyssey*, the latter a famous moment of revelation for Keats ('On first looking into Chapman's Homer'), says that 'Homer's poems were writ from a free fury, and absolute and full soul, Virgil's out of a courtly, laborious, and altogether imitatory spirit', and he goes on to hammer home the point about Virgil's total dependence on Homer.

John Dryden wrote probably the best English translation of Virgil, a poet with whom he shows a deep sympathy in his own works. Yet after translating the first book of the *Iliad* at the end of his life (published in

his *Fables Ancient and Modern*, 1700), Dryden claimed that 'I have found by trial, Homer a more pleasing task than Virgil [...] For the Grecian is more according to my genius, than the Latin poet [...] Virgil was of a quiet, sedate temper; Homer was violent, impetuous, and full of fire. The chief talent of Virgil was propriety of thought, and ornament of words: Homer was rapid in his thoughts and took all the liberties both of numbers, and of expression, which his language and the age in which he lived allowed him.'

Genius, freedom, inspiration: these are some of the key terms in the almost complete revolution in the comparative ranking of Virgil and Homer that was taking place by the end of the eighteenth century. For the Romantics Homer was the original genius, Virgil a late-coming imitator, servile not only in his dependence on Homer, but, even worse, a lackey of the autocrat Augustus.[25] In England the Augustanism of the seventeenth and early eighteenth centuries had been guided not just by a desire to match the aesthetic standards of the poets of the time of Augustus, Virgil and Horace chief among them, but also by the analogy perceived between Augustus' establishment after civil war of a settled form of government and the Restoration of Charles II and the re-imposition of a peaceful and prosperous monarchy after the English Civil War. A Royalist Virgil became less acceptable after the Glorious Revolution of 1688 and the introduction of a constitutional monarchy. Whig republicanism idealized the liberty of Republican Rome, swept away by the autocrat Augustus. A poem of 1740 is an early expression of the reaction against the politics of Horace and Virgil: 'Were they not flattering, soothing tools? | Fit to praise tyrants, and gull fools.'[26] The critic John Upton explained Virgil's desire to burn the *Aeneid* on his deathbed as the result of a guilty conscience, 'because it flattered the subverter of the constitution'.[27] For readers of this way of thinking, the great Roman poem of freedom is Lucan's epic on the civil war, the *Bellum Civile*, a protest written in the reign of Nero against the enslavement of free Romans by Julius Caesar and the Julio-Claudian emperors who followed him, an epic which modern critics often categorize as an 'anti-*Aeneid*'.

Add to this the growing fashion for the sublime and the rejection of the order and regularity of Augustanism. In the preface to Christopher Pitt's 1763 translation of the *Aeneid* (1763) the poet and critic Joseph Warton makes a striking comparison between Homer and Virgil:

He that peruses Homer, is like the traveller that surveys mount Atlas; the vastness and roughness of its rocks, the solemn gloominess of its

pines and cedars, the everlasting snows that cover its head, the torrents that rush down its sides, and the wild beasts that roar in its caverns, all contribute to strike the imagination with inexpressible astonishment and awe. While reading the *Aeneid* is like beholding the Capitoline hill at Rome, on which stood many edifices of exquisite architecture, and whose top was crowned with the famous temple of Jupiter, adorned with the spoils of conquered Greece.[28]

The contrast here between nature and artifice, between the original and the copy, is seen at its sharpest in Germany, in the worship of the new god Nature and its high priest Homer from the later eighteenth century. The consequent denigration of Virgil was reinforced by the association of Augustan Rome with Louis XIV's France.[29] August Schlegel, one of the leading figures in German Romanticism and translator of that other great child of Nature, Shakespeare, described Virgil as a 'skilful worker in mosaic' ('geschickter Mosaikarbeiter'), reducing him to little better than a composer of centos. Hegel said that 'Virgil seems to have copied Greek models completely, imitating them slavishly and lifelessly, and so they appear as plagiarisms more or less devoid of spirit.'[30] In Germany Virgil's reputation did not really recover until the twentieth century, a landmark in his rehabilitation being what is still one of the best studies of the *Aeneid*, *Virgils epische Technik*, by the great scholar Richard Heinze, published in 1903.[31]

In England Virgil's reputation never went into the near-total eclipse that it did in Germany, but some of the biggest names in English poetry did not pull their punches. Samuel Taylor Coleridge asked, 'If you take from Virgil his diction and metre, what do you leave him?', and Byron in a letter of 1817 referred to Mantua as the birthplace of that 'harmonious plagiary and miserable flatterer, whose cursed hexameters were drilled into me at Harrow'. A late and maverick example of Virgil-bashing is Robert Graves' 'The Virgil cult' (1961),[32] in which Graves reacts violently against T.S. Eliot's claim that Virgil was *the* canonical writer of the west. Graves lambasts Virgil's 'pliability, his subservience; his narrowness; his denial of that stubborn imaginative freedom which the true poets who preceded him had prized', and accusing him of helping to perpetuate Augustus' 'divine mystique'.

The poetic 'summits' chosen by Joseph Warton in his comparison of Homer and Virgil, Mount Atlas and the Capitoline Hill, in fact both feature in the landscape of the *Aeneid*. The description of the man-mountain Atlas at *Aeneid* 4.246–51 is one of the most striking and hyperbolical – indeed sublime – images in the poem;[33] and when Aeneas visits

what will one day be the Roman Capitol in *Aeneid* 8 it is the scene of mysterious and terrifying divine manifestations of a kind that well exemplifies the 'judicious obscurity' that Edmund Burke identifies as a source of sublimity in his *A Philosophical Enquiry into the Origin of Our Ideas of the Sublime and Beautiful* (1757).[34] Any simple opposition of the sublimity of Homer and the craftsmanship of Virgil (a literary-critical polarity that goes back to the ancient opposition of *ingenium* 'natural gifts, genius' and *ars* 'art, technique') quickly breaks down, as such oppositions always do. The increasing unease felt in the eighteenth century with the politics of the *Aeneid* had the effect of diverting attention to the discovery of features of the poem that were more in tune with the interests of the age, and to a focus on the 'sublime', the 'pathetic' and the 'picturesque'.[35] Joseph Warton does indeed comment that Virgil's description of Mount Atlas is 'very sublime and picturesque'; the storm that opens the narrative in *Aeneid* 1 and the description of Etna in *Aeneid* 3 were also recognized as set-pieces of sublimity. The eighteenth century responded to the emotional qualities of the *Aeneid*: Warton notes that 'the art of Virgil is never so powerfully felt, as when he attempts to move the passions, especially the more tender one. The pathetic was the grand distinguishing characteristic of his genius and temper.'[36]

Pathos in the sense of the arousal of emotions shades over into a view of Virgil as a poet of an acutely tender sensibility, the Virgil to which many nineteenth-century readers responded.[37] Already at the end of the eighteenth century the influential Scottish rhetorician and literary critic Hugh Blair asserted that 'The principal and distinguishing excellency of Virgil, and which [...] he possesses beyond all poets, is tenderness. Nature had endowed him with exquisite sensibility; he felt every affecting circumstance in the scenes he describes; and, by a single stroke, he knows how to reach the heart.'[38] This is the side of Virgil highlighted by the great French critic Charles Sainte Beuve in his *Étude sur Virgile* (1857), which draws out the poet's *humanité, pitié, sensibilité,* and *tendresse profonde*. Tennyson casts Virgilian sensibility in a solemn light in his poem 'To Virgil', written at the request of the Mantuans for the nineteenth centenary of Virgil's death in 1881. After evoking the laughter of the pastoral world of the *Eclogues* and the Golden Age of *Eclogue* 4, the poem turns towards thoughts of loss and impermanence with the following stanza (vv. 21–4):

Thou that seest Universal
Nature moved by Universal Mind;
Thou majestic in thy sadness
At the doubtful doom of human kind.

This generalized melancholy at the human lot is associated above all with one of the most famous lines in the *Aeneid*, and one of the hardest to translate, a line spoken by Aeneas as he looks at scenes depicting the sufferings of the Trojan War in the temple of Juno in Carthage in Book 1 (462), *sunt lacrimae rerum et mentem mortalia tangunt*. Here is the translation of John Campbell Shairp, a nineteenth-century Professor of Poetry at Oxford, 'Tears there are for human things | And hearts are touched by mortal sufferings,' 13 words for Virgil's seven.[39] Shairp was a protégé of Matthew Arnold, who found in the *Aeneid* 'an ineffable melancholy' and 'a sweet, a touching sadness', which Arnold also saw as a testimony to the *Aeneid*'s incompleteness, a melancholy rooted in 'the haunting, the irresistible self-dissatisfaction of his heart, when he desired on his death-bed that his poem might be destroyed'.[40] The mysterious phrase *lacrimae rerum* ('tears for things', 'tears of things'?) has come to be a motto for a worldview felt as a peculiarly Virgilian sensibility, expressing something, quite what is a matter for varied and conflicting views, about a tearfulness and sadness inherent in the nature of the world and/or in man's experience of the world.[41]

If the paths of the political and the pathetic diverged in the eighteenth century, they came together again in the twentieth. A soft-focus Tennysonian indulgence in the melancholy of things could not survive the horrors of World War I. A far more bitter response to the dehumanizing effects of war is registered in Wilfred Owen's 'Arms and the Boy', whose title satirizes the Virgilian heroic 'Arms and the man'.[42] But Virgil too becomes an uncompromised poet of the pity of war if a distance is set between those passages in the *Aeneid* where he celebrates the foundation and growth to world-empire of Rome and her ruling family, and those where he laments the premature deaths of those caught up in Aeneas' Roman destiny, Dido and all those young men who die in battle in the second half of the poem. Dominating criticism of the *Aeneid* in the second half of the twentieth century was some version of a 'two voices' reading of the poem, which sees the poem as split between a 'public voice' of triumph, celebrating the Roman establishment of peace and order and civilization, and a 'private voice' of regret for what is lost along the way.[43]

'The two voices of Virgil's *Aeneid*' is the title of a classic article of 1963 by Adam Parry,[44] for whom the emotions of grief are sublimated aesthetically in 'an artistic finality of vision'. Parry ends: 'The *Aeneid* enforces the fine paradox that all the wonders of the most powerful institution the world has ever known are not necessarily of greater importance than the emptiness of human suffering.' A New-Critical savouring of 'fine paradox'

will not satisfy those who insist that the aesthetic cannot be detached from the political. In what has become the prevalent reading in the English-speaking world the 'other' voice of the *Aeneid* is read as a voice of political criticism, dissent or even downright opposition to the brave new world of Augustus' Rome.

It is easy enough to sense in this the desire on the part of the tender liberal consciences of modern scholars to make Virgil 'one of us', and to save what by any standards is a great work of literature from the taint of having been written to the order of, or, even worse, in whole-hearted support of, an autocratic regime. One may compare versions of a 'republican Virgil' found in eighteenth-century criticism, reflecting the discomfort with a Royalist Virgil discussed above. Joseph Trapp, translator of the *Aeneid* into blank verse, says that 'It appears from many [...] passages that Virgil was a republican in his heart, as all honest men among the Romans then were; because a republic was the ancient established form of their government. But because he found that government utterly overturned, he wisely endeavoured to conciliate the affections of the people to that of Augustus.'[45] Edward Gibbon, in his *Critical Observations on the Sixth Book of the Aeneid* (London, 1770, pp. 12–13) adduces the figure of Mezentius, the monstrous Etruscan tyrant killed by Aeneas in *Aeneid* 10, as evidence that Virgil shared Milton's support for 'the daring pretensions of the people, to punish as well as to resist a tyrant. Such opinions, published by a writer, whom we are taught to consider as the creature of Augustus, have a right to surprise us: yet they are strongly expressive of the temper of the times; the Republic was subverted, but the minds of the Romans were still Republican.'

In the later twentieth century critics of Virgil have been somewhat schematically divided into 'optimists' and 'pessimists'. The optimists, also known as the 'European School' because of a series of continental, mostly German, studies, read the *Aeneid* as a text offering a positive account of Roman and Augustan history, while the pessimists, also known as the 'Harvard School' because of a seminal article written by Wendell Clausen who spent most of his career at Harvard,[46] find in the poem a dark message about Roman history and Augustan politics. More recently Craig Kallendorf, doyen of studies on the Renaissance reception of Virgil, has attempted to rebalance the history of the reception of the *Aeneid* by finding in early modern criticism and imitation of the *Aeneid* anticipations of a pessimist reading.[47] Richard Thomas, himself a noted Harvard Virgilian, has argued that what must still be acknowledged as a predominantly 'optimist' pre-twentieth century reception of the *Aeneid* amounts to little

less than a conspiracy to cover up the secret that Virgil was not a fully committed panegyrist of Augustus.[48]

This debate over the politics and ideology of the *Aeneid* is doubtless felt as a more burning issue inside the academy than outside. Despite the recovery of the poem's reputation from the negative judgements of the age of Romanticism and Revolution, it is true that the Homeric epics have enjoyed a greater popularity than the *Aeneid* in the modern age, and that they have been put to a wider range of uses in literary, cultural and intellectual spheres, a story told adroitly in Edith Hall's *The Return of Ulysses*, to which the present volume is a companion. For example, the *Aeneid*, unlike the *Odyssey*, has had a very limited reception in film[49] – a couple of silent films, now lost, on Dido and Lavinia, a 1962 sword-and-sandal movie *The Avenger* with Steve Reeves as Aeneas, a 1987 art film *Didone non è morta* directed by Lina Mangiacapre, an Italian television series based on the *Aeneid*. And there is the popular science-fiction series *Battlestar Galactica*, with its rather Virgilian plot-line of a leader guiding the remnants of a destroyed civilization towards a fated new home.[50]

I do not foresee a time when the *Aeneid* could again be labelled the central classic for contemporary culture. Yet Virgil has found a prominent place in the memorial for what has become one of the defining moments of the first century of the third millennium. In the National September 11 Memorial Museum, built underground on the site of the twin towers, the wall in front of the repository containing the remains of those victims as yet unidentified, bears an inscription in steel letters reforged from salvaged World Trade Center steel: 'No day shall erase you from the memory of time.' This is the pathos-laden line with which, in a rare moment of direct authorial engagement with his characters, Virgil addresses Nisus and Euryalus, two young Trojans who have been killed on a night expedition, *Aeneid* 9.447 *nulla dies umquam memori uos eximet aeuo*.

And if the *Aeneid* is no longer a central classic, there are signs of a continuing and flourishing longevity at a more local level: for example, the stream of new translations, which shows no signs of drying up; or the importance of Virgil for the Noble laureate Seamus Heaney, the sales of whose poetry have, unusually for the late twentieth and twenty-first centuries, broken through into something like a popular market. And the pockets of interest may not always be in expected places: a recent study of Virgil's presence in contemporary women's writing, in novels by, for example, Margaret Drabble, A.S. Byatt, and Ursula Le Guin, and poetry by Ruth Fainlight, Eavan Boland and others, points to the paradox that 'for the first time in literary history it is women writers who are creating

and defining this new *aetas Vergiliana* ['Virgilian Age']', when Virgil's works, and in particular the epic *Aeneid*, have for so long been associated with a masculine and patriarchal order of things.[51]

That the *Aeneid* should have been interpreted and assessed in such a bewildering diversity of ways, and appropriated by so wide a range of readers and writers, over the last two thousand years might be seen only as proof of the fact that 'meaning is only realized at the point of reception', as the modern theory of reception will have it. On the other hand it might be taken as an index of the inexhaustible complexity of the *Aeneid* itself, a text to which could be applied Walt Whitman's defiant boast in *Song of Myself*:

> Do I contradict myself?
> Very well then I contradict myself.
> (I am large, I contain multitudes.)

2

UNDERWORLDS

We start at the heart of the *Aeneid*, in a place where the laws of time in the historical world are suspended, and where the epic allows the hero and reader to range into the past and future. The hero's journey to the other world, the world of the dead, and, in some versions, of those yet to be born, is a standard feature of epic traditions as far back as the Babylonian *Epic of Gilgamesh*.[1] The ability to go beyond the limits of this world marks the exceptional status of the hero, and it gives him access to sources of knowledge unavailable to ordinary mortals. At the same time, both the journey and the initiation into privileged kinds of knowledge give the hero a better understanding of how to lead the limited existence that is this life, when he returns to his obligations in this world.

What the hero sees and learns in the other world is also for the benefit of us, the mortal readers of epic poems. The two major journeys to the land of the dead in classical epic are Odysseus' voyage to the Land of the Cimmerians and the world of the dead in *Odyssey* 11 (the so-called *Nekyia*, 'Necromancy'), and Virgil's reworking of the Homeric episode in the descent of Aeneas to the Underworld in *Aeneid* 6. Both episodes have a limited practical usefulness for the hero himself. Circe has instructed Odysseus to consult the dead seer Teiresias on how to achieve his return home, but in the event it is she who delivers most of the detailed geographical instructions when Odysseus returns to her island from the land of the dead. Aeneas is told about his descendants and about the city, Rome, which those descendants will build, but in the second half of the *Aeneid* he acts as if he has no recollection of what he has experienced in the Underworld. There may be good reasons for this in terms of plot-management – after all an Aeneas who faces all the dangers and tragedies of war in Italy armed with the constant foreknowledge of his people's glorious future might not be a very interesting hero. But one effect is to isolate the Underworld as an almost free-standing episode within the *Aeneid*, and this is

reflected in many of the later reworkings of the Virgilian Underworld.

This self-contained feel is enhanced by two differences between the Homeric and Virgilian journeys to the other world. Firstly, the *Nekyia* in *Odyssey* 11 is followed by another book of Odysseus' narrative of his wanderings and adventures, before his return to Ithaca and the beginning of the second half of the *Odyssey* in Book 13. Aeneas' descent in *Aeneid* 6 is the conclusion to the first, 'Odyssean', half of the *Aeneid*, and so the last episode of the hero's wanderings and adventures, before his arrival in the 'promised land' of Latium in Book 7, which is marked as the beginning of the second half of the poem by a new invocation to the Muse and by an elaborate sequence of divine machinery which motivates the 'Iliadic' war in Latium.

Secondly, Odysseus' journey to the land of the dead is undertaken by the normal means of travel, by ship, to the distant and murky land of the Cimmerians where Odysseus summons up the ghosts to the surface to be revitalized with sacrificial blood (although in the last part of the *Nekyia* Odysseus suddenly finds himself down in the Underworld itself). Aeneas undertakes a *katabasis*, 'descent', from this world to the Underworld, and his experience is sharply marked off from the world of normal waking consciousness by liminal passages at start and close. At the beginning an invocation by the narrator to the gods and ghosts of the Underworld is followed by a journey through a shadow-land to the insubstantial personifications that cluster at the entrance to Hades. At the end of *Aeneid* 6 Aeneas and the Sibyl leave the Underworld through the Ivory Gate of 'false dreams' (*Aen.* 6.893–8). These are mysterious lines that take a more straightforward Homeric description of the two gates of dreams, the ivory gate of false dreams, and the gate of true dreams made of horn (*Odyssey* 19.562–7), and rework them in such a way as to provoke an endless and inconclusive series of attempts at interpretation.

Taken as a whole the Virgilian Underworld is a signal example of the reception of a Homeric episode (the *Nekyia*). While the same might be said of many episodes in the *Aeneid*, the Underworld is peculiarly alert to cultural and textual memories and afterlives. It is a place where the hero Aeneas is reminded of his own past through a series of figures who also carry with them intertextual pasts, and where he also meets a parade of individuals who have a very literal kind of afterlife, since these are the souls of unborn Roman heroes whose lives on earth will come after the time of the primary narrative of the *Aeneid*. The 'Parade of Heroes' presents a great sweep of futurity down to the time of Virgil's own contemporary readers, the time of the new ruler of Rome, Augustus (Fig. 1).

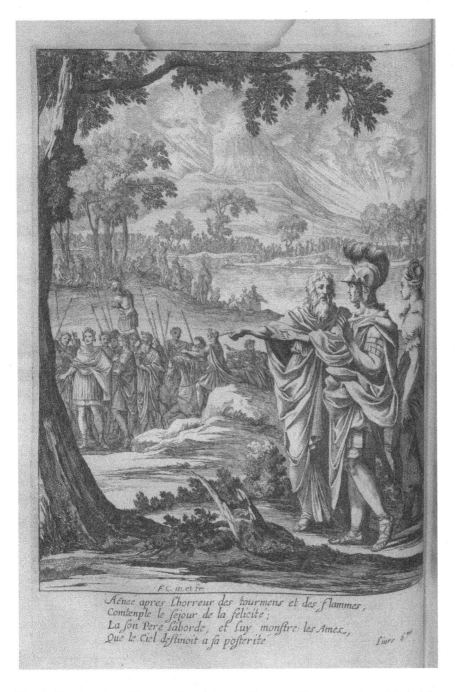

Aénée apres l'horreur des tourmens et des flammes,
Contemple le séjour de la félicité;
La son Pere l'aborde, et luy monstre les Ames,
Que le Ciel destinoit a sa posterité.

Liure 6.^{me}

Fig. 1. The Parade of Heroes. Engraving by François Chauveau, from Michel de Marolles, *Les Oeuvres de Virgile traduites en prose* (Paris, 1649).

What for Aeneas is a mixture of memories and prophetic revelation is, for Virgil's reader, a matter of memory, because of Virgil's peculiar technique of conveying history in the form of prophecy, both in the Parade of Heroes in *Aeneid* 6 and on the Shield of Aeneas in *Aeneid* 8 with its scenes of Roman history. In Book 6 both Aeneas and the reader travel through time. In what some modern critics have interpreted as a psychotherapeutic working through of past trauma, Aeneas first traverses his personal past, meeting people close to him who have died violent deaths, Palinurus, Dido, Deiphobus. He arrives finally at his own biological origin in the person of his father Anchises, who then throws the direction of time into reverse with the revelation of the future heroes of Rome, Aeneas' descendants, down to Augustus.

We the readers travel through time as registered in traditions historical, cultural and literary down to Virgil's own day. We pass firstly through a series of Homeric-style encounters, modelled on the series of people from his past whom Odysseus meets in the *Nekyia*, in a landscape that is recognizable as that of the traditional mythological topography of the other world as it had developed by the fifth century BC. When we arrive in the Elysian Fields we move on to the age of philosophy, as Anchises delivers, in the first part of his speech to Aeneas, a piece of philosophical didactic poetry, 'On the Nature of the Soul and the Nature of the World'. This injects the secrets of the natural world into the mythological Underworld, and hints at an allegorization of the traditional picture. The second and longer part of Anchises' speech, the Parade of Heroes, moves from philosophical didactic to historical epic, in an updating of Ennius' *Annals*, the Roman national epic written in the first half of the second century BC which narrated Rome's history from Romulus down to Ennius' own time. The Parade of Heroes reaches a climax with the new saviour-god Augustus, who surpasses the epic journeyings of the legendary Hercules and challenges the ambitions of the historical Alexander the Great, himself the subject of lost epics. The Roman *princeps* is thus the culmination of the whole of the previous epic tradition.

Allusion to Ennius' *Annals* also introduces another crucial element into the Virgilian Underworld. Aeneas' meeting with the shade of Anchises alludes to the dream in the prologue to the *Annals* in which the phantom of Homer announces to the sleeping Ennius that the true soul of Homer has been reincarnated in Ennius. This stunning scene of transmission, in which the earlier author has been received fully within the person of the later author, is a prime example of what was to become a common conceit in Renaissance and later literature, metempsychosis as a figure for

the 're-embodiment' of an earlier author by a literary successor. An oft-cited example is that by Francis Meres (1598): 'As the soul of Euphorbus was thought to live in Pythagoras, so the sweet witty soul of Ovid lives in mellifluous and honey-tongued Shakespeare.'[2] In the Virgilian scene paternity, rather than metempsychosis, is an implicit figure for poetic succession, as Anchises-Ennius hands over to Aeneas-Virgil the baton of Roman historical epic.[3]

The epic Underworld, which stores the shades of all those who have ever lived, is a kind of time-free repository for memory and tradition, into which succeeding epic poets can descend to draw material for new poems. It is already possible to see the Homeric Underworld as performing this function of storehouse of tradition.[4] Enacting its own reception of pre-Virgilian literary history, the Virgilian Underworld also looks forward as it offers itself for reception and adaptation by later writers.

The histories embedded in the Virgilian Underworld have a largely positive trajectory: towards a ruler, Augustus, whose coming marks a new era in human history and the beginning of a Golden Age, and towards the epic poem, the *Aeneid*, which bids both to incorporate and to outdo the previous epic tradition. Modern critics have pinpointed moments of doubt and criticism in the politico-historical message of the main body of the Speech of Anchises,[5] but it requires no hermeneutic suspicion to register the grief and sense of loss in the coda, the threnody for the younger Marcellus, nephew of Augustus, whose premature death in 23 BC cut off a promising future. Here Anchises' and Aeneas' personal sorrow at the fate of one of their descendants merges with the communal grief of the Romans of Virgil's day, 'the huge grief of your people' (*ingentem luctum [...] tuorum*), as Anchises tells his son (*Aen.* 6.868). A journey to the other world that concludes with the snatching away of something promised points back to the other great Virgilian Underworld narrative, the story of Orpheus and Eurydice in the fourth *Georgic*, of which there are echoes in other episodes in the *Aeneid* that have an infernal quality to them: Aeneas' loss of his wife Creusa in Book 2 just as they are about to escape from the Hellish night of the sack of Troy, and Nisus' failure to check that his boyfriend Euryalus is following him as they try to escape from their Italian pursuers in the night episode in Book 9. Later authors sometimes combine imitation of the Underworlds of *Georgics* 4 and *Aeneid* 6.

The reception of the Virgilian Underworld begins with the Roman epic successors to Virgil. Ovid offers a typically oblique and fragmented response to *Aeneid* 6. As he tracks the plot of the *Aeneid* in *Metamorphoses* 14, the momentous Virgilian journey of Aeneas to the Underworld

in the company of the Sibyl is dispatched in a breezy four-line summary (14.116–19), matching the four-line summary of the tragic matter of Dido and Aeneas shortly before (*Met.* 14.78–81). In some of the most famous, and most quoted, lines in the *Aeneid* Virgil's Sibyl tells Aeneas before his descent (6.126–9), 'Easy is the descent to Hades (*facilis descensus Auerno*): dark Pluto's door is open day and night. But to retrace one's steps and make it back to the upper air, that is the task, that is the labour.' In Ovid the difficulty of the return is no more than that of a hard uphill slog through the darkness, which Aeneas whiles away in conversation with the Sibyl, who tells an erotic story of how Apollo tried to take her virginity. Here it is hard not to use the word 'parody', and the portentous solemnity of the Underworld episode irresistibly provokes burlesque (for further examples see Chapter 8, pp. 178–80).

Ovid had provided a fuller infernal topography in *Metamorphoses* 4, in the course of a series of Theban stories in Books 3 and 4 which together constitute an 'anti-*Aeneid*', a deformation of the providential teleology of the *Aeneid* that anticipates the large-scale 'anti-*Aeneid*' of Lucan's epic on the civil war between Caesar and Pompey.[6] Juno descends to the Underworld to summon the Fury Tisiphone to send Athamas and Ino mad. Here Ovid combines the physical descent to the Underworld of *Aeneid* 6 with Juno's evocation from Hades of the Fury Allecto in *Aeneid* 7 in order to infuriate Turnus and Queen Amata against the Trojans, newly arrived in Latium. As a form of reception 'combinatorial imitation' of two separate Virgilian episodes implicitly registers a connection that the reader Ovid has seen within the *Aeneid*. Books 6 and 7, the two books that straddle the division between the two halves of the epic, offer two very different accounts of the relationship between the Underworld and this world. The ordered topography of the eschatology of Book 6 presents a clarification of the chaotic experience of living in this world.[7] The various classes of the dead are put in their proper places, and Aeneas is offered a vision of the whole course of future Roman history *sub specie aeternitatis*, ending with a new Golden Age under Augustus, the fiction of the end of history. Shortly before the final stage of his infernal journey Aeneas comes to a fork in the road, the left leading to Tartarus, the right to the Elysian Fields, a sharp dichotomy between the places of the damned and the blessed not found in the Homeric *Nekyia*, but fully developed by the time of Plato.[8] Aeneas takes the path to the Elysian Fields to meet his father; the Sibyl tells him that no pure (*castus*) human being can enter Tartarus, and describes the punishments suffered inside by the great sinners of myth. The security-guard at the gate of Tartarus is the Fury Tisiphone with her

whip. This orderly classification is taken up and developed, sometimes at great length, in post-classical cartographies of the afterlife, as in Dante's *Divine Comedy* or in Charlemagne's visit to the other world in the neo-Latin epic on Charlemagne, the *Carlias* by Ugolino Verino (1438–1516) (see p. 41 below).

Thus the dualism of good and evil is safely policed in the Underworld of Book 6. It seems that after the revelation of a vision of the glorious future of Rome Aeneas safely crosses the boundary between the other world and the world of the living when he exits via the Gate of Ivory. But in Book 7 the Trojans' idyllic arrival at their promised land of Latium quickly turns into a hell on earth when Juno summons up from the Underworld one of Tisiphone's sisters, the Fury Allecto, in order to provoke all-out war between the Trojans and the Italians. Virgil projects the dichotomy of Heaven (the Elysian Fields) and Hell (Tartarus) as places of reward or punishment in the next life, on to a dualistic struggle in the processes of history in this world between the forces of light and darkness, order and disorder, Heaven and Hell.[9] This is not an absolute theological dualism, since the chief protagonists on either side, Jupiter and Juno, are brother and sister, husband and wife, and Virgil has no sooner constructed his dualistic template than he begins to deconstruct it in various ways. Nevertheless the *Aeneid*'s tendency to structure its narrative as a Manichaean dualism, unprecedented in what survives of earlier Greek and Roman epic, translated easily into any number of narratives based on a Christian view of the world and of history (see Chapter 6).

Juno's use of the forces of Hell to inject new and demonic life into the second half of an epic which is in danger of running out of steam after the hero's safe arrival in Italy was much imitated by Virgil's Latin epic successors in antiquity from Ovid onward. A fuller machinery for this plot device, now transferred to the beginning of an epic narrative, was provided by the late-antique epic poet Claudian (born *c.* 370). Claudian combines the motif of summoning a Fury (or other Hellish agent) to create madness and strife on earth with the stock epic scene of a council of gods, but in this case a council of the gods of the Underworld. The main narrative of Book 1 of *In Rufinum*, Claudian's invective against Rufinus, the Praetorian Prefect of the eastern Roman Empire (AD 392–5), opens with the word *Inuidiae*: Allecto is fired with 'envy' at the sight of cities of the earth enjoying peace. She convenes a council of her sisters, their numbers swollen with a crowd of personifications of evils that is modelled on the personifications that cluster at the entrance to the Virgilian Underworld. Allecto takes the podium, and complains of the Furies' passivity in the

face of a new Golden Age presided over by the emperor Theodosius and Justice. The Furies have been expelled from all their kingdoms (59: *omnibus eiectae regnis*). Allecto appeals to her sisters to 'recognize what befits the Furies, and to resume the powers that have fallen into disuse'. This is an invitation to an intertextual recognition and renewal of the actions of the Furies, familiar from the line of earlier Latin epics going back to *Aeneid* 7. Warning against a direct attack on the gods, Allecto's sister Megaera advocates instead an assault on the world of humans through the agency of her nursling, the monstrous Rufinus. Megaera ascends to the surface at a place on the coast of Gaul identified with the land of the Cimmerians where Odysseus consulted the dead. In a replay of Allecto's approach to Turnus, Megaera disguises herself as an old man and rouses Rufinus to action.[10]

Claudian's *In Rufinum* is the main model for the many councils of devils summoned by Satan in medieval and Renaissance epics that operate with a Christian divine machinery. In the tenth and last book of the twelfth-century Walter of Châtillon's widely read epic on Alexander the Great, the *Alexandreis*, Nature is enraged by Alexander's determination to open up hidden parts of the world. She descends to an Underworld which contains personifications of sins, corresponding to the personifications of evils at the threshold of the Virgilian Underworld, together with a landscape of Christian purgatorial fire. Nature complains to Leviathan-Satan, who calls a council of the captains of Hell, and asserts that Alexander is planning to invade and conquer Hell itself – Leviathan has heard that it is fated that a human being will burst open and lay waste the Underworld with 'triumphal wood', mistaking Alexander for Christ. The personification of Treachery undertakes to engineer the fatal poisoning of the Macedonian king.[11] The Renaissance tradition of infernal councils reaches a climax in the particularly complex example of the 'great consult' summoned by Satan in Book 2 of Milton's *Paradise Lost*.

Another hellishly disruptive creature in the *Aeneid* is the personification of *Fama*, 'Rumour', who bursts forth after the union of Dido and Aeneas in the cave in *Aeneid* 4 in order to propagate rumours about the sexual scandal (Fig. 2).[12] *Fama* is a chthonic being, the daughter of Earth and sister to the Giants who fought against the Olympian gods. She is the major example in the *Aeneid* of an extended personification allegory. Together with the Virgilian Fury Allecto, who is herself virtually a personification of madness and frenzy (*furor*), *Fama* is a crucial model for the five major personifications in Ovid's *Metamorphoses* (Envy; Hunger; Sleep; Morpheus, the god of dreams; *Fama*).[13] The Virgilio-Ovidian series

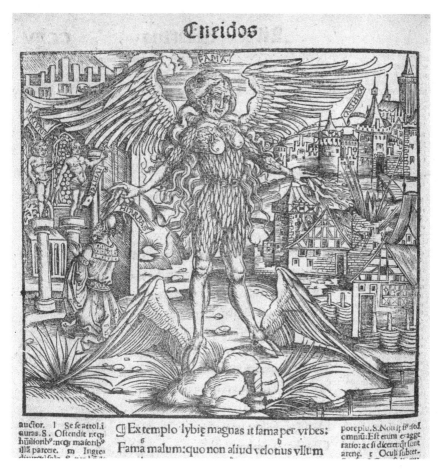

Fig. 2. *Fama* in *Aeneid* 4, woodcut in *Publii Virgilii Maronis Opera*,
ed. Sebastian Brant (Strassburg, 1502).

of personifications spawns a vast progeny in the medieval and Renaissance
tradition of personification allegory. The Houses of the Ovidian personi-
fications are places closely related to the Virgilian Underworld, and this
affinity offers further Ovidian comment on the nature of the Underworld,
as well as exemplifying the frequent presence in epic of figurative or allu-
sive underworlds.

Like the door of the Virgilian Underworld, the Ovidian House of
Fama 'lies open night and day' (*Met.* 12.46), a reminder that the Virgil-
ian Underworld is a vast repository of cultural and literary 'tradition' (one
of the meanings of the Latin word *fama*). This connection is picked up

by Chaucer and Alexander Pope.[14] In Chaucer's *House of Fame* the whirl-ing house of twigs, a conduit for all manner of news and reports, and a lower-class version of the main palace of fame, has doors open day and night, like Ovid's House of Fame and Virgil's Underworld. Allusions to Revelation, to the Last Judgement and to Dante's otherworldly journey in the *Divine Comedy*, import Christian eschatological associations into Chaucer's dream-vision. Queen Fame's distribution of fame or blame to her petitioners as she sits in judgement, totally arbitrary though it is, hints at the function of the Underworld as a place for final judgements on the lives lived in this world. Pope, in his *Temple of Fame*, a neoclassical updat-ing of Chaucer's medieval poem, further develops the otherworldly asso-ciations. The Temple is set on top of a (Chaucerian) rock of ice: 'Steep its ascent, and slippery was the way' echoes and inverts Virgil's *facilis descen-sus Auerno*, via Dryden's English translation of Virgil's Latin, 'Smooth the descent, and easy is the Way'. The description of the Temple itself is much indebted to an infernal architectural masterpiece, Pandaemonium, the palace of the fallen angels at the end of Book 1 of Milton's *Paradise Lost*.

Yet another Ovidian version of the world of the dead is the House of Sleep in *Metamorphoses* 11, located near the land of the Cimmerians, the setting for Odysseus' necromancy in *Odyssey* 11. Ovid's House of Sleep is a place of darkness through which flows Lethe, the infernal river of 'forget-fulness'. In answer to a request from Juno, Sleep sends Morpheus, the god of dreams, to appear to Alcyone in the likeness of her drowned husband Ceyx, a *revenant* from the world of the dead. Sleep and Death are already brothers in Homer.

Ovid also exploits a frequent connection between visits to the Under-world and dream-visions. The use of a narrative of a literal journey, either in the body or as disembodied soul, to the other world as a vehicle for phil-osophical instruction opens itself to the charge of being a poetic fiction. One defence is to frame such an experience as (just) a dream-vision, for example Cicero's Dream of Scipio at the end of his *Republic*, a reworking of the Myth of Er at the end of Plato's *Republic*, in which Er's soul travels to the afterlife in an out-of-the-body experience. The Platonic and Cicero-nian passages are both important models for Aeneas' *katabasis*; Aeneas' exit via the Homeric Ivory Gate of dreams is perhaps a hint that it was all just a dream, and Aeneas' entry into the Underworld has an equally unreal quality to it. Virgil takes care not to presume too much on the credu-lity of his sophisticated readers. Dream-visions, a staple form of medieval narrative in particular, are often vehicles for accounts of the Underworld; Chaucer's eschatologically coloured *House of Fame* is a dream-vision.

Signally missing from the Ovidian episodes reviewed so far is the philosophical and historiographical content of the Speech of Anchises in *Aeneid* 6. Ovid displaces this from the other world into the mouth of a living character, but one who has privileged first-hand experience of the soul's transmigration through a series of embodiments, a doctrine of which Virgil's Aeneas had learned from the shade of his father. The philosopher Pythagoras' long speech in the last book of the *Metamorphoses* was valued in the Middle Ages and Renaissance as a poetic exposition of the secrets of natural philosophy, just as the Virgilian Underworld was prized for its revelation of the mysteries of the universe. These are not qualities high on the list of most modern readers of poetry. The Ovidian Pythagoras' sermon on metempsychosis and the consequent need to practise vegetarianism, to avoid the risk of eating a reincarnated relative, modulates into a disquisition on the universal principle of mutability, of which the last examples are the rise and fall of cities. The latest of these cities is the nascent Rome, whose future world-rule Pythagoras remembers to have heard prophesied in a previous incarnation. As in the Speech of Anchises, Roman history forms the climax of a grand philosophico-historical package, but a doctrine of universal change can only put in question the Virgilian message that long historical process will culminate in the enduring world-rule of Rome in a new Golden Age.

Lucan, in his epic on the civil war between Caesar and Pompey, mounts a frontal assault on the Virgilian message of a *pax Augusta* achieved after centuries of wars foreign and civil. In another sixth book Sextus Pompey, the degenerate son of Pompey the Great, learns of the secrets of the dead not through a *katabasis*, but through necromancy, a variant on the Homeric *Nekyia*. Where Odysseus had called up the shades of the dead and given them blood to drink to enable them to speak, Lucan's terrifying night-witch Erictho revives a body left on the battlefield and forces it to speak against its will. The dead man reports that civil war has broken out among the Roman shades (6.780), introducing the chaos of Roman history into the orderly dispositions of the traditional Underworld. Sextus Pompey is offered no vision of future world-empire, but instead is warned that he will find no safe hiding-place in any of the three continents of Europe, Africa or Asia.

Silius Italicus (*c.* AD 26–102) combined close imitation of the *Aeneid* in his epic on the war between Rome and Hannibal, the *Punica*, with a more direct devotion to the shade of Virgil, whose tomb near Naples he bought and venerated (see p. 9 above). Unsurprisingly, Silius pays homage to Virgil in what is the longest rewriting of Aeneas' visit to the Underworld in any

ancient Roman epic. In *Punica* 13 Silius' hero, Scipio Africanus, goes to Cumae, the site of Aeneas' previous descent, to ask the current Sibyl of Cumae to allow him to call up the ghosts of his father and uncle, recently killed in battle. Contact with the other world is established through the Homeric method of giving sacrificial blood to the ghosts, since a literal *katabasis* would be out of place in a historical epic. Intertextuality manifests itself in ghostly presences:[15] the first shade to drink the blood and to be given back her voice is that of the Sibyl who accompanied Aeneas to the Underworld. Scipio is presented with a pageant of great men in Roman history, past and future. He also encounters two famous Greeks: firstly, Alexander the Great, whose glorious career is a stimulus to Scipio's own achievement, as, allusively, it had been a model for Anchises' praise of the unborn Augustus in the Virgilian Parade of Heroes;[16] and secondly Homer, the author of the first heroic visit to the Underworld, and the source of the whole Greek and Roman epic tradition, which is thus safely stored *in nuce* within the Silian Underworld. Scipio, repeating the famous wish expressed by Alexander the Great at the tomb of Achilles that he too might have a Homer to celebrate his deeds, wishes that the fates might allow Homer to praise the deeds of the Romans. That wish has in a sense come true between the lifetimes of Scipio and Silius: the 'Roman Homer', Virgil, had written the great national Roman epic. Scipio's own sense of unfulfilled potential is reinforced by dense verbal echoes in the lines on Homer of the episode of the younger Marcellus at the end of *Aeneid* 6.[17] More generally that sense of loss may be felt to colour the relationship of an epigonal poet to a great predecessor, of a Silius to a Virgil, who can only ever be present in the ghostly form of his text.

Both the wish for a second Homer and the impossible yearning for contact with the great poet of the past feature in Petrarch's Latin epic poem on the second Punic War, the *Africa*, left unfinished at Petrarch's death in 1374.[18] The hero of this epic is again Scipio Africanus, Petrarch's ideal of classical pagan virtue. Ironically Petrarch was thwarted of any contact with Silius Italicus' epic on the same subject by the brute fact that Silius' *Punica* was only rediscovered by the humanist book-hunter Poggio Bracciolini in 1417, although knowledge of the *Punica* might have deterred Petrarch from his own project. In the last book of the *Africa* Scipio returns in triumph to Rome from his victory over Hannibal in Africa, accompanied by the epic poet Ennius, who modestly regrets that Scipio, like Alexander the Great, does not have a Homer to celebrate his deeds. Ennius then recounts a dream in which the shade of Homer appeared to him, ragged, with unkempt beard, and with empty eye-sockets. This recon-

struction of the Ennian Dream of Homer at the beginning of the *Annals*
is full of other literary ghosts, alluding as it does to several Virgilian
apparitions, including Aeneas' dream of the mutilated ghost of Hector on
the night of the sack of Troy in *Aeneid* 2, and also to Dante's meeting with
the shade of Virgil in the first canto of *Inferno*.[19] As Petrarch converses
with Homer in his dream he catches sight of a young man sitting apart
in an enclosed vale (9.216 *clausa sub ualle*), which is both a version of the
sequestered vale (*Aen.* 6.703 *in ualle reducta*) in the Elysian Fields where
Aeneas sees the souls of the unborn, and Petrarch's own Provençal valley
of poetry, Vaucluse. The words exchanged between Petrarch and Homer
on the subject of this young man carry multiple echoes of the exchange
between Aeneas and Anchises on the subject of the younger Marcellus
in *Aeneid* 6. It turns out that the young man is none other than Petrarch
himself, whose *Africa* will celebrate the deeds of Scipio. Ennius is eager
to converse with his poetic rival from the distant future, but is prevented
when the morning trumpet in Scipio's camp wakes him from the dream.
The pathos overlaid on the frustrated encounter by the echoes of Virgil's
Marcellus reflects in part the possibility that Petrarch may not be able to
realize his own potential in his literary aspirations, in part the impossibil-
ity of that full encounter in person between Petrarch and the great dead
authors of the ancient world.

Petrarch's project of reviving the classical past is often conducted in
the mode of necromancy.[20] Dreams and the Underworld provide spaces
in which the living and the dead can meet. One of Petrarch's most popu-
lar works in the Renaissance was the *Trionfi*, the successive 'Triumphs'
of Love, Chastity, Death, Fame, Time and Eternity, with pageants of
famous people from the past. In form the *Trionfi* are another dream-
vision, in which the dreamer comes into the presence of the dead, and the
characters who pass in procession constitute an encyclopedic review of a
largely classical tradition in a Dantesque setting. Petrarch also attempts
to establish contact with those long dead in a series of letters to great
writers of the classical past, including a verse epistle 'To Virgil the heroic
[i.e. epic] poet and the first poet of the Latins' (*Fam.* 24.11). In his letter
Petrarch imagines Virgil in an Underworld that combines allusion to the
Elysian Fields in *Aeneid* 6, where Aeneas encounters the mythical poets
Orpheus and Musaeus, with allusion to the first circle of Inferno where
Dante finds the great poets of pagan antiquity.[21]

The intensity of the desire to be reunited with a dead loved one
conveyed by Virgil in the story of Orpheus and Eurydice in *Georgics* 4 is
replicated in *Aeneid* 6 both in the emotional reunion of Aeneas with the

shade of his father, and in the book's concluding lament for the younger Marcellus. Elsewhere Virgil evokes the uncanny power of the *revenant* in the unsettling confusion of the living with the dead Hector on the part of Aeneas in his reaction to his dream of Hector on the night of the sack of Troy (*Aeneid* 2.270–86), and in Andromache's initial inability to decide whether Aeneas is alive or a ghost when he comes to Buthrotum in *Aeneid* 3 (306–12). Passages like these prompt a necromantic and visionary strain both in the reception of Virgil's poetry, for example the visions of dead Trojan heroes who appear to Aeneas in Act V of Berlioz' opera *Les Troyens* to order him to leave Carthage, and in the medieval legends about Virgil the magician and necromancer.[22] Virgil himself has a way of coming back, or almost, from the dead. In a development of the legend that St Paul visited Virgil's grave at Naples, and wept that he was too late to have converted the living poet to Christianity, the thirteenth-century Gautier de Metz relates Paul's grief on arriving at Rome to find that Virgil had just died, too late to be converted. 'Ah, if I had found you, I would have given you to God!' Paul discovers the subterranean chamber in which Virgil has been buried, and sees him seated between two lighted tapers surrounded by books thrown in confusion, with a lamp hanging above him and before him an archer with a drawn bow. The archer's arrow flies against the lamp and everything falls into dust.[23]

The sixth-century Fulgentius presents his *Exposition of the Content of Virgil* as the revelation to the author of the mysteries of the *Aeneid* by the stern ghost of Virgil himself. In one of a number of stories of dreaming about Virgil, St Hugo, Abbot of Cluny, saw a host of snakes and wild animals lying beneath his head; on shaking his pillow he found a copy of Virgil beneath it. The ninth-century Ermenrich of Ellwangen writes to the Abbot of St Gall telling of a terrifying night vision. Laying down his head after reading Virgil he was visited by a horrible dark monster, carrying sometimes a book and sometimes a pen at his ear, as if about to write, and laughing at Ermenrich, or mocking him for reading his words.[24] The eleventh-century Wilgard was visited at night by three devils in the shapes of Virgil, Horace and Juvenal.[25] And if Petrarch was in the habit of writing letters to dead poets, a twentieth-century classicist, the South African Theodore Haarhoff, used spirit-writing and mediums to communicate with the dead Virgil, and put questions to him from the Virgilian scholar W.F. Jackson Knight concerning the interpretation of the text, as Jackson Knight prepared his Penguin translation of the *Aeneid*.[26]

To return to Petrarch: Ennius' dream in Book 9 of the *Africa* is only a part of the poem's response to the Virgilian Underworld, of which

Petrarch, like Ovid, makes multiple copies. A survey of Roman history, past and future, is supplied to Scipio by his father in a dream, which, in a very unclassical management of the epic narrative, takes up the whole of the first two books of the poem, reworking both the Ciceronian Dream of Scipio and the Parade of Heroes shown to Aeneas by Anchises in a scene already indebted to the Ciceronian Dream. Petrarch's Scipio breaks off in the middle of his encomiastic survey of Roman history to deliver a full-blown sermon on the vanity of the ambition and achievements of this world. The seed of this is the elder Scipio's lesson to Africanus, in the Ciceronian Dream, of the insignificance of Roman glory within the longer temporal and spatial perspectives of the afterlife, but Petrarch develops this with the vanity topics of late antiquity and the Middle Ages, together with a nod to the Ovidian Pythagoras' doctrine of universal mutability. Qualification of praise, pessimism, even, are aspects of the Virgilian Parade of Heroes that recent criticism has sought to highlight. An aversion to imperialisms and a distaste for panegyric are factors that favour this modern turn in Virgilian criticism; Petrarch's leavening of panegyrical history with vanity topics has more to do with religious motives, and can also be seen as an expression of the famous Petrarchan 'dissidio', his inner division between the values of this world, values framed by Petrarch in largely classical terms, and the Christian values of the next world.

Finally, Petrarch gives us the full mythological version of the Underworld when Sophonisba, the African queen who has committed suicide for love like Dido, descends to confront the judges of the dead at the beginning of *Africa* 6. They send her to the Virgilian 'Fields of Mourning', the proper place for those who have died for love, and which, since the time that Aeneas met Dido there, has also received Turnus, grieving for the wife who was snatched from him, Lavinia (*Africa* 6.64).

Virgil, like Homer, was regarded as a source of profound scientific and philosophical wisdom, and the mysteries of *Aeneid* 6 were the greatest proof of Virgilian profundity. We have seen how Ovid comments on the philosophical content of the first part of the Speech of Anchises by putting an imitation in the mouth of an actual philosopher, Pythagoras. The late-antique commentator Servius writes of *Aeneid* 6: 'All of Virgil is full of learning, but in this respect this book, the greater part of which is taken from Homer, claims first place. Some things in it are simple narrative, but much is taken from history, and much shows a deep knowledge of the philosophers, the theologians, and the wisdom of Egypt, with the result that many have written whole treatises on individual topics in this book.' Bernardus Silvestris in the twelfth century says of *Aeneid*

6 that 'Virgil reveals philosophical truth more profoundly in this book.' Throughout the Middle Ages and Renaissance a vast amount of exegetical energy was expended on *Aeneid* 6, often applying an allegorical interpretation in order to extract philosophical and theological truths.[27] Virgil, we have seen, hedges his bets as to the reality of Aeneas' descent to the Underworld. The line of least resistance was to say that the narrative of *katabasis* is an allegory of non-literal kinds of descent. The idea that the legendary punishments of sinners in the Underworld are really figures for the self-inflicted torments of the vices of greed, ambition, lust, etc. in this world goes back to Plato (in the *Gorgias*) and to Lucretius, who as an Epicurean materialist denies the survival of the soul after death, and allegorizes the mythological punishments in his diatribe against the fear of death in Book 3 of *On the Nature of Things*.

Macrobius' early fifth-century commentary on the Ciceronian Dream of Scipio is a treatise whose reception is tied closely to that of the Virgilian Underworld. In it Macrobius distinguishes another way in which this life may be said to be a kind of death, through the Platonic doctrine of the descent of the soul into a lower part of the universe when it enters the 'tomb' of a human body in the life of this world. A fully developed typology of descent emerges in the twelfth century: Bernardus Silvestris distinguishes four types: 1. 'The descent of nature', the 'entombment' of the soul in a natural body. 2. 'The descent of virtue', the wise man's consideration of worldly matters in order to turn more effectively to the invisible world. This was the descent of Orpheus and Hercules. 3. 'The descent of vice', the irreversible immersion in the vices of this world. 4. 'The artificial descent', the use of necromancy to consult demons.[28] Versions of this are found in the preface to the commentary on the *Divine Comedy* by Dante's son Pietro Alighieri; in the mythological handbook *On the Labours of Hercules* by the early Florentine humanist Coluccio Salutati (1331–1406), the whole of whose fourth book is devoted to a discussion of the descent to the Underworld; and in the allegorization of the first six books of the *Aeneid* in the *Camaldulensian Disputations* (c. 1473), a dialogue written by Cristoforo Landino, the major Florentine commentator on classical texts and Dante of the second half of the fifteenth century.[29] Landino adds a fifth kind of descent to Bernardus' four, the Christian descent to Hell of the souls of the damned, but this is not a descent that can be read into pagan narratives of heroes who go to the land of the dead and then return. For Landino, Aeneas' descent is that of reason to contemplate evil and vice, Bernardo's 'descent of virtue'. Landino's interpretation of Virgil may already have been partly shaped by his interests as a reader of Dante.

In later antiquity Virgil's Underworld drew the attention of Christian readers, as well as of pagan readers with philosophical interests.[30] The story is one of correction and accommodation, the latter encouraged by the affinities between Christian teaching and Neoplatonism, the dominant philosophical school of late antiquity: the Speech of Anchises contains clear Platonic elements, and the possibility has been raised of a lost Neoplatonic Virgilian commentary.[31] Christianity shares with Platonism an ascetic teaching about the relationship between body and soul, although Anchises' Pythagorean-Platonic doctrine of reincarnation was clearly unacceptable to Christian readers. The account of the elemental purgation of the souls at *Aeneid* 6.735–43 is the text for Augustine's engagement in *The City of God* on the subject of purgatorial punishments with the Platonists (21.13), against whom Augustine asserts the Christian doctrine of eternal punishments after the Last Judgement while allowing for the possibility in this life and the next of purgatorial punishment.[32] Sir John Harington in the preface to his translation of *Aeneid* 6 presented to King James and his son Prince Henry in 1604 notes the 'affinity' between Virgil's expiation through fire and the 'popish' doctrine of purgatory. In Shakespeare's *Measure for Measure* Claudio shrinks from death because he cannot bear (3.1.133–7) 'To bathe in fiery floods, or to reside | In thrilling region of thick-ribbed ice; | To be imprison'd in the viewless winds | And blown with restless violence about | The pendant world.' This echoes the elemental purgation by wind, water and fire described by Anchises.

The Church Father Lactantius (*c.* 240–*c.* 320) discerns glimmers of the Christian truth in Virgil's Underworld. He says that the poet's request in his invocation to the gods of the Underworld that he 'may be allowed to speak of what he has heard' (*Aen.* 6.266) shows that 'the pagan poets did not know the mystery of the divine sacrament, and a hint of the resurrection to come had reached them only through dark rumours; what they had heard of casually and by chance they presented by way of a fictitious tale' (*Divine Institutes* 7.22). Like others, Lactantius saw in Anchises' impressive opening description of a spirit and a mind pervading and animating the universe (*Aen.* 6.724–7) an inkling of the truth of the Christian God or Holy Spirit (*Divine Institutes* 1.5.11). Virgil's description of the beautiful landscape (*locus amoenus*) of the Elysian Fields (*Aen.* 6.637 ff.) was easily adapted by Christian poets to the biblical paradise.

In the following sections I turn the spotlight on two writers in whose works the Virgilian Underworld, and its post-Virgilian reception, play a major role, Dante and Milton.

Dante

The great German commentator on *Aeneid* 6 Eduard Norden discusses the place of the Virgilian *katabasis* within the longer history of apocalyptic literature from the sixth century BC to Dante, and concludes that Virgil had very little influence on the late-antique and medieval tradition of apocalyptic visions prior to Dante.[33] The *Divine Comedy* is thus a key moment both in the history of Italian literature and in the reception of Virgil in Christian literature of the west.[34]

The detachable nature of the Virgilian *katabasis* is fully realized by Dante in a full-scale 'epic' that consists entirely in a journey through the afterlife, a journey that is also a panorama of all aspects of human life in this world. Dante chooses Virgil as his guide in acknowledgement of the supreme classical model for an encyclopedic epic, and as the literary model for Dante's own 'bello stilo' (*Inferno* 1.82–7). The epic Underworld is a repository of tradition, and a place where the new poet meets his predecessors and takes on their mantle. Dante goes further than any other poet in exploiting this aspect of the classical Underworld, as the poet whom he acknowledges as 'my master and my author' (*Inf.* 1.85 'lo mio maestro e 'l mio autore') becomes his personal guide through Inferno and Purgatory (Fig. 3).

There are multiple instances of succession. Just as Virgil's Sibyl hands over authority to Anchises for the prophecy of future Roman history, Dante's Virgil, allegorized as natural Reason in the commentary tradition, hands over to Beatrice, standing for Grace, authority for the vision of those granted entry to Paradise by the Christian dispensation. But just as Aeneas takes over from Anchises the role of father of the Romans, and, correspondingly, Virgil, in the figure of Aeneas, takes over from 'father Ennius' as the poet of the national Roman epic, so Dante the voyager takes on an Aeneas-role that supersedes the role of the Virgilian Aeneas. Dante's protest at *Inferno* 2.32 'I am not Aeneas, I am not Paul' masks the fact that Dante the man is cast in the role of a traveller whose pilgrimage far outdoes Aeneas' journey to a promised land, while Dante the poet takes over from Virgil as the poet of the Christian epic that supersedes the *Aeneid*, an epic of a this-worldly Roman imperialism. Virgil finally acknowledges Dante's superiority at *Purgatorio* 27.139–42: 'Await no further word or sign from me: your will is free, whole and erect, and to act against that will would be to err: therefore I crown and mitre you over yourself.'

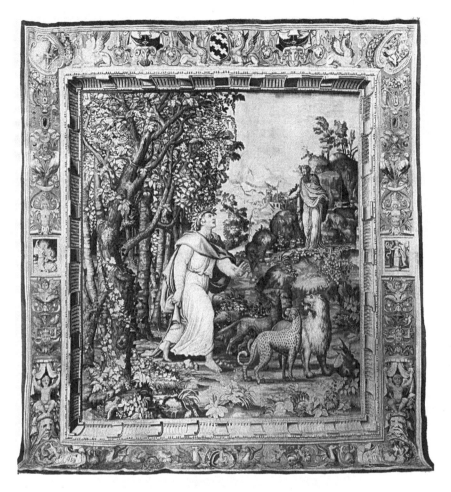

Fig. 3. Meeting of Dante and Virgil. Tapestry after
design by Francesco Salviati.

The limitation of the Virgilian vision is registered in the fact that a
version of the Elysian Fields of *Aeneid* 6 is encountered right at the begin-
ning of the *Divine Comedy*, rather than at the end, in the Limbo of *Inferno*
4, which is where Dante is accepted as the sixth in the company of Virgil
('the most exalted poet'), Homer, Ovid, Horace and Lucan. We shall enter
superior versions of the Elysian Fields in *Purgatorio*, in the Valley of the
Princes (*Purg.* 7–8) and the Earthly Paradise (*Purg.* 28–33). Statius, one of
the ancient epic successors of Virgil, appears in the *Comedy* as a forerun-
ner of Dante, fired by a love for the *Aeneid* (*Purg.* 21.94–9) comparable

to Dante's 'great love' for Virgil (*Inf.* 1.83). In what appears to be Dante's invention, Statius tells how he was first converted from the vice of avarice by Aeneas' exclamation at the power of 'the cursed hunger for gold', on learning of the murder of Priam's son Polydorus (*Aen.* 3.56–7; *Purg.* 22.40–1), and then converted to Christianity by the 'Messianic' fourth *Eclogue*. In a simile (*Purg.* 22.67–9) Statius compares Virgil to one who carries a lamp behind him, shedding no light for himself, but instructing those who follow after. Dante is one of those who can see the potential for Christian truth in Virgil's poetry, hidden to Virgil himself.

One of the most intensely Virgilian passages in the *Comedy* occurs at the point where Virgil ceases to be Dante's guide. At the end of *Purgatorio* Dante has his first sight of Beatrice, riding in a triumphal chariot. The angels accompanying the chariot combine biblical and Virgilian citations. They call out *Benedictus qui venis*, 'blessed art thou that cometh' (*Purg.* 30.19), the salutation to Jesus as he entered Jerusalem; and they scatter flowers with the words with which Anchises calls for a floral tribute to the doomed younger Marcellus at *Aeneid* 6.883 *manibus date lilia plenis* 'give lilies in handfuls' (*Purg.* 30.21). But where Anchises laments untimely loss, Dante celebrates the restoration of the full presence of his beloved Beatrice. At the appearance of Beatrice herself the stunned Dante turns to Virgil and says 'Conosco i segni dell'antica flamma' 'I recognize the signs of the old flame', translating the words with which Dido confesses to her sister Anna that her feelings for Aeneas have awakened the desire she thought had died with her first husband, *Aen.* 4.23 *agnosco ueteris uestigia flammae*. This is also an intertextual 'recognition' of the 'signs' of Virgil's epic. But Virgil himself is no longer there to respond (30.49–51):

> Ma Virgilio n'avea lasciati scemi
> Di sè, Virgilio dolcissimo padre,
> Virgilio a cui per mia salute dièmi.

> But Virgil had left us bereft of him, Virgil the sweetest father, Virgil to whom I gave myself for my salvation.

The threefold repetition of Virgil's name echoes the threefold repetition of the name Eurydice on the dying lips of Orpheus after his head has been torn from his shoulders by the maenads at *Georgics* 4.525–7. Dante is poised between an acute Virgilian moment of loss, and an un-Virgilian future of restored and redeemed love. On the one hand he is losing his poetic 'father', although the father's poetry will continue to live, not least

in the poetry of Dante, a poet who will not suffer the fate of Orpheus. On the other hand Beatrice is restored to Dante, reversing the Virgilian plots of both Orpheus and Eurydice and of Dido and Aeneas, which end without comfort. When Aeneas sees Dido for the last time in the Underworld she will not speak to him; Beatrice does speak, and using Dante's name for the first and the last time in the *Divine Comedy* tells him not to weep.[35]

Dante's compelling rewriting of Virgil ensures that in the later reception the Virgilian Underworld is often mediated through, or combined with, the Dantean. This is already the case in the eschatological visions in Petrarch's *Trionfi* and *Africa*. In the *Carlias*, a Virgilianizing Latin epic on Charlemagne by Ugolino Verino (1438–1516), a pupil of Landino, the hero's journey to the afterlife, spread over three books, proceeds through a Hell and a Purgatory closely modelled on Dante's.[36] Tennyson's 'To Virgil' (see Chapter 1, p. 15) comes close to being a necromantic evocation of the dead poet. Virgil himself has become a poetic talisman, a Golden Bough that continues to gleam when parades of earthly power such as that which passes before Aeneas in *Aeneid* 6 have returned to the shadows: 'Golden branch amid the shadows, | Kings and realms that pass to rise no more.' The last stanza begins 'I salute thee, Mantovano', alluding to the words with which another poet, the thirteenth-century troubadour from Mantua, Sordello, salutes the shade of Virgil when the latter mentions his home town at *Purgatorio* 6.74–5: 'O mantovano, io son Sordello | Della tua terra.'[37] Tennyson hints that he and Virgil share a poetic citizenship, for all that by birth he comes from a country far away (the end of the previous stanza), 'I, from out the Northern Island | Sundered once from all the human race', an alienness expressed through further Virgilian allusion, to the description of Britain as a prospective place of exile at *Eclogue* 1.66 *et penitus toto diuisos orbe Britannos* 'the Britons utterly separated from the whole world', a line that early modern English writers delighted to play with (see Chapter 5, pp. 105–7).

The superimposition of Virgil on Dante continues in modern poetry,[38] and was given a major boost by T.S. Eliot's self-positioning within a tradition whose major landmarks include Virgil and Dante: both are strong presences in *The Waste Land*.[39] In 'The Bottle Garden' the Irish poet Eavan Boland (b. 1944) is prompted by the otherworldly quality of greenery growing in a glass globe, where 'The sun is in the bottle garden, | submarine, out of its element' (compare Virgil's Elysian Fields, which have 'their own sun and stars', *Aen.* 6.641), to a moment of Dantean introspection: 'And in my late thirties, past the middle way, | I can say how did I get here?' Retracing the path of her life so far takes her back to herself as a

schoolgirl in the convent library, 'reading the *Aeneid* as the room darkens | to the underworld of the Sixth book'.

Milton

Paradise Lost is framed by pairs of books that each relate to Virgilian uses of the Underworld. Books 1 and 2 record the original creation of the Underworld, in the form of the Hell which receives the fallen angels, and then use the Underworld as the source of the Hellish energy that motivates the human plot. Satan journeys from Hell to invade the pastoral-georgic idyll of Paradise and engineer the tragedy of the Fall of Man (9.5–6 'I now must change | These notes to tragic'), just as in *Aeneid* 7 the Hellish Allecto, a Fury at home in the world of Greek tragedy, invades the rustic tranquillity of primitive Italy to provoke all-out war between two peoples who should be at peace. Satan's ascent to this world is preceded by the very first, and one of the grandest, of all Infernal Councils.

At the entrance to the Underworld in *Aeneid* 6 Aeneas encounters personifications, including Death, and monsters, including Scyllas. When Satan reaches the Gates of Hell on his ascent (*Paradise Lost* 2.643 ff.) he encounters two monsters who are also personifications, Sin and Death. Sin has metamorphosed into the shape of the classical Scylla, 'Woman to the waist, and fair, | But ended foul in many a scaly fold' (2.650–1). Death's shapeless and shadowy person embodies, if that is the right word, the empty unreality of the shadow-world through which Aeneas passes on his way to meet the persons from his past who once had a very solid reality. In a moment of infernal comedy Aeneas draws his sword to attack the terrifying phantom monsters, and has to be warned by the Sibyl of the futility of striking at shadows. In a passage of tremendous sublimity, that might have had momentous consequences, Milton's Satan and Death take their stand against each other, and have to be separated by Sin, who tells them that they are father and son.

On his further ascent it takes Satan no little labour to battle his way through chaos to the world above. But the reverse journey, from our world to Hell, will become a *facilis descensus* 'easy descent' after the Fall, when Sin and Death build a bridge over the abyss from Hell to 'this now fence-less world | forfeit to death; from hence a passage broad, | Smooth, easy, inoffensive down to Hell' (10.303–5). In this new order of things the bridge also provides a path for 'all th' infernal host, | Easing their passage hence' (259–60). The bridge over 'the foaming deep' and an indignant Chaos is a

calming of the storm as if by a devilish Neptune (293–5): 'The aggregated soil | Death with his mace petrific, cold and dry, | As with a trident smote, and fixed as firm | As Delos floating once.' This is also a mastering by Hell of the storm-forces that had blasted Lucifer from Heaven as if he were a thunderbolt hurled by omnipotent Jupiter, to lie 'vanquished, rolling in the fiery gulf' (1.52). 'Him the almighty power | Hurled headlong flaming from th' ethereal sky' combines the classical image of the thunderbolt hurled by almighty (*omnipotens*) Jupiter with biblical allusion, *Luke* 10:18 'I beheld Satan as lightning fall from heaven.'

The 'floods and whirlwinds of tempestuous fire' that overwhelm Satan and his companions at the start of *Paradise Lost* (1.77) are a narrative analogue to the storm at the beginning of the *Aeneid*. At the beginning of the first half of Virgil's epic Aeolus, the king of the winds, unleashes the storm-winds from a figurative Underworld, as if he were unchaining Titans or Giants to assault the gods above, in a scene which closely foreshadows Juno's unleashing of the infernal Fury Allecto at the beginning of the second half of the *Aeneid*. At the start of *Paradise Lost*, in an inversion of the Virgilian model, it is the Gigantomachic Lucifer who takes the place of the storm-tossed hero Aeneas, sorely assailed by God's firestorm, preparing the reader for Satan's assumption of the Odyssean role of wandering hero that is taken on by Aeneas in the first half of the *Aeneid*.

If the ascent from Hell is easier for Satan and his infernal crew after the Fall, the re-ascent from the figurative Hell into which Adam and Eve have fallen will be much harder. Satan thinks to have achieved world-wide monarchy through his victory over Adam and Eve, and a detail of the description of the bridge between Hell and Earth points to the very last scene of the images of Augustan world-empire in the pageant of Roman history represented on the Shield of Aeneas in *Aeneid* 8. 'Disparted Chaos overbuilt exclaimed, | And with rebounding surge the bars assailed, | That scorned his indignation' (*Paradise Lost* 10.416–18). The last triumphal image placed on the Shield of Aeneas by Vulcan (and in a Miltonic context we might remember that Vulcan is also the architect of Pandaemonium) is, 'the Araxes indignant at being bridged'(*Aen.* 8.728 *pontem indignatus Araxes*), a symbol of Augustus' extension of his empire to the ends of the earth. The Shield of Aeneas at the end of *Aeneid* 8 forms a pendant to the Parade of Heroes at the end of *Aeneid* 6, and the two together are a statement of the providential view of Roman history, culminating in Augustus.

Of the two passages, it is the Parade of Heroes that is the main Virgilian model for the vision of universal history granted to Adam, as

consolation for the expulsion from Eden, in the last two books of *Paradise Lost*. The mound, *tumulus*, like a reviewing-stand on a parade ground, from which Anchises shows Aeneas the souls of unborn Roman heroes, has become 'a hill | Of Paradise the highest' (11.377–8) with a view over the whole hemisphere of earth, as high as the hill on which 'the Tempter set | Our second Adam in the wilderness, | To show him all earth's kingdoms and their glory' (382–4) – for which we might also read the show of earthly, Roman, glory laid before Aeneas in the Parade of Heroes and on the Shield of Aeneas. The first visions, of Cain and Abel and of a catalogue of diseases, prompt Adam to question the point of life, 'Why is life giv'n | To be thus wrested from us? Rather why | Obtruded on us thus?' (502–4). This is a variant of Aeneas' incomprehension at the desire of the souls in the Underworld to re-enter bodies in new lives in this world: 'What terrible desire for the light afflicts these poor things?' (*Aen.* 6.721). The vision and prophecy of biblical history given to Adam by Michael is not so much a parade of heroes as a series of tableaux of sinners and saints, but it ends in a triumph greater than the triple triumph of Augustus: 'Then to the heaven of heavens he shall ascend | With victory, triumphing through the air | Over his foes and thine' (12.451–3). This is an 'empire without end' (*Aen.* 1.279 *imperium sine fine*) of which Milton can speak more confidently than Virgil, empowered as he is by biblical prophecy to look forward beyond his own times to a true end of history, to 'New heavens, new earth, ages of endless date' (12.549).

Virgil's Underworld and modernity

Modern Underworlds continue to be places where writers confront literary tradition. They are also places of interior, personal exploration, but what awaits discovery within are not so much absolute moral and spiritual truths as darker secrets of the psyche.[40] Freud noted that 'Psychoanalysis may be said to have been born with the twentieth century; for the publication in which it emerged before the world as something new – my *Interpretation of Dreams* – bears the date "1900".'[41] At the threshold of his new science Freud places, as epigraph, the Virgilian quote *flectere si nequeo superos, Acheronta mouebo* (*Aen.* 7.312), Juno's resolution that if she 'cannot bend the gods above [to further her opposition to the Trojans], I will rouse the Underworld'. Freud will open the lid on the repressed thoughts and desires buried in the psyche. The Jewish Freud may also have felt a sympathy with Juno as goddess of the Semitic Dido and Hannibal: Hannibal was a boyhood hero of his. This is not the only Virgilian liminal moment

in Freud: near the beginning *The Psychopathology of Everyday Life* (1901) Freud cites as an example of a suppressed memory the faulty quotation, by a fellow-Jew met while travelling, of a famous line from Dido's curse that conjures up another return from the dead, *exoriare aliquis nostris ex ossibus ultor* 'may some avenger arise from my bones' (*Aen.* 4.625; the 'avenger' will be Hannibal). Freud's friend omits the *aliquis*, and through a chain of punning associations on 'liquid', 'liquefaction', 'reliques', he is led by Freud to think of the liquefaction of St Januarius' blood, and so to the cause of the 'forgetting', an anxiety that he might hear that a woman he had met in Naples had missed her period. Pouring cold water on Freud's depth psychology, the Italian philologist Sebastiano Timpanaro pointed out that there is a linguistic reason why Freud's friend might omit *aliquis*: Virgil anomalously, but deliberately, juxtaposes the third-person pronoun 'someone' with a second-person verb, *exoriare* 'may you arise', as Dido appeals across the centuries to an unborn avenger who does not yet have an identity.[42]

Katabasis in the form of dream leads to self-discovery and the modification of a planned future in Michel Butor's *nouveau roman, La Modification* (1957).[43] The novel narrates the thoughts and memories of Léon Delmont, Parisian sales-representative of a typewriter firm in Rome, in the course of a train journey from Paris to Rome undertaken with the intention of announcing to his girlfriend in Rome, Cécile, that he will finally leave his Parisian wife, Henriette, and bring Cécile back to Paris. In what is planned as a self-imposed exile from his family, Rome and his Roman girlfriend stand for the dream of a new life. But during the journey Delmont comes to realize that to bring Cécile to Paris would not lead to a new life, but rather turn their relationship into a repetition of the disillusionment and failure that has brought about his alienation from his wife. The climax of this narrative of interiority is a dream sequence that confirms him in this realization.

A number of apparently incidental references to the *Aeneid* and to the Underworld cue the reader for the Virgilian subtext. At one point Delmont recalls listening at home to Monteverdi's *Orfeo* on the radio, and taking the Budé edition of the *Aeneid* from his shelves and opening it at Book 6. On the train he invents names and lives for the strangers in his compartment; an elderly couple turn into the prophet Zacharias and the Sibyl. In his dream the Virgilian Sibyl tells him that there is no golden bough for those who are strangers to their desires. Instead of meeting his own father in his dream, he sees a papal procession, and the Holy Father asks him why he pretends to love Rome, when the Pope is 'the phantom

of the emperors, who has for centuries haunted the capital of their world, now destroyed and the object of regret'. The extension of the Virgilian Parade of Heroes into the line of the Christian leaders of Rome collapses the opposition between pagan Rome, identified with Cécile (who has an aversion to visiting Catholic monuments in Rome), and Catholic Rome, identified with the religious Henriette. The opposition between Paris, as point of departure, and Rome, as destination, is also undermined throughout the novel, and the Virgilian teleology is further subverted as Delmont reflects, at the end, that the age when the world had a centre is past: that centre has been displaced from Rome to Byzantium, and later to imperial Paris. And in our age 'the memory of the Empire, so powerful for so many centuries on all European dreams, is now an inadequate figure to chart the future of this world, which has become for all of us much vaster and organized in quite other ways'.

Like the *Aeneid*, *La Modification* is dense with literary and cultural reference, and, as in the *Aeneid*, personal and cultural memories are closely intertwined. The novel's combination of a slice of everyday life with legendary patterns puts it in the line of descent from Joyce's *Ulysses*, of which Butor himself notes: 'In one day in Dublin it is possible to rediscover the whole of the *Odyssey*. In the midst of the alien contemporary world are reincarnated the ancient myths, and the relationships expressed in them remain universal and eternal.'[44]

In the Underworld of *Aeneid* 6 Virgil reviews the literary traditions that go into the making of his own poem. The final end of *La Modification*, once Delmont abandons his plan to revolutionize his personal life, is his realization that he will write a book about his experiences, *this* book that we are reading, the book that he had bought in the station at Paris but left unread during the journey, using it only to keep his place in the compartment. The dream-*katabasis* takes us to the places in the unconscious from which the modern novelist draws his material.

The Virgilian Underworld is also a reservoir of tradition and a source of poetic making for Seamus Heaney, who in the course of his career made much use of the *Eclogues* and *Georgics*, as well as the *Aeneid*. Continuing the tradition of Tennyson and T.S. Eliot of combining Virgil and Dante, *Seeing Things* (1991) is framed by translations from the *Aeneid* and the *Divine Comedy*, opening with 'The Golden Bough', Aeneas' request to the Sibyl to journey to the Underworld and the Sibyl's instruction to find the Golden Bough (*Aen.* 6.98–148) (Fig. 4); and concluding with 'The Crossing', Dante's and Virgil's encounter with Charon, ferryman of the Styx (*Inferno* 3.82–129). Within this frame the first poem, 'The Journey

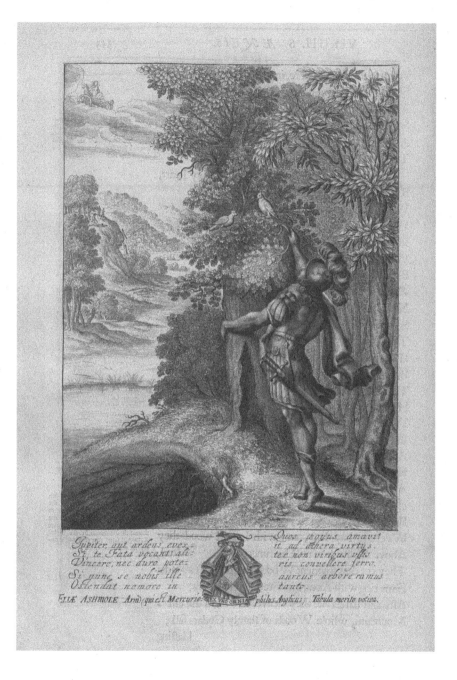

Fig. 4. Aeneas plucks the Golden Bough. Engraving after drawing by Franz
Cleyn, in *The Works of Publius Virgilius Maro*, translated by
John Ogilby (London, 1654).

Back', is a meeting with a modern dead poet: 'Larkin's shade surprised me. He quoted Dante.' Larkin's shade quotes a translation of the opening of *Inferno* 2, the proem to Dante's journey through Inferno, as Larkin himself sets out on what 'felt more like the forewarned journey back | Into the heartland of the ordinary', and concludes by describing himself as 'A nine-to-five man who had seen poetry'.

For Heaney too translation is not just a linguistic act, but the transferral of the otherworldly experiences of Virgil and Dante into the poet's own present day, domesticating the visionary poetry of the past but at the same time giving a visionary quality to the ordinary. 'The Riverbank Field' in *Human Chain* (2010) starts with the description of the Elysian Fields in *Aeneid* 6, in the translation of the Loeb Library of parallel Latin and English texts, as Heaney sets out to 'confound the [classical] Lethe in [the Northern Irish] Moyola'. A string of local place-names engineers the translation of Virgil's otherworldly *domos placidas* into '"those peaceful homes" | Of Upper Broagh'. Topographical metamorphosis is matched by Heaney's own retranslation of the Loeb version of Anchises' account of the disembodied soul's 'longing to dwell in flesh and blood', to be reborn in this world, after drinking of Lethe: '"In my own words"', as Heaney had often been told to translate at school.

In the Underworld Aeneas journeys through his personal past, as well as through the traditions of Greece and Rome. 'The Golden Bough' translation that opens *Seeing Things* includes the line in which Aeneas 'pray[s] for one look, one face-to-face meeting with my dear father'. Later in the collection Heaney re-encounters his own father in 'Man and Boy', playing with time in a manner that might be Virgilian as he slips from memories of himself as a child with his father, to a vignette of his father as a child running through the fields 'On the afternoon of his own father's death'. 'I feel his legs and quick heels far away | And strange as my own – when he will piggyback me | At a great height, light-headed and thin-boned, | Like a witless elder rescued from the fire.' This is a striking inversion of the group of Aeneas carrying his father from burning Troy, but through the poem the grown-up Heaney-*fils* also rescues from oblivion an intimate image of his father as a child.

In *Human Chain* 'The Riverbank Field' is followed by a tour-de-force translation of Aeneas' journey through the Underworld into Heaney's journey through his own past and future, in 'Route 110'.[45] In the first of 12 poems of 12 lines each, the narrator buys 'a used copy of *Aeneid* VI' in a secondhand bookshop from an assistant, whom we may think of as the Sibyl. 'Dustbreath bestirred in the cubicle mouth | I inhaled as she slid

my purchase | Into a deckle-edged brown paper bag.' The dusty book is also the source of the breath of inspiration, as the poet will put the used book to new uses in what follows. Again the Virgilian infernal topography is cunningly mapped on to places and occasions in Heaney's Northern Ireland, and the Golden Bough, Virgil's vegetable metal, becomes an ornamental jam-pot of stalks of oats which have been wrapped in silver foil. Palinurus is a neighbour's son who drowned in the Bristol Channel, and the mangled Deiphobus turns into those who met violent deaths in the Troubles. In the past Heaney, like Aeneas, has abandoned a Dido, last seen as a face 'At the dormer window, her hurt still new', as he drives away. But the sequence ends with 'the age of births', an upbeat look to the future, as 'fresh-plucked flowers' are brought not for the funeral of a young Marcellus, but for the birth of a granddaughter, 'Whose long wait on the shaded bank has ended'. The narrator 'arrive[s] with my bunch of stalks and silvered heads', the Golden Bough that has led him through memories of sadness and loss to hope and joy.

3

'LA DONNA È MOBILE': VERSIONS OF DIDO[1]

W omen in the *Aeneid* are difficult to read. The first woman that Aeneas meets in Book 1, shortly after landing on the shore of Carthage, is not what she seems: so far from being a mortal virgin huntress she turns out to be the goddess of love, his own mother Venus. The contrast between the realm of Diana, the virgin goddess of hunting, and the realm of Venus, and the transition from one to the other, is programmatic for the further plot of the *Aeneid*, and it is a contrast frequently explored in the reception of the *Aeneid*. The disguised Venus tells her son the previous history of Dido, the new ruler of the land. When Aeneas meets Dido herself in the temple of Juno in Carthage, he is again involved in a process of judging appearances. Just before Dido's entry Aeneas is looking at the last of a series of paintings of the Trojan War in the temple, the striking image of the Amazon warrior Penthesilea, a woman in the male world of war. An after-image superimposes itself on his first sight of the flesh-and-blood Dido, a woman playing the male role of founder and ruler of a city. We might say that Aeneas' gaze on Dido retrospectively triggers a reception of the painting of Penthesilea, as Aeneas, and we the readers, see in a new light a figure whom Aeneas, as a participant himself in the Trojan War, had at the first viewing recognized simply as the Amazon queen he had known at Troy. And we might guess that Dido herself had chosen to include this scene in the selection of episodes from the Trojan War in her new temple of Juno because she herself identified with Penthesilea when she was unexpectedly thrust into the role of leader of her people. There follows a famous simile comparing Dido to Diana amidst her nymphs (1.498–502). This reminds the reader of the previous apparition of the disguised Venus, mistaken by Aeneas for Diana or one of Diana's nymphs, and it is an easy conclusion that the Diana simile is focalized through the eyes of the character Aeneas.

The resulting series of female figures – Venus (in the likeness of Diana) – Penthesilea – Dido (in the likeness of Diana) – is seen through the eyes of a character, Aeneas, who functions as an interpreter or reader within the text, and it prompts the reader of the *Aeneid* to further interpretations of the woman whose story this is, Dido.

These models within the text ask the reader to gauge how far Dido really is like Diana or Venus or Penthesilea. The intratextual models are multiplied by the intertextual models, allusions to characters in other texts. All of the characters in the densely allusive work that is the *Aeneid*, an epic consciously drawing on the whole of the previous Greco-Roman literary tradition, are built up with traits from a plurality of earlier literary – and in some cases historical – characters, but Dido is probably the most allusively complex of them all, bearing traces of female characters in previous epic, tragedy and other genres. Dido is Virgil's most 'intertextual heroine', to use a phrase of Stephen Hinds.[2] An awareness of the intertextual density of Dido complicates our response to her actions and sufferings, and it also encourages the forward projection of this intertextuality on to rewritings of Dido in other characters. Once again, Virgil almost seems to inaugurate the reception of his own text.

The question of how to perceive, and what to say about, Dido (and Aeneas) is embodied within the text in the monstrous personification of *Fama*, 'Rumour', who spreads a slanderous version of the love affair of Dido and Aeneas after their union in the cave. *Fama* in Latin can also mean poetic or historical 'tradition', and the personification is also an embodiment of the vagaries of reception and tradition. The indirect speech reporting the content of what *Fama* puts about (4.191–4) is the first retelling of the narrator's own prior account, and so the first instance of the story's reception. It is as if Virgil knowingly builds into his Dido narrative a prophecy of the long history of re-readings and rewritings that it would stimulate. An awareness of what is said about Dido is insistent elsewhere in *Aeneid* 1 and 4, on the part both of Dido and of other characters, and the Virgilian text's own concern with *Fama* reverberates through the whole of the later tradition. The enduring fame of the story is described by Macrobius in terms that allude to the operations of Virgil's own *Fama* in Book 4 (*Saturnalia* 5.17.5–6):

> The story of the wanton Dido, which the world knows is false, has for so many ages maintained the appearance of truth and so flits about on the lips of men as if it were true, that painters and sculptors and weavers of tapestries use this above all in fashioning their images [...] and it is no

less celebrated in the gestures and songs of actors. The story's beauty has had such power that though everyone knows of the Phoenician queen's chastity and is aware that she took her own life to avoid the loss of her honour, they connive at the fable, suppress their belief in the true story, and prefer to celebrate as true the sweetness instilled in human hearts by the fiction.

Macrobius here refers to the particular scandal of the Virgilian story of Dido, the fact that it is in conflict with an older version according to which Aeneas never came to Carthage (legendary chronology makes it impossible). In this version, when she had founded Carthage, Dido, faithful to her first husband Sychaeus, who had been murdered in her home city of Tyre by her wicked brother Pygmalion, committed suicide in order to avoid marrying her African suitor Iarbas. It is possible that the version in which Dido falls in love with Aeneas had already been told in Naevius' *Bellum Punicum*, an earlier Roman epic on the First Punic War between Rome and Carthage of which only a few fragments survive. Nevertheless the prominence given to *fama*, with both a capital and a lower-case *f*, in *Aeneid* 4 betrays an awareness that Virgil's account of Dido is a mixture of truth and falsehood, if by 'truth' is understood the earlier version found in the historians.[3] Virgil himself may stand accused of slandering the chaste and virtuous Dido. Mercury's shocking words on the fickleness of women, spoken in order to jolt Aeneas into leaving Dido, 'woman is an inconstant and changeable thing' (4.569–70 *uarium et mutabile semper | femina*) could more justly be applied to poetic tradition, reception, *Fama*, whose person and utterances are notoriously shifting and changeable.

The defence of Dido against Virgil becomes something of a common-place. An anonymous Greek epigram 'On a painting of Dido' (*Greek Anthology* 16.151) puts words in Dido's mouth: 'I was just like this image, but I did not have the character that you hear about, having gained glory rather for reputable behavior. I never set eyes on Aeneas, nor did I come to Libya at the time of the sack of Troy [...] Muses, why did you arm chaste Virgil against me to tell lies against my virtue?' The sixteenth-century Italian humanist Sperone Speroni has a different slant on it in his *Discourses on Virgil*, making out that the historical impossibility of the episode is consciously used by Virgil to warn against Rumour, which would call Aeneas 'treacherous' and Dido 'unchaste'. In the Spanish Golden-Age playwright Gabriel Lobo Lasso de la Vega's *Tragedy on the Restored Honour of Dido*, *Fama* appears for the first time in the epilogue to proclaim the honour of the queen and to denounce Virgil's false accusations against her, so inverting the role of *Fama* in *Aeneid* 4.

The 'two Didos' approach has a long history.[4] The Church Fathers, including Tertullian and Jerome, used the chaste Dido as an example in urging women to observe virginity or at least not to marry for a second time.[5] Jerome alludes to St Paul's advice that 'If they cannot contain, let them marry: for it is better to marry than to burn' (1 Corinthians 7:9), when he praises Dido for 'preferring to burn rather than marry' (*Against Jovinian* 1). Of the 'three Florentine crowns' of early Renaissance Italian literature, Dante, Petrarch and Boccaccio, Dante places Dido, who killed herself for love and was unfaithful to the ashes of Sychaeus, in the circle of the lustful in Inferno, between the Babylonian queen Semiramis and Cleopatra (*Inferno* 5.61–2). But the other two 'crowns', Petrarch and Boccaccio, were central in propagating the chaste Dido. In the *Trionfi* Petrarch awards Dido a place in the Triumph of Chastity (155–9), for 'wishing to meet her end for her beloved and faithful husband, not for Aeneas [...] Dido, driven to death by love of honour, not idle love, as the popular rumour has it'. 'Popular rumour' ('publico grido') is a nod in the direction of Virgil's *Fama*, who spreads the report of Dido's love affair with Aeneas. In Petrarch's Latin epic the *Africa*, the African bard who sings of the chaste Dido concludes with an indignant reflection on the damage that would be done to Dido's name if someone overconfident in his own wit were to traduce the queen by writing of an illicit love affair. This is another arch allusion to the version of Virgil, a poet who has not been born at the time of the events narrated in the *Africa*.

In his Italian works Boccaccio consistently recycles the Virgilian version of Dido's story, but retails the historical, chaste, Dido in his Latin works: the *Genealogy of the Gods*, a standard Renaissance handbook of classical mythology; *On Famous Women*; and *On the Falls of Famous Men* (*De casibus virorum illustrium*).[6] The last two works were very influential in fourteenth- and fifteenth-century vernacular literature: both were translated into French, and the latter, from the French translation, into English by John Lydgate as *The Fall of Princes*. In *On Famous Women* (Ch. 42) Boccaccio draws on the ancient tradition in his praise of Dido for 'putting aside womanly weakness and resolving on a masculine strength of mind'. Boccaccio appeals to the claim (going back to Servius) that in Punic 'Dido' means 'virago'. This is also the Virgilian Dido, but only up to the point at which she meets Aeneas: 'a woman was leader of the undertaking', as Venus describes the Dido who led her followers into exile (*Aen.* 1.364 *dux femina facti*), where *dux*, a word usually used of male leaders, is strikingly juxtaposed with *femina*. Boccaccio then veers into the kind of praise showered on the chaste Dido by the Church Fathers: 'O unsullied glory of

chastity! O venerable and everlasting specimen of unbowed widowhood, Dido! I could wish that all widows might gaze on you, and that Christian women above all should look on your resolve.' The chaste Dido has a lot in common with Lucretia, the faithful wife who committed suicide to prove her innocence after being raped by the son of Tarquin the Proud, the last king of Rome. The two are paired as examples of unbending chastity from Tertullian onwards. Indeed it is arguable that traces of the chaste Dido are still visible in the fallen Virgilian character, in her lament, too late, over the loss of her sense of shame and of her reputation, and in the manner of her death. The parallels between the two stories are picked up in a long line of 'contaminations' of the Virgilian narrative with the history of Lucretia.[7]

The opposition of the chaste and the unchaste Didos is not the only duality in her story. In Virgil she starts out as the welcoming host (*hospes*) in whom Aeneas recognizes his double as a civilized and compassionate leader of men, but she turns into Aeneas' implacable enemy (*hostis*), whose dying curse will, in the fullness of time, summon up the avenger Hannibal, Rome's Carthaginian mortal enemy. Carthage post-*Aeneid* 4 is the dangerous Other of Rome, as later still another north African kingdom, Cleopatra's Egypt, will be the enemy Other of Octavian's Rome, conveniently for propaganda purposes. The story of Dido and Aeneas is an aetiology of the ethnic polarization of Rome and Carthage; the point of national differentiation is also the point at which the beautiful Dido metamorphoses into a terrifying Fury, as she promises Aeneas that after her death she will pursue him with the black torches of the Furies, present everywhere as a threatening shade (*Aen.* 4.384–6). Silius Italicus finds the narrative impetus for his own highly Virgilian epic on the war between Hannibal and Rome in a shrine dedicated at the heart of Carthage to the shade of Dido. Here the boy Hannibal swears an oath by the ghost of Dido to pursue the Romans with iron and fire, by land and sea, when he grows up (*Punica* 1.114–15). *Sequar* 'I will pursue' is the verb used by Dido first in her threat to Aeneas that 'When I am gone I will pursue you with black flames', and again in her curse, when she calls for an avenger to arise from her bones to pursue the Trojans with torch and iron (*Aen.* 4.625–6). The shrine of Dido is a portal through which the forces of Hell are summoned into the world above: as Hannibal's oath revives the terms of Dido's curse, he himself becomes the embodiment of Dido's fury.

Virgil develops the contrast between welcoming queen and avenging Fury, between like-minded friend of the Trojans and implacable foreign foe of the Romans, with subtlety and psychological plausibility. The

transformation of beautiful woman into monstrous Fury will become a schematic contrast between fair and foul in Christianizing constructions of the feminine.

There have also been positive appropriations of Dido's ethnicity. The Church Father Tertullian, who was born in or near Carthage, may have championed the chaste Dido partly out of African pride.[8] She is of course herself not a native African, but a Phoenician exile from the city of Tyre in Lebanon. Virgil makes little of her semitic origins, although he is aware of the Punic etymologies of her name, Dido ('wanderer') and of the name of her city Carthage ('new city', *Kart Hadasht*).[9] Juno, who has ambitions for Carthage to rule the world, was syncretized in antiquity with the Punic goddess Tanit. Punic colouring is introduced in one of the several novelistic handlings of Dido's story, David MacNaughton's *Dido. A Love Story* (London, 1977), a retelling of the story-line of *Aeneid* 1–4 in the mouth of Ascanius, with the twist that Dido has passionate and prolonged sex with Ascanius before succumbing to her passion for his father Aeneas. Aeneas himself is revealed to be half-Phoenician, the son of Anchises by a Phoenician priestess of Aphrodite (assimilated to the Phoenician Astarte) from Paphos in Cyprus. In the novel Dido's sister Anna teaches Ascanius some Punic, and there is some exotic religious colouring in the identification of the Virgilian Juno with the Punic goddess Asherat (rather than Tanit).

Unsurprisingly, ancient Carthage, now a suburb of Tunis, figures in the works of some modern Tunisian writers.[10] A more pan-African slant informs 'L'Élégie de Carthage' (1975) by the Senegalese poet, and first president of Senegal, Léopold Sédar Senghor, who also coined the word 'négritude', the label for a francophone black movement that rejected French colonial racism. 'L'Élégie' is dedicated to Habib Bourguiba, the first president of Tunisia. In the second 'Chant' the poet weeps over Dido with tears of pride and regret, very unlike the tears shed for Dido for which Augustine reproached himself (see p. 135). Part of the regret springs from the cause for Dido's own tears:

You cried for your white god, his golden helmet on his crimson lips,
And you cried wonderfully for Aeneas in evergreen scents.
His eyes of Northern Lights, the April snow in his speckled beard.
What had you asked so faithfully of the black Woman.
The Great Priestess of Tanit, color of night?
She listens to the distant sources of rivers in the shadowy woods,
To all the heartbeats of Africa. She would have reminded you of Iarbas,
Son of Garamantia [Dido's African suitor].

In the third 'Chant' the poet weeps over Dido's inheritor Hannibal, who was 'so close to overthrowing | The forces of the north'.[11]

When we first catch sight of Dido's new city of Carthage in the *Aeneid* it seems indistinguishable from other Hellenistic – or Roman – cities around the Mediterranean, with properly functioning political institutions and public buildings. And, like an Alexandria or a Rome, Carthage is a city of wealth and luxury. Ancient moralists often characterize the luxury endemic to an advanced urban civilization as infection by the vices of the Other, and in particular, in classical antiquity, by the decadence and effeminism of the Orient. Dido's extravagant royal banquet at *Aeneid* 1.697–756 is modelled on the palace and banquet of Alcinous, king of the hyper-civilized Phaeacians in Books 7 and 8 of the *Odyssey*. The Phaeacian lifestyle was taken by some ancient commentators hostile to Epicureanism as an image of a crude hedonism, and Virgil may hint at this. The luxury of Dido's palace is painted in more lurid colours by the Neronian epic poet Lucan in the banquet at which the Egyptian queen Cleopatra receives Aeneas' descendant Julius Caesar in Book 10 of the *Civil War*. Lucan's Cleopatra is a rewriting of Virgil's Dido, but Virgil's Dido already alludes to the oriental queen demonized in Augustan propaganda as a mortal enemy of the Roman state, who had had an affair with Aeneas' descendant Julius Caesar, and who seduced Mark Antony from his duties as a Roman statesman and general.

Dido and Cleopatra continue to be twinned in the later reception. Shakespeare's Mark Antony famously misremembers – or wishfully rewrites – the end of the Virgilian story when he addresses the dead Cleopatra (*Antony and Cleopatra* 4.14.58–62): 'Stay for me: | Where souls do couch on flowers, we'll hand in hand, | And with our sprightly port make the ghosts gaze: | Dido and her Aeneas shall want troops, | And all the haunt be ours.'[12] The French tragedian Robert Garnier in his *Marc Antoine* (1578; translated in English as *Antonius* by Mary Sidney, Countess of Pembroke in 1592) puts into the mouth of the dying Cleopatra a close adaptation of the dying Dido's words in the *Aeneid* (4.653–8): each woman says that she could have been happy had, respectively, the Roman and the Trojan ships not come to their shore. Dryden pairs the two tales in his rewriting of Shakespeare's *Antony and Cleopatra*, *All for Love*, Prologue 8–9: 'And [the poet] brings a tale which often has been told: | As sad as Dido's, and almost as old.'

The night of Dido's banquet in *Aeneid* 1 is also the night in which Dido falls hopelessly in love with Aeneas. In the moralizing tradition luxury and lust are constantly paired. Given Dido's struggle with her

own emotions and her wish to remain loyal to her dead husband, and given also Virgil's notorious reticence on the subject of Aeneas' feelings for Dido, it is one of the injustices, or at least ironies, of the reception of the Virgilian Dido that Aeneas' diversion from his mission to travel to Italy and lay the foundations for the future Roman race often becomes the basis for narratives of the seduction of the hero by an alluring temptress, or of the hero's surrender to the pleasures of the flesh.[13] In so far as we can judge of the Virgilian Aeneas' motives, Carthage seems to offer rather a welcome break from wandering and hardship, and possibly the prospect of a successful nation-building union of Trojans and Carthaginians.

In a persistent late-antique and medieval allegorization of the story of Aeneas according to the ages of man, Book 4 represents youth's suscepti- bility to lust. In the late fifth-century *Exposition of the Content of Virgil* (see also Chapter 4, pp. 87–8) the shade of Virgil tells Fulgentius that in *Aeneid* 4 Aeneas:

> on holiday from the judgement of his father goes out hunting and is scorched by love, and driven by storm and cloud, as if in mental turmoil, commits adultery. Having lingered long in this, at the prompting of Mercury he abandons a love that he entered on to evil ends because of his lust. Mercury is introduced as the god of intellect; thus at the prompting of intellect youth abandons the territory of love. This love dies of neglect, and burned out it turns to ashes.

The twelfth-century Bernardus Silvestris develops a physiological alle- gory of the provocation of carnal desire by an excess of food and drink in his reading of *Aeneid* 4: 'he is driven to the cave by storm and rain, in other words he is led to carnal uncleanliness by the disturbances of the flesh and by the abundance of moisture deriving from excess of food and drink.' Petrarch, who elsewhere subscribes to the version of the chaste Dido, applies an allegorical reading to the Virgilian narrative in his *Letters of Old Age* 4.5, an important document of early Renaissance allegorism. Here the initial temptation of the fleshly pleasure is located in Aeneas' meet- ing with his disguised mother in Book 1: 'Venus meeting Aeneas in the middle of the wood is pleasure itself [...] with the appearance and dress of a virgin, to deceive the unwary. For if one were to see pleasure in its true shape, one would doubtless flee terrified by the mere sight of it; for as there is nothing more enticing than pleasure, there is nothing more foul.'[14] Petrarch understands that within the narrative economy of the *Aeneid* Aeneas' encounter with Venus in disguise foreshadows his first sight of

Dido, a vision of female beauty eroticized through the filter of the virginal unattainability of an Amazon and the goddess Diana, but a woman made all too attainable through the *force-majeure* of Venus.

Petrarch's misogynistic contrast between fair and foul is the product of a puritanical rejection of the world and the flesh that goes back to Augustine's self-flagellation for the tears that he shed for Dido when first he learned to read (*Conf.* 1.13.21–2). Yet a 'two faces of Dido' reading is not a total distortion of the Virgilian narrative, in which the beautiful Dido will be transformed into a raging Fury. Even before that the Carthaginian queen, quasi-virginal at her first appearance, has already metamorphosed into the destructive witch. These are the two faces of Medea, an impor-tant model for Virgil's Dido, innocent virginal princess and also powerful witch, and ultimately pitiless murderer of her own children. In classical mythology the sea-monster Scylla appears as a sharp contrast of fair and foul, maiden and monster, in Virgil's description: 'she has a human face and as far as the groin she is a girl with lovely breasts, but below she is a monstrous sea creature'(*Aen.* 3.426–7). Ovid combines other fragments of Virgil in his description of Scylla in the *Metamorphoses*: 'her dark womb is girdled with fierce dogs; she has the face of a maiden and, if the poets have not invented everything, she was at one time a maiden' (13.732–4). Line 732 is modelled on Virgil's description of Scylla in *Eclogue* 6, but lines 733–4 echo the language used of the disguise of Venus in the Carthaginian woods in *Aeneid* 1 (315), 'bearing the face and dress of a maiden, and the weapons of a maiden'. Ovid's allusion to Virgil hints that the fair maiden Scylla was turned into a homicidal monster, just as the jilted Dido had been driven by anger to call down destruction against the Trojans.

The fair and foul cliché has a long history as a warning of the danger of succumbing to the temptation of female beauty. In the epic tradition the archetypal seductress is Circe, who detains Odysseus for a year on her island.[15] The Homeric Circe, a dangerous but relatively sympathetic char-acter, was later allegorized as lust, and her power to change men into beasts was interpreted as the figurative bestialization of human beings through surrender to bodily desires. Circe, together with the other goddess who detains Odysseus, Calypso, is among the models for Dido, and in *Fama*'s distorted report of Dido and Aeneas as slaves to luxury and lust (*Aen.* 4.193–4) Virgil registers the moralizing tradition of Homer interpreta-tion. In the Renaissance epic romances of Ariosto, Torquato Tasso and Edmund Spenser, elements of both Circe and Dido are incorporated in the temptresses who detain the hero from their heroic goal, respectively Alcina, Armida and Acrasia. For example, Armida's curse on Rinaldo in

Tasso's *Gerusalemme Liberata* (16.57–60) before she swoons is modelled on Dido's curse against Aeneas. In Spenser's *The Faerie Queene* the approach of Atin, an agent of 'strife and cruel fight', to stir Cymochles, a personification of concupiscence, from his immersion in the delights of Acrasia's Bower of Bliss, is modelled on Mercury's approach to Aeneas in Carthage to shock him into recollection of his epic mission (II.v.35–8) (Fig. 5).

Dido appears in many reflections and transformations in Spenser's *The Faerie Queene*.[16] The first canto shuffles a number of the inaugural events of *Aeneid* 1 and 4. The hero, the Red Cross Knight, is overtaken by a storm, but on land not sea, and takes refuge with his companion, the beautiful Una, in a dark wood, where he encounters a monstrous female. Error, half-woman, half-serpent, shares with the Virgilian Venus-in-disguise the feature of hybridity. Error is the first of the series of female epiphanies that punctuate the poem, in her hideous fertility a negative version of the series of Venus-*uirgo* apparitions of beauty. Spenser's Error is all foul, in the terms of Petrarch *Letters of Old Age* 4.5 the true face of Venus. Taking shelter in a storm with a woman also replicates Aeneas' less innocent encounter in the wilds with a woman, Dido, in the storm in *Aeneid* 4. But nothing untoward happens between the Red Cross Knight and Una. The Dido model continues to play in inverted form when, through the magic trickery of Archimago, Red Cross is made to abandon Una. But for this hero, unlike for Aeneas abandoning Dido, this is to abandon his true path, and to devote himself to the service of Duessa, who in truth is the temptress Dido figure.[17] The fair Duessa will eventually be revealed for the hideous hag that she really is, just as in Ariosto's *Orlando Furioso* Alcina is unmasked as a hideous crone (7.72–4).

Visions of virginal beauty in *The Faerie Queene* are so many reflections of the virgin queen Elizabeth I. In his *Letter to Sir Walter Raleigh* Spenser identifies Elizabeth in her person of 'a most royal queen or empress' with Gloriana, the Fairy Queen herself who never appears in person in the six books that Spenser wrote; in her person of 'a most virtuous and beautiful lady' Elizabeth is identified with Belphoebe, the unattainable maiden of the woods. The relationship within *The Faerie Queene* between the virgin huntress Belphoebe and Queen Gloriana mirrors that between Virgil's Venus disguised as virgin and huntress and Queen Dido. Aeneas' response to the apparition of female beauty in the woods of Carthage, 'O what should I call you, maiden? O, a goddess to be sure' (1.327–8 *o quam te memorem, uirgo? […] o dea certe*) is echoed on a number of occasions by Spenser, most circumstantially in the appearance in the forest to Trompart and Braggadocchio of Belphoebe (*Faerie Queene* II.iii.21–42). Trompart

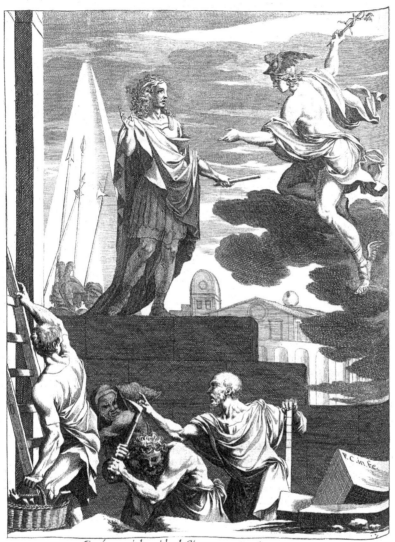

Aénée, a qui le Ciel destine vne autre terre,
Goutoit auec Didon les plaisirs de L'Amour,
Quand Mercure énuoyé par le Dieu du Tonnerre
Le presse de sa part de quitter ce Sejour

liure 4.me

Fig. 5. Mercury descends to Aeneas in Carthage. Engraving by François
Chauveau, from Michel de Marolles, *Les Oeuvres de Virgile
traduites en prose* (Paris, 1649).

opens his address with the words 'O Goddess, (for such I thee take to be)'. Two stanzas earlier the narrator has made his own comparisons, in a double simile likening Belphoebe to 'Diana by the sandy shore | Of swift Eurotas [...] Or as that famous Queen | Of Amazons, whom Pyrrhus did destroy', i.e. Penthesilea. These are, in reverse order, the images that frame Aeneas' first sight of Dido in *Aeneid* 1, the painting of Penthesilea and the Diana simile. Spenser's association of these three, Penthesilea, Dido, Diana, with a version of the disguised Venus earlier in *Aeneid* 1 acknowledges the close interconnection of all four. The further connection with Elizabeth is reinforced by the use of the Virgilian tags *o quam te memorem, uirgo?* and *o dea certe* as emblems for the two shepherds at the end of the fourth, 'Aprill', eclogue in Spenser's earlier book of pastoral poetry, *The Shepheardes Calender*. The emblems footnote the fact that the apparition of the Virgilian Venus is a subtext for Colin Clout's 'lay of fair Elisa', in which Elisa/Elizabeth also takes the role of the child of Virgil's fourth *Eclogue*. Spenser thus praises the queen with reference to two Virgilian epiphanies, the miraculous boy of *Eclogue* 4 and the appearance of Venus in *Aeneid* 1.

The near identity of Dido's other Virgilian name Elissa with the short form of Elizabeth, Eliz/sa, encouraged further allusion to Dido in the literary and artistic packaging of the English queen.[18] The problems that arose through Dido's 'marriage' with a foreign prince could be used as a conveniently indirect way of raising the delicate issue of whether Elizabeth should look for a husband or not. Panegyric and diplomacy are both involved in a neo-Latin drama *Dido*, written by the prominent university dramatist William Gager, and performed with lavish staging and musical accompaniment in the hall of Christ Church, Oxford, in June 1583 in honour of the Polish prince Albertus Alasco; this was in response to Queen Elizabeth's request to the Earl of Leicester to provide lodging and entertainment in Oxford for the prince.[19] This was two years after Elizabeth ceased to play the 'engagement game' with the Duke of Alençon. Gager's play is largely a close adaptation of Virgil's hexameters into dramatic trimeters, with some additions. A 'Hymn to Aeneas' in the mouth of Dido's court-bard Iopas, is transparently designed as praise of Elizabeth's distinguished visitor Albertus. Iopas reminds Aeneas/Albertus that however great he is, nevertheless Elisa is greater, for 'The world sees nothing similar, or even second in place, to our Elisa'. The moralizing *Epilogue* opines that 'foreign marriages rarely turn out well', and concludes with extravagant praise of Elizabeth, trustworthy in foreign relations. Confident that 'our Elisa' will not succumb to an Aeneas, Gager

can safely put in her mouth, in praise of Albertus, the words with which Dido had expressed her admiration – and infatuation – for Aeneas.

A series of nine scenes from the Virgilian story of Dido and Aeneas, from Aeneas' flight from Troy to Dido's suicide and the Trojans' departure from Troy, appears on a pillar behind and to the left of the figure of Elizabeth in the 'Sieve' portrait, painted *c.* 1580 (at the time of the flirtation with the Duke d'Alençon) (Plate 3). The portrait is named for the sieve held in Elizabeth's left hand, a symbol of chastity (after the story that the Vestal Tuccia had proved her virginity by carrying water in a sieve without leakage). Behind and to the right of the queen are a group of men in courtiers' clothes and carrying halberds, in a long colonnade, the world of men in which Elizabeth rules. Tuccia appears in Petrarch's *Triumph of Chastity* (148–51) shortly before the chaste Dido, and the message of the painting seems to be that Elizabeth's success as ruler and empire-builder will depend on her *not* following the path of the Virgilian Dido. But Dido as she was before she met Aeneas could be a suitable model: William Camden writes in his *Annals* of the reign of Elizabeth that after the defeat of the Spanish Armada coins were struck showing the Spanish fleet devastated by incendiary ships, with the legend *Dux Foemina Facti*, 'A woman was conductor of the fact', the words with which the disguised Venus described Dido.[20]

The figure of Dido, the Virgilian queen who at first succeeds in a masculine role before being brought low when she succumbs to love, through an all too 'feminine' weakness, was useful to the male writers of Elizabethan England in conceptualizing the power and potential frailty of their own queen, who famously said 'I have but the body of a weak and feeble woman, but I have the heart and stomach of a king.' Issues of gender, and of appropriate gender roles, have always been central to the reception of Dido, and women writers have also used Dido to explore their place in male-dominated societies. Christine de Pizan (1365–1430), often regarded as a proto-feminist writer, finds in Dido an image of her own authorial self.[21] From Boccaccio's *On Famous Women*, which she translated as *Des cleres femmes*, Christine took the figure of the chaste Dido as the prudent and judicious city-builder celebrated in Book 1 of *La Cité des dames*, the symbolic city of women which Christine constructs with conscious reference to Augustine's *City of God*. In Book 2 the Virgilian Dido is praised for the strength and fidelity of her love for Aeneas, virtues not shared by the unfaithful Aeneas. In the *Livre de la mutacion de la fortune* Christine represents herself as being transformed after the death of her husband into an 'homme naturel parfaict', taking on a masculine role like the widowed

Dido leading her people into exile and a new city.

An identification with Dido also forms an important part of the self-presentation by the well-educated sixteenth-century French writer Hélisenne de Crenne, the *nom de plume* of Marguerite Briet.[22] Hélisenne is the name of the female protagonist in her novel *Les Angoysses douloureuses qui precedent d'amours*, which alludes repeatedly to the story of Dido and Aeneas, as the novel explores issues of love and infidelity, and of what is expected of the female sex. These interests may also have been a strong motivation for Briet's translation into French prose of the first four books of the *Aeneid* (*Eneydes*, 1541). Dido's other name 'Elissa' resonates within Briet's pseudonym 'Hélisenne'.

Charlotte von Stein was the close friend and muse of Goethe in Weimar until his sudden departure in 1786 on his Italian journey, after which their relationship never fully recovered. In 1794 she wrote a tragedy, *Dido*, based on the version of the chaste Dido, in which Dido takes her life to remain true to her dead husband Acerbas and to avoid marriage with the African king Jarbes (Iarbas).[23] Dido is betrayed by her own envoys to Jarbes, who support his suit for her hand, a historian Aratus, a philosopher Dodon, and a poet Ogon. Ogon has often been seen as a mask for Goethe, and the play a bitter comment on what Charlotte von Stein saw as her betrayal by him. Alternatively, it has been suggested that through using the non-Virgilian version of Dido she constructed an image of how she would like to be perceived, as an independent and superior human being, in reaction to an uncomfortable series of parallels between the history of her previous relationship with Goethe and the Dido and Aeneas story in the *Aeneid*. For example, Charlotte shared with Dido a significant cave: Goethe had a great sentimental attachment to a cave under the Herrmannstein, to which he had brought Charlotte and in which he carved their two names.[24] Schiller's 1792 translations of Books 2 and 4 of the *Aeneid* may have served to remind Charlotte of the parallels.

Mexico's leading twentieth-century female poet, and a feminist icon, Rosario Castellanos (1925–74), wrote a striking *Lamentación de Dido*.[25] She ends: 'It would be preferable to die. But I know that for me there is no death. Because grief – and what else am I but grief – has made me eternal.' This is the eternity of her own reception, and earlier in the poem she expresses her awareness of the long tradition of her sufferings: 'My name carved itself in the bark of the huge tree of traditions, and every year, when the tree comes into leaf, it is my spirit, not the wind without history, it is my spirit which shakes its foliage and makes it sing.' Dido has metamorphosed into the animating force of *Fama* as tradition.

Weddings and dynasties

At its simplest the story of Dido and Aeneas is one of a conflict between love and duty, or love and destiny. The *Aeneid* is an epic about founding cities and founding a family: Rome and the Julian *gens*, the family of Julius Caesar and his adoptive son Augustus, are the distant goals of the poem. Both Dido and Aeneas have lost a city and a spouse, and so might seem to be the perfect match. Dido has already founded a new city, and at first Aeneas eagerly joins in the building work. Book 4 also contains the only description of a wedding in the poem, in the shape of the weird elemental manifestations that accompany the coupling of Dido and Aeneas in the cave. There is a hint of the possibility of a new Trojan-Carthaginian blood-line in Dido's forlorn wish, when she realizes that Aeneas is set on leaving Carthage, that at least she might be bearing his child, a 'little Aeneas' (*paruulus Aeneas*, 4.328–9). A Roman reader might have thought of a child of Aeneas' descendant Julius Caesar, Caesarion, 'little Caesar' (a Greek diminutive form of the name), the offspring of Caesar and another African queen, Cleopatra, raising the nightmare for all right-thinking Romans of a Roman-Egyptian line of rulers. Caesarion was put to death by Octavian.

Aeneas' destiny and duty is to found a city in Italy and to marry an Italian princess. That princess is Lavinia. From one point of view the most important woman in the poem, Lavinia is yet almost entirely faceless, and certainly speechless. To be accurate, her face in fact is her most vocal feature, since her only 'action' in the poem, her only reported 'communication', is her famous blush (12.64–9), whose meaning is not easy to read. Lavinia's silence has been a provocation to the industry of supplementing the *Aeneid*, in Ursula Le Guin's novel *Lavinia* (2008), which tells the story of the Trojans' arrival in Italy through the mouth of Lavinia, continuing beyond the end of the *Aeneid* to the death of Aeneas. The *Aeneid*'s reticence on the character and thoughts of Aeneas' future wife allow a space in which Le Guin's Lavinia, engaging in a 'nowhen' dialogue with the ghost of her creator Virgil, is able to develop her own female perspective on the coming of the Trojans to a pastoral and georgic early Italy.[26]

Apart from Lavinia the other major (mortal) female characters in the *Aeneid* all have stories that are concluded, usually with death: Creusa (Aeneas' first wife), Andromache (who exists in a kind of living death), Dido, Amata (the mother of Lavinia), Camilla (the Italian Amazon). Lavinia by contrast might be described as virginal potency. Her wedding to Aeneas lies beyond the ending of the poem, and within the time-span

of the main narrative she and Aeneas never meet. She is not even a Helen, the fame of whose beauty made men who had never seen her fall in love with her, for all that Turnus claims that Aeneas, in taking a woman whom Turnus regards as his by right, is repeating the crime of Paris in the rape of Helen. Virgil's management of the hero's relationship with the woman over whom is fought the war that takes up the second half of the *Aeneid* is in striking contrast to the lengthy exploration of the relationship between Odysseus and Penelope as they are reunited at the end of the *Odyssey*. The comparison between a bride-to-be and a wife of some decades is not as off-colour as might at first appear, since Lavinia is in a sense already Aeneas' wife, in the book of Fate, and to win her hand Aeneas has to fight a suitor in a kind of civil war that repeats on the large scale Odysseus' battle with the suitors in his own house.

Virgil's reluctance to narrate a fulfilled relationship between a man and a woman and the absence from the *Aeneid* of scenes of happy married life are reflected in Milton's imitative practice in *Paradise Lost*. Milton's epic centres largely on the vicissitudes of the relationship between Adam and Eve; *Paradise Lost* is, to an unusual extent, an epic about the domestic matter of marriage. Adam and Eve's happier marital moments are narrated with allusion to married couples in Ovid's *Metamorphoses*, a poem of epic length and epic pretensions in which love and marriage play a prominent role.[27] Adam and Eve as happy gardeners in Eden are like Vertumnus and Pomona, who seal their mutual love in the garden of Pomona in *Metamorphoses* 14. Their hospitality to their angelic visitor Raphael makes them a younger version of Philemon and Baucis who offer humble hospitality towards the gods who come visiting in *Metamorphoses* 8. In the shared repentance that restores marital harmony after Adam and Eve have quarrelled after the Fall they are compared in a simile to the devoted couple Deucalion and Pyrrha, who restore the human race after the Flood in *Metamorphoses* 1 (*Paradise Lost* 11.8–14). In contrast, Milton highlights key moments in the history of the Fall by allusion to the Virgilian tragedy of Dido and Aeneas. When Adam looks longingly after Eve for the last time before the Fall, the last moment of innocent conjugal desire, there is an echo of Aeneas' last view of Dido in the Underworld: with *Paradise Lost* 9.397–8 'Her long with ardent look his eye pursued | Delighted, but desiring more her stay' compare *Aen.* 6.475–6 'Aeneas was no less stricken by her unjust fate (*casu percussus iniquo*), and long did he gaze after her (*prosequitur [...] longe*), weeping and pitying her as she went.' An awareness of the Miltonic lines retrospectively lends fresh point to *casu [...] iniquo*: Eve is about to meet an 'adverse fall'. The most emphatic allusion

to the Dido and Aeneas story comes at the eating of the apple, first by Eve, and then by Adam, now united with Eve in original sin as he knowingly partakes of the apple: *Paradise Lost* 9.781–4 'she plucked, she ate: | Earth felt the wound, and Nature from her seat | Sighing through all her works gave signs of woe, | That all was lost'; 1000–4 'Earth trembled from her entrails, as again | In pangs, and Nature gave a second groan; | Sky loured, and muttering thunder, some sad drops | Wept at completing of the mortal sin | Original.' Later in human history there will be similar signs in the elemental accompaniments to the 'wedding' of Dido and Aeneas in the cave, the moment of Dido's 'fall', *Aen.* 4.166–70: 'Earth and Juno, giving away the bride, first gave a signal: lightning flashed and sky witnessed the wedding, and the Nymphs cried out on the mountain top. That day first brought death, that day first brought woe.'[28]

One response to the Virgilian unwillingness to develop a narrative of wooing and wedding was to supplement the *Aeneid*. This is the strategy of the *Roman d'Eneas*, written probably around 1160 at the court of the Plantagenet king Henry II, and one of the earliest of the French romances.[29] Eneas' affair with Dido is elaborated at even greater length than in the *Aeneid*. This disastrous relationship, in which female desire and intelligence threaten the hero's mission, is balanced in the last part of the poem with the narrative, spread out over two thousand verses, of the love affair of Lavine and Eneas, ending with the wedding of the happy couple. But not before much erotic pain, first on the part of Lavine, whose experience and inner debates are described at great length, and then of Eneas, who falls in love with Lavine after reading a letter that she has delivered to him wrapped round an arrow. Love strikes through their gazes on each other, Lavine looking down to the battlefield from her tower, and Eneas looking up to the tower. Eneas confesses to himself (9090–4) that 'I have never known such torment; if I had had such feelings towards the queen of Carthage, who loved me so much that she killed herself, my heart would never have left her.' Through this mutual love Eneas becomes the ideal chivalric lover. Love gives Eneas strength in his fight with Turnus; Lavine says that 'if he has any care for my love, when he sees me at the window, he will become much the bolder' (9392–4). Lavine's sorrows in her love for Eneas, elaborated through copious use of Ovid's amatory works, provided a model of romantic love for the medieval tradition of courtly narrative. In this second major episode of erotic obsession in the *Roman d'Eneas* love helps rather than hinders (as it had in the case of Dido) the pursuit of a heroic goal, and a woman's desires and ruses end up by furthering the goals of patriarchal power and lineage. A circumstantial account of the

wedding of Aeneas and Lavinia is also contained in the Book 13 of the *Aeneid* composed in Latin in the early fifteenth century by Maffeo Vegio, in order to tie up the ends left loose at the end of Virgil's Book 12 (on Vegio see p. 85).[30]

Dynastic epic

The detailed attention paid by the *Roman d'Eneas* to the relationship between Aeneas and his future queen, leading to a marriage through which he will succeed to a kingdom, may reflect the historical reality of the powerful queen Eleanor of Aquitaine, through whom the English king Henry II, Eleanor's second husband, succeeded to his French dominions.[31] The historical context may have given a strong impulse to the positive association of the power of love and political power that becomes the norm in the Italian epic romance of the sixteenth century and in Renaissance epics in other languages. Where Virgil's warrior-maiden Camilla is deflowered in death, Amazonian warriors of the Renaissance combine military prowess with erotic love and are destined to found dynasties. Ariosto's Bradamante will marry the Saracen warrior Ruggiero, once he has converted to Christianity, and the couple will become the ancestors of the d'Este family of Ferrara. Spenser's Britomart pursues her beloved Artegall, by whom she will eventually become the ancestor of the Tudor kings and queens. In Tasso's *Gerusalemme Liberata* the dynastic ancestress is the representative not of the Virgilian Amazon, but of the Homeric-Virgilian figure of the seductress and temptress, Circe-Calypso-Dido. The Saracen sorceress Armida leads the hero Rinaldo away from his heroic duties as the Christian champion in the siege of Jerusalem to her enchanted garden. From there he is recalled to the world of epic by Carlo and Ubaldo, playing the role of Mercury in Virgil's Carthage. Rather than commit suicide, Armida follows Rinaldo, and is finally converted from her mission of revenge into the Christian wife of Rinaldo, and the two become ancestors of the d'Este family. In the dynastic romance, honour and love as motivating forces are brought into a harmonious collaboration, in a revision of the conflict between fame and love that makes the *Aeneid* in many ways so bleak a poem.[32]

We have seen above how the story of Queen Dido is used in often oblique and not altogether comfortable ways to comment on the historical Queen Elizabeth and on speculation about a possible dynastic union with the Duc d'Alençon. An unembarrassed rehabilitation of the Dido story in the service of a celebration of the beginning of the Tudor dynasty is found

in *Pancharis* by Hugh Holland, later author of a dedicatory poem in the First Folio of Shakespeare. Only the first book was completed, published in the year (1603) of the death of the last monarch of the dynasty, Elizabeth. It is an account of 'the preparation of the love between Owen Tudor and the Queen' (Catherine of Valois, the widow of Henry V), in which the plot of Dido and Aeneas is turned to the celebration of a wound of love that leads to the line of the Tudors. Catherine, like Dido, is initially determined to preserve honour and reputation by remaining faithful to her dead husband, but Venus' and Cupid's plot to make Owen fall in love with her will eventually win out, this time without tragic consequences. Spenserian in language, the poem self-consciously swerves from the martial subject matter of traditional epic, so reversing Spenser's exchange of his pastoral oaten reed for 'trumpets stern' (*The Faerie Queene* I prol. i.): *Pancharis* 36 'That argument a louder trump doth ask, | To sound a march too slender is my reed; | Enough is it to tune a courtly masque.' The Ovidian is mingled with the Virgilian, and in the dedication to Queen Elizabeth a famous Ovidian tag is readjusted in line with this epic masque's harmonization of love with the proper exercise of royal power: 'And thou, O second sea-borne Queen of Love! | In whose fair forehead love and majesty | Still kiss each other' – in contrast to Jupiter's descent from his royal dignity to indulge his passion for Europa: 'Between the state of majesty and love is set such odds, | As that they can not dwell in one' (Golding, *Metamorphoses*, 2. 1057–8; Ovid, *Met.* 2.846–7 *non bene conueniunt nec in una sede morantur* | *maiestas et amor*).

Non-epic Didos

Virgil's Dido narrative is marked by a generic instability. Epic is diverted into the world of tragedy, and as a consequence the majestic Dido descends from her epic throne into an erotic obsession reminiscent of the self-absorption typical of Latin love elegy. Generically, the reception of the Dido story has also been very varied, in epic, tragedy, elegy, lyric, the novel and not least opera.

The reception of Dido was given a decisive twist by Ovid, one of Virgil's earliest and most acute readers. In his self-defence to Augustus from exile, the elegiac poet of love claims that love is a central concern of epic too: 'What is the *Iliad* itself, if not a disgraceful adulteress over whom there was a fight between her lover and her husband? [...] Or what is the *Odyssey*, if not one woman wooed by many suitors because of love, while her husband was away?' (*Tristia* 2.371–2, 375–6). The *Aeneid* too, Ovid tells

Augustus, is read largely for its erotic content: 'And yet that happy author of your *Aeneid* brought his "Arms and the man" into a Carthaginian bed; no part of the whole work is more often read than the love joined in an illegitimate union' (*Tristia* 2.533–6). Dido is naturalized in the solipsistic world of elegiac erotic complaint in the seventh of Ovid's *Heroides*, love letters of abandoned mythological heroines. Dido pens her epistle to Aeneas as he is on the point of leaving Carthage, but no reply is forthcoming or indeed expected. There is thus no answer to Dido's portrayal of Aeneas as a liar and deceiver, and to her charge that the pious hero is in truth a monster of impiety. Virgil's Dido had wished that if only she were pregnant by Aeneas, she would have 'a little Aeneas' by which to remember him; Ovid's Dido thinks that she may really be pregnant, in which case by forcing her to commit suicide Aeneas will be guilty of a double murder (*Her.* 7.133–8).

Heroides 7 is not just a free composition on the theme of *Aeneid* 4, but a particular way of reading Virgil's Dido, one that privileges the values of love and personal relationships over the calls of fate and empire, a woman's point of view. Ovid calls attention to the prior existence within *Aeneid* 4 of elements of love elegy, a genre bursting on to the Roman literary scene at the same time as Virgil was writing the *Aeneid*. Dido's point of view has also been that of many modern readers, attracted to the 'private voice' of the *Aeneid*, as opposed to the 'public voice', in a prevalent 'two voices' approach to the poem that was reinforced by feminist readings (see Chapter 1 p. 16).

An alternative reading strategy has been to contrast Virgilian and Ovidian views of the world: Virgil writes the story of the painful but necessary struggle of the hero to achieve his destiny, forced to sacrifice much along the way, while Ovid gives voice to those victimized by the forces of history. The tension between these two ways of reading is vividly presented in Chaucer's *House of Fame*.[33] In the first book the narrator 'Geffrey' views scenes from the *Aeneid* engraved in a temple of Venus. The greatest space is devoted to the Dido episode. The narrator takes the view that Aeneas only 'seemed good', but in reality was false, 'for he to her a traitor was' (267). Dido is given a lengthy complaint, which focuses on the damage done to her fame, and reputation by what people say and will say about her. 'For through you is my name lorn, | And all mine acts red [spoken] and sung | Over all this land, on every tongue. | O wicked Fame' (346–9). She expects to be harshly judged: 'Lo, right as she hath done, now she | Will do eft-soons, hardly [certainly].' The reader who wants to know 'all the manner how she died, | And all the words that she

said', is told to 'read Virgil in Eneydos | Or the Epistle of Ovid' (378–9). Reference to *Heroides* 7 triggers a catalogue of men who were false lovers, in fact a catalogue of seven other of Ovid's *Heroides*. Chaucer returns from this Ovidian digression to the straight path of the *Aeneid* at the end of the section on Dido and Aeneas: 'But to excuse Aeneas | Fully of all his great trespass, | The book sayeth Mercury, sauns fail, | Bade him go into Itayle, | And leave Afric's region, | And Dido and her fair town' (427–32). Finally, then, a clear line is drawn between the Virgilian narrative of the hero of destiny and Ovidian female complaints. Dido's earlier reference to 'wicked Fame' reveals Chaucer's awareness that the *Fama* of *Aeneid* 4 looks beyond Virgil's legendary narrative to the competing judgements on Dido in the literary tradition.

In *Aeneid* 4 Dido is given six long speeches, two addressing Aeneas, two giving instructions to her sister Anna, and two monologues, the second of which climaxes in her dying curse against Aeneas and his descendants. Aeneas is given only one lengthy section of direct speech, a vain attempt to justify to Dido his departure from Carthage. He pleads the command of the gods and the Italian kingdom owed to his son Ascanius, but succeeds only in provoking her to greater anger and scorn. Aeneas is otherwise notable for his taciturnity in *Aeneid* 4. Virgil's disproportionate focus on the thoughts and feelings of Dido has a long afterlife in smaller-scale complaints, laments and psychological portraits of Dido, beginning with Ovid's unanswered epistle to Aeneas. Laments of Dido proliferate in the Middle Ages. Helen Waddell writes of the wandering scholar poets: 'Dido they took to their hearts, wrote lament after lament for her, cried over her as the young men of the eighteenth century cried over Manon Lescaut.'[34] In Gottfried of Strassburg's *Tristan*, Tristan, disguised as a minstrel, plays the 'lay of Dido' for Isot and Gandin. The *Carmina Burana* include a lament by Dido beginning *o decus, o Libie regnum, Kartaginis urbem* 'O my glory, O kingdom of Africa, city of Carthage'.[35] The fragmentary collection *La Terra Promessa* (1935–53) by the Italian Hermeticist poet Giuseppe Ungaretti draws out themes of loss and desire in the *Aeneid* (the title refers to Italy as Aeneas' 'promised land'); it includes 19 brief 'Choruses descriptive of Dido's states of mind' ('Cori descrittivi di stati d'animo di Didone'), in which Dido's despair is generalized into an autumnal grief for (in Ungaretti's words) 'the disappearance of the last gleams of youth from a person or from a civilization, for civilizations are also born, grow, decline and die'.[36] The link in the *Aeneid* between the death of Dido and the future decline and destruction of her city, seen in the bright summertime of its first building (*Aen.* 1.430), is taken up by

others. English readers of this book will perhaps remember Dido particularly for her haunting lament 'When I am laid in earth' at the end of Purcell's opera *Dido and Aeneas*.

Dido's, however, is only one point of view. The events of *Aeneid* 4 are presented as conflicts of desires and duties, conflicts both between Aeneas and Dido, and within each of the two characters. These conflicts call for judgements and decisions on the part of the actors, and also from readers, provoking a critical debate about the culpability for the tragic outcome of the encounter between Trojans and Carthaginians that has lasted from antiquity down to the present day. It is a debate whose intensity is matched only by the disagreement as to how to judge the final action in the poem, Aeneas' killing of Turnus. The word 'tragic' is used with precision: the reader is alerted to the close affinity of the story of Dido's downfall with the genre of tragedy through formal signals, such as the use of the word *scaena*, literally 'stage' of a theatre, to refer to the backdrop of woods in the harbour at Carthage (*Aen.* 1.164), and by the delivery to Aeneas by his mother, playing the part of a virgin huntress and wearing 'buskins' (1.337), of a kind of Euripidean tragic prologue summarizing Dido's previous history. *Culpa*, the word used of Dido's 'fault' in surrendering to her love for Aeneas (4.172), could be a translation of Greek *hamartia*, the Aristotelian tragic 'flaw'. Some scholars have even tried to find in the structure of *Aeneid* 4 the schema of a five-act drama.

The agonistic genre of Attic tragedy stages debate and the clash of competing values and responsibilities. By building a tragic dialectic into his epic narrative, Virgil seems once again to have pre-programmed the reception of his Dido story, in a series of tragic and operatic dramatizations. The impress of *Aeneid* 4 is clearly visible in the tragedies of Seneca the Younger. In the *Medea* and the *Phaedra* Seneca chooses protagonists whose careers in previous tragedies had been part of the intertextual mix out of which Virgil had forged his Dido. Tragic aspects of Dido return, as it were, to their original owners in Seneca's plays. Senecan elements work their way back into post-classical dramatizations of the Dido story, for example a neo-Latin *Dido* of 1559 by Aulus Gerardus Dalanthus, which contains much material from Seneca's *Phaedra*.[37]

Dido figures large in the revival of the classical form of tragedy from the sixteenth century onwards, in both Latin and the vernaculars.[38] Some of these plays are close adaptations, amounting at times almost to translations, of the Virgilian text, and others are free developments of the Virgilian plot. Aeneas' inner struggle between love and duty is explored at length, and further erotic entanglements are introduced. In Italy there

were plays by Alessandro Pazzi de' Medici (1524), Giraldi Cinthio (1543) and Lodovico Dolce (1547). In the prologue of Dolce's *Didone*, the best known of the Italian Dido dramas, the divinity who motivates the action is Cupid. Having inspired Dido with the poison of love, as he does on Venus' instructions in *Aeneid* 1, he now goes a step further and announces his intention to make Dido kill herself and to bring about the sack of Carthage, as vengeance for Juno's persecution of Aeneas. He will raise the shade of Sicheo (Sychaeus) and madden Dido with a serpent from the hair of the Furies. In this last detail Dolce signals a connection between Cupid's erotic inflaming of Dido in *Aeneid* 1 and the Fury Allecto's infuriation in *Aeneid* 7 of Amata against the marriage of her daughter Lavinia to Aeneas, a connection in the Virgilian text to which modern critics have drawn attention. In an early scene between Enea and his close companion Acate (Achates), here a figure for Aeneas' conscience, Aeneas is torn between his desire to stay in Carthage and the god's command to leave, between love and the pursuit of honour and fame. The messenger-speech reporting the death of Dido is close to the Virgilian narrative, but ends with a translation of the epigram that Dido writes for herself at the end of Ovid *Heroides* 7 (2051–4): 'Thus did Aeneas leave to Dido the sword and the cause of her death; thus, for having loved too much, the famous lady has killed herself by her own hand.'

Etienne Jodelle founded French tragedy in the antique manner with his *Cléopatre captive* (1552), praised by the poets of the Pléiade. The date of his tragedy *Didon se sacrifiant* is unknown, but was possibly prompted by Du Bellay's publication of his translation of *Aeneid* 4 in 1558.[39] In the first act Enée runs through the horrors of the sack of Troy and his subsequent wanderings, the events that he narrates at length in *Aeneid* 2 and 3, but finds that all these are less terrible than the prospect of having to betray Dido's love (pp. 156–8). In making a connection between the frame-narrative of Dido and Aeneas in *Aeneid* 1 and 4 and Aeneas' flashback narrative in *Aeneid* 2 and 3 of the sack of Troy and his wanderings before reaching Carthage, Jodelle shows an interest in drawing out interconnections between different parts of the *Aeneid* which is anticipated in Dolce's *Didone*, which Jodelle possibly knew, and foreshadows modern studies of the ways in which framed and framing narratives reflect on each other. Later, in Act III, Aeneas says that the present agitation of his spirit makes him relive his experience in the storm at the beginning of the *Aeneid* (pp. 192–3). A psychological reading of the fury of the storm raised by Juno is one of the many possible ways of responding to that highly symbolic episode. Dido amplifies her threat to Aeneas to pursue him with a Fury's

black torches (*Aen.* 4.384–6) with a translation of Juno's words as she sets about calling up Allecto in *Aeneid* 7, 'And if the gods of the sky will not do me justice, I will stir up, I will stir up ('j'esmouvrois') the infernal abodes' (cf. *Aen.* 7.312 *flectere si nequeo superos, Acheronta mouebo*).

The invectives of Jodelle's Dido contain attacks on superstition and religion; a Lucretian scepticism about the value of religion, already present at points in *Aeneid* 4, surfaces in the Chorus's retort to Aeneas' defence that obedience to the gods requires him to leave Dido that 'Were it not for Religion, Iphigeneia would still be alive' (p. 177), alluding to Lucretius' use of the sacrifice of Iphigeneia as an example of the evils of religion. But in Act III Dido's anxiety that she may have offended Venus leads her to utter a prayer to Venus as a universal goddess of love that echoes the Hymn to Venus that opens Lucretius' *On the Nature of Things* (pp. 186–8). Aeneas' deep feelings for Dido, in Jodelle's and other Dido tragedies, include pity. Pity is the last emotion that we are told Virgil's Aeneas feels for Dido, as he watches her shade walk away from him in silence in the Underworld (*Aen.* 6.476 *miseratur euntem*).

Jodelle's *Didon se sacrifiant* is one of the models for the tragedy of the same name by the leading French playwright of the early seventeenth century, Alexandre Hardy (1624), which also plays up Aeneas' indecision and his pity for Dido;[40] Aeneas promises that he will come back and pay Dido a visit after he has arrived in Italy. Dido enjoyed a great popularity on the seventeenth- and eighteenth-century European stage, in the company of other royal heroines whose stories involved difficult choices between love and duty, Sophonisba, who killed herself after her love was renounced by the Numidian king Masinissa, and the Jewish queen Berenice, who survived the renunciation of her love by the Roman emperor Titus.

Christopher Marlowe's *The Tragedy of Dido, Queen of Carthage* may be Marlowe's earliest dramatic work, possibly written while he was still at Cambridge (1586?). It owes little or nothing to the continental tradition of Dido tragedies. Where most of those dramatize only the last part of the story in *Aeneid* 4, Marlowe's play covers the events of Books 1 and 4 from the Trojans' landing at Carthage to the death of Dido, followed immediately by the suicides of Iarbas, Dido's thwarted suitor, and Anna, who in this version is in love with Iarbas. In this extension and complication of the Virgilian erotic triangle of Dido, Aeneas and Iarbas, *The Tragedy of Dido* is in the company of numerous other adaptations of the Virgilian plot. Like William Gager's Latin *Dido*, performed probably a very few years before Marlowe wrote his *Dido*, but which Marlowe seems not to have known,

the play at points tracks Virgil's Latin very closely. *Dido, Queen of Carthage* has provoked very varying critical reactions, some seeing in it a celebration of erotic desire, and others a condemnation of passion.[41] The debate between 'romantic' and 'pro-duty' Marlovians is parallel to, but, it would seem, largely independent of, the continuing debate among Virgilians as to the assessment of the relative claims of the 'private' and 'public' voices in *Aeneid* 4. The first scene takes us to Olympus, but only to discover Jupiter dandling Ganymede upon his knee: what in Virgil is mentioned briefly as one of the causes of Juno's hostility to the Trojans (*Aen.* 1.28 *rapti Ganymedis honores*: Ganymede was a Trojan) is expanded into an Olympian version of the invitation to love in Marlowe's lyric *The Passionate Shepherd to His Love*. Marlowe heightens the generic polymorphism that already characterizes the Virgilian Dido narrative, and he follows in the line of Ovidian readers of the story.[42]

Marlowe's *Dido* is one of his least-read plays, and none of the continental Renaissance Dido plays ever achieved classic status to equal that of Racine's *Bérénice*, for example. In the case of opera there are two acknowledged masterpieces, Purcell's *Dido and Aeneas* (libretto by Nahum Tate)[43] and Berlioz' *Les Troyens*, the last three of whose five acts are on the story of Dido.[44] But these standard items in the repertoire are the tip of an iceberg of operas on Dido. The first of these was Cavalli's *Didone* (Venice 1641; librettist Giovanni Busenello,[45] who also wrote the libretto for Monteverdi's *L'incoronazione di Poppea*). In Busenello's libretto Dido directs her anger against herself, not Aeneas, tormented by her own conscience. A focus on Dido's guilt and expiation for her betrayal of her queenly responsibilities is found much later in a stream of German Dido tragedies produced between the 1820s and World War I.[46] In Busenello's second version of the libretto a repentant Dido becomes the happy wife of Iarbas, one of a number of rewritings of the story with a happy ending, catering for the Baroque predilection for musical dramas with a *lieto fine*. Between 1641 and 1863, the date of the first performance of Berlioz' *Les Troyens*, about a hundred Dido-operas have been counted.[47] About 70 of these are settings of Pietro Metastasio's libretto *Didone abbandonata*, Metastasio's first great hit when it was performed during Carnival in Venice in 1724, set to music by Domenico Sarro.[48] Metastasio complicates the plot with erotic and political intrigue, disguise and doubletalk: Dido's sister, here called Selene, is also in love with Aeneas, perhaps following a variant tradition already current in antiquity that Anna, not Dido, was in love with Aeneas. Selene is repeatedly in danger of giving away her feelings to Aeneas, but covers her own emotions by telling him that she shares

Dido's sufferings because (I.ix.) 'She lives in me, and I live in her, in such a way that all her woes are my woes'. This is a clever twist on the very close relationship that binds the Virgilian Dido to Anna, introduced as her 'like-minded sister', or even 'soul-partner' (*Aen.* 4.8 *unanima*). Jarba's confidant Araspe is in love with Selene, and Dido has a wicked adviser Osmida, who tries to betray her to Jarba. Aeneas is much given to 'pietà' in the sense of 'pity'. At the end of the opera Jarba has launched a full-scale attack on Carthage and the city is in flames. Dido hurls herself into the burning palace. In the version of the opera performed at the Spanish court in 1754, in a curious prefiguration of the ending of Wagner's *Götter-dämmerung*, the sea rises and dense clouds gather, to the accompaniment of stormy music. The furious clash of fire and water is finally won by water, whereupon the sky clears and the music turns joyful, and from the waves rises the bright palace of Neptune the calmer of storms. In the 'Licenza' (Envoy) Neptune looks into the future when as the god of calm seas he will carry the laws of Spain to remote worlds, developing the political imagery of Neptune's calming of the storm in *Aeneid* 1. The allusion here is to the peace-loving policies of Ferdinand IV of Spain after the Treaty of Aix La Chapelle (1748), ending the War of the Austrian Succession.[49]

4

THE MANY FACES
OF AENEAS

A rich account of the reception of classical antiquity could be given through a study of the successive reincarnations of some of the major heroes and heroines of classical myth and legend. Thus there are books tracing the journey through the last two and a half millennia of Hercules and Odysseus, of Helen and Electra, and studies of the Achillean hero; Oedipus and Electra have given their names to psychological complexes; Narcissus and Pygmalion have a rich afterlife in both literature and the visual arts. But although the *Aeneid* quickly established itself as the central literary text of the western Latin tradition, there is no subgenre of books on the theme or figure of Aeneas in the classical tradition. Even within Virgilian studies more narrowly conceived there are only two books (known to me) on the character and role of Aeneas.[1]

Dido is the Virgilian character who has achieved something like archetypal status, and to whose reception whole studies are dedicated. Aeneas has suffered in comparison with Dido, and although ways have been found to account for and even justify the relative taciturnity and inhibition manifested by Aeneas, above all in Book 4, the comparison with the abandoned Carthaginian queen continues to be odious. What is often perceived as the colourless quality of Aeneas' character is largely the result of the roles forced on him by the plot of the *Aeneid*: rather than being strongly driven by an internal desire or ambition, he is forced into a mission by circumstances outside his control. Flight (*fuga*) rather than a self-willed search for a goal is his lot. This unwilling career he shares with Hercules, but Hercules is a larger-than-life hero who tests the limits of humanity in a way that Aeneas does not. Aeneas has much in common with Jason, a hero forced into a quest not of his choosing, and whose erotic history is tarnished by a lack of constancy and consistency. Jason too is a character without a very well-defined *Nachleben*, in contrast both to the

archetypal journey of the Argo and to the main female character in the story, Medea.

As a character Aeneas comes to life most vividly in the anger that is provoked, in *Aeneid* 10 and 12, by the death of Pallas. But Aeneas' attachment to the young warrior is not central to his ambitions and goals in the way that Achilles' attachment to Patroclus, the Homeric model for the relationship between Aeneas and Pallas, is central to the *Iliad*. Rather than being something by which readers and the later tradition define the hero, Aeneas' affection for Pallas and his consequent outburst of anger, leading to the death of Turnus at the end of the poem, create a problem in the assessment of the ancestor of the Romans to which succeeding centuries have responded in a variety of ways. In other respects Aeneas is more of a *heros patiens* than a *heros agens*.

The quality for which Aeneas is above all famous is his *pietas*, wider in meaning than English 'piety', denoting a dutiful respect towards the gods, country and family. The emblem of pious Aeneas is the image of Aeneas fleeing from Troy, carrying on his shoulders his father Anchises, bearing the gods of Troy, and with his son Ascanius at his side (*Aen.* 2.721–4). This is the text for perhaps the most famous single image associated with the *Aeneid* (see Chapter 9, p. 198). This is the hero at the crucial moment of flight, thinking of his duty to others, and appearing as one in a group, not in the splendid isolation of a Hercules or Achilles.

The group of Aeneas with father and son is also an emblem of Aeneas' role as a bearer of tradition, transitional between one city and its culture and another city. Where he comes from and where he is going to are, in a way, more important than who he is. As a character in the *Aeneid* he is also transitional in the sense that he carries the burden of many characters in earlier literature and legend, and in turn he foreshadows and offers a pattern for persons in future Roman history, a 'model Roman' for every Roman, and above all for the latest and greatest Roman leader, Augustus.[2] Intertextuality spills over into exemplarity. Virgil's Aeneas already embodies vistas of reception receding into the past, which will be continued in future instances of reception of the *Aeneid* and its hero, in ancient Rome and after.

If for some readers the character of Aeneas threatens to dissolve into earlier models of heroism and later avatars, others have questioned whether he really deserves the label of 'hero' at all. He has been called an 'unheroic hero',[3] and a 'wimp'.[4] In the introduction to his French translation of the *Aeneid* (Paris, 1668, 1681) Jean Renaud de Segrais records a view of Aeneas as (p. 35) 'timid [...] ungrateful [...] too often with tears in his eyes, and

in the end the character of piety which Virgil has given him is not as attractive as the character of love which our writers of romances give to their heroes'. Dryden, who was well read in French criticism of Virgil, complains of 'wretched critics' who 'make Aeneas little better than a kind of St. Swithin hero, always raining'.[5] De Segrais' contrast between Virgil's epic hero of piety and novelistic heroes of love helps to explain what might otherwise seem puzzling, that a character whose lacrimosity is notorious has also been charged by more recent scholars with indifference and taciturnity. A recent survey for high school teachers of approaches to the character of Aeneas has the title '"Frigid indifference" or "soaked through and through with feeling"?'[6]

However, one well-known anecdote on the subject perhaps does not mean quite what it seems to. One of W.B. Yeats' favourite anecdotes, recorded by Ezra Pound in his *ABC of Reading* (London, 1934, 29) tells how 'A plain sailor man took a notion to study Latin, and his teacher tried him with Virgil; after many lessons he asked him something about the hero. Said the sailor: "What hero?" Said the teacher: "What hero! Why Aeneas, the hero!" Said the sailor: "Ach, a hero, him a hero? Bigob, I t'ought he waz a priest".' But rather than reflecting a naïve – and hence unprejudiced? – judgement on the buttoned-up piety of Aeneas, the sailor may only have assumed that a character referred to 17 times in the poem as *pater Aeneas* was called 'Father Aeneas' because he was a priest, like a present-day 'Father Malone'.[7]

Aeneas the perfect hero

One answer to the question of 'what kind of a hero is Aeneas' has been to claim that Aeneas is the perfect hero, the model of heroic and kingly virtue. To a modern readership, brought up on a 'Harvard School', or a 'two voices', reading of the *Aeneid* (see Chapter 1, pp. 16–18), this may seem strange, even counter-intuitive, but it is one of the oldest strands in the reception of the poem. It is linked to the close connection between epic, as a genre, and praise, a connection which goes back to the Homeric definition of narratives about the deeds of heroes as *klea andron* 'the famous deeds of men/heroes'. *Virum*, the second word of the *Aeneid* ('Arms and the man'), can as well be translated 'hero', as 'man'. A philosophically slanted reading of the *Odyssey* saw in Odysseus the pattern of the wise and virtuous man, a tradition summed up in Horace's claim in *Epistles* 1.2 that the Homeric epics contain a clearer and better account of moral philosophy than the treatises of Stoic and Academic philosophers: 17–18

'Homer set before us in Ulysses a useful model of what virtue and wisdom are capable of.'[8] The stress is on the practical usefulness of reading Homer for learning how to live one's life, the 'useful' (*utile*) being one half of the combination of the *utile* and the *dulce*, the useful and the charming, profit and pleasure, that Horace identifies as the two functions of poetry in the *Art of Poetry* (343). Horace here draws on a particular tradition of Homeric commentary, represented also in pseudo-Heraclitus' *Homeric Allegories* and the pseudo-Plutarchan *Life and Poetry of Homer*. This philosophical and exemplary reading was partly sustained by the central place held by the Homeric poems in ancient pedagogy. Just as Virgil models his epic on the poems of Homer, so the tradition of commentary on Virgil that started from the time of the poet's death followed in the tracks of Homeric commentary.

It was more difficult to see in the squabbling, amorous and irascible chieftains of the *Iliad* exemplars of virtue to be imitated, and, in order to extract a moral lesson from that epic, Horace in *Epistles* 1.2 sets them up as examples of vice to be avoided: Paris revealed his folly in refusing to hand Penelope back to the Greeks; Achilles and Agamemnon are driven by love and anger to quarrel with each other. In support of the notion that Virgil may have been thinking of moralizing commentary on Homer in constructing the character of Aeneas, it may be noted that in his extensive reworking of Iliadic material in the *Aeneid* Virgil includes a version of neither the quarrel between Agamemnon and Achilles, nor the rape of Helen. It is true that Turnus tries to portray Aeneas as a wife-snatcher, a second Paris, but on any reasonable assessment of the fact he is deluded in this. Out of the list of vices that Horace says are practised both inside and outside the walls of Troy, (15) 'discord, deceit, criminality, lust and anger' (*seditione, dolis, scelere atque libidine et ira*), Aeneas can be charged only with lust (possibly) and anger (certainly, or at least if the kind of angry fits into which Aeneas falls are examples of a reprehensible kind of anger).

The connection between the genre of epic and praise and blame is reinforced by the subsequent linkage of epic with 'epideictic' or 'demonstrative' rhetoric, that branch of oratory whose business is praise or blame (as distinct from the rhetoric of the law-courts or of political gatherings). The *Aeneid* already contains specimens of this kind of oratory, in this respect too reflecting the Homeric poems and ancient Homeric commentary, which regarded the speeches of the heroes as providing outstanding models of what would later be formalized as 'rhetoric'. At the court of Dido in *Aeneid* 1, before Aeneas and Achates emerge from the cloud in which Venus has wrapped them so that they can enter Carthage unob-

served, the Trojan Ilioneus addresses Dido and praises his missing leader, 1.544–5 'we had a king, Aeneas: none was more just and pious, none was greater in warfare'.

Ilioneus has a rhetorical purpose, to persuade Dido to receive the Trojans hospitably, and Virgil's reader is not bound to take this as an unbiased and accurate description of Aeneas. Praising the hero is identified as one of the two overarching goals of the poet, rather than of his characters, in the late-antique commentator Servius' definition of the 'intention of Virgil' as 'to praise Augustus through his ancestors' (the other goal being 'to imitate Homer'). But the most extensive panegyrical reading of the *Aeneid* is found not in Servius, but in the other extant late-antique commentary, the 'Virgilian Interpretations' by Tiberius Claudius Donatus (not to be confused with Aelius Donatus, the source of much of the material in Servius).[9] Tiberius Donatus maintains that Virgil was a supreme orator, and he assigns the *Aeneid* to the 'genre of praise' (*genus laudatiuum*); praise of Aeneas is fitting for the ancestor of Augustus, who should be shown as free from every fault and trumpeted in fame. In his detailed commentary Donatus exercises his casuistry to defend the hero against any possible charge of misconduct. With regard to the liaison with Dido, for example, he makes the points that Aeneas himself did not fall in love, as a common and base man might have, but that he was the object of love. Furthermore, when Aeneas met a beautiful and unaccompanied virgin (as she seemed, in reality Venus in disguise) in the woods in Book 1, he did not think of raping her, as many men might have (and one might add as an Ovidian god certainly would have done). Tiberius Donatus also defends Dido herself, in order that Aeneas should not be tarnished by association with an unworthy woman: she was a chaste, rich and beautiful woman, deceived by Cupid, not a woman who willingly cast aside her sense of shame.

The panegyrical reading of Aeneas has a very long history, and was a dominant strand in the Renaissance.[10] Petrarch held that in Aeneas Virgil described 'the demeanour and character of a perfect man' (*Fam.* 10.4), and Maffeo Vegio, author of a 13th book of the *Aeneid*, described Aeneas as 'endowed with every virtue'. The seventeenth-century French critic René Rapin in his *Comparison of the Poems of Homer and Virgil* (Paris, 1664, 32–3), takes at face value Ilioneus' list of Aeneas' three main virtues: 'the three supreme qualities which make up his essential character, religion, justice, courage, and which were the qualities of Augustus, whose portrait Virgil drew in the hero that he dedicated to him'.

The notion that an epic offers a portrait of virtues in action to be

imitated by the prince or nobleman forms part of the self-presentation of the authors of new epics. In his 'Letter to Raleigh' Spenser says of *The Faerie Queene* that 'The general end therefore of all the book is to fashion a gentleman or noble person in virtuous and gentle discipline.' The knights of the projected 12 books of the poem each stand as a 'patron' of a particular virtue (the Red Cross Knight of holiness, and so on), while 'in the person of Prince Arthur I set forth magnificence in particular, which virtue [...] is the perfection of all the rest, and containeth in it them all'. General statements of intent need not, of course, correspond closely to the detailed practice of a poet, any more than a moral and rhetorical tradition of reading Virgil is (we would feel) wholly adequate to the detailed texture of the *Aeneid*. While a moral allegory is continuously present in *The Faerie Queene*, modern readers will probably locate the real interest of that poem elsewhere.

Similarly, Dryden presents his long-cherished but never-realized ambition of writing a heroic epic of his own, apparently on an Arthurian or Plantagenet subject, as a panegyrical project: 'I could not have wished a nobler occasion to do honour [...] to my king, my country, and my friends; most of our ancient nobility being concerned in the action [...] after Virgil and Spenser, I would have taken occasion to represent my living friends and patrons of the noblest families, and also shadowed the events of future ages, in the succession of our imperial line.'[11] In the event it was into his translation of the *Aeneid* that Dryden worked allusion to the history and politics of his own day, showing himself in this a faithful translator of Virgil's own mirroring of recent Roman history in the remote legendary narrative of Aeneas and the Trojans. The experiences and goals of Aeneas, an exile with a destiny of settling in a promised land, reflect in complex and not entirely panegyrical ways on the careers of both the exiled king James II and the invading William III.[12] The complexity is not matched by the crude alteration for the publication of Dryden's *Aeneid* of the engravings in John Ogilby's 1654 Virgil to superimpose the features of William III on those of Aeneas.

The killing of Turnus

In the last scene of the *Aeneid* the fallen Turnus begs Aeneas to remember his own father Anchises and to have pity on Turnus' aged father as Aeneas contemplates whether to kill him or not. Aeneas hesitates, but on seeing the sword-belt of Pallas which Turnus is wearing he explodes in anger and kills Turnus. This final action has been the greatest stumbling-

block for modern readers in the way of a positive judgement of Aeneas, and more broadly of a positive evaluation of the epic as a whole. Already the Church Father Lactantius (*c.* 240–*c.* 320) argued that Aeneas' angry vengefulness invalidated his claim to a true *pietas* (*Divine Institutes* 5.10). Running together Aeneas' killings of the suppliant Magus in *Aeneid* 10 and of Turnus at the end of the poem, Lactantius puts his finger on the problem: how could a hero who ignored appeals to the memory of his own dead father, prime focus of Aeneas' *pietas*, and who blazed out in a stubble-fire of fury, be truly labelled 'pious'?

The problem continued to be felt in the Renaissance, as witnessed in rewritings of and supplements to the *Aeneid*.[13] Ariosto has more than one bite at the cherry. Cantos 18–19 of *Orlando Furioso* tell the story of Medoro and his friend Cloridano, who attempt to recover the body of their commander and engage in a night-slaughter of the enemy, in a repetition of the Nisus and Euryalus episode in the *Aeneid* and of the episode of Hopleus and Dymas in Book 10 of Statius' *Thebaid*, an episode itself closely modelled on Virgil's Nisus and Euryalus. The self-contained Nisus and Euryalus episode in *Aeneid* 9 has been read by modern Virgilians as a mise-en-abyme of the *Aeneid* as a whole:[14] when Medoro is caught by the Christian captain Zerbino, Ariosto switches model to the end of the *Aeneid*. Fired by *ira* 'anger' and *furor* 'fury' (the Italian and the Latin words are identical in form), like Aeneas when he sees Pallas' sword-belt (*Aen.* 12.946–7 *furiis accensus et* **ira** | *terribilis* 'fired by fury and fearsome in his anger'), Zerbino tells Medoro that he will pay the penalty. But when his eyes light on the beautiful face of the young boy he is overcome with *pietade* and does not kill him. *Pietade* here means simply 'pity', a meaning that *pietas* rarely has in the *Aeneid*, and then only in association with the meanings that relate to a sense of duty. This is an example of the development of the 'repressed remorse' and lacrimosity of the Virgilian epic into the chivalric virtue of an uninhibited pitifulness in the medieval and Renaissance romance, as Virgilian *pietas* evolves into the 'pity' of the Romance languages.[15] In the next stanza Medoro pleads for the burial not of his own body (as Turnus does), but of that of his commander, and he so moves Zerbino that 'd'amor tutto e di pietade ardea' 'he was all afire with love and pity' (19.12.8). *Pietade* as 'pity' is now associated with Zerbino's reaction to Medoro's pious devotion to the dead Dardinello, together with a love fired both by the boy's physical and by his moral beauty. Thus Ariosto avoids the terrible ending of the *Aeneid*, where violence is the product of a clash between competing claims on Aeneas' *pietas*, and where any possibility of pity on Aeneas' part for the

fallen Turnus is obliterated by his love for the dead Pallas.

In the final duel in *Orlando Furioso* between Ruggiero, ancestor of Ariosto's patrons the d'Este family, and the monstrous Saracen Rodomonte, the ambiguities of the duel between Aeneas and Turnus are wiped away. Rodomonte is labelled an 'impious giant', the extreme representative of the contrast between the pious Christian army and the impious Saracens, and he is associated with the mythical monster Typhoeus. In Virgilian terms Rodomonte is more of a Mezentius, despiser of the gods, than a Turnus. Dryden in his translation of the *Aeneid* goes in the same direction, building up a contrast between a generous-spirited Aeneas and the violence and disorder of Turnus' followers.[16] Turnus shares the last two lines of Dryden's *Aeneid* (12.1376–7) with Mezentius (10.1312–13), 'The streaming blood (10.1312 'crimson stream') distained his arms around, | And the disdainful soul came rushing through the wound.' In Virgil's Latin the last line of the poem, 'with a groan his life fled indignant down to the shades' (12.952 = 11.831), is shared by Turnus with the dying Camilla, a more sympathetic victim of the war in Italy than Mezentius. Ariosto's Rodomonte finally alienates the reader when he rejects Ruggiero's offer of mercy, and attempts to stab him in the back.

Tasso sanitizes the final duel in a similar way, making the behaviour of his hero conform to a code of honour that Renaissance critics had found wanting in Aeneas' killing of Turnus. In Canto 19 of *Gerusalemme Liberata* the Christian Tancredi wounds the pagan Argante, and begs him to surrender. Argante refuses, and continues to fight. Again he is brought down, and in answer to Tancredi's repeated request that he surrender, he stabs at Tancredi's heel, a Satanic move, alluding to the serpent 'bruising the heel' of the seed of Eve. Tancredi is left with no alternative but to kill him.[17]

The death of Argante is not the end of *Gerusalemme Liberata*. The abrupt close of the *Aeneid* in the heat of Aeneas' anger with the flight of the dying Turnus' soul has never ceased to disconcert, and finds few imitators. After killing Argante Tancredi gives thanks to God and sees to his enemy's burial. Nor is this even the final duel in the poem. In Canto 20 the pious Goffredo, leader of the Christian army, comes across the wounded Altamoro, who offers a ransom in exchange for his life. Like Aeneas in answer to the offer of a rich ransom by the Italian Magus in *Aeneid* 10, Goffredo refuses the ransom, but unlike Aeneas he spares his enemy's life, replacing Virgilian vengeance, in the case of both Magus and Turnus, with Christian mercy.

Answering questions about the character of Aeneas by continuing

beyond the end of the *Aeneid* is also the strategy of the 13th book of the *Aeneid*, in Latin, written by the early fifteenth-century Italian humanist Maffeo Vegio.[18] This skilful pastiche of Virgil's manner, which was regularly printed in editions of the *Aeneid* down to the eighteenth century, tells of the burial of Turnus, the wedding of Aeneas and Lavinia, the foundation of Lavinium, and finally the translation of Aeneas' soul to the stars as a reward for his virtuous actions. Vegio's *Aeneid* 13 is full of speeches of praise (of Aeneas) and blame (of Turnus), giving a distinctly 'epideictic' quality to the work.[19] Vegio provides the resolutions and reassurances that Virgil so stunningly withholds at the end of *Aeneid* 12. Vegio imposes closure partly through ring composition. After marking the end of the war in Italy with formal sacrifice, Aeneas addresses the Trojans, keeping his earlier promise that in the event of his defeating Turnus, Latinus should retain his throne, and offering himself not as a ruler but as an example of virtue, 13.97–9 'Latinus will bear the lofty sceptre [...] But learn to follow my example in war and excellence in battle, and in piety' (*at bello uos et praestantibus armis | discite me et pietate sequi*).[20] This echoes the praise of Aeneas to Dido by Ilioneus, in the first book of the *Aeneid*, quoted above (1.544–5), 'we had a king, Aeneas: none was more just and pious, none was greater in warfare' (*quo iustior alter | nec pietate fuit, nec bello maior et armis*). Would it attribute too much allusive cunning to Vegio to see a pointed disjunction, in Aeneas' rephrasing of Ilioneus' words, between the claim to military prowess and piety, on the one hand, and the title of king, on the other? Or is the ceding of the royal sceptre to Latinus by Aeneas itself an exemplification of the virtue of justice, which Aeneas does not here mention by name?

Good kings and allegorical heroes

Ilioneus' speech in praise of Aeneas to Dido is the starting-point for one of the few modern readings of the Virgilian Aeneas within a framework related to panegyric of the ruler, Francis Cairns' attempt to see the hero as an exemplification of the virtues of the 'good king' as laid out in the ancient treatises on kingship.[21] Cairns makes a good case for the relevance of this tradition, although many will feel that the complexities of the Virgilian narrative transcend any simple mapping of the schemata of the kingship treatises on to the person of Aeneas. Cairns' book, which coincidentally appeared in the same year, 1989, as Kallendorf's *In Praise of Aeneas*, makes no reference to the late-antique and post-classical 'epideictic' reading of the *Aeneid*. But this is a good example of how a largely neglected strand in

the later reception of the *Aeneid* may interact fruitfully with interpretation by modern classicists. In this case this is because Renaissance panegyrical readings of epic are continuous with kinds of scholarship and criticism current in antiquity, and which are a part of the historical context within which Virgil himself worked.

Medieval and Renaissance receptions also converge with modern in another way of reading Aeneas, not as either the perfect hero, or a consistently flawed and weak human being, but as a man on a path towards a greater strength of character and maturity. It is uncontested that the *Aeneid* is in important ways an epic of passage and transition, in terms of history, cultural and literary authority. It is perhaps paradoxical that there is no agreement on the extent to which the character of the hero undergoes any development. One widespread view has been that Aeneas makes the transition from being an old-style Iliadic hero, motivated by epic anger and the desire to fight to win personal glory, to being a new-style 'Roman' hero, learning to take on the responsibilities of leadership and to place the good of the community before his own interests. Against this may be set the fact that the emotions of fury and anger which impel Aeneas to kill Turnus in his last action of the poem are barely distinguishable from the fury and anger that hurl him into a suicidal defence of the city on his first appearance, in absolute chronology, on the night of the sack of Troy (2.316–17 *furor iraque mentem | praecipitat*; 12.946–7 *furiis accensus et **ira** | terribilis*).

One approach that had some traction in the twentieth century was Richard Heinze's use of a philosophical model for spiritual and moral development, the Stoic notion of the path to wisdom undertaken by the Stoic student 'making his way' (*proficiens*) towards a perfect wisdom that is attainable by very few. Making progress rather than achieving the goal is what matters.[22] A philosophical subtext in a classical epic would not in itself surprise: almost from the beginning of Greek scholarship and criticism there was a view that the Homeric poems contained deep philosophical truths, and this was an exegetical tradition of which Virgil was well aware. Similarly, from its beginnings and through into the Renaissance, interpretation of the *Aeneid* is permeated by the conviction that the poem contains philosophical messages, particularly but not exclusively in the Underworld in Book 6. The first part of the Speech of Anchises (6.724–51) is unambiguously a specimen of natural-philosophical didactic on the nature of the world and of the soul, with Platonic and Stoic affiliations (see Chapter 2, p. 24). Anchises describes the progress of the disembodied soul, as the taint of the body is cleansed through elemental purgation by

wind, water and flame, until a few choice souls are given access to the Elysian Fields. This is a process that bears some analogy to the broad outline of the story of Aeneas in this life, as he endures the fires of Troy and the winds and waves of the storm in order to reach his promised land of Italy.[23] That might suggest a Platonizing allegory of the story of Aeneas, of a kind that is well attested in the Renaissance (see below), and which Virgil himself might have found in (now lost) Middle Platonic interpretations of the sufferings and wanderings of Odysseus in the *Odyssey*.

Philosophical readings of the *Aeneid* begin early. Seneca the Younger (*Ep.* 76.33) takes the words in which Aeneas tells the Sibyl that no hardship can take him by surprise, since he has mentally anticipated all eventualities (*Aen.* 6.105), as the utterance of a Stoic sage. Modern scholars agree with Seneca that Virgil, here as elsewhere in the *Aeneid*, is using the language of the Stoics. They would not subscribe to a tradition of schematic and overarching allegorizations of the poem as a 'Pilgrim's Progress' type of narrative, starting in late antiquity and continuing into the Renaissance. We should not, however, forget that what seems to us an implausible way of reading Virgil is continuous with a tradition of allegorizing epic and of finding philosophical and spiritual truths in the texts that has a long pedigree in the ancient world itself.

One of the strangest documents in the history of Virgilian interpretation is the *Exposition of the Content of Virgil according to the Moral Philosophers* of the sixth-century north African Christian writer Fabius Planciades Fulgentius.[24] Fulgentius recounts the appearance to him in a vision of Virgil, in the pose seen in pictures of poets deep in poetic meditation. Virgil explains that in the 12 books of the *Aeneid* he has given 'an extensive account of the condition of human life'. He then reveals how the stages of life are plotted across the epic: the shipwreck in *Aeneid* 1 represents the hazards of childbirth, in a storm raised by Juno, goddess of childbirth. Aeneas meets but does not recognize his mother Venus, as newborns are not capable of understanding what they owe to their mothers. Wrapped in a cloud he can see but not talk to his companions in Carthage, like an infant as yet incapable of speech. The stories of Books 2 and 3 are like the fairytales used to amuse children. The death of Anchises marks the youth's rejection of paternal authority, after which he gives in to the stormy passion of love in Book 4, until reason/Mercury gains the upper hand. The games in honour of Anchises in Book 5 mark the return to the memory of the father now that Aeneas has reached a wiser age. Fulgentius is expansive when he comes to Book 6, the book which lends itself most readily to philosophical and theological allegory: Aeneas

comes to the temple of Apollo/the place of learning, and the descent to
the Underworld is a journey to the secrets of knowledge and wisdom. The
encounter with the shade of Dido is a penitential memory of the lusts
of his youth; this is not totally unlike the notion of some modern critics
that Aeneas' meetings in the Underworld with a series of people from his
past are a kind of psychotherapeutic working through of his past from
which the hero will emerge strengthened for the trials that lie ahead.
Fulgentius' Virgil is resolutely a pagan, but his explanation that Anchises,
whom Aeneas meets in the Elysian Fields, is to be understood as (Helm
102) 'the one God the father, the king of all things, dwelling alone on
high' makes him sound not unlike the Christian God: perhaps to avoid
collapsing Virgil's teaching into the Christian truth, Fulgentius immedi-
ately proceeds to rebuke Virgil for nodding when he peddles the fallacious
doctrine of the reincarnation of souls.

Having grown up and completed his moral education, in the second
half of the *Aeneid* the perfected hero Aeneas, armed with the 'blazing
good counsel' of the weapons forged by the fire-god Vulcan, confronts
a number of enemies who are identified as personifications of vices:
Turnus is 'fury' (*furor*), opposed by the arms of wisdom; his sister Juturna
is persistence in ruin, and Turnus' charioteer Metiscus, impersonated by
Juturna, is drunkenness. This way of reading is not entirely alien to more
modern interpretations which see in the *Aeneid* a more abstract clash
between *furor* and *ratio* 'reason', or between *furor* and *pietas*. Fulgentius'
reduction of individual characters to one-dimensional vices or virtues may
be compared to the fully allegorical narrative of Prudentius' *Psychomachia*
'War for man's soul' (*c.* AD 400), a highly Virgilian battle narrative which
stages a series of encounters between personified virtues and vices,
and which is a central text for the medieval and Renaissance history of
personification allegory. The closest that a modern reader might allow
the *Aeneid* to come to this kind of schematic allegory is in Aeneas' visit to
the site of Rome in *Aeneid* 8, where King Evander, whose name etymolo-
gizes in Greek as 'good man' (*eu* + *aner* – one of the few etymologies that
Fulgentius gets right), tells the story of the fight between Hercules and
the monster Cacus, whose name means 'bad' (Greek *kakos*). But although
it is hard to see anything but evil in the frenzied Cacus, his opponent
Hercules is complex in character and motivation, and Virgil/Evander
does not present him as the simple figure of virtue and wisdom that he is
in some ancient philosophizing allegorizations.[25]

Allegorizing interpretations of the career of Aeneas as a progress
through the ages of man to a perfection of wisdom have a long life,

through the Middle Ages and on into the seventeenth century.[26] The twelfth-century commentary attributed to Bernardus Silvestris interprets the *Aeneid* as charting the conflict between the body and soul, establishing a one-to-one correspondence between ages and books: *Aeneid* 1 = birth, 2 = boyhood, 3 = adolescence, 4 = youth, 5 = manhood. Dante touches briefly on the ages of man allegory in the *Convivio* (4.26), illustrating the presence in *Aeneid* 4–6 of the five virtues appropriate to the second of his four ages of man, youth. The most important Renaissance Italian Virgilian scholar, Cristoforo Landino (1424–98), whose commentary on the whole *Aeneid* was frequently reprinted in the late fifteenth and early sixteenth centuries, developed a detailed and lengthy version of the moral allegorization of the first six books of the *Aeneid* in his dialogue the *Camaldulensian Disputations* (1472) (see Chapter 2, pp. 36–7).[27] Landino follows in the steps of Fulgentius and Bernardus, and adds a Platonizing gloss to the allegorization. Aeneas moves through a hierarchy of virtues, from the 'civic' virtues (Carthage for Landino is above all the place where Aeneas engages in the political life), through the 'purgatorial' virtues', from which he emerges purified, reaching the perfection of the contemplative life and putting the active life behind him. The final stages of this development take place in the descent to the Underworld in *Aeneid* 6. Developing a typology of interpretations of the descent that goes back to Macrobius (see Chapter 2, p. 36), Landino identifies the correct interpretation of the descent in *Aeneid* 6 as the 'descent' of the light of reason into contemplation of the nature of vice and evil, so that the soul can free itself from them.

The typology of descents had also entered the fourteenth-century commentaries on Dante. Landino was himself the author of a major commentary on Dante, and it is likely that his reading of the *Aeneid* was to some extent influenced by his exegesis of Dante, whose *Divine Comedy* substitutes for the wanderings of Aeneas in search of a home and a destiny the journey of Dante/everyman through an education in vices and virtues towards a Christian *summum bonum*.[28] The *Divine Comedy* could be described as an allegorization of the *Aeneid*, and more specifically of Book 6, writ large. Marsilio Ficino, the leading Florentine Neoplatonist, claims that Virgil and Dante are both Platonists, in the preface to his translation of Dante's *On Monarchy*: 'Virgil was the first to follow this Platonic order of things, which was then followed by Dante, using the vessel of Virgil to drink at the Platonic springs.'

This kind of allegorical interpretation of the hero's progress towards moral perfection is a presence in much Renaissance epic and in the

commentaries thereon. Torquato Tasso composed his own 'Allegory of
the Poem' (1581) to his *Gerusalemme Liberata*, according to which the three
main Christian heroes correspond to the parts of the Platonic tripartite
soul (Godfrey = Understanding, Tancredi = Concupiscence, Rinaldo =
Irascibility). In Book 2 of *The Faerie Queene* Spenser offers a version of this
approaching more closely to the schematic flatness of personification alle-
gory in the characters of Cymochles (sensual abandonment) and Pyroch-
les (fiery anger), opposed to the hero Guyon, the Knight of Temperance.

The Spenserian knight with the most straightforward 'Pilgrim's
Progress' kind of career is the Red Cross Knight in the first book of *The
Faerie Queene*, the 'Legend of Holiness'. The Red Cross Knight's quest
intersects at various points with themes and motifs from the Virgilian
story of Aeneas. After overcoming the temptations of pride and despair,
and the lures of a false woman, Red Cross is prepared for his final duel
with the dragon by being taught repentance and the way to heavenly bliss
in the House of Holiness, culminating in a vision from the Mount of
Contemplation of the celestial Jerusalem, the final goal of his pilgrimage,
and a city which, Red Cross acknowledges, outshines the Fairy Queen's
earthly city, Cleopolis ('Glory City'), another name for London, the
Troynovant, 'New Troy', founded by the Trojan Brut. Spenser's 'Legend
of Holiness' overgoes the secular goals of the *Aeneid*. The book also adds
a supplement to the ending of Virgil's epic in the manner of Vegio's Book
13, since it continues for a canto after the climactic slaying of the dragon in
Canto 11 with an account of the following celebrations, and the betrothal
of Red Cross to Una.

The modern hero

Modern Virgilian criticism has largely turned away from laudatory or
philosophical readings of the character of Aeneas, and emphasized instead
his backslidings, his moments of weakness and doubt, with a perhaps
disproportionate focus on the hero's lethal outburst of anger at the very
end of the poem. In part this fashion has been politically determined,
by a sometimes visceral reaction against the idea that Virgil might have
written up a hero as a panegyrical foreshadowing of Augustus. In part it
reflects a wish to claim for Virgil's hero the complexities and frailties of
the twentieth-century human condition as diagnosed by psychoanalysis,
existentialism and the modern and post-modern novel. A recent book by
the Italian classical scholar Guido Paduano on 'The birth of the hero'[29]
sees a movement towards modernity in a comparison of the Homeric

Achilles and Odysseus with the Virgilian Aeneas. Paduano's gaze lights not on Aeneas' outburst of anger at the end of the *Aeneid*, but on the moment immediately preceding, as Aeneas hesitates (12.940 *cunctantem*) whether or not to kill Turnus, a moment of hesitation that is indeed the most striking divergence from the Homeric model, the duel of Achilles and Hector. Paduano (198) makes a connection with the First Player's rehearsal of 'Aeneas' tale to Dido' in Shakespeare's *Hamlet*, the point at which Pyrrhus is briefly distracted from striking Priam: II.ii.419–24 'For, lo! his sword, | Which was declining on the milky head | Of reverend Priam, seem'd i'th'air to stick. | So, as a painted tyrant, Pyrrhus stood | And, like a neutral to his will and matter, | Did nothing.' Within the structure of the *Aeneid* modern critics perceive a ring between the merciless killing in Book 2 by Pyrrhus, the son of Achilles, of, firstly, a son of Priam, Polites, and then Priam himself, and the killing by the 'new Achilles', Aeneas, of another son with an aged father, Turnus, at the end of Book 12. Do Shakespeare's hyper-sensitive literary antennae register that connection? Be that as it may, within the economy of Shakespeare's own play, the image of a momentarily frozen Pyrrhus mirrors the incapacity to act of Hamlet, often seen as the most modern of Shakespeare's characters. Paduano generalizes to the following statement: 'In the last moment of unease suffered by Aeneas before his victory may be glimpsed an unease constitutive of the human condition.' On the dust-jacket this has become a sales point: 'the "all too human" Aeneas, torn apart by the contradictions of a modern society'.

The foregrounding of a doubting and hesitant Aeneas, and the attention to the end of the poem, have been reinforced, consciously or not, by the famous doubt said to have been experienced by his creator Virgil at the end of his life, according to the story that in his final illness he asked that the *Aeneid* be burnt.[30] A kind of autobiographical allegory of the poem's hero has become fashionable recently thanks to metapoetical and self-reflexive readings.[31] There is a rudimentary foreshadowing of this approach in the tendency in ancient lives to find biographical details in poets' works. An extreme example from the beginning of the Renaissance, forced out by an especially close bond of sympathy between an early modern writer and Virgil, is the comment written by Petrarch in the margin of his text of Virgil against the last line of the *Aeneid* ('with a groan his life fled indignant down to the shades'): 'Virgil, you were too accurate a prophet of your own fate; for as you spoke these words, your life too deserted you, also fleeing indignant, if I am not mistaken.'

An intermittent identification of Virgil with his hero helps to structure

the mental journeying of the dying poet in Hermann Broch's *The Death of Virgil* (1945), a novel described by George Steiner as 'represent[ing] the only genuine technical advance that fiction has made since *Ulysses*'.[32] In the second of the novel's four movements, 'Fire – The Descent', Virgil experiences a *katabasis* which merges into an apocalyptic vision of burning cities. Here perhaps is another example of a creative writer feeling connections within the *Aeneid* on the pulse: Michael Putnam and others have drawn attention to the infernal quality of Aeneas' experiences on the night of the sack of Troy in *Aeneid* 2, whose final catastrophe, as Aeneas makes his way out of the burning city, is the loss of his wife, a repetition of Orpheus' loss of Eurydice in the fourth *Georgic*.[33] In a further association on the part of Broch the fires of the burning cities become the fires of rebirth, but what may be reborn is nothing so earthly as the creation of new cities in Italy out of the ashes of Troy. In the dying Virgil's mind the thought is followed by an urgent whispering that everything that has served a false life must disappear, that all of Virgil's writings must be burned. Like Aeneas, Broch's Virgil is also an exile, journeying to a place even more unknown than is Italy to Aeneas, a place that transcends Virgil's own time and place in Augustan Rome, and for the expression of which his own poetic art falls hopelessly short. Virgil's loss of control over his own poem, and the failure of communication, are the prelude to a final movement to reintegration as Virgil undergoes another journey through the Underworld, but this time reaching a Garden of Eden where the fourth *Eclogue* becomes a Christian reality. Broch's take on Virgil is profoundly indebted to Theodor Haecker's view of Virgil as 'a soul Christian by nature' (*anima naturaliter Christiana*: see Chapter 6, pp. 143–7), and in fact shows little evidence of any detailed immersion in the text of the *Aeneid* itself.

5

EMPIRE AND NATION

Whatever other uses the *Aeneid* has been put to, until the middle of the twentieth century it was generally uncontroversial to claim that a central purpose of Virgil's epic was the celebration of the foundation and history of Rome, and the glorification of Aeneas and his distant descendant Augustus, the first emperor of Rome. The *Aeneid* plays a major part in the invention of the European myth of empire. While the Greek-speaking eastern Roman Empire, for which the Latin *Aeneid* was never a central educational or cultural text, survived until the fall of Constantinople in AD 1453, the continuity of the Latin-speaking western Roman Empire was broken in AD 476 with the deposition by the Germanic Odoacer of the last emperor of Rome, the all too aptly diminutive Romulus Augustulus. But the idea of Augustus, and the ambition of recreating the greatness of Augustan Rome, were revived in the institution of the Holy Roman Empire, and in the ideology and panegyric of successive rulers in the various territories into which the Roman Empire fragmented, and indeed beyond. As well as being a charter for empire, the *Aeneid* is also an epic of nation-building, and it provided one of the templates for the construction of the legendary origins of later European nations.

The choices made by Virgil in shaping his epic on Rome and Augustus made it easily adaptable to other times and places. It is not a historical epic on the particular achievements, at a particular point in history, of a particular ruler. Its legendary hero Aeneas is both the ancestor of Augustus, and a model for the deeds of his historical descendant. Events in Roman history are foreshadowed in the events of the primary narrative of the poem. History is, for the most part, present through analogy and typology, in the sense of 'typology' as used in biblical exegesis, whereby persons and events in the past – the Old Testament – prefigure, are types of, persons and events of more recent times – the New Testament.[1] Analogy and prefiguration are easily extendable beyond the history of Rome

and Augustus to the aspirations and achievements of other nations and other rulers. The *Aeneid* is open to ever new versions of what Theodore Ziolkowski calls the 'Roman analogy'.[2]

Within the frame of the legendary narrative Roman history itself is delivered through self-contained forms of prophecy, vision and display: the Speech of Jupiter in *Aeneid* 1, sketching out for the benefit of his daughter Venus the whole future course of the history of her son Aeneas' Roman descendants; the parade of the souls of unborn Roman heroes in the Underworld in *Aeneid* 6; and the ecphrasis of scenes from Roman history, from Romulus and Remus to Augustus, on the shield delivered to Aeneas by Venus in *Aeneid* 8. In all three cases the view into the future is stamped with the weight of authority, respectively of the supreme god Jupiter, the sanctified father Anchises and the artist-god Vulcan. All three passages are imitated, often in combination, countless times in the later tradition. The visuality of the Parade of Heroes and the Shield of Aeneas also encouraged the use of the *Aeneid* in visual forms of celebration and propaganda, the pageant, the masque, painting and sculpture.

Both the primary legendary matter and the historical insets of the *Aeneid* are structured according to a set of narrative patterns that can easily be transferred to other locations and other cast-lists. Repetition and return are related to the structure of analogy. In Italy Aeneas will found the first city (Lavinium) in a series of cities, culminating in the eternal city of Rome. These are in a sense all refoundations of the sacked city of Troy, *Troia resurgens* (1.206 *illic fas regna resurgere Troiae* 'there, in Latium, it is right for the kingdom of Troy to rise again', Aeneas reassures his men). But these are repetitions with a difference. The new Troy will surpass the old, and the old must be firmly relegated to the past. Nostalgia is a dangerous emotion in the *Aeneid*. Yet from another point of view the Trojans' voyage from their destroyed home into exile in Italy is a homecoming, a *nostos*, the Greek word for Odysseus' return to Ithaca in the *Odyssey*, since the Trojan ancestor Dardanus originally came from Italy.

In the fullness of time, Anchises tells Aeneas in the Underworld (*Aen.* 6.792–4), Augustus will refound another kind of kingdom that formerly existed not in Troy, but in a remote past in Italy itself, the Golden Age once ruled over by the god Saturn when he came as an exile from Olympus to earth, fleeing the victorious arms of his son Jupiter (*Aen.* 8.319–20). However, the Golden Age of Augustus will be no primitive pre-agricultural and pre-technological idyll (the standard image of a Golden Age), but an age of peace secured by the world-wide conquests of the advanced urban civilization of Rome. This is a paradoxical Golden Age that leads

some modern readers to suspect Virgil of insincerity or subversion.[3] One might think of it rather as another example of repetition with a difference.

The *Aeneid*'s version of the Golden Age restored is certainly a repetition with a difference of the return of the Golden Age in Virgil's fourth *Eclogue*. This riddling poem announces the arrival of the final age foretold in the Sibyl's song, with the return of the Virgin (Justice), the return of the Golden Age of Saturn, and the descent from Heaven of a mysterious child. As the child of *Eclogue* 4 grows up the Iron Race (or Age) will give way to a new age of heroes, before the perfection of a new and lasting Golden Age in a wonderland of nature's spontaneous bounty. The idea of the return of the Golden Age is perhaps Virgil's most influential single contribution to a political mythology. The myth of the metal races of mankind in Hesiod's *Works and Days* (109–201) is a story of degeneration: the races of Gold, Silver and Bronze (a sequence preserved in the three classes of Olympic medals) are followed by a temporary improvement in the race of Heroes who fought at Thebes and Troy, but which in turn is followed by the woeful present-day race of Iron. For Hesiod the Golden Race is no more than the dream of an irrecoverable time of unfallen bliss in the remote past. Virgil reverses time's inexorable decline and holds out the possibility of the restoration of a primitive perfection in the near future or even the present day. For the Christian age there is an obvious parallel with another story of fall from an original state of perfection to be followed by restoration, the story, in Milton's words, of an act of disobedience which (*Paradise Lost* 1.3–5) 'Brought death into the world, and all our woe, | With loss of Eden, till one greater man | Restore us, and regain the blissful seat'. Dryden alludes to the Christian myth of the 'fortunate fall' (*felix culpa*) when he translates Ovid's encapsulation of the Virgilian plot of Troy fallen and Troy restored at *Metamorphoses* 15.451–2: 'Troy revived anew, | Raised by the fall, decreed by loss to gain.'

The fourth *Eclogue* raises the generic level of Virgilian bucolic in the direction of epic. Its schematic story-line of the career of a godlike hero which coincides in time with a second voyage of the *Argo* and a second Trojan War, leading to a renewal of the Golden Age, might almost be taken as a blueprint of the plot of the *Aeneid*, in which Aeneas is forced on to a journey that has some elements of a quest for a Golden Fleece, and which takes him to Italy where he must fight a 'second Trojan War' in order to assert the Trojans' right to settle in Italy. That is the precondition for the reintroduction to Rome and Italy by Aeneas' distant descendant, Augustus, of a new Golden Age, as Anchises prophesies at *Aeneid* 6.791–4. This passage and *Eclogue* 4 are the starting-points for the ideological use

of Golden Age imagery by any number of later emperors and kings, and non-monarchical regimes, which claim to usher in a new age of peace and prosperity. The parallelism between the temporal patterning of the prophecy of *Eclogue* 4 and the plot of the *Aeneid* encourages the frequent combination in later centuries of combined allusion to both texts in political and religious propaganda.

Other patterns in the *Aeneid* are linear. Two in particular are endlessly suggestive for political allegories. Firstly, the pattern of the outburst of chaotic disorder in the human world, and in a natural world that mirrors the human, followed by the re-imposition of order. This is the simplest of narratives with which a ruling power justifies, or excuses itself for, its elimination of strife or its repression of resistance. Both halves of the *Aeneid* begin with violent eruptions of disorder engineered by Juno against her human enemy Aeneas. In Book 1 she cajoles the king of the winds, Aeolus, to unleash the forces of the storm against the Trojans (Fig. 6). The hyperbolic storm is quickly calmed by Neptune, who is compared in the first simile in the poem to a Roman statesman calming an angry mob (1.148–53), so establishing the analogy between order and disorder in the human and natural worlds. Jupiter's prophecy of Roman history, reassuring Venus after Aeneas' near-death in the storm, ends with the closing of the Gates of War and the image of *Furor*, 'Madness, Frenzy', in chains, echoing Neptune's dispatch of the storm-winds back to their subterranean prison.

In Book 7 Juno summons the Fury Allecto from the Underworld in order to unleash a storm of war that will not be calmed until the very end of the poem. The model offered by the re-motivation of the epic action at the start of the second half of the *Aeneid* by a Hellish disorder was particularly attractive to rulers and ideologues of Christian Europe, who could represent their opponents as the agents of Satan. The late-antique epic poet Claudian (b. *c.* 370), probably Christian, but working within the conventions of the pagan divine machinery, set a precedent for *beginning* an epic narrative with the agency of Hell when he started his *Against Rufinus* with a Council of Furies (see Chapter 2, pp. 27–8). Many later epic narratives working with an overtly Christian theology begin with an intervention of the Devil, either on his own or in council with his fellow-devils. Potent examples of this ultimately Virgilian plot device in the mythology of a British Protestant nationalism are found in a series of Latin poems on the Catholic plot to blow up the House of Lords in 1605, 'Anglo-Latin gunpowder epic' as it has been called.[4] One specimen is the 17-year-old Milton's 'On the Fifth of November', which begins with

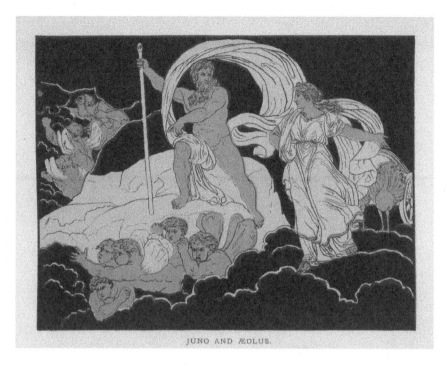

JUNO AND ÆOLUS.

Fig. 6. Juno and Aeolus. After design by Bartolomeo Pinelli.

Satan's envious outburst at the sight of the prosperous condition of James I's Britons, referred to as 'the people of Trojan descent' (*Teucrigenas populos*), an allusion to the myth of the Trojan origin of Britain (see p. 123 below). These opening lines rework Juno's outburst in *Aeneid* 7 when she sees Aeneas and his Trojans happily arrived in Italy. Gunpowder, as often in the Renaissance, is presented as a devilish invention; the Pope, urged on by Satan, instructs his agents to blow the British king and his ministers into thin air with 'Tartarean dust' (*Tartareo puluere*).

The models offered by the version of the 'order restored' plot at the beginning of the *Aeneid*, the calming of the storm and *Furor* bound, also spawned imitations. Neptune calming the winds made for a stirring composition in the visual arts, often bearing a political message (Fig. 7). Rubens' painting of the scene formed part of the lavish pageant for the entry to Antwerp on 17 April 1635 of the Hapsburg Ferdinand Cardinal Infante of Spain, brother of Philip IV, to serve as governor of the Netherlands (Plate 4).[5] The image alluded to adverse winds that had held up Ferdinand on a sea-journey from Barcelona to Genoa, but there was also a

Virgilian message about the calming of political storms by the wise ruler. There is furthermore a Christianizing touch, in the similarity between the white-haired and bearded Neptune and God the Father in Rubens' religious pictures.[6] The temporary structures erected for Ferdinand's entry bore other Virgilian images and texts. The inscription on the title page of the sumptuous folio of engravings of the pageant edited by Rubens' humanist friend and adviser Jean Gevaerts[7] adapts some of the most frequently cited lines in the *Aeneid*, Anchises' advice on good kingship at *Aen.* 6.851–3: 'German prince, be mindful to govern the Belgians with your rule, and to spare the submissive and crush in war the proud.'

Rubens' paintings for the entry included those for a Temple of Janus, its doors burst open and a torch-bearing Furor 'Fury' rushing out. On either side were scenes of Peace and War, with an adaptation of Jupiter's words, at the end of his prophecy of Roman history in *Aeneid* 1, on the closing of the Gates of War and the chaining of Furor (1.291–6). The binding or conquest of Furor figures both in composite political allegories, and in single groups. In an earlier example, a panegyrist of Constantine the Great imagined among the personified vices paraded in a triumph 'Furor bound and bloody Cruelty gnashing their teeth' (*Panegyrici Latini* 4.31.3). In a sixteenth-century statue by Leone Leoni, now in the Prado, a heroically nude Charles V stands over Furor defeated and in chains.

The analogy between political disorder and disorder in the natural world suggests a mystifying legitimation of the power of the human ruler as a reflection or manifestation of a providential ordering of the cosmos itself. Virgil's account of the demonic storm-winds released by Aeolus from their subterranean prison where they had been imprisoned by a Jupiter fearful that they might otherwise bring chaos to earth, sea and sky (*Aen.* 1.58–63) alludes to the myth of Gigantomachy, the story of the assault by Giants (or Titans) against the Olympian gods and their ruler Jupiter (Zeus). The myth was often used as an allegory of political rebellion and of the need for a strong ruler acting under the aegis of a divinely sanctioned order. The *Aeneid* makes recurrent allusion to Gigantomachy, right up to the death of Turnus in the last scene of the poem, whose complex layers of meaning include the image of Turnus as an enemy of the gods blasted by Aeneas in the role of a Jupiter wielding a figurative thunderbolt.[8] The exaltation of the hero or emperor to a status like that of Jupiter, ruler of the universe, also coheres with another strand in the *Aeneid*'s political imagery, the expansion of Roman power to world-rule, and the equation of *urbs* 'city' and *orbis* 'world', a jingling pairing attested before Virgil. Although the wordplay itself is not found in the *Aeneid*,

Fig. 7. *Quos ego*: Neptune calming the storm.
Engraving by Raimondi after Raphael.

the Shield of Aeneas at the end of Book 8 is a large-scale icon of Roman
history viewed as the growth of the city of Rome to rule the world, and
the description of the climactic battle of Actium contains Gigantomachic
imagery.[9] Ovid neatly presents the *urbs/orbis* equation at *Fasti* 2.683–4:
'other peoples have lands with a fixed boundary; the city of Rome covers
the same space as the world' (*Romanae spatium est urbis et orbis idem*). The
jingle survives in *Vrbi et Orbi* 'for the city and the world', the phrase that
introduces the Apostolic Blessing of the Bishop of Rome, the Pope, head
of the Rome-based power that sees itself as the successor to the claim to
universal rule by the pagan Roman Empire.

The second linear pattern offered by the *Aeneid* is the progression from
human to divine, the apotheosis of the ruler. The Homeric hero is 'godlike'
in his strength and beauty, and he may, like Achilles, be the child of a god
or goddess, but he is irredeemably separated from the gods by his mortal-
ity. Virgil's Aeneas is both the son of a goddess, and destined himself for
godhead after his death. Jupiter reassures Venus of this in Book 1 (259–60),
and reminds Juno of this fact in his final interview with his wife (12.794–
5), although the main narrative of the *Aeneid* does not extend as far as a
detailed account of Aeneas' divinization. The path taken by Aeneas to
Heaven will be followed by his distant descendants, firstly Julius Caesar,
whose apotheosis, as the 'Divine Julius' was the model for the deification
of subsequent Roman emperors, including that of Julius Caesar's adoptive
son, Augustus. The major Virgilian text for the apotheosis of the ruler is
the proem to the first *Georgic*, in which an invocation to the gods of the
countryside culminates with speculation as to which part of the universe,
earth, sea or sky, Octavian will choose for his habitation as a future god,
concluding with an invitation to the human ruler to start getting used to
being the object of prayers. The Virgilian texts contribute to the construc-
tion of the divinity of the Roman emperor, whose iconography fed the
fantasies of panegyric of the ruler or great man in the Renaissance and
later, for example in Rubens' *Apotheosis of James I* on the ceiling of the
Banqueting House in Whitehall, or the same artist's *Apotheosis of Henri
IV and Proclamation of the Regency of Marie de Médicis* (Louvre). The impe-
rial idea is revived in Appiani's *Apotheosis of Napoleon* in the throne room
of the Palazzo Reale in Milan (1808), and put to the service of an anti-
imperialist hero in the *Apotheosis of Washington* by Constantino Brumidi
in the rotunda of the Capitol in Washington DC (1865).

Virgil's imperial iconography instantly became the common coin of
subsequent Roman poets praising Augustus and later Roman emperors,
with whatever degree of sincerity or detachment. The return of the Golden

Age is proclaimed again and again at the beginning of a new reign, loudly, for example, at the accession of Nero. Repeated disenchantment did nothing to tarnish the image in ancient Rome, or in later centuries. Hope springs eternal in the panegyrist's breast. Ovid spins deft variations on the Virgilian themes of rebirth out of destruction, Gigantomachy and cosmocratic imperialism, for example in the submerged political allegory underlying the accounts in *Metamorphoses* 1 of the creation of the world and the primitive struggles between the gods and the forces of evil, and explicitly in the narratives of Trojan and Roman history in the last books of the poem. The *Metamorphoses* contains three full accounts of Trojan-Roman apotheosis, for Aeneas, Romulus and Julius Caesar. At the beginning of Ovid's elegiac poem on the religious calendar, the *Fasti*, which together with the hexameter *Metamorphoses* represents Ovid's response to the challenge laid down by the *Aeneid* to all later epic poets, the two-faced god Janus prefaces the historical matter of the Roman calendar with an account of the creation of the universe. Part of the doubleness of Janus is that he is a guardian of both the natural order and of Roman world-power, a fitting emblem for the Virgilian pairing of *cosmos* and *imperium*. Ovid often has his tongue in his cheek: present-day Rome is the true Golden Age, because girls will only give themselves to their lovers for gold (*Art of Love* 2.277–8). 'Golden Rome' of the present day is where Ovid wants to be because of its elegance and refinement (*cultus*, *Art of Love* 3.113–28).

Lucan, in the proem to his epic on the *Civil War*, looks forward to the apotheosis of Nero, alluding to the prospective apotheosis of Octavian at the beginning of Virgil's *Georgics*. Gigantomachy and the cosmic analogy pervade Lucan's narrative of Roman civil war. The destruction of Republican Rome is tantamount to the destruction of the world. History repeats itself, city follows city, but not in a constructive way. After the climactic battle of Pharsalus in which Pompey is defeated and the Roman Republic destroyed, Julius Caesar pays a sightseeing visit to the ruins of Troy. There he surveys a landscape that mirrors both the rural site of Rome in *Aeneid* 8 *before* the city has been founded, and the pale imitation of Troy that is the city founded by the Trojan exile Helenus at Buthrotum (on the coast of modern Albania) in *Aeneid* 3, an example of how *not* to make Troy rise again in greater form. The wasteland of what was once Troy is an image of what civil war is doing to the landscape of Italy. Caesar, distant descendant of Aeneas, is the opposite of a founding hero. Critics continue to be puzzled by the dissonance between the praise, based on the model in the *Georgics*, of the current Julio-Claudian emperor in the proem of Lucan's *Civil War* and the inversion of the plot of the *Aeneid* in

the 'anti-*Aeneid*' that constitutes the main narrative of the epic.

A more straightforward imitation of the political messages of the *Aeneid* is found in the late first-century AD *Punica* by Silius Italicus, devoted follower of Virgil (see Chapter 1, p. 9). In Silius the commonplace that the war was a struggle with Carthage for world-rule is transformed into a theological struggle between the forces of cosmic good and evil. Jupiter and Hercules, champions of Rome, oppose the Titans and Giants in the persons of Hannibal and his supporters. 'The *Punica* tends to the status of a philosophically coloured Gigantomachy in a historical dress.'¹⁰

Virgilian themes and images form the armature for the narratives in the classicizing late-antique epics and panegyrics of Claudian, celebrating the emperors Theodosius and Honorius, and the regent Stilicho.¹¹ These were Christian rulers, but Claudian drapes their deeds in the pagan mythology of the Virgilian tradition, to make the point that they are the legitimate rulers of the Roman Empire against their usurping enemies. Theodosius has restored the Golden Age (*Against Rufinus* 1.51–2), and embodies the *pietas* of Aeneas against the *furor* of his opponents. Nature, as well as the gods, are on the side of Theodosius and Honorius: at the battle of Frigidus (394) a Virgilian storm had blown back their weapons on the enemy: *On the Third Consulship of Honorius* 96–8 'O much beloved of the god, in whose service Aeolus unleashes the armed storms from their cave, for whom heaven goes to war, and the winds muster under oath at the call of the trumpet.' The winds of Aeolus which had attacked Aeneas in the storm at the beginning of the *Aeneid* now fight with the pious young Augustus, Honorius – just as, by the end of the *Aeneid*, Aeneas figuratively embodies the force of the storm. Claudian makes recurrent use of the image of Gigantomachy for his propagandistic purposes.¹²

Virgilian motifs and parallels also punctuate the imperial panegyrics in prose of the late third and fourth centuries AD collected in the *Panegyrici Latini*, for example in two speeches on Constantine's decisive victory over Maxentius at the battle of the Milvian Bridge (AD 312). The role given to the river Tiber in aiding Constantine recalls the aid given to Aeneas in *Aeneid* 8 both by the river-god and by the waters of the river itself. We are also reminded of the Sibyl's vision, in her prophecy to Aeneas of the coming war in Italy, of the Tiber foaming with blood (*Aen.* 6.87),¹³ a line which saw Virgil briefly propelled into the modern British political spotlight when it was used by a politician who was also a classical scholar, Enoch Powell, in his notorious 1968 'rivers of blood' speech against Commonwealth immigration.

After the fall of Rome Aeneas continues his journey from east to west, crossing the Alps to participate in the myths of foundation and empire of new nations and new kingdoms which seek to inherit the mantle of Rome. The *Aeneid*'s plots of transition, from one powerful city to another, and from Greek cultural hegemony to the rivalrous pretensions of a Latinate culture, make it a natural text for successive instalments of the *translatio imperii*, the transfer of imperial power from Rome, and the *translatio studii*, the transfer of education and culture from Greece to Rome, and thence to other countries and other languages.[14] Charlemagne's coronation as Holy Roman Emperor in Rome on Christmas Day, AD 800, marked his claim to be the successor to the western Roman Empire. The so-called 'Carolingian renaissance' is the first of a series of revivals of classical learning and culture before the Italian Renaissance of the fourteenth and fifteenth centuries. One of its leading lights was the Northumbrian Alcuin, who joined the group of scholars at the court of Charlemagne and taught the king himself.[15] The *Life of Alcuin* (5) tells us that as a boy he was more a lover of Virgil than of the Psalms. A continuing tension in Alcuin's own writings between a love of Virgil and the self-admonition to cleave more strictly to biblical texts is perhaps in part a defensive reaction to the central place occupied by Virgil in Carolingian culture and ideology. In a panegyric addressed to Charlemagne in Rome Alcuin celebrates the recently crowned emperor as a new King David, but he also reaches for Virgil in alluding to Anchises' instructions to his son on how to be a good king (*Carmina* 45.67–8 Dümmler): 'raise up the defeated and now put down the proud, so that peace and holy piety may everywhere reign' (*erige subiectos et iam depone superbos,* | *ut pax et pietas regnet ubique sacra*; cf. *Aen.* 6.853); the epithet *sacra* Christianizes Aeneas' key virtue of *pietas*.[16]

In an anonymous poem on the meeting at Paderborn of Charlemagne and Pope Leo III in AD 799, the Frankish king is given the title Augustus, and Aachen, the seat of Charlemagne's court, is a second Rome.[17] The description of the building of Aachen alludes to several city-building moments in the *Aeneid*: Dido's foundation of Carthage in Book 1, Aeneas' foundation of the Sicilian city of Segesta in Book 5, and his construction of a camp at the mouth of the Tiber in Book 7, the first Trojan act of 'city'-founding on Italian soil – so suggesting a correspondence between Aeneas and Charlemagne as city-builders. As Rome was a second Troy, so Aachen is a second Rome. The idea of the second Rome is combined with the idea of the Golden Age in Moduin's *Egloga*, which uses Virgilian pastoral as the frame for thinking about the new imperial age, 24–7 'looking from the high citadel of the new Rome my dear Palemon [a pastoral

mask for Charlemagne] sees that through his triumph all kingdoms are a part of his empire, and that the times have changed back to the ancient ways. Golden Rome, once more renewed, is born again for the world' (*aurea Roma iterum renouata renascitur orbi*). This last line is already part of a chain of literary repetition and renovation, alluding to the Neronian bucolic poet Calpurnius Siculus' reworking of Virgil's fourth *Eclogue* in his own first eclogue, v. 42 *aurea secura cum pace renascitur aetas* 'the Golden Age is born again in carefree peace.'

Dante, a great believer in the imperial idea, acclaimed the crossing into Italy in 1310 of Henry VII of Luxembourg on his way to being crowned as Holy Roman Emperor (1312) as the return of the successor of Caesar and Augustus. 'Many, anticipating their prayers, joyfully sung, with Virgil, of the return of the reign of Saturn and of the Virgin' (*Epistle* 7.1). Dante criticizes Henry for tarrying in north Italy and for forgetting that the 'glorious power of the Romans' is not circumscribed by geographical limits. The world awaits Henry. Dante then turns to the *Aeneid* for Jupiter's prophecy of the birth of a Caesar of Trojan descent, whose empire will be bounded by the Ocean, his fame by the stars (*Aen.* 1.286–7). Further to stir Henry into action, Dante reminds him of the expectations of his son Prince John, a second Ascanius, and quotes the words with which in *Aeneid* 4 Mercury rebukes Aeneas for dallying ingloriously in Carthage, telling him at least to have a care for the hopes of his son, who is owed an Italian kingdom and the land of Rome (*Aen.* 4.272–6).[18]

The imperial idea is resurgent in the sixteenth century, firstly in the spectacular revival of the ideal, if not the substance, of the empire in the person of the Holy Roman Emperor, the Hapsburg Charles V, and secondly in the strongly nationalistic monarchies of England and France.[19] In the full flood of the Renaissance, the political iconographies are heavily classical, and Virgilian themes and images play a central part. A typical example of Hapsburg panegyric, near the beginning of a tradition which saw Virgilian-style epics in praise of emperors being produced in Vienna well into the nineteenth century, was the pageantry for Eleanor of Toledo's entry into Florence on 29 June 1539, as the wife of Cosimo I de' Medici. This included a triumphal arch in honour of Charles V, with the inscription AUGUSTUS CAESAR DIVUM GENS AUREA CONDIT SAECULA 'Augustus Caesar, of the race of the gods, founds the Golden Age' (adapted from *Aen.* 6.792–3).[20] A 1576 epic on Rudolf I, the founder of the Hapsburg dynasty, uses the full Virgilian machinery, including the incitement of Rudolf's main opponent, Ottokar, by a Fury, a prophetic shield with scenes of future Hapsburg rulers down to Maximilian II, the appearance

of a river-god, here the Danube not the Tiber, to prophesy the building of Vienna as the new Rome, and the discovery of the New World.[21]

In France a tradition of Augustan imperialism began with Henri IV (ruled 1589–1610), to reach its apogee with Louis XIV.[22] In England a full-blown use of Virgilian motifs in praise of the ruler starts early in the Tudor dynasty. In 1496 the itinerant poet Johannes Michael Nagonius presented Henry VII with a deluxe illuminated manuscript of panegyrical poetry, a diplomatic gift from Pope Alexander VI angling for support against the French king Charles VIII. The Sibyl of Cumae has foretold Henry's reign as a successor of Aeneas, with a Parade of Heroes culminating in the appearance of Henry as a second Augustus.[23]

The return of the Golden Age is a cliché of European imperialisms, but has a particular aptness in late sixteenth-century England, because of Virgil's proclamation at the beginning of the fourth *Eclogue* of 'the return of a virgin'. The 'virgin' is Justice, who, according to the Greek astronomical poet Aratus, fled from earth in the Iron Age and took up her place in the skies as the constellation Virgo. She receives the name 'Astraea' in Ovid's version of the Iron Age (*Met.* 1.149–50). In the anti-Papist ideology of sixteenth-century England Queen Elizabeth is the imperial virgin who brings in the golden age of pure religion and national peace and prosperity.[24] Elizabeth as the Golden Age Virgin is combined with the Arthurian story and the legend of the Trojan origin of the Britons (on which see pp. 123–5 below) in Thomas Hughes' tragedy *The Misfortunes of Arthur* (1588), performed before the queen at Greenwich in 1588, in which Elizabeth is described as 'That virtuous Virgo born for Britain's bliss: | That peerless branch of Brute: that sweet remain | Of Priam's state: that hope of springing Troy'.

James I's triumphal entry into London in March 1604 took over much of the Elizabethan iconography.[25] Astraea has fled to Heaven with the death of the queen, but returns with the new just king. In his printed account of the entry, *The Magnificent Entertainment* (1604), Thomas Dekker says that the four kingdoms united under James 'touch not only earth, but they kiss heaven, | From whence Astraea is descended hither, | Who with our last Queen's spirit, fled up thither, | Fore-knowing on the earth, she could not rest, | Till you had locked her in your rightful breast'.[26] The seven triumphal arches commissioned from the joiner and architect Stephen Harrison to stand at points along the route included various Virgilian tags drawn from both the *Eclogues* and the *Aeneid*.[27] The Arch of Londinium had a model of the city of London on its roof (Fig. 8). Below was the figure of British Monarchy, with on her lap a globe bearing the inscription *Orbis*

Fig. 8. Arch of Londinium, from Stephen Harrison, *The Arch's of Triumph Erected in Honour of the High and Mighty Prince James I* (London, 1604).

Britannicus. Divisus ab orbe 'The world of Britain, divided from the world', alluding to *Eclogue* 1.66 *et penitus toto diuisos orbe Britannos* 'and the Britons utterly divided from the whole world'. For Virgil's shepherd Meliboeus Britain is a place of harsh exile from the pastoral landscape, at the end of the world. British writers of the Renaissance frequently allude to the line in a positive way, to refer to Britain's special geographical position, protected from invasion by the surrounding sea; in Ben Jonson's words,

A Masque of Blacknesse 241–5, 'Britannia [...] this blest isle [...] A world, divided from the world.' The Italian Arch, commissioned by the Italian residents in London, turns to the *Aeneid* for its texts (Fig. 9). The panel at the top of the arch showed Henry VII seated, with James I approaching on horseback to receive the crown, a scene of royal *aduentus* ('arrival'), with the inscription, *Hic Vir Hic Est* 'This is the man, this is he', the words with which Anchises announces the appearance of Augustus at the climax of the Parade of Heroes in the Underworld (*Aen.* 6.791). James' legitimacy is sealed by his descent from Henry VII, and implied is the intervening parade of Tudor monarchs. The royal arms are beneath this panel, and below that another piece of Anchises' advice to Aeneas, *Tu Regere Imperio populos Iacobe memento* 'Be mindful to govern the peoples with your rule, James', substituting *Iacobe* for *Romane* (*Aen.* 6.851). The final arch at Temple Bar took the form of a Temple of Janus, in which the principal figure was Peace with War grovelling at her feet. The iconography of this arch was laden with the scholarship of no less than Ben Jonson, who included the inevitable tag from *Eclogue 4*, *redeunt Saturnia regna* 'the reign of Saturn returns', on which Jonson comments, 'Out of Virgil, to show that now those golden times were returned again'.[28] The scholarly James I was the ideal audience for this show, very familiar as he was with the Virgilian texts: he concludes *Basilikon Doron* ('royal gift') (printed 1599) which, as James VI, he had written as advice on ruling for his eldest son Henry, later Prince of Wales, as follows: 'Let it be your chiefest earthly glory, to excel in your own craft, according to the worthy sentence of that sublime and heroical poet Virgil, wherein also my dictone [dictum] is included', quoting Anchises' advice to his son Aeneas on how to be a good ruler at *Aeneid* 6.847–53, ending with 'to spare the submissive and crush in war the proud'.[29]

The pageantry for James I was repeated at the restoration of the Stuart monarchy, with four arches erected for Charles II's procession from the Tower of London to his coronation in Westminster Abbey in 1661.[30] The idea of the return of the Golden Age was particularly apposite in the context of a returning king. The publication of engravings of the arches by John Ogilby, a translator of Virgil, is accompanied by a weighty paraphernalia of classical learning, citing the evidence of coins and inscriptions, as well as Virgil and other ancient poets, including lots of Claudian, whose Virgilianizing imperial panegyric was popular in the Renaissance. The second, Naval, arch (Fig. 10) celebrated the 'British Neptune, Charles II, at whose command the seas are either freely open or closed', which will remind us of the equation of Neptune with the Roman statesman at the

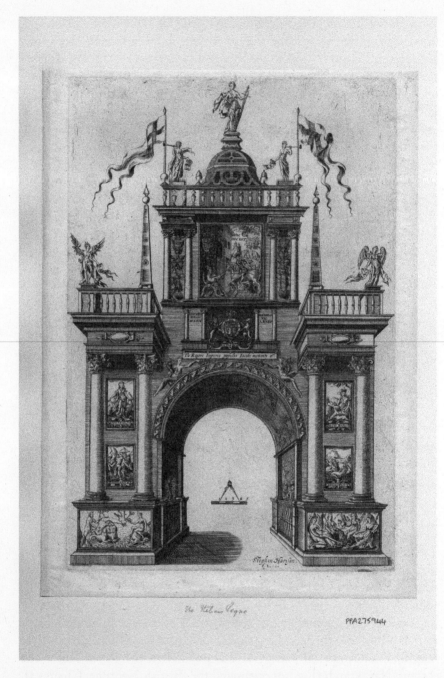

Fig. 9. The Italian Arch, from Stephen Harrison, *The Arch's of Triumph Erected in Honour of the High and Mighty Prince James I* (London, 1604).

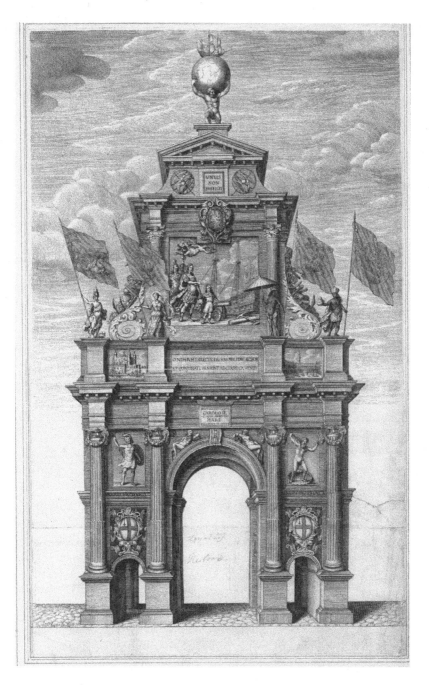

Fig. 10. The Naval Arch, from John Ogilby, *The Entertainment of His Most Excellent Majestie Charles II, in his passage through the City of London to his coronation* (London, 1662).

beginning of the *Aeneid*. In the attic of the arch are two small scenes. A quotation from the *Georgics*, 4.249 *generis lapsi sarcire ruinas* 'to repair the ruin of their fallen race' (of the bees eager to restore the damaged hive), accompanies a scene of the Royal Exchange, the hive of activity in the newly restored civil society: the restoration of Aristaeus' bees at the end of *Georgics* 4 is often read as alluding to the restoration of Roman society by Octavian after the civil war. This is balanced with a picture of the Tower of London, labelled *claudentur Belli portae* 'the Gates of War will be closed' (*Aen.* 1.294), from the end of the prophetic Speech of Jupiter. Above, under the main scene, of Charles inspecting a naval dockyard, are the lines *o nimium dilecte deo cui militat aequor | et coniurati ueniunt ad classica uenti* 'o much beloved of the god, in whose service the sea goes to war, and the winds muster under oath at the call of the trumpet', a lightly adapted version (*aequor* 'sea' for *aether* 'sky') of the lines in which Claudian diverts the Virgilian topos of divinely favoured control of the storm to the victory of Honorius at the battle of Frigidus (see p. 102 above).

Similar use of Virgilian themes is found in panegyrics on Charles II by Dryden, perhaps the most Virgilian of all the English poets, endlessly inventive in reading contemporary political messages into Virgilian texts, messages which shift according to Dryden's stance vis-à-vis the reigning monarch, both in his independent compositions and in his translations of the works of Virgil.[31]

Dryden's *Astraea Redux*, 'A poem on the happy restoration and return of his Sacred Majesty Charles II, 1660', has for epigraph the expected line from *Eclogue* 4 (6) *Iam Redit & Virgo, Redeunt Saturnia Regna*. Its account of the events leading to the restoration of Charles culminates in a reminiscence of Anchises' prophecy in *Aeneid* 6 of the return of the Golden Age with Augustus: 320–3 'Oh happy age! Oh times like those alone | By Fate reserv'd for great Augustus' throne! | When the joint growth of arms and arts foreshow | The world a monarch, and that monarch you.'

The title of Dryden's *Annus Mirabilis* ('The year of wonders, 1666') takes for its title a phrase familiar in the non-conformist vocabulary of prophecy and apocalypse, and diverts it to an epic poem on episodes of loss and recovery that work to the glory of King Charles.[32] Classical, and specifically Virgilian, themes and language help to articulate the narrative of the naval war with Holland, followed by the Great Fire of London. In the prefatory letter to Sir Robert Howard, Dryden says that Virgil 'has been my master in this poem [...] my images are many of them copied from him, and the rest are imitations of him.' The reader is called on to compare ancient and modern, in a nuanced form of panegyric. The sea-battle of the

Duke of Albemarle is mythologized according to Virgilian archetypes: the Dutch ships come on (329–30) 'silent in smoke of cannons | (Such vapours once did fiery Cacus hide)', alluding to the monstrous Cacus' vain attempt to outwit Hercules (*Aen.* 8.251–5). A few lines later elemental imagery is combined with a hint of Gigantomachy, 335–6 'Two grappling Etnas on the ocean meet, | And English fires with Belgian flames contend.' This alludes to Virgil's comparison of the clash of fleets at the climactic battle of Actium to the uprooted Cyclades or mountains clashing with mountains (*Aen.* 8.691–2). These are the weapons used in the war of the gods and giants, as also in Milton's Gigantomachic war in Heaven, *Paradise Lost* 6.664–5 'So hills amid the air encountered hills | Hurled to and fro with jaculation dire.'

The battle of Actium, between the forces of the west, backed by the Greco-Roman Olympian gods, and the barbarian hordes of the east, led by the monstrous gods of Egypt, in the distorted and propagandistic version portrayed on the Shield of Aeneas, is the last of the military encounters between Roman and foreign forces before the final establishment of the *pax Augusta*. The greatest of these encounters, the wars for which Dido's dying curse against Aeneas is the legendary cause, was that with Carthage. There is then a Virgilian perspective to Dryden's comparison, not peculiar to him, of the flourishing mercantile state of Holland to Carthage, *Annus Mirabilis* 17–20 'Thus mighty in her ships stood Carthage long, | And swept the riches of the world from far; | Yet stooped to Rome, less wealthy but more strong: | And this may prove our second Punic War.' Later Carthage's trading wealth might be seen as a more suitable analogy for commercial Britain, with the more aggressive role of Rome assigned to France.[33]

One of the Latin epigraphs to *Annus Mirabilis* alerts the reader to the model of the burning of Troy for the Fire of London, (*Aen.* 2.363) *Urbs antiqua ruit, multos dominata per annos* 'An ancient city that had ruled for many years, collapsed.' With an eye on the Virgilian revival of Troy in Rome, Dryden looks forward to the rise of a new and greater city from the ashes of the old London, 1177–8 'More great than human, now, and more August, | New deified she from her fires does rise.' The epithet 'August' is glossed with the note: 'Augusta, the old name of London.'[34] The association with this late-Roman name may remind us that Augustus famously claimed to have transformed the face of Rome, finding it a city of brick and leaving it a city of marble (Suetonius, *Life of Augustus*, 28). The rebirth of London is anticipated at the beginning of the section on the Fire, with a cosmic image that suggests the Virgilian equation of city and world, and

the role of Fate in determining the death and birth of cities, 845–8:

> Yet, London, Empress of the northern clime,
> By an high fate thou greatly didst expire:
> Great as the world's, which at the death of time
> Must fall, and rise a nobler frame by fire.

A late example of Virgilianizing Stuart panegyric is Alexander Pope's *Windsor-Forest*, published in March 1713 to celebrate the imminent Peace of Utrecht, and more generally trumpeting the age of peace of the Stuart queen Anne, who by a quasi-divine fiat ('Let Discord cease!') has brought an end to the catalogue of plague (1665), fire (1666) and 'intestine wars' viewed as punishment for the execution of Charles I. 'Peace and plenty tell, a Stuart reigns' (42). Pope will have been aware that in 1607 the first Stuart, James I, set out his vision of an age of 'peace, plenty, love', to be achieved through the union of England and Scotland, a union which was finally realized a hundred years later in 1707 when another Stuart, Queen Anne, gave the royal assent to the Act of Union.

In *Windsor-Forest* 'Pope drew upon a particularly rich and various background of both classical and native materials [...] Like the England it celebrates, the poem is sustained by a rich and far-flung commerce.'[35] Permeating the whole is a series of Virgilian allusions and structures that draws on all three of Virgil's major works, so acknowledging the far-reaching strands of continuity that tie together the three different genres, pastoral (*Eclogues*), agricultural-didactic (*Georgics*) and epic (*Aeneid*) (see Chapter 1, p. 3). This Virgilian underpinning gives the lie to an earlier critical commonplace that the poem falls into two ill-coordinated parts, a first portion (to line 290) that is essentially a juvenile work of 'pastoral simplicity', to which, in 1712, Pope attached a piece of Tory political propaganda. The poem starts in pastoral 'forests', but these are the green retreats of Windsor, seat of kings: 'At once the monarch's and the Muse's seats' (2), so suggesting the combination of lofty deeds and poetic-pastoral retreat that characterizes Virgil's fourth and fifth *Eclogues*. This specimen of 'local poetry', for which Denham's *Cooper's Hill* (1642) is the dominant model in English literature, gravitates, in terms of the Virgilian models, above all to the *Georgics*, in its celebration of present-day agricultural plenty against the backdrop of a long view of the vicissitudes of history, culminating in the urban prosperity and world-wide empire, in this case mercantile rather than military, of Queen Anne's new age of peace and prosperity, whose capital London is

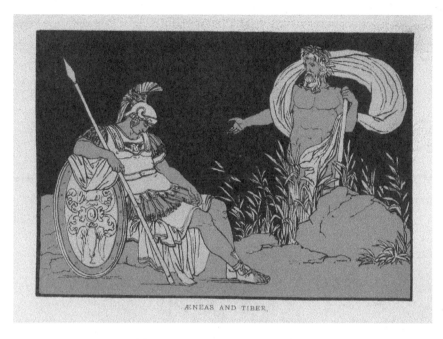

ÆNEAS AND TIBER.

Fig. 11. The Tiber appears to Aeneas in a dream.
After design by Bartolomeo Pinelli.

referred to as 'Augusta', suggesting a new Augustan age.

As we move to the end of the poem a more epic register asserts itself: the Thames of the pastoral landscape at Windsor becomes 'Old Father Thames', a prophetic river-god as numinous as the Father Tiber who prophesies to Aeneas at the beginning of *Aeneid* 8 (Fig. 11). The forests themselves will metamorphose into the vehicles for world-wide empire, 384–6 'Thy trees, fair Windsor! now shall leave their woods, | And half thy forests rush into my floods, | Bear Britain's thunder, and her cross display.' Strangely attired peoples from the ends of the earth will sail to London, just as the various and variegated conquered nations of the world process in the triumph of Augustus at the end of the prophetic Shield of Aeneas in *Aeneid* 8, a vision of the *pax Augusta* to which corresponds the reign of 'fair peace' foretold by the Thames, with the difference that in Pope's enlightened British Empire not only will 'conquest cease' (408), but also 'slavery [shall] be no more'. Father Thames concludes with a vision of the binding of Discord and other personifications of disorder, including 'hateful Envy', combining allusion to passages from both the *Georgics* and the *Aeneid*: firstly, Envy consigned to Hell at the conclusion of the description

of scenes of the triumph of Octavian/Augustus on a poetic temple at the beginning of the third *Georgic*, a trial run for the ecphrasis of Augustus' victory and triumph on the Shield of Aeneas in *Aeneid* 8; and, secondly, the closing of the Gates of War and the chaining of Furor at the end of Jupiter's prophecy of Roman history in *Aeneid* 1. The last words of Father Thames strongly evoke Jupiter's final image of Furor bound in chains, roaring and with bloody mouth: 421–2 'There Faction [shall] roar, Rebellion bite her chain, | And gasping Furies thirst for blood in vain.'

In later eighteenth-century Britain the Whig idealization of the liberty of Republican Rome led to a less favourable assessment of the monarchical or tyrannical Augustus, and to an unease with a contemporary application of the imperialist plot of the *Aeneid* (see Chapter 1, p. 13). This was only strengthened by British hostility to Louis XIV's pretensions to an Augustan-style autocracy, and then to Napoleon's claim to the title of emperor. There also developed an English poetic tradition of anti-imperialism, stretching from Milton on into the nineteenth century, and which works itself out through largely Virgilian patterns.[36] Nevertheless a straightforward analogy between Virgilian statements of achieved empire and the British Empire is still possible in the nineteenth century, for example in Tennyson's 'To the Queen' (1872), the envoi to the *Idylls of the King*, in which Tennyson speaks patriotically (and against calls for the separation of Canada from the Empire) of 'Our ocean-empire with her boundless homes | For ever-broadening England, and her throne | In our vast Orient' (Victoria was soon to be crowned Empress of India): *imperium sine fine*.[37] But a more complex Virgilianism pervades the *Idylls of the King* themselves, which have been described, in terms closely corresponding to a late twentieth-century view of the *Aeneid*, 'as poems intended both to laud the growing British empire and to respond to its moral and human costs'.[38] Norman Vance says that the *Idylls* 'enshrine a moral vision, an ideal of order for the contemporary world, set about with difficulties as was the quest of Aeneas and the founding of Rome, drawing on dim legends of an earlier time touched with strangeness as well as sadness, like Virgil's poem'.[39] The *Aeneid*'s quality of being a poem of transition, a narrative that unfolds between two places and two times, was foregrounded above all in Christianizing readings of Virgil as the poet who somehow looks towards the Christian era that he himself did not live to see (see Chapter 6, pp. 128–9, 143–5). A sense of reaching towards something that cannot (yet) be securely grasped is found in the 12th and last of the *Idylls* (whose number corresponds to the number of books of the *Aeneid*), 'The Passing of Arthur', which ends with reference to what lies

beyond a limit, and cannot be encompassed within a present British order
of things, a boundary beyond, 457–69 (Sir Bedivere):

> Then from the dawn it seemed there came, but faint
> As from beyond the limit of the world,
> Like the last echo born of a great cry,
> Sounds, as if some fair city were one voice
> Around a king returning from his wars.
>
> Thereat once more he moved about, and clomb
> Even to the highest he could climb, and saw,
> Straining his eyes beneath an arch of hand,
> Or thought he saw, the speck that bare the King,
> Down that long water opening on the deep
> Somewhere far off, pass on and on, and go
> From less to less and vanish into light.
> And the new sun rose bringing the new year.

Tennyson footnotes the sources in Malory and Layamon for the belief
that Arthur will return to Britain, a parallel to the central motif of return
in Virgilian ideology. The return of the new year in the last line suggests
the possibility, but no more, of the return of the king in some remote age.
An awareness that 'and saw […] Or thought he saw' (463–5) is a transla-
tion of the words that describe Aeneas' difficulty in making out the shade
of Dido in the darkness of the Underworld (*Aen.* 6.454 *aut uidet aut uidisse
putat*) heightens the spectral pathos of the scene.

It has even been claimed that the sense of being at a turning-point in
history in Tolkien's *The Lord of the Rings* is a Virgilian reflex, as the fall of
Sauron brings in the Fourth Age, the age of humans.[40]

Doubts and dishonesties

Virgil's works provide strong models for optimistic and teleological myths
of nationhood and empire, for one-sided panegyric and sloganizing.
Since antiquity he has faced the charge of being a court poet, a lackey to
Augustus. Individual episodes in the *Aeneid* taken out of context, such as
Jupiter's prophecy in Book 1 or the Shield of Aeneas, make this an easy
charge to press. But a larger view of the contexture of the poem yields a
more nuanced nationalism and imperialism, one less certain of the goals
towards which it is travelling. Furthermore there is a disparity of perspec-
tives. Jupiter's universal view, which may be a view that Virgil's contem-

porary reader is invited to share, envisages sharply defined beginnings and ends (the distant ancestor Dardanus, the apotheosis of Aeneas, the final triumph of Augustus). But the primary narrative, and hence the experience of Aeneas and his fellow-Trojans, is located in a space in-between. From this perspective the *Aeneid* is an epic of displacement, exile, mobility, of intermittent hope rather than final and lasting achievement.[41] This too has been registered in the political reception of the poem.

The dubieties and uncertainties of the poem form a counterbalance to its optimistic prophecies, of which the most confident is Jupiter's proclamation of the eternal city when he tells Venus 'I have granted them empire without end', *imperium sine fine dedi*.[42] This was shown up as the hostage to fortune that it is when Rome was sacked in AD 410. Augustine (*Sermon* 105.10) imagines Virgil's reply to the taunt that his prophecies were inaccurate:

> I know. But what was I to do, when I was selling my words to the Romans, except flatteringly to promise something that was false. However I was careful in this: when I said 'empire without end', I wheeled on their Jupiter to make the statement. I would not have uttered falsehoods in my own person, but I made Jupiter wear the mask of falsehood. The poet was mendacious to the extent that the god told lies.

This is not so far from the responses of some modern critics, who have stressed the fact that Jupiter is, in the end, just another character in a work of fiction,[43] and also noted that, within that fiction, Jupiter's speech is a piece of rhetoric addressed in the first instance not to the Romans, but to Venus, who needs reassuring that her son and his family do have a future: consolation rather than adulation.[44]

Noting Virgil's sleight of hand in presenting history in the form of prophecy, Augustine referred to pagans who criticized Judaeo-Christian prophecies as having being written after the event, in the same way as the Virgilian Parade of Heroes (*Sermon* 374.2): 'Aeneas was shown the Roman leaders yet to be born, when the writer of this episode himself knew of them as having already been born. For he told of events in the past, but he wrote them as prophecies, as if they were events in the future.' This is the ground on which W.H. Auden criticized the intellectual honesty of Virgil's celebration of Augustan empire, in his poem 'Secondary Epic' (1959). Auden takes issue with the prophetic mode of the Shield of Aeneas at the end of *Aeneid* 8, whose scenes of Roman history, fashioned by the god Vulcan, 'not without knowledge of time to come' (*Aen.* 8.627), go

Plate 1. Simone Martini, frontispiece to Petrarch's copy of Virgil. From *Francisci Petrarcae Vergilianus codex* [facsimile] (Milan, 1930).

Plate 2. Joseph Wright of Derby, *Silius Italicus in the Tomb of Virgil*.

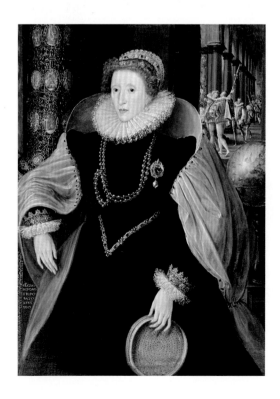

Plate 3. 'Sieve Portrait'
of Elizabeth I.

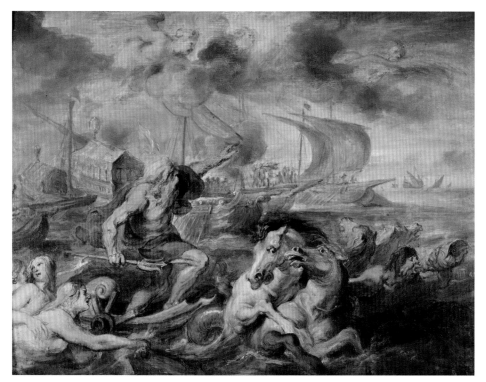

Plate 4. Peter Paul Rubens, *The Voyage of the Cardinal Infante Ferdinand of Spain from Barcelona to Genoa in April 1633, with Neptune Calming the Tempest*, 1635.

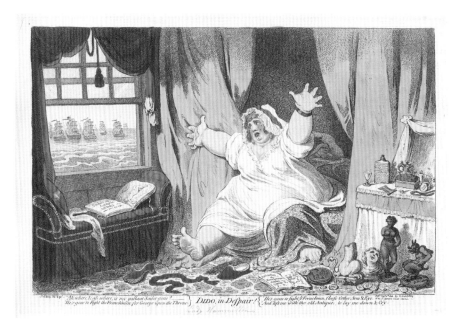

Plate 5. James Gillray, *Emma, Lady Hamilton ('Dido, in despair!')*.

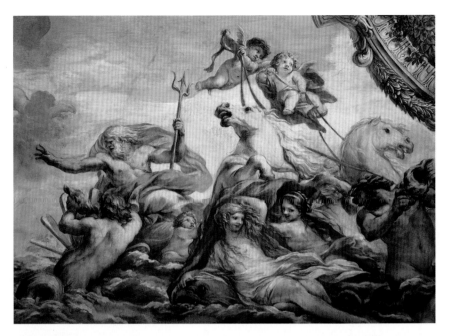

Plate 6. Pietro da Cortona, *Neptune calming the storm*. Palazzo Pamphilj, Rome.

Plate 7. G.B. Tiepolo, *Aeneas presenting Cupid in the guise of Ascanius to Dido*.

Plate 8. Sir Joshua Reynolds, *The death of Dido*.

Plate 9. Henry
Fuseli, *Dido*.

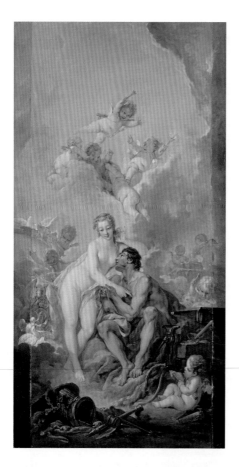

Plate 10. François Boucher, *Venus and Vulcan*.

Plate 11. N. Poussin, *Landscape with Hercules and Cacus*.

Plate 12. Claude Lorraine, *The Landing of Aeneas at Pallanteum*.

Plate 13. J.M.W. Turner, *Dido building Carthage*.

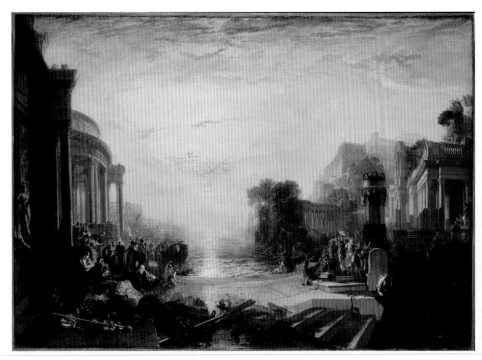

Plate 14. J.M.W. Turner, *The Decline of the Carthaginian Empire*.

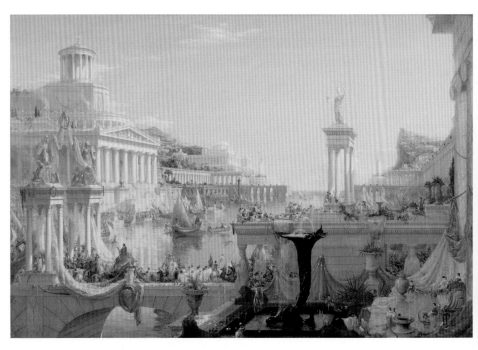

Plate 15. Thomas Cole, *Course of Empire: The Consummation of Empire*.

up to, and no further than, the climactic triumph of Octavian/Augustus in 29 BC. Whatever Vulcan may know, the mortal poet Virgil cannot see beyond this point. Auden scoffs, 'Not even the first of the Romans can learn | His Roman history in the future tense,| Not even to serve your political turn; | Hindsight as foresight makes no sense.' Proclaiming the end of history is always dangerous, and with the benefit of a further two thousand years of hindsight Auden shows just how wrong Virgil was. 'Wouldn't Aeneas have asked: – "What next? | After this triumph, what portends?"' Auden imagines a continuation scrawled in the margin of the text by a late antique 'refugee rhetorician' seeking employment in the service of a Germanic 'blond princeling', a scrap of panegyric praising the throwing off of the Roman yoke by Vandals and Goths, and ending with the news that 'Alaric has avenged Turnus', at the sack of Rome in AD 410. Jumping forward some decades, Auden asks why the long-sighted Anchises could not foresee the final conclusion to the Parade of Heroes with the deposition by 'Arian Odoacer' in AD 476 of the last western Roman emperor, whose names must surely have been predestined by that Providence, or Fate, of which the *Aeneid* purports to be the script: Romulus Augustulus. A last emperor bearing the names of the first and second founders of Rome must be more than a coincidence.

Auden criticizes the shortsightedness of both Vulcan, in *Aeneid* 8, and Anchises, in *Aeneid* 6. But where the Shield of Aeneas ends with triumph and world-rule, the Parade of Heroes, appropriately enough within the quasi-funereal setting of the Underworld, ends not with a triumph but a funeral, that of the younger Marcellus, Augustus' nephew, who died prematurely in 23 BC. This is also a question-mark left hanging over the confident expectation that the roll-call of great and successful Roman leaders will extend into the indefinite future, *sine fine*. At the beginning of the Augustan principate it was not certain that the new order, which had put an end to the disastrous civil wars of the preceding decades, would outlast the lifespan of its none too robust leader. The question of imperial succession, a recurrent and often disastrous problem in the history of the later Roman Empire, is already felt as a keen issue in the *Aeneid*'s thematization of fathers and sons. The very personal grief for the death of the younger Marcellus is registered in the anecdote that his mother Octavia, Augustus' sister, fainted when Virgil recited this passage to the imperial family, a scene popular in neoclassical paintings by Angelica Kaufmann, Ingres and others. This was also the national and public loss of a prince who may have been being groomed for the succession, rupturing both the generational and the political continuity emblazoned in the grand sweep

of the parade of Roman heroes up to this point in the Underworld. *Pace* Auden, this is an uneasy point of provisional closure at the end of the first half of the epic.

In *The Faerie Queene* Spenser faces the problem head-on in one of his reworkings of the Virgilian Parade of Heroes, Merlin's prophecy to the warrior-maiden Britomart, ancestor of the Tudor dynasty. After prophesying the Tudors and Elizabeth, Merlin delivers a half-line, 'But yet the end is not' (III.iii.50), and then breaks off suddenly, as he might if he had seen some 'ghastly spectacle'. But neither we nor the two women listening to him, Britomart and her nurse, discover the reason, and once the fury is past Merlin resumes his 'cheerful looks'. Our uncertainty as to whether this fictional character is really cheerful, or just putting on a show for his audience's sake reflects the uncertainty that necessarily confronts Spenser as he peers into the future.

Merlin's refusal to say more has a counterpart in the episode in the third canto of Ariosto's *Orlando Furioso*, through which the Virgilian Parade of Heroes is mediated to the Spenserian episode of Britomart and Merlin. Bradamante has been tricked into falling into a deep hole, a kind of comic *katabasis* (III.vi.6) 'And had been taught a gambol for the nonce, | To give her death and burial at once' (Harington's translation). She finds herself in a subterranean church containing the tomb of Merlin, within whose 'dead corpse the living soul doth dwell'. Merlin himself delivers a brief prophecy of the glorious progeny of Bradamante's womb, great warriors and righteous magistrates who will 'to us bring back the golden age'. But it is the witch Melissa who assembles a crowd of spirits who take on the resemblance of a parade of the descendants of Bradamante, ancestress of the d'Este family of Ferrara, Ariosto's patrons. At the end of the famous show, Bradamante asks to know the identity of two who 'differed from the other, | That came with backward steps and looked so sad' (III.lx-lxi), like Virgil's Marcellus 'with no cheerful look and eyes cast down' (*Aen.* 6.862). Here the sadness is not that of undeserved premature death, but that of two traitors in the d'Este family, Ferrante and Giulio, who conspired against the virtuous and glorious Ippolito and Alfonso. A cadence in a minor key to end the parade, the full meaning of which is withheld from Bradamante by Melissa, who breaks off further explanation with the words, 'I must (said she) deny you this desire, | I say no more, content you with the sweet, | For you this sour morsel is not meet.'

One response to the problem highlighted in Auden's 'Secondary Epic' is to accept that Rome will fall, but that the empire will be continued or renewed elsewhere, by a *translatio imperii* that is a further instalment of

the Virgilian pattern of destruction followed by rebirth. A Renaissance commentator, Badius Ascensius (Josse Bade, 1462–1535), notes on Jupiter's promise of empire without end at *Aeneid* 1.278–9: 'its years are not yet complete, since we see that the empire has now been transferred (*translatum*) to the Germans.'[45] In one of the many Hapsburg exercises in imperial panegyric in a Virgilian vein, a Supplement in Latin to *Aeneid* 6 by L.B. Neander published at Vienna in 1768, the story told in the Parade of Heroes is taken down to the Hapsburg Empire and the Golden Age restored by Maria Theresa.[46] In Neander's version Aeneas' 'thirst for the future' does persuade a reluctant Anchises to continue, and Aeneas is shown the destruction of Rome by the Vandals and Goths, in a repetition of the sack of Troy. But what has fallen will rise again, through the rise and civilization of the Germans and the foundation of a new Rome, Vienna. In the Hapsburg Parade of Heroes particular weight is given to Charles V, as a new Augustus: 'This is the man, this is he, whose crown will be the equal of the Roman empire, and who will cross the Ocean to the Indies.' The Dark Ages, unforeseen by Virgil, are also put to the service of panegyric of the Medici family by the Italian neo-Latin poet Girolamo Vida in his didactic poem *Art of Poetry* (1527), in a history of letters that tells of the restoration of the Muses to Italy by the Medici after the long process of decline from the time of 'golden Virgil' (1.172 *aureus*), firstly through literary degeneration and then through barbarian invasions. Here the Virgilian pattern of renewal coincides with what we call the Renaissance.

The experience of exile

In the *Aeneid* lengthy sufferings of exile precede narratives of foundation and restoration. Aeneas' exilic experience is put to work in later accounts of exile that may or may not be followed by homecoming. In Ovid's self-mythologization of his own exile the model of Aeneas is used together with that of Ulysses to create a picture of the epic quality of the poet's sufferings, starting with the detailed comparison in *Tristia* 1.3 of Ovid's last night in Rome to the night of the sack of Troy in *Aeneid* 2. Ovid's vivid recollection of that sad night is also a literary recollection of the Virgilian narrative through which he re-experiences his own enforced flight from his city. Ovid's '*Aeneid*' was not to have a happy ending; for Ovid there was to be no homecoming of any kind.

The Dryden who had adapted Virgilian plots to celebrate the return from exile of Charles II in the 1660s, came himself to sympathize with

the exiled Aeneas after his conversion to Roman Catholicism, probably in 1685. *The Hind and the Panther* is a dialogue between a milk-white hind (the Church of Rome) and the beautiful but dangerous panther (the Church of England). The Panther draws an analogy between the terms offered by the Hind and the terms of peace offered by Aeneas to King Latinus in Book 7 of the *Aeneid*, 3.766–80 (cf. Ilioneus' speech to Latinus at *Aen.* 7.213–48):

> 'Methinks such terms of proffered peace you bring,
> As once Aeneas to the Italian king:
> By long possession all the land is mine;
> You strangers come with your intruding line,
> To share my sceptre, which you call to join.
> You plead like him an ancient pedigree,
> And claim a peaceful seat by fate's decree.
> In ready pomp your sacrificer stands,
> To unite the Trojan and the Latin bands;
> And, that the league more firmly may be tied,
> Demand the fair Lavinia for your bride.
> Thus plausibly you veil the intended wrong,
> But still you bring your exiled gods along;
> And will endeavour, in succeeding space,
> Those household puppets on our hearths to place.'

The Hind's claim to an ancient pedigree, mirroring the Trojans' claim to an Italian ancestor of their own in Dardanus, is brushed aside as specious by the Panther. Dryden's own position is indicated by one of the Latin epigraphs to the poem, *Antiquam exquirite matrem* 'search out your ancient mother' (*Aen.* 3.96). Dryden's sympathy for exiles, and his personal sense of exile, increased after the 'Glorious Revolution' and the ousting of the Catholic James II by the Protestant William III.[47]

The Trojans' experience of exile is one with which those, like Dryden, convinced of the right of their cause may buoy themselves up. Exile may be a potent element in myths of nationhood or religious confession. One of the most famous works of Joost van den Vondel, the greatest writer of the Dutch Golden Age and the author of a prose translation into Dutch of Virgil's works (1646), is his historical drama *Gijsbreght van Aemstel* (1637), written to inaugurate the first city theatre in Amsterdam, and performed annually on New Year's Day between 1638 and 1968. The subtitle of the play is 'the destruction of his city and his exile'. The hero Gijsbreght, modelled on Aeneas in *Aeneid* 2, was the Lord of Amsterdam who unsuccessfully defended Amsterdam against a siege in 1304, and went into exile

in Prussia, never to return. He is finally dissuaded from his pious defence of the city by the angel Raphael, who tells him that the city is lost, and that he is to found a new Holland in Prussia, but that in 300 years a glorious new Amsterdam will rise. It is as if Virgil's national Roman epic consisted just of Book 2 of the *Aeneid*. Exile also had contemporary resonances for Vondel: the play is dedicated to Hugo Grotius, in exile in France at the time because of his opposition to Calvinist ideas, and the Catholic Middle Ages may have appealed on a personal level to Vondel, like Dryden at odds with the national religion of his time, and who converted to Catholicism in 1641.[48]

Trojan genealogies

In the *Aeneid* there is an analogical relation between the adventures of Aeneas and later Roman history, above all the career of Augustus, through various kinds of 'typology' and foreshadowings. There is also a direct genealogical relation, since Aeneas is the ancestor of the Julian family, and so of Julius Caesar and Augustus. Other leading Roman families also claimed descent from Trojan ancestors, in a genealogical chic. More generally *Aeneadae* 'descendants of Aeneas' is a poetic name for the 'Romans'. Family trees also matter for the medieval and Renaissance political uses of the legend of Troy and the Virgilian story of Aeneas, through the claim for Trojan descent by a number of European peoples. Furthermore, the Trojan line is extended backwards into a biblical lineage descending from Noah, so effecting a syncretism of the pagan Trojan and the biblical, Hebraic, traditions.

The legend of Rome's Trojan ancestors originated with Greek historians concerned to find a place for Rome within Greek historical traditions, but the Romans themselves found diplomatic, political and cultural uses of their own for the Trojan legend.[49] Among other things, the *Aeneid* is a large-scale exercise in defining the place of Rome in relation to the Greek world, hitherto culturally superior to Rome, if now militarily subject. Similarly, post-classical uses of the Trojan legend serve to lay claim to political and cultural authority. These legends develop a momentum independent of the *Aeneid*, but not least of their uses is that of facilitating the writing of national epics parallel to and imitative of the *Aeneid*.[50]

Writing in the mid-twelfth century the historian Henry of Huntingdon commented that 'Like many of the peoples of Europe, the Franks derive their origin from the Trojans.' The Trojan legend of the Franks goes back to the seventh-century 'Chronicle of Fredegar' and the eighth-

century *Liber Historiae Francorum*, and underwent various evolutions over the centuries. In the version of Jean Lemaire de Belges, *Illustrations de Gaule et singularitez de Troye* (1510–14), it was Gauls who founded Troy, and the arrival of the Franks in Gaul was thus a homecoming, as in Virgil the Trojans, the descendants of Italian Dardanus, are returning to their original home. The Fourth Crusade of 1204, when the Franks sacked Constantinople, could be presented as the revenge of the Franco-Trojans on their old enemy the Greeks. Serious French historians had exploded the Trojan legend by the later sixteenth century, showing that the Franks were in origin a Germanic people, but the more flattering story of Trojan descent continued to be peddled in the seventeenth century. As late as 1714 the scholar Nicolas Fréret was thrown into the Bastille for showing that the Franks were Germans.[51]

Ronsard took the Trojan legend of the Franks, substantially from the version of Jean Lemaire de Belges, as the subject for his attempt at a French national epic, the *Franciade*, largely a patchwork of sustained imitations of passages from Homer, Virgil and Apollonius of Rhodes' *Argonautica*, and dedicated to Charles IX.[52] In the preface he says that he is not bothered whether the story is true or not, whether our kings are Trojans or Germans, Scythians or Arabs. Unlike the historian, the poet is concerned only with what is possible, not what is true. Only the first four books (published in 1572) were completed of a planned 24 that would have taken the hero Francion to Gaul and celebrated the glorious deeds of his descendants down to Charles IX. The St Bartholomew's Day Massacre of 1572, followed by the death of Charles in 1574, probably squashed any incentive to continue with what has never been regarded as one of Ronsard's more successful works. Basing himself closely on Homeric and Virgilian models, the four books tell the story of Francion (Francus), who is in fact Hector's son Astyanax, who was not after all killed when Troy was taken. In the *Aeneid* the ghost of Hector hands over to Aeneas the mission to find a future for the Trojans and their descendants. Ronsard swerves from his poetic model Virgil by reverting to the bloodline of Hector. Elements of the Virgilian plot are rearranged as the founding story of the Franks runs parallel to the *Aeneid*'s founding story of the Romans. Jupiter sends down Mercury to bestir Francion from his leisurely life with his uncle Helenin (Helenus) in Buthrotum to pursue his destiny, just as Mercury is sent to Carthage to shock Aeneas into leaving Carthage. A Virgilian storm, raised by Neptune and Juno, drives Francion to Crete, where he is embroiled in a love interest with the two rivalrous daughters of the king. The fourth book is a book of prophecy, in which Francion learns of his

voyage to Gaul, and is shown a parade of future French kings, both good and bad, down to Pépin. The Virgilian Parade of Heroes ends with the prematurely dead Marcellus; in the 1578 edition Ronsard appended to his incomplete epic an epilogue on the early death of a French king: 'If King Charles had lived, I would have finished this long work. As soon as death overcame him, his death overcame my resolve.'

The British myth of Trojan origins received its standard formulation in the twelfth-century Geoffrey of Monmouth's *History of the Kings of Britain*. In a narrative that partly follows in the footsteps of Virgil's story of Aeneas, a great-grandson of Aeneas, Brutus (or Brut), leaves Italy to go into exile after tragically fulfilling a prophecy that he would kill both his parents. In Greece he frees a band of Trojans enslaved by a Greek king. Brutus and his Trojans have various adventures in the Mediterranean and Gaul, including a visit to an island with an abandoned temple of Diana, where the goddess gives him a vision of the island in the western ocean that he is destined to settle. He finally arrives at Albion, where he kills the native giants, and becomes the first king of the island, which Brutus renames Britain after himself. On the banks of the Thames he founds a city called Troynovant, 'new Troy' (later renamed London after King Lud).[53]

The story of Brut is central to the genealogies of Spenser's *The Faerie Queene*, in which the Tudor dynasty marks the return to the British throne of Briton blood, descended from Britomart, the Amazonian knight of chastity, who is herself descended from the Trojan Brut. The story of Albion and Brutus is first told in the chronicle of 'Briton moniments' that Prince Arthur reads in the House of Alma (*Faerie Queene* II.x.5–13). We return to the origins of Troynovant in a densely Virgilian context in the next book, at the dinner-table of Malbecco and his wife Hellenore (III. ix.33–51). In order to ingratiate himself with Hellenore, the knight Paridell tells of his descent from Paris, whose rape of Helen he will repeat in his seduction and rape of Hellenore. For Paridell Troy, which fell because of his ancestor's sexual misdemeanor, is now 'nought but an idle name, | And in thine ashes buried low dost lie'. Britomart, also at the table, on hearing 'Of Trojan wars and Priam's city sacked', feels pity and indignation at the Greeks' cruel acts. Spenser now starts to tread in Virgilian footsteps: Britomart asks Paridell to tell of 'What to Aeneas fell' at the sack of Troy, as Virgil's Dido asked Aeneas himself about 'what befell his people' (*Aen.* 1.754). Paridell then moves quickly beyond Aeneas' narratives of the fall of Troy and his wanderings before reaching Carthage, to take the story down to the Trojans' arrival in Latium, and the subsequent foundations

of Alba Longa and Rome. Britomart then takes over, describing Rome as the revival of Trojan glory ('And Troy again out of her dust was reared'), and continues with the prophecy of a third kingdom that

> yet is to arise
> Out of the Trojans' scattered offspring
> That in all glory and great enterprise,
> Both first and second Troy shall dare to equalise.
>
> It Troynovant is hight, that with the waves
> Of wealthy Thamis washed is along,
> Upon whose stubborn neck, whereat he raves
> With roaring rage, and sore him self does throng,
> That all men fear to tempt his billows strong,
> She fastened hath her foot; which stands so high,
> That it a wonder of the world is sung
> In foreign lands; and all which passen by,
> Beholding it from far, do think it threats the sky.

The 'new Troy' (London) repeats the Virgilian trajectory of Rome, rising from the destruction of the original Troy. Like Rome, London challenges the elements: the prophetic scenes of Roman Empire on the Shield of Aeneas end with an image of the eastern river Araxes 'chafing at a bridge' (*Aen.* 8.728), and Virgil also has an image of a sky-scraping Augustan Rome (*Aen.* 8.99–100).

The subject of Brutus continued to attract poets into the eighteenth century. Towards the end of his life Alexander Pope planned an epic in blank verse on Brutus as a founding hero of enlightenment and benevolence, of which only the opening sentence survives, beginning, in Virgilian manner: 'The Patient Chief, who lab'ring long, arriv'd | On Britain's Shore and brought with fav'ring Gods | Arts Arms and Honour to her Ancient Sons: | Daughter of Memory! from elder Time | Recall.'

In 1792 the playwright and artist Prince Hoare put on an opera *Dido Queen of Carthage* (an adaptation of Metastasio's *Didone*) at the Haymarket Theatre in London, with music by Storace.[54] It was a celebration of empire and the spoils of conquest, setting the European Aeneas against the wily Moor Iarbas. The opera was followed by *The Masque of Neptune's Prophecy*, in which Neptune tells Aeneas and Ascanius of the race of kings that will descend from them. 'Third from thy sire shall Brutus rise, | Who, far beneath yon western skies, | Ordain'd to empire yet unknown, | On Albion's coast shall fix his throne, | And, crown'd with laurels, spoils, and

fame, | Shall change to Britain Albion's name.' The opera closed after only five performances.

Geoffrey of Monmouth is also the major source for that more enduring legend of British kingship, Arthur. In *The Faerie Queene* Arthur, who is in love with Gloriana the Fairy Queen, is the embodiment of Magnificence, the perfection of the several virtues represented by the knights of the individual books. Milton planned an epic on Arthur before turning to a biblical subject-matter. King Arthur is a transparent allegory for William III in the much derided epics by Richard Blackmore, *Prince Arthur* (1695, in ten books) and *King Arthur* (1697, in 12 books), which combine Virgilian plot-lines with a Miltonic dualism of angels and devils that was itself part of a long tradition of Christianizing the Heaven–Hell dualism already present in the *Aeneid*.[55] For example, *Prince Arthur* begins with the intervention of Satan and a storm raised against Arthur, and ends with the Turnus-like death of Tollo. This is a world away from the Arthurianism of Tennyson's *Idylls of the King*, which also embody a very different reading of the *Aeneid* (see pp. 114–15 above).

Many other European nations also had their legends of Trojan origins; more surprisingly, so too did the Turks, helped by the closeness in sound between *Turc(h)i* and *Teucri*, one of Virgil's names for the Trojans, derived from one of their ancestors, Teucrus.[56] After taking Constantinople in 1453, the Ottoman Mahomet II is said to have visited the site of Troy, a short journey down the Hellespont, and announced himself as the avenger of Troy, sacked by the Greeks. An epigram by Julius Caesar Scaliger points up the repetitions of legendary history: 'Twice ancient Troy was overthrown by Greek arms; twice has new Greece mourned for her victorious ancestors, once when great Rome brought back the descendants of the Trojans, and again now that the Turks hold sway.'[57] The neo-Latin *Amyris* (the title derives from the Arabic 'amir', meaning 'prince', 'emir') by Gian Mario Filelfo, written in the 1470s, is a curious example of 'humanistic Turcophilia', an epic on the life of Mahomet II.[58] In a replay of the 'Choice of Hercules' (choosing Virtue over Pleasure), the young Mahomet rejects Venus in favour of Bellona, goddess of war, who appears in a vision to tell him to avenge Troy. A further mark of Greek perfidy is their transfer of the seat of empire from Trojan Rome to Greek Constantinople. In an example of the diplomatic use of Trojan origins, whose history stretches back to the alliance between Rome and the Sicilian city of Segesta in the First Punic War on the basis of their shared Trojan ancestry, Mahomet II is alleged to have written a letter to Pope Nicholas V, complaining of the preaching of a crusade in Europe,

and appealing to the Trojan ancestry shared by the Turks with European nations. This is not an argument that has been aired in recent discussions about the enlargement of the European Union.

6

IMPERIUM SINE FINE: THE *AENEID* AND CHRISTIANITY

ccording to a legend that can be traced back to the eighth century, and which is frequently illustrated in medieval and Renaissance art, the Roman senators, considering the great physical beauty of the Emperor Augustus and the age of prosperity and peace that he had brought about, asked to be allowed to worship him as a god. Augustus demurred, and consulted the Sibyl, who answered, 'there will come from heaven a king whose reign will be for the ages to come, so that being present in the flesh he may judge the world.' While the emperor listened, the heavens opened and he saw a beautiful virgin holding a child in her arms, and heard a voice saying, 'This is the altar of the Son of God.' Augustus fell down in adoration. On the spot on the Capitol where he had the vision was later built the church of S. Maria in Ara Coeli, on the site of the ancient temple of Juno.[1] In a related medieval story Virgil is said to have built a noble palace, the *Salvatio Romae* ('Safekeeping of Rome'), containing wooden statues of the provinces of the empire, each carrying a bell which the statue struck when a province plotted against Rome. When asked how long the gods would allow the building to stand, Virgil answered, 'Until a virgin shall bear a son'. The people applauded, thinking that the building would stand for ever. But the impossibility turned into reality at the birth of Christ, whereupon the building fell into ruins.[2]

In these stories the Emperor Augustus and his poet Virgil are associated both with the new era of pagan Roman Empire and peace, inaugurated with the principate of Augustus, and with the birth of Christ, the beginning of a new age in the history of the world that will see the end of the pagan gods. The providential coincidence of Augustan world-empire with the birth of Christ became a part of Christian ideology. Eusebius, in

the time of Constantine the Great, followed by St Ambrose and Pope Leo the Great, maintained that Rome's achievement of a world-empire leading to an age of peace was divinely ordained to open the way for the universal spread of the Christian word.[3] The early Christian poet Prudentius (AD 348–after 405), whose poems 'On the Crowns of the Martyrs' (*Peristephanon*) are full of Virgilian allusions, has it that, as he is roasted on the gridiron, St Laurence tells the Roman magistrate that Christ has sanctioned Roman world-rule, which unites the peoples with one language, so that Christianity can bind the world together. Roman triumphs prepare the way for the kingdom of Christ. In another poem Prudentius tells his pagan opponent Symmachus that Constantine's bloodless triumph over the pagan gods, identified with demons, assured the Roman people of an everlasting divine rule (*Against Symmachus* 1.539–44). Prudentius transfers to this new Christian empire the words with which the Virgilian Jupiter promises Venus everlasting empire for the Roman descendants of her son Aeneas (542), *denique nec metas statuit, nec tempora ponit* 'he imposes no limits of space or time' (cf. *Aen.* 1.278).

The, at first sight paradoxical, idea that Virgil, the poet who wrote an epic on the foundation of Rome and the heroic deeds of the ancestor of the first Roman emperor, Augustus, should also be a herald of the coming of Christ was encouraged by the history of the interpretation of Virgil's fourth *Eclogue*, often labelled the 'Messianic Eclogue' (see Chapter 5, p. 95).[4] This riddling poem, dedicated to one of the Roman consuls of 40 BC, uses oracular language to express hopes for future political and social stability after years of Roman civil war. But its annunciation of the arrival of the final age foretold in the Sibyl's song, with the return of the Virgin (Justice), the return of the Golden Age of Saturn, and the descent from Heaven of a mysterious child, could be taken as a prophecy of a very different kind of order of things. The Church Father Lactantius, a friend of the first Christian Roman emperor Constantine I (the Great), was the first to give the poem a Christian reading, seeing in it a reference by the Cumaean Sibyl, reported by Virgil, to the Golden Age that will follow the second coming of Christ. Constantine himself in a speech at the Council of Nicaea (AD 325) interprets the eclogue as a prophecy of the birth of Christ to the Virgin Mary. The 'death of the serpent' in the new Golden Age announced in the eclogue is taken to refer to the serpent in the Garden of Eden. Constantine says that Virgil himself was privy to the truth that the Sibyl foretold the birth of Christ, but deliberately obscured the message for reasons of safety. The belief that *Eclogue* 4 contained a prophecy of Christ, whether Virgil was conscious of the fact or not, and

the idea that the Sibyls were pagan prophets of Christianity, had a long life. Dante gives it a new twist when the Roman poet Statius explains to Dante's guide Virgil, in Purgatory, that it was Virgil who set him on the path firstly to becoming a poet, and then to converting to Christianity with the fourth *Eclogue* (*Purg.* 22.70–2) 'When you said: "Time is renewed; justice returns and the first age of man, and a new offspring descends from the sky"' (see also Chapter 3, p. 40). But, living and dying before the Incarnation, Virgil himself is doomed to spend eternity in Limbo, the first circle of Inferno.

The story told in the *Aeneid* also has some points in common with biblical plots: Aeneas, like Moses, leads his people into exile to a prom-ised land that is also their original homeland (the Trojan ancestor Dardanus came from Italy). Moses does not live to enter his promised land; Aeneas reaches Italy, but dies centuries before the fulfilment of the divine promise to the Trojan exiles of the foundation and world-empire of the city of Rome. Ideas of advent and salvation attach to human heroes destined for godhood: Hercules, who delivers the site of Rome from the monstrous Cacus in *Aeneid* 8, is a forerunner of Octavian/Augustus who will deliver Rome from the monstrous gods of Egypt at the battle of Actium, as depicted on the Shield of Aeneas at the end of *Aeneid* 8. The terminology of biblical figuralism, the kind of 'concrete' prophecy whereby an Old Testament 'type' (e.g. Jonah in the belly of the whale) is fulfilled in a New Testament 'antitype' (Christ's three days and nights in the Underworld before his resurrection), is sometimes applied, perhaps misleadingly, to this kind of figurative mirroring within the *Aeneid* (see Chapter 5, p. 93). But hopes and expectations of a saviour are shared by the pagan Mediterranean world of the first century BC with the Judaic Messianism out of which emerged Christianity, and it is not impossible that similarities between Virgilian and biblical plots are to be traced ultimately to shared ancient patterns of thought. There is at least a strong possibility that the fourth *Eclogue* draws on Jewish Messianism and eschatology as preserved in the Eastern Sibylline oracles produced by the Hellenized Jews of Egypt.[5]

But the *Aeneid* maintained its hold on the consciousness of Christians of the late-antique western Roman Empire not so much because of paral-lels with biblical stories or because Virgil was thought to have been privy to Christian revelation before the birth of Christ, but for the simple fact that it continued to be the central text in ancient education, based on the reading of the poets. Augustine, albeit in a passage of some irony, speaks of 'Virgil, whom small children read, it would seem so that this great

poet, of all poets the most famous and the best, should be drunk in by tender minds and not easily erased by forgetfulness' (*City of God* 1.3). The revolution in belief system brought about by the introduction of Christianity had major consequences for the reception of a poem whose characters include the pagan gods traditional in the divine machinery of ancient epic, and which celebrates the foundation of the earthly Roman Empire. But in other respects the mixture of homage, correction and criticism found in Christian imitations and rewritings of the Virgilian epic continued the practice of the earlier, non-Christian, poetic successors of Virgil, and in particular Ovid, Lucan and Statius, whose epics were also intensively imitated in Christian epics in both Latin and the vernaculars, from late antiquity down to the Renaissance. And as long as epic continued to be a major genre in the Latinate west, the *Aeneid*, as the great Latin classic of the genre, provided a storehouse of themes, motifs and diction.

A long line of epics on biblical subjects begins with a series of Latin verse paraphrases of the Old and New Testaments.[6] The earliest, Juvencus' *Four Books of The Gospels* (*c.* AD 330), recasts the humble language of the Christian gospels in the culturally prestigious form of Virgilian epic. The polemical overbidding of the pagan epic models is made clear in the Preface, in which Juvencus acknowledges the power of the poems of Homer and Virgil to bestow fame and glory both on their heroes and the poets themselves, but whose words will last only until the end of the world. By contrast the subject of Juvencus' epic, the word of God, is truly eternal, as Matthew tells us (24:35): 'Heaven and earth shall pass away, but my words shall not pass away.' Furthermore, while the pagan poets weave falsehoods into their narratives, Juvencus deals in nothing but the pure truths of the life of Christ.[7]

As well as drawing continuously on the Virgilian store of vocabulary and phrasing, Juvencus, like his successors in the field of biblical paraphrase such as Sedulius' *Paschal Song* (*c.* AD 435, based on the Gospels), and Arator's *History of the Apostles* (AD 544, on the Acts of the Apostles), imitates particular passages of the *Aeneid*, as well as a wide range of other classical Latin poetry. Awareness of the Virgilian models may prompt further interpretative effort on the part of the reader. Juvencus elevates the storm on the Lake of Galilee (Matth. 8:16–27) into a hyperbolical epic storm (*Evang.* 1.25–38), drawing on the storm that assails the Trojans at the beginning of the *Aeneid* (1.81–123). The waves strike the sky, and the sea-bed is opened up (with 32 *disiectoque aperitur terra profundo* cf. *Aen.* 1.107 *terram inter fluctus aperit*). Aeneas is helpless in the storm, and only a god, Neptune, has power to command the winds and calm the seas.

Juvencus' hero, the man-god Jesus, can do this himself. Another example: Christ is brought bound before Pilate in the words with which Aeneas narrates the capture by the Trojans of the Greek trickster Sinon in *Aeneid* 2 (*Evang.* 4.589–90, based on *Aen.* 2.57–8). For such a scene the capture of Sinon is in fact the only possible model in the *Aeneid*, but that does not preclude further allusive point. One can read it as 'contrast-imitation' (the innocent Jesus is pointedly the opposite of the devious Sinon), but the allusion may also be pressed for similarities: neither character is what they seem to their immediate audience. The theme of sacrifice is also shared: Sinon claims (falsely) that he has escaped from being sacrificed by his fellow-Greeks as an offering for a safe return to Greece, and Jesus will sacrifice himself to save mankind.

The limits of interpretability are tested by the cento, that peculiar testament to the authority and re-usability of the Virgilian text (see Chapter 1, pp. 10–11). The earliest biblical cento is that by Proba, Old and New Testament narratives patched together from fragments of Virgil in 694 lines, written between AD 353 and 370.[8] In the Prologue Proba announces that she will 'say that Virgil has sung of Christ's holy gifts', not through a claim that he somehow had access to Christian truth, but through the manipulation of Virgil to yield Proba's own Christian message. But it is hard not to feel that Proba senses that Christian truths are already hidden in Virgil. Her call for inspiration quotes lines from the Speech of Anchises in the Underworld on the world-soul and on the celestial origin of the individual soul (*Aen.* 6.726–7 and 731–2), lines which were often read as in conformity with Christian doctrine on the Holy Spirit and the immortality of the soul. For the storm on the Lake of Galilee Proba, like Juvencus, draws on the storm in *Aeneid* 1, and applies to Jesus fragments of the lines describing Neptune's calming of the storm. The serpent in the Garden of Eden is stitched together from various Virgilian creatures of evil to whom allusion is also made in later Christianizing narratives in the Virgilian tradition: the serpents that kill Laocoon in *Aeneid* 2, the Fury Allecto in Book 7, and the monster Cacus in Book 8. The language used by King Evander in praise of Cacus' slayer, the man-god Hercules, lends itself naturally to the account of the advent of Christ, combined with allusion to the divine child of *Eclogue* 4: 338–40 'your offspring has come down from high heaven, and in answer to our prayers time has at last brought us too the help and presence of a god' (*Ecl.* 4.7 and *Aen.* 8.200–1). There is a long history of the Christian Hercules, the story of the son of the supreme god, who has a career on earth as a man before ascending to Heaven as a god, and whose labours include a harrowing of Hell.[9]

The Virgilian cento has a long life. A late example is by the prolific Aberdonian, and Laudian clergyman, Alexander Ross (1591–1654), who has earned a minor notoriety because of his belated defence of Aristotelian cosmology against the Copernican heliocentrism. His 13-book 'Christiad of the Evangelizing Virgil' (London, 1638)[10] recounts the prophecies and narratives of the life of Jesus in both Testaments 'on the lofty-sounding divine trumpet of Maro, blown by Alexander Ross of Aberdeen'. A couplet on the title-page encapsulates the diversion of Virgilian material to its Christian subject: 'Virgil sung of arms and the man, I sing of acts and God: let the arms of the man give way, while I tell of the acts of God' (*Arma virumque Maro cecinit, nos acta Deumque;* | *Cedant arma Viri, dum loquor acta Dei*) (Fig. 12).[11]

Eclogue 4 and the *Aeneid* share with the Bible a habit of recording prophecies. The *Aeneid* contains a number of passages that present what for Virgil's readers was past Roman history as prophecy delivered in the remote legendary past of Aeneas. The first and grandest of these prophecies, Jupiter's unrolling to Venus of the whole future history of Rome down to a new age of peace under Augustus, with the promise of unending empire for the descendants of Aeneas (*Aen.* 1.257–96), was frequently adapted to Christian prophetic ends. We have already seen Prudentius so using it. In another of the early Christian biblical epics, Avitus' *On the Deeds of Spiritual History* (*c.* AD 494, from the Creation to the Crossing of the Red Sea), Jupiter's prophecy is adapted for God's promise to the newly wed Adam and Eve of eternal life and endless generations of progeny (1.171–8):

> Live in harmony and fill the world, and may the happy seed of your offspring grow and be long-lived: may their years not be numbered, and may their life have no end. I have given you progeny without end (*non annis numerus, uitae nec terminus esto.* | *progeniem sine fine dedi*), which you will behold for all time, you who are established as the first author of the race. Let your great-grandson sow his grandsons and raise them up through the centuries, and may he count his living ancestors, and may long-lived sons bring children into the world before their parents' eyes (*inque ora parentum* | *ducant annosi natorum pignora nati*).

The last line incorporates allusion to another major prophecy in the *Aeneid*, Apollo's promise of world-rule to Aeneas and all his descendants, *Aen.* 3.98 'his sons' sons and those who will be born of them' (*et nati natorum et qui nascentur ab illis*). But this prophecy in the Garden of Eden will be derailed by the Fall and the introduction of death into the world. By the

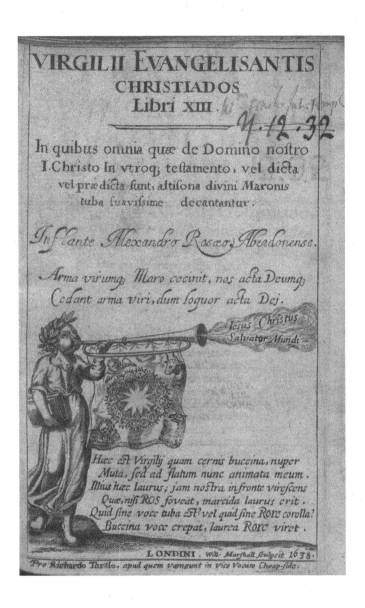

VIRGILII EVANGELISANTIS
CHRISTIADOS
Libri XIII.

In quibus omnia quæ de Domino noſtro
I.Chriſto In vtroq; teſtamento, vel dicta
vel prædicta ſunt, altiſona divini Maronis
tuba ſuaviſsime decantantur.

Inſtante Alexandro Roſæo, Aberdonenſe.

Arma virumq; Maro cecinit, nos acta Deumq;
Cedant arma viri, dum loquor acta Dei.

Iesus Christus
Salvator Mundi

Hæc eſt Virgilij quam cernis buccina, nuper
Muta, ſed ad flatum nunc animata meum.
Illius hæc laurus; jam noſtra in fronte vireſcens
Quæ, niſi ROS foveat, marcida laurus erit.
Quid ſine voce tuba eſt? vel quid ſine RORE corolla?
Buccina voce crepat, laurea RORE viret.

LONDINI. Will. Marshall ſculpſit 1638.
Pro Richardo Thralo, apud quem væneunt in Vico Vocato Cheap-ſide.

Fig. 12. Title page to Alexander Ross, *Virgilii Evangelisantis*
Christiados Libri XIII (London, 1638).

late fifth century the Virgilian Jupiter's prophecy of everlasting Roman empire will have come to sound very hollow. Avitus' imitation perhaps registers that failure.

More usually the confidence of Jupiter's speech is transferred to the certainties of the Christian age of grace and the second coming, a divine empire without limits in time or space. As Milton's Michael brings to an end his prophetic review to Adam of the whole of history after the Fall in the last book of *Paradise Lost*, he tells of the second coming of Christ, to 'raise | From the conflagrant mass, purged and refined, | New heavens, new earth, ages of endless date | Founded in righteousness and peace and love, | To bring forth fruits, joy and eternal bliss' (12.547–51; see Chapter 2, p. 44).

The contrast between pagan and Christian ideologies of empire is the underlying theme of Augustine's *City of God*, written after the sack of Rome in AD 410 as an answer to those who saw in the catastrophe punishment for neglect of the pagan gods.[12] In an exhortation to the Romans to abandon the cult of the pagan gods (*City of God* 2.29), Augustine asserts that the true fatherland is that for which Christian martyrs have spilt their blood, and he repeats the words with which Aeneas praised the noble souls who died in battle to win Italy for the Trojans, those who 'with their blood secured this fatherland for us' (*Aen.* 11.24–5). In the heavenly fatherland they will find not the pagan tokens of eternal empire, but the one true god, who 'sets no limits in space or time to his power, and will grant empire without end' (*nec metas rerum nec tempora ponit,* | *imperium sine fine dabit*, lightly adapting *Aen.* 1.278–9).

Augustine subjects Roman history and Roman religion to a searching and learned critique to show up the emptiness and turpitude of belief in the pagan gods. The contrast between the values of the (Roman) earthly city and the Christian city of God, and the need to exercise care in distinguishing between Christian and pagan values, is brought out by the juxtaposition of biblical and Virgilian quotations in the Preface of the *City of God*. Augustine acknowledges the difficulty of convincing the proud of the power of humility (*uirtus humilitatis*), and quotes Proverbs 3:34: 'God withstands the proud, but gives grace to the humble'. This Christian truth is aped by pagans, and Augustine quotes one of the most famous, and most controversial, lines in the *Aeneid*, Anchises' definition of the Roman mission as 'to spare the conquered and war down the proud' (*Aen.* 6.853 *parcere subiectis et debellare superbos*). Modern readers of the *Aeneid* often point to an apparent contradiction with Aeneas' final action in the poem when he savagely strikes down the fallen and suppliant Turnus (see

Chapter 4, pp. 82–4). Augustine spies a contradiction within the context of the speech of Anchises itself, in which a policy of being harsh with the proud and accommodating to the humbled is spoken as an expression of the praise that the proud pagan spirit loves to hear spoken of itself. Virgilian quotations are frequent in Augustine's critique of Roman imperialism in the first five books of the *City of God*, fading away in later books as Rome is put in perspective by other empires, and with an increasing focus on the history of Israel.

In his *Confessions* Augustine famously remembers how as a schoolboy learning to read and write he was made to memorize the wanderings of Aeneas, oblivious to his own spiritual wandering, and how he wept for the death of Dido, because of her love for Aeneas, but did not weep for his own spiritual death, the result of not loving the true god but whoring after strange gods (1.13.20–1).[13] The terms used here hint at an allegorical reading of the *Aeneid* as a tale not about the sufferings of legendary characters but about the wandering soul in search of its spiritual fatherland. This episode in Augustine's autobiography is one of a number of references and allusions to the *Aeneid* that, intermittently, construct a life as a version of the story of Aeneas. Virgilian fiction and autobiography coincide when Augustine comes to Carthage to study rhetoric and finds himself seething in a cauldron of lustful love (3.1.1). Later he leaves Carthage for Rome, abandoning a woman wild with grief on the shore (5.8.15). This is not Dido, but his mother Monica, who will in the next book follow her son to Rome, 'a mother made brave by her piety, following me on land and sea', fortified by the key Virgilian virtue to emulate the mother of Euryalus who alone of the Trojan mothers followed her son by land and sea (*Aen.* 9.492). Augustine immediately 'corrects' the inauspicious Virgilian model (Euryalus dies a premature death) by comparing his mother to the widow whose dead son was brought back to life by Jesus (Luke 7:12–15). In his last extended conversation with his mother shortly before her death, son and mother look forward to the eternal and blissful life of the saints (9.10.23–6), a contrast with the vision of the future of the earthly city that Anchises reveals to his son in *Aeneid* 6. An even more interiorized version of the Virgilian Underworld is suggested as, in his search for God, Augustine passes beyond the senses of seeing and hearing into the fields and broad palaces of memory (10.8.12 *campos et lata praetoria memoriae*), where Heaven, earth and sea present themselves to him, and where he can hold, as if present, all things in his past experience and, based on those, images of possible future actions and hopes. Aeneas in his journey through the Underworld comes finally to the Elysian

Fields (*Aen.* 6.640 *campos*), where his father reveals to him the secrets of the universe, before presenting him with a pageant of heroes from the whole sweep of Roman history.[14] The epic Underworld is always a place of collective memory and tradition.

Gods and heroes

Epic, the grandest of the genres of ancient literature, is a suitable vehicle for the propagation of the power and universality claimed by the Christian message, and for the proclamation of the glory of God. But in several respects there is a dissonance between the expectations raised by the classical, and more specifically Virgilian, model, and Christian views of history and Christian values.

One problem is the polytheism of the classical epic model, and not just because of the danger of doctrinal error. The typical epic plot involves the interaction of a number of divine, as well as human, characters, and monotheism threatens narrative impoverishment.[15] However, the persons of the Trinity, or at least the interactions between Father and Son, give some scope for narrative interest, as well as allowing the development of one of the fundamental epic themes, that of fathers and sons, as in the important scenes in Milton's *Paradise Lost* between God the Father and God the Son.

An alternative epic divine machinery can be supplied through the deployment of angels and demons. The strong dualism that marks the *Aeneid*, a struggle between the providential designs of the supreme god Jupiter and Juno's recurrent summoning of chthonic and Hellish forces in order to thwart Jovian Fate, means that the Virgilian plot is easily adaptable to the Christian dualisms of good and evil, Heaven and Hell, God and the Devil. Compared to the Homeric Zeus, the head of a squabbling Olympian household, the loftiness and superior power of Virgil's Father Jupiter brings him closer to the status of the biblical god, who in Christian epic may be given the pagan labels of *rector Olympi* 'ruler of Olympus', *summus tonans* 'supreme thunderer', or simply *Jupiter*.

The epic hero and his goals also present a problem for Christian narratives. But here there is continuity as well as rupture, for the epic hero has always been problematic, from Homer onwards. Indeed it is in the nature of the epic hero to be problematic, as he tests the limits of humanity at its borders with the divine and the bestial, undergoes the strain between his own ambitions and the needs of the collectivity that he leads or defends, and tries (or does not) to channel his own excessive emotions and desires

to socially useful ends. The nature of heroic virtue is constantly being questioned. The greatest of Homeric heroes, Achilles, is perhaps the most problematic of all. The history of epic is the history of the ongoing reception, reassessment and correction of models of heroism. The character of Odysseus in the *Odyssey* is developed very probably in conscious reaction to the patterns of heroism on the battlefield in the *Iliad*: a hero confronting difficulties that require the application of intelligence rather than military prowess, and coming home to reclaim a home and a wife from the usurping suitors rather than going overseas to besiege and sack an enemy city, needs a different package of skills and values from an Agamemnon or an Achilles.

Virgil in turn critiques and corrects the heroic models of both the *Iliad* and the *Odyssey*, as Aeneas plays the roles, often very closely, of a range of Homeric characters: most obviously Odysseus (in *Aeneid* 1–6) and Achilles (in 7–12), but also Agamemnon, Menelaus, Paris (at least in the false perspective of Iarbas and Turnus) and Telemachus, not forgetting his own Homeric self (Aeneas is an important second-rank hero in the *Iliad*). The Homeric models pass through the cultural, historical and political filters of Virgil's own day, and are overlaid with the expectations required of the Roman general or of the new emperor Augustus, and bear the traces of the appropriation by classical and Hellenistic schools of philosophy of the heroes of legend, Ulysses and Hercules above all, as models for philosophical definitions of virtue.[16] For example, Aeneas is a Ulysses minus the Homeric hero's crafty 'Greek' cunning, an attribute suspect to the Roman mind. He is an Achilles minus the latter's obsession with honour and fame. A hero without a strong desire for personal glory is an implicit comment on the disastrous effects of the competition for glory that drove the leading Romans in the last decades of the Republic.

The ongoing revaluation of the epic hero is given fresh impetus by the new kinds of heroism required by the Christian revolution of hierarchies and values. On the one hand, the Christian epic hero has access to supernatural sources of power denied to the pagan hero, and, on the other, the earthly goals of the pagan hero are devalued. Milton's *Paradise Lost* sums up much of the previous history of the Christian rewriting of epic heroism.[17] The programmatic statement comes at the beginning of Book 9 as Milton starts on the narrative of the Fall, 9.13–15 'Sad task, yet argument | Not less but more heroic than the wrath | of stern Achilles on his foe pursued'; and he protests that he is (27–33) 'Not sedulous by nature to indite | Wars, hitherto the only argument | Heroic deemed, chief mastery to dissect | With long and tedious havoc fabled knights | In

battles feigned; the better fortitude | Of patience and heroic martyrdom | Unsung.' Milton is somewhat disingenuous here, turning a blind eye to the vast amount of biblical epic that had accumulated by the seventeenth century. Moreover patience is already a defining characteristic of Homer's 'much-enduring', *polutlas*, Odysseus, and this aspect of the suffering hero was emphasized by Cynic-Stoic interpretations of both Odysseus and Hercules, which feed into Virgil's Aeneas, who conforms in some respects to a Hellenistic ideal of the 'suffering king'.[18] Aeneas is associated with the giant Atlas, who patiently holds up the heavens, and whose name is from the same root as Odysseus' epithet *polu=tlas*.[19]

Christianity teaches the virtues of humility and obscurity, and mounts a radical critique of the earthly fame and glory that form a core value of pagan epic (even if in its history on earth the Christian Church has often seemed oblivious to its own teaching). This has generic consequences: the lowly characters of Virgil's pastoral *Eclogues* and the values of a peaceful and unambitious life on the farm in the *Georgics* are suitable texts for a 'georgics and bucolics of the soul'.[20] The first writer of a biblical epic, Juvencus, incorporates allusions to the *Eclogues* and *Georgics*, as well as the *Aeneid*, developing biblical imagery of Jesus as shepherd and as harvester. Paraphrasing Jesus' statement to his disciples that (Matthew 9:37) 'The harvest truly is plenteous, but the labourers are few', Juvencus alludes to the opening of the *Georgics*, announcing the subject-matter of 'what makes the crops flourish'.

A complex working of lowly pastoral into elevated epic is found in one of the best of the neo-Latin biblical epics of the Renaissance, the *De Partu Virginis* 'The Virgin Birth' (1526), by Jacopo Sannazaro, better known today as the author of the *Arcadia* (in Italian), the single most important work of vernacular Renaissance pastoral.[21] Book 3 of the *De Partu*, which tells of events after the birth of Christ, opens with a standard epic scene, the descent from Heaven (of a god or a god's messenger), which is also a social and generic descent. God the Father, looking and sounding very like Jupiter in council at the beginning of *Aeneid* 10, summons his angels and orders them to go down to the site of the nativity (72–5): 'First of all, bring radiance to the bed of straw beneath the hard rocks of the tiny cave, search out the blessed spot with its simple reeds. All together humbly approach the new cradle.' 'Hard rocks', 'simple reeds', 'humbly' signal the humble pastoral setting of the lowly cradle of the heavenly king. God the Father then brings the shepherds to the cave, where they sing (142) 'a song unfamiliar to the woods [of pastoral poetry]'. For those who know their Virgil this song is very far from unfamiliar, being a reworking of the

fourth, 'Messianic', *Eclogue*, long believed to be a prophecy of the birth of Christ. The last line of the shepherds' song in Sannazaro, 232 'dear offspring of God, a mighty addition to the sky' (*cara dei soboles, magnum coeli incrementum*) adapts one of the grandest lines in *Eclogue* 4, 49 *cara deum suboles, magnum Iouis incrementum*. *Eclogue* 4 repeatedly uses *magnus* and *maior*, 'big', 'bigger', to mark this eclogue's elevation above the usual height of pastoral poetry.

The generic play that begins in the *Eclogues* continues in both the *Georgics* and the *Aeneid*, where, for example, the Arcadian king Evander's small settlement, in the time of Aeneas, on the site of what one day will be Rome, is a quasi-pastoral origin of the epic grandeur of Augustan Rome. In the *Aeneid* a pastoral or georgic simplicity sometimes represents an alternative to, or precursor of, epic achievement. A more radical reassessment of the hierarchy of genres is made possible within a Christian world-view, for example in the highly Virgilian epic in six books on the life of Christ by Girolamo Vida (1535), a poem much read until the end of the eighteenth century. The *Christiad* is an exemplification of Vida's own prescriptions on how to write poetry in his earlier didactic poem *On the Art of Poetry*, which is more precisely a manual on how to write poetry in the manner of Virgil (see Chapter 1, p. 6).

Christ is the hero, often referred to as *heros*, of the *Christiad*, but his heroism is of a very different kind from that of an Achilles, an Odysseus or an Aeneas. A radical inversion of Virgilian patterns of heroism occurs at a climactic point in Vida's *Christiad*. As Christ hangs on the cross, the angels muster for war in a repetition of the war in Heaven against Lucifer and the rebel angels, but they are prevented by God the Father, who sends the personification of Clemency to recall them. The angels are reduced to being spectators of the Crucifixion, and a long simile (5.694–702) compares the situation to a duel between two well-matched young warriors, in which one falls, prompting his faithful companions to rise to their feet, but unable to intervene. Readers who know their Virgil will not miss the allusion to the final duel between Aeneas and Turnus, where the Italians rise with a groan when Turnus is brought down by Aeneas' spear-throw. The effect is twofold. First, this is a conflict, between Christ and his enemies, that is not to be decided by force of arms (Vida's abortive war in Heaven is even more of a farce than Milton's). Second, and shockingly, Christ is implicitly compared to the loser in the *Aeneid*. But this is an epic where defeat and disgrace are paradoxically the means to triumph, where the youthful victim of a *funus acerbum*, 'premature death', is the true victor. At the end of the sixth and last book Christ's reception by

the angels in Heaven is compared to the return to Rome of a triumphing consul (6.701–7). As in Spenser's Legend of Holiness, the goal of this epic is not an earthly city, but the walls of Heaven.

Although the glory to which Christ's story tends is not of an earthly kind, the propagation of the Christian message does depend on the world-wide spread on earth of the word about the Word incarnate, crystallized in the Gospels. This is not the kind of fame that attaches to great warriors and kings, nor is it controlled by the epic poets who celebrate the great of the earth. In an insightful engagement with and revaluation of the Virgilian discourse of *fama*, both 'renown, fame' and 'gossip, rumour', Vida tells of the unsuccessful struggle by the elite priests of Jerusalem to stamp out the (true) rumours of the resurrection of Christ, which spread as irrepressibly as *Fama* 'Rumour' in *Aeneid* 4 (*Christiad* 6.392–404). But this is the babbling of the many-headed beast, the *multiplex uulgi sermo*, that has now been revalued as Gospel truth. In generic terms this is also a deliberate lowering of the sublime language of epic to the *sermo humilis*, the 'lowly speech' privileged by Christianity with its attachment to the humble and the common.[22]

Vida himself is not immune to the allure of more self-centred kinds of fame. In an interview at the end of the *Christiad* that alludes to father Jupiter's prophecy to his daughter Venus of the future glory of Rome in *Aeneid* 1, God the Father reassures his Son that the name and teachings of Christ will fill the world, bringing about a new Golden Age. God looks 15 centuries into the future when a song on the Passion will sound out in Cremona (Vida's birthplace) – the poem that we are reading at this very moment. This is the supreme accolade for a poet who has clearly felt the desire for praise that Vida identifies as an indispensable incentive for the boy who would become a poet in his instruction on the education of the poet in the first book of the *The Art of Poetry*. Vida uses a phrase, *laudis succensus amore* 'fired by the love of praise' (1.7), borrowed from Virgil's description of the boy Ascanius' desire for success in the hunt, *Aen.* 7.496 *ipse etiam eximiae laudis succensus amore* 'himself fired by the love of outstanding praise'. That 'love of praise' leads to the disastrous shooting of Sylvia's stag, provoking war between the Italian farmers and the Trojans. Does the allusion convey a warning to Vida and his ambitious readers against excessive pride in poetic achievement, and a lesson in the need for a proper Christian humility, nowhere greater than in writing a Virgilian epic on the life of Christ?

Milton's *Paradise Lost* and *Paradise Regained* emerge from a tradition of biblical epic going back over a millennium; Milton knew and admired

Vida's works, and the *Christiad* is one of the myriad of sources on which Milton drew in his own Christian epics. *Paradise Lost* is also a profoundly classicizing poem, and with it Milton succeeded in creating the central classic of English poetry. Although written from the political margins of what became the new Augustanism of the restored monarchy, *Paradise Lost* soon claimed a literary and cultural authority analogous to that of the *Aeneid* within imperial Roman culture. Like the *Aeneid*, *Paradise Lost* is an encyclopedic poem, encyclopedic not least in registering the multiplicity of ways in which the *Aeneid* had been assimilated, critiqued and overbidden in earlier responses by Christian writers. But, just as the *Aeneid* engages in an immediate and detailed encounter with the founding texts of Greco-Roman literature, the *Iliad* and *Odyssey*, so *Paradise Lost* confronts the *Aeneid* itself head-on in an epic tussle between the Roman and Christian poets.[23]

Milton's adaptation of Virgilian narrative structures to a biblical plot followed a path well trodden in the Renaissance. I end this section with two further examples which perhaps do not deserve the almost total oblivion into which they have fallen. A highly classicizing neo-Latin example is the two-book *Joseph* by Girolamo Fracastoro (?1478–1553), the author of the better-known *Syphilis*, the poem that gave its name to the disease (see Chapter 7, pp. 160–3).[24] The proem presents its hero as a 'pious young man', whose career mimics that of Aeneas, one of suffering followed by victory and the foundation of a race from which in time will come a greater historical consummation: 'Tell me, Muses, of all that he endured, until finally victorious he might exercise great rule (*imperium*) in Egypt and found a blessed people, whence came the salvation of mankind, the hope of a future life, and the unbarring of the locked gate of Olympus.' The main narrative begins with one of the countless rewritings of Juno's summoning of the forces of Hell against the Trojans at the beginning of the second half of the *Aeneid*, as Pluto/Satan, hostile to the race of Abraham, uses the Fury Allecto to sow envy and hatred in the brothers of Joseph, who proceed to put him in the well. The Hellish plot is then countered by a switch to Heaven, where God is found watching events on earth, just as in *Aeneid* 1 the sequence of the storm and its aftermath, unleashed by Juno and the Hellish winds of Aeolus is followed by the scene in Heaven between Jupiter and Venus, after which Jupiter sends down Mercury to make the Carthaginians hospitable towards the Trojans. Fracastoro's God sends down an angel, the biblical equivalent of the pagan messenger-god Mercury,[25] who foretells the history of his people to Joseph, down to the entry into the Promised Land and beyond,

to the coming of Christ. Potiphar's wife plays the role of Dido, attempting to derail Joseph's career through an erotic *furor* that is engineered by a Hellish agent of Pluto, another avatar of the Virgilian Allecto. This 'combinatorial imitation' of both Venus' supernatural infatuation of Dido in *Aeneid* 1 and Allecto's infuriation of Queen Amata in *Aeneid* 7 is eased by the detailed correspondences between those two episodes in the *Aeneid*.

As an English-language classical epic on a biblical theme *Paradise Lost* has a predecessor in Abraham Cowley's *Davideis* (first published 1656), of which only four books (the first also in a Latin version by Cowley) were completed of a projected 12, 'after the pattern of our master Virgil', as Cowley says.[26] Like the *Aeneid* the *Davideis* launches *in medias res* at a point where a temporary lessening of Saul's hostility to David is suddenly reversed by the intervention of the Devil and his agent, the personification of Envy. Compare the opening of the *Aeneid*, where the Trojans, temporarily in a cheerful mood on setting sail from Sicily, are confronted with the sudden violence of the storm unleashed by their divine enemy, Juno. But the main model for Envy's mission from the Council of Devils to inspire the sleeping Saul with renewed enmity against David is once more the Juno and Allecto sequence at the beginning of the second half of the *Aeneid*. The contrast between the opening sequence of the Council of Devils in Hell and Envy's assault on Saul, and the following scene in Heaven, introduced with a description of a supra-celestial realm of light that pointedly counterbalances the description of Hell's nocturnal horror, is broadly comparable to the contrast in the first book of the *Aeneid* between the Cave of the Winds, a place of elemental turmoil with hints of an Underworld setting, and the appearance, after the storm, of Jupiter, the god of bright air and calmer of storms, 'at the summit of Heaven'. Cowley's schematic – and Virgilian – contrast between Hell and Heaven is also replicated on a much grander scale in the contrast in *Paradise Lost* between the first two books, set in the darkness visible of Hell, and the ascent in the third book with the poet to the 'pure Empyrean', the seat of God the Father and God the Son.

The 'Proposition' of the *Davideis* advertises that we are embarking on a Virgilian epic:

> I sing the man who Judah's sceptre bore
> In that right hand which held the crook before;
> Who from best poet, best of kings did grow;
> The two chief gifts heav'n could on man bestow.
> Much danger first, much toil did he sustain,
> Whilst Saul and Hell crossed his strong fate in vain.

Nor did his crown less painful work afford;
Less exercise his patience, or his sword;
So long her conqu'ror fortune's spite pursued;
Till with unwearied virtue he subdued
All homebred malice, and all foreign boasts;
Their strength was armies, his the Lord of Hosts.
 (*Davideis* 1.1–12)

This closely tracks the proem of the *Aeneid*, announcing the subject with
a first-person singular verb (*arma uirumque cano*), followed by a relative
clause introducing a summary of the hero's trials and sufferings, until
such time ('Till', *dum*) as he achieves his goal. The contrast in the first
two lines between David's 'crook' and 'sceptre' hints at a progression
from pastoral (David as shepherd) to epic (David as king), generic play
of a kind that has precedent in the *Aeneid* and many other texts in the
Virgilian tradition.

Anima naturaliter Christiana

The idea that the *Aeneid* is a work peculiarly alive to the impending revo-
lution in history brought about by the advent of Christianity continued
into the nineteenth century; Ste-Beuve, proponent of Virgil as the poet
of tender humanity, opined that 'Even the coming of Christ has noth-
ing to surprise one, when one has read Virgil.'[27] But it was an idea which
saw a striking revival in the twentieth century in the decades following
World War I.[28] It was fostered by a widespread sense of the relevance of
the age of Augustus to the modern world, not now as a model for a new
peak of cultural and artistic perfection and urbanity, as in the various
Augustanisms of the seventeenth and eighteenth centuries, but as an age
of transition and crisis following a destructive war. A wider consciousness
of Virgil was raised by the bimillennium of the poet's birth in October
1930, celebrated with particular enthusiasm in Italy where the Mussolini
government was at the peak of its popularity. In Germany there was a
wave of interest in, accompanied by translations of, the *Eclogues*, with a
particular focus on the fourth *Eclogue*, accompanied by a conviction that
Virgil's prophecy of the return of the Golden Age was a profound expres-
sion of the hopes and longings of an age of crisis, a symptom of millenar-
ian tendencies of the time that found perverted expression in the Nazi
ideology of the Third Reich.

 One of the most influential books on Virgil of the period was written
by an outspoken anti-Nazi, Theodor Haecker: *Vergil. Vater des Abendlandes*

(1931; published in English as *Virgil: Father of the West* in 1934). For Haecker the pious and humble hero Aeneas in whom, according to Haecker, there develops (1931: 87) 'a longing, prepared for self-sacrifice, for a second homeland', is like Abraham, the 'father of faith, fated to leave his homeland'. Virgil is the poet of what Haecker calls an 'adventist paganism'; the famous Virgilian phrase *sunt lacrimae rerum* prepare the way for Christ's tears in the Garden of Gethsemane (117). In the last chapter Haecker develops a version of the early Christian belief that Virgil had a presentiment of the Incarnation, and that he was singled out by Providence in the adventist spirit of his times to give shape to a mythical material that was related to the eternal truth of the patriarchs and prophets. Virgil was an *anima naturaliter Christiana* 'a soul by nature Christian', the phrase used as the title of the last chapter of the book.

That phrase was used by Tertullian to refer not to Virgil, but to the natural propensity of any human soul to talk of one god (*Apologeticus* 17.5). It has enjoyed a certain currency with reference to Virgil, not least because it was picked up by T.S. Eliot in a lecture on 'Vergil and the Christian world' (1951),[29] heavily dependent on Haecker to the point of plagiarism. Eliot also appeals to Dante, whose assignment in the *Divine Comedy* to Virgil of 'the role of guide and teacher as far as the barrier which Vergil was not allowed to pass [...] is an exact statement of Vergil's relation to the Christian world'. Eliot varies the Old Testament analogy, comparing Aeneas not to Abraham, but to Job; and the analogy with Christ is also explicit: the destiny imposed on Aeneas 'is a very heavy cross to bear'.

A curious example in a scholarly journal of an adventist reading of the *Aeneid* which is also a belated example of a 'pilgrim's progress' interpretation of Aeneas' career (see Chapter 4, p. 87) is the 1959 article 'The spiritual itinerary of Virgil's Aeneas', by Francis A. Sullivan, SJ. Sullivan sets out to show that Aeneas is 'a pre-Christian religious hero'. Stressing the religious dimension of Aeneas' *pietas*, Sullivan traces a spiritual progress through the 'drama of conversion' and the 'dark night of the soul' on the night of Troy's fall. Using a schema of the kind beloved of the Neoplatonists, Sullivan applies to 'Aeneas' spiritual itinerarium' a threefold path of Purgative, Illuminative and Unitive ways to God. Aeneas is 'a tired dust-covered pilgrim'. This kind of reading usually runs out of steam after Aeneas' initiatory experience in the Underworld in *Aeneid* 6, but Sullivan continues, seeing in Aeneas' visit to Pallanteum in Book 8 a 'vital contact with the living memory and cult of Hercules, the toiling benefactor of mankind, who had chosen between Way of Pleasure and Way of Virtue', a reference to the Choice of Hercules at the Cross-Roads,

a philosophical personification allegory that goes back to the fifth century BC.[30] The 'adventist' thrust of Sullivan's reading becomes clear when he describes Virgil as 'groping towards the Christian idea of grace'.

These twentieth-century views of the *Aeneid* do not place it at the culmination of a historical process, whether as marking the peak of Rome's literature and culture, the major monument of an Augustanism to be emulated by later centuries, or as the text that announces the resolution of decades of military and political conflict in the new Golden Age of the *pax Augusta*. Rather the *Aeneid* and its author are placed at a point of transition, between two worlds, between the old order of the pagan Greco-Roman world and the new Christian order, towards which history is somehow groping in the darkness. This between-ness is registered by writers and scholars alike. Eliot, in the footsteps of Haecker, says that Virgil has 'a significant, a unique place, at the end of the pre-Christian and at the beginning of the Christian world'.[31] Hermann Broch commented in 1939 on his novel in progress, *The Death of Virgil*: 'Virgil, standing on the threshold between two ages, [...] summed up antiquity, as he anticipated Christianity.'[32] The scholar Bruno Snell in a classic article 'Arcadia' (1945) locates the between-ness in the fourth *Eclogue*: 'it is not contingent alone on the prophecy of the fourth *Eclogue* that Virgil was regarded by the Middle Ages as a forerunner of Christianity. His Arcadia is not only a midway-land between myth and reality, but also a midway-land between the ages, a here in the beyond, a land of the soul that is longing for its distant home.'[33] The language is similar to that used by Haecker in his account of Aeneas' dawning longing for a new spiritual home. Finally, Friedrich Klingner, one of the most influential Virgilians of the middle of the last century, claims that Virgil lived through 'a boundary situation between the ages, surrounded by the horror of the end, of nothingness'.[34]

Statements of this kind do speak to something fundamental to the conception of the *Aeneid*, to the extent that mobility and communication across time and space are central themes in the *Aeneid*. At the level of the primary plot the poem is about a hero in transition between one home, now lost, and another, whose fullest realization lies far beyond his own lifetime. The legendary passage between two worlds reflects the transition that Rome was undergoing in Virgil's own day between one political order and another, and, in our age of self-reflexive readings, we readily discern the transition involved in the appropriation of the cultural and literary goods of the Greek world, as Virgil creates one of the monuments of what we know as Augustan literature. In the 1930s to 1950s this transitional quality of the poem was referred to the passage from paganism to Christianity.

There is a final twist, a reception of the adventist reception of the *Aeneid* in the modern reading of another Roman poet of the Augustan age. Hermann Broch's *The Death of Virgil* was published in 1945, another year of transition, from the war years to the post-war world. That year also saw the publication of Hermann Fränkel's *Ovid. A Poet between Two Worlds*. The German Fränkel, like the Austrian Broch, was a refugee from the old world in the new.[35] Fränkel curiously makes no reference to the view of Virgil as a poet between two worlds, but he must have been very well aware of the views of Haecker and others, to which his own formulations on Ovid cannot help being indebted: '[Ovid's] place in the history of mankind was between two worlds, between the wonderful self-contained world of Antiquity and that newer one which was to bring Christianity and a different civilization, but which began with empty disillusion and dumb, hopeless confusion [...] It was Ovid's mission to sing the song of Dawn and to perpetuate the fugitive beauty of the uniquely precious moment of transition.'[36] No Ovidian today would take seriously this view of Ovid's place in the history of the world. But Fränkel does diagnose persuasively a quality in Ovid of being betwixt and between, a quality which from a historical perspective operates at both the national and the personal level. The *Aeneid*'s narrative of transition from east to west, Greece to Rome, from Republic to Empire is repeated with variation in the *Metamorphoses*, and in the exile poetry Ovid mythologizes his own woes as a reversal of Aeneas' journey from Troy to Italy. The sense of the painful transition from civilized Rome to wild Tomis is constant in the *Tristia* and *Ex Ponto*. That a book could be written about Ovid as a poet between two worlds is in itself a comment on Ovid's response to the 'transitionality' of the *Aeneid*. In this respect, as in others, Ovid, one of Virgil's earliest readers, is also one of his best. And the 'transitionality' of Ovid has spawned its own subgenre of 'Ovid between two worlds' novels.[37] In David Malouf's *An Imaginary Life* (1978) the exiled Ovid makes the further passages from hyper-civilization to primitivism and, finally, a oneness with nature, and from the sophistication of adulthood to the simplicity of childhood. This personal journey is overlaid with a version of 'between the pagan and Christian worlds': Malouf's Ovid introduces himself as (19) 'born [...] between two cycles of time, the millennium of the old gods, that shudders to its end, and a new era that will come to its crisis at some far point in the future I can barely conceive of.' In the Romanian exile Vintalia Horia's novel *Dieu est né en exil* (1960) Ovid's secret journal in exile records his interest in religion, including his meeting with the Dacian priest of the monotheistic religion of Zalmoxis, and his acquaintance with the Greek

physician Theodore, who tells him of the birth of a miraculous child-saviour that he had witnessed in Bethlehem. At the end Ovid concludes that he is living in a transitional age, 'the time of waiting'.

7

THE *AENEID* AND NEW WORLDS

The *Aeneid* follows closely in the footsteps of its Greek model the *Odyssey*. Odysseus and Aeneas both set off from the sacked city of Troy, both endure a series of wanderings in order to reach their destination. Once that destination has been reached, at the beginning of the second half of each poem, both heroes must undergo further trials before a climactic episode of military action that establishes them securely in possession of the land to which they have come, and securely in possession of a wife. But the two epics diverge radically because of the identity of their respective heroes. Odysseus is one of the Greek chiefs who have succeeded in their Iliadic goal of capturing and destroying Troy, and his journey is a homecoming, in a process of the rediscovery of his former self as the peacetime ruler of Ithaca and husband of Penelope. Aeneas is one of the defeated Trojans whose native city has been destroyed, and he loses his Trojan wife in the chaos of the departure from the burning city. His journey is into exile in search of a land that is new and strange to him, although promised to him by Fate. In the course of the journey Aeneas must come to terms with a new identity, as the leader of the remnants of his own people, the Trojans, and as the ancestor of a people, the Romans, whose city will only be founded centuries after Aeneas' own lifetime.

The direction of Aeneas' journey, from east to west, also has a significance lacking in the *Odyssey*, since this was also the direction of the transfer to Rome of the culture and power of the Greek world. In the first detailed prophecy of the promised land to which Aeneas must travel from Troy, the shade of his wife Creusa tells him (*Aen.* 2.780–1): 'A long exile awaits you, and you must plough a vast expanse of sea, and you will come to the land of Hesperia.' Hesperia, a Greek poetic name for Italy, means 'land of the west'. A truly vast space of sea had to be ploughed in the early modern period to reach the western lands of the Americas, epic journeys

to a new world followed by epic encounters with the peoples already living in those lands. Between the sixteenth and the nineteenth centuries these journeys and encounters provoked a body of epic, largely in a Virgilian mould, on the New World, and some of it written in the New World. European perceptions of the New World were to a considerable extent processed through existing cultural and literary filters, among which the classical tradition loomed large,[1] and the *Aeneid* offered a particularly compelling set of parallels for the New World experience. The greatest transfer of political and cultural hegemony in the last two centuries has been from Europe to North America; although this shift postdates most of the texts to be examined in this chapter, with hindsight the Virgilian plot is a good fit in this respect also.

For a voyage of discovery into the unknown, the journey of the first ship, the *Argo*, opening up the seas for the first time to a remote destination, albeit in the far east, might seem a closer analogy than the wanderings of Aeneas. Indeed the discovery of the Americas seemed to have been predicted in a chorus of Seneca the Younger's tragedy the *Medea* (301–79), which moralizes on the audacity and the evil consequences of the voyage of the *Argo*, concluding that (369) 'every boundary-stone has been moved', and looking forward to an age in the distant future (375–9) 'when Ocean will loosen the chains of nature, the earth will be laid open in its immensity, Tethys [a sea-goddess] will uncover new worlds, and Thule will not be the most distant land'. The sixteenth-century English commentator Thomas Farnaby reported that the Flemish geographer Abraham Ortelius, creator of the first modern atlas, regarded these lines as a prophecy by the Spaniard Seneca of the discovery of America by his fellow-countrymen. (Their captain, Columbus, was himself of course Italian.) Columbus himself included the lines in his *Book of Prophecies*; his son Ferdinand, reading Tiphys, the name of the helmsman of the *Argo*, for Tethys in line 378, wrote in the margin of his copy of Seneca 'This prophecy was fulfilled by my father, Admiral Christopher Columbus, in the year 1492.'[2] The removal of 'every boundary-stone' through journeys into the unknown was given emblematic expression in the motto of Charles V (and now the motto of Spain), *plus ultra* 'further beyond', with the image of the Pillars of Hercules (the Strait of Gibraltar). The motto may have originated in a bold challenge to Dante's warning that Hercules set up his pillars at the Strait 'so that man should not travel any further' 'acciòche l'uom **più oltre** non si metta' (*Inferno* 26.109, Ulysses' comment as he comes to, and passes, the Pillars). *Plus ultra* makes an implicit claim to extend the Hapsburg Empire, and Christianity, to the New World.[3]

If Aeneas' wanderings are limited to the eastern and central parts of the Mediterranean, his descendant Augustus had greater geographical ambitions. According to Anchises in the Parade of Heroes (*Aeneid* 6.794–6), he will 'extend his empire beyond the Garamantes [in Africa] and the Indians', to a land 'beyond the stars and beyond the paths of the sun in its annual course'. In a mythological comparison, Anchises says that Augustus will go even further than did Hercules in carrying out his labours, or Bacchus in his triumphal procession through the east.

Torquato Tasso has this passage in mind in the prophecy of the voyage of Columbus put in the mouth of Lady Fortune, who steers the boat taking Carlo and Ubaldo to the garden of Armida in the Fortunate Isles (the Canaries) in *Gerusalemme Liberata* 15.32:

> Thy ship, Columbus, shall her canvas wing
> Spread o'er that world that yet concealed lies,
> That scant swift fame her looks shall after bring,
> Though thousand plumes she have, and thousand eyes;
> Let her of Bacchus and Alcides sing,
> Of thee to future age let this suffice,
> That of thine acts she some forewarning give,
> Which shall in verse and noble story live.
> <div align="right">(transl. Edward Fairfax, 1600)</div>

Even with her thousand feathers Virgil's swift and all-seeing *Fama* ('Rumour'/'Fame'), from *Aeneid* 4, will have difficulty in following the sails of Columbus as they fly to a 'new pole'. She can sing of Hercules (Alcides) and Bacchus for all she likes (with reference to *Aeneid* 6), but a mere mention of Columbus' voyage will provide ample material for poetry and history.

But, setting aside the length of the journey, the journey of Augustus' ancestor Aeneas was itself adaptable to the history of the New World in ways that the story of the Argonauts was not. The *Aeneid* is a story of the journey of exiles to find a new home in the west; of the fulfilment of a divinely ordained mission by a hero whose distinguishing virtue is his piety (*pietas*); of encounters with natives both friendly and hostile; of the discovery of a land that both preserves features of a Golden Age and a pastoral innocence, and is the locus of a Hellish violence;[4] of settlement and colonization; of the foundation of cities and of empire, with an emphasis on the contrast between humble, almost pastoral, beginnings and the greatness, in time, of imperial civilization. Different selections of

these elements were combined for the various narratives spun at various times about the New World.

Peter Martyr, in *Decades of the New World*, one of the earliest and most widely read accounts of Columbus' voyages (1516), reaches for a Virgilian analogy to describe the state of Hispaniola (Haiti) at the time of Columbus' arrival: 'as when Aeneas arrived in Italy, he found Latium divided into many kingdoms and provinces, as Latium, Mezentium, Turnum and Tarchontem, which were separated with narrow bounds.'[5] The first of a series of neo-Latin epics on Columbus' voyage is the *On the Navigation of Christopher Columbus* by Lorenzo Gambara (1581, in four books).[6] Gambara uses the Virgilian (and Odyssean) device of a story told at a dinner-table to introduce Columbus' first-person narrative. Cardinal Granvelle rises to tell the story of Columbus as he had heard it from his father, who heard it from Columbus himself in Barcelona, and starts by alluding to the passage in *Aeneid* 6 on the future travels of Augustus to the ends of the world: 'Let Greek poets be silent on the subject of Hercules' journeys over countless parts of the earth, and on Bacchus' travels deep into the Indies.' Columbus, like Virgil's Augustus, goes further still. However, Gambara is in general sparing in his use of Virgilian plot-structures and episodes. When the Spaniards land on an island inhabited by cannibals, a local interpreter warns them to flee in a repetition of the warning to Aeneas by the marooned Greek Achaemenides to flee from the land of the Cyclopes in *Aeneid* 3 (Fig. 13). Homer's man-eating Polyphemus provided an obvious analogy for the West Indian cannibalism that so obsessed the European mind in its early encounters with the New World. Later, Gambara's Columbus describes a valley reminiscent of the landscape of the Golden age, but home to a lethally poisonous tree, and plagued by occasional incursions of cannibals. Unmistakeable are the overtones of the Garden of Eden, the biblical myth which, together with the classical Golden Age, often provided a lens for viewing the more paradisiacal qualities of the New World, but with danger lurking at its heart. Virgil has his own counterpoint of the idyllic and the Hellish, both in the Arcadian Evander's quasi-pastoral settlement on the site of the future Rome in *Aeneid* 8, from which the monstrous and murderous Cacus has already been eliminated by the time of Aeneas' arrival, and in the Fury Allecto's invasion of the pastoral idyll enjoyed by Sylvia and her pet-stag in the kingdom of Latinus, in *Aeneid* 7.

Gambara's Columbus punctuates his narrative with hymns and prayers to the Christian god, and concludes with an account of his own politic manipulation of the religiosity of the natives of Hispaniola. At a moment

Fig. 13. Achaemenides and Polyphemus. Engraving by Giuseppe Zocchi, in *L'Eneide di Virgilio del commendatore Annibale Caro* (Paris, 1760).

of extreme danger he 'predicts' a lunar eclipse, which, through access
to European science, he knows to be imminent, and thus persuades the
Hispaniolans that the prophecy of their own gods (the Cemes) has been
fulfilled, and that the Spaniards are indeed those 'of whom our Cemes sung
that they would come to the kingdom of Quiqueia, and would conquer all
the surrounding kingdoms of the Ocean, where the sun directs his course
to the shores of the west'.

This prophecy of an empire in the west reworks the language of the
oracle of the native Latin god Faunus in *Aeneid* 7 (98–101), who tells
King Latinus of the arrival of foreign sons-in-law (the Trojans), whose
descendants will rule the world, from the lands where the sun rises to
the lands where it sets. The prophecy of the Cemes is worked as a struc-
tural, as well as linguistic, parallel with the Faunus prophecy in Giulio
Cesare Stella's *Columbeis* (1585, 1589; only two books of a projected four
were written). Stella's epic incorporates the divine machinery lacking
in Gambara's poem, in a far-reaching mapping of the Virgilian plot on
to Columbus' historical voyage. The 11-line prologue projects on to the
canvas of the 'new-found world' (*Columbeis* 1.1 *inuentum [...] orbem*) many
of the elements of the 11-line prologue of the *Aeneid*: this 'great-souled
leader' was the first to journey from Spain to a land on the other side
of the world, as Aeneas, according to Virgil, was the first to travel from
Troy to Italy. Like the *Aeneid*, the epic will tell of both journeying and
wars. *Pia bella* 'pious wars' transfers to the battles fought in Hispaniola
the defining virtue of Aeneas (*Aen.* 1.10 'a man distinguished by piety').
Aeneas' mission is to found a city and to introduce gods to Latium; Stella
places more emphasis on Columbus' religious goals, 8–11 'he had much
experience also in warfare, before he could establish safe dwellings for his
people and institute pious rituals and sacred practices, whence (Christian)
religion has now come to be held in the highest respect, venerated univer-
sally on new altars'. For this view of his goals Columbus bore an appro-
priate Christian name, Christopher, *Christum-ferens* 'carrying/bearing
Christ'. Where Juno is the great obstacle to Aeneas' easy achievement of
his fated goal, Satan is the theological obstacle to Columbus' prosperous
undertaking. The opening sequences of the main narrative of the *Colum-
beis* and the *Aeneid* launch the reader *in medias res*, at an identical point
in their respective voyages. The hero's fleet is sailing on calm seas when
his divine enemy suddenly intervenes. Juno raises a storm; Stella's Satan
wishes that he too could raise a storm, but is deterred by the knowledge
that it is God the Father's firm resolve that Columbus should introduce
Christianity to the New World. Avoiding too slavish an adherence to the

Virgilian script, Stella's Satan resorts to his accustomed arts of fraud and deception, and impersonates a crew-member in order to suborn one of his companions to mutiny.

Stella's motivation of his epic plot through a Satan rebellious to the dispositions of God is an example of a very familiar Christianization of the opposition of Juno and her chthonic agents to Jupiter and Fate, which forms the major motivating drive of the plot of the *Aeneid*, and which already goes far in the direction of a dualism of Heaven and Hell. British Protestant and Spanish Catholic settlers in the Americas shared a stereotype of the New World as the Devil's fiefdom, either a seductive but false paradise or a wilderness that needed to be transformed into a garden by Christian heroes.[7] The label 'Satanic epic' has been given to the many theological epics of colonization written in Portuguese and Spanish America, in which Christian heroes battle Satanic adversaries. In these epics the Devil repeatedly raises storms against European sailors, as part of an epic struggle between Satan and God, for example in José de Anchieta's *On the Deeds of Mem de Sà* (Coimbra, 1563), which portrays the third governor of Brazil as a Christian Ulysses, ousting Satan from the New World; or Gabriel Lobo Lasso de la Vega's *Mexicana* (Madrid, 1594), in which Pluto/Satan's attempt to persuade Neptune to sink Cortés' fleet in a storm is thwarted by the archangel Michael.

The Virgilian theological scaffolding also supports the plot of José Antonio de Villerías y Roelas' *Guadalupe* (Mexico City, 1724), an aetiological narrative of the events of 1531 leading to the institution of the cult of Our Lady of Guadalupe. Pluto/the Devil, expelled from the lands of the east (Europe), has taken refuge in the Americas. Through the exertions of the conquistadors Charles V has extended his empire beyond the remotest limits traversed by Alexander the Great or Augustus, and threatens Pluto in his last retreat. Pluto is given a monologue that opens with the first words of Juno's monologue in *Aeneid* 1 (37 = *Guadalupe* 1.114), 'To think that I should admit defeat and give up my plan', as he deliberates how to expel the Spanish 'heroes' from what he regards as his own land. The scene switches to Heaven where the Virgin Mary beseeches God to fulfil her hopes of an empire in the west, in a replay of the scene in Heaven in *Aeneid* 1, following on the storm, in which Jupiter reassures Venus that she will see the world empire promised to the descendants of her son Aeneas. The theological Virgilian stage is set for the human narrative of Juan Diego's visions of the Virgin, and the miraculous flower icon with which he finally persuaded Bishop Zumárraga to believe him.[8]

New World epics echo in Milton's *Paradise Lost*. Satan embarks on a

journey of discovery to 'another world, the happy seat | Of some new race called man' (*Paradise Lost* 2.347–8). His aim is to 'conquer this new world' (4.391), and after the Fall he returns to Pandaemonium 'the great adventurer from the search | Of foreign worlds' (10.440–1). When Adam and Eve hide their nakedness with leaves after the Fall, they are compared to American Indians such as 'of late | Columbus found [...] so girt | With feathered cincture' (9.1115–17).[9] Satan's credentials as an epic voyager and quester have often been noted. His flight through the 'fighting elements' is compared in a simile to the epic voyages of the *Argo* through the Clashing Rocks, and of Ulysses through Scylla and Charybdis (*Paradise Lost* 2.1016–20). But the theme of the journey of an exile in search of a new power-base to replace what he has lost also reminds the reader of Aeneas. A particular moment in Aeneas' journeying is invoked when Satan first comes to the border of Eden, whose 'hairy sides' are protected with dense forest, 'A sylvan scene, and as the ranks ascend | Shade above shade, a woody theatre | Of stateliest view' (4.140–2). The word 'theatre' activates the etymology of 'scene', 'stage-building' or theatrical 'set' (Greek *skēnē*), the word used in what in Latin is a very live metaphor to describe the wooded cliff that forms the backdrop to the harbour where the Trojans make landfall in Carthage, *Aen.* 1.164–5 'Above there is a backdrop (*scaena*) of quivering woods; a dark grove overhangs with its shivering shadows.' The theatrical metaphor prepares Virgil's reader for the 'tragedy' of Dido; Eden will be the setting for the tragedy of the Fall (*Paradise Lost* 9.5–6 'I now must change these notes to tragic').

As well as anticipating the future epic voyages of Ulysses, Jason and Aeneas, Milton's Satan also blazes a trail, so to speak, for Vasco da Gama, the hero of the national Portuguese epic, Camões' *The Lusiads* (1572). Milton frames Satan's journey from Hell to Eden with similes of journeying in the Indian Ocean: *Paradise Lost* 2.636–42 (as Satan sets off from Hell) 'A fleet [...] | Close sailing from Bengala, or the isles | Of Ternate and Tidore [in the Moluccas]'; 4.159–62 (as he arrives at Eden) 'As when to them who sail | Beyond the Cape of Hope, and now are past | Mozambic, off at sea north-east winds blow | Sabean odours from the spicy shore'. *The Lusiads* narrate da Gama's voyage round the Cape of Good Hope to India both as a defining moment in the history of Portugal and as the foundation of the Portuguese maritime trading empire. As in the *Aeneid*, a primary plot restricted to a limited section of time is set against a much wider backdrop of cosmic and human history which, through internal narrative, prophecy, and ecphrasis, gives larger meaning to the hero's experiences. In the opening stanzas Camões advertises his

debt to classical epic, and to the *Aeneid* in particular, at the same time as he claims to overgo the ancient models (1.1, 1.3, in Sir Richard Fanshawe's 1655 translation):

Arms, and the men above the vulgar file,
Who from the Western Lusitanian shore
Past ev'n beyond the Taprobanian isle [Sri-Lanka],
Through seas which never ship had sailed before;
Who (brave in action, patient in long toil,
Beyond what strength of human nature bore)
 'Mongst nations, under other stars, acquired
 A modern sceptre which to heaven aspired.

Cease man of Troy, and cease thou sage of Greece,
To boast the navigations great ye made;
Let the high fame of Alexander cease,
And Trajan's banners in the East displayed:
For to a man recorded in this piece
Neptune his trident yielded, Mars his blade.
 Cease all, whose actions ancient bards expressed:
 A brighter valour rises in the West [i.e. Portugal].

In a Virgilian brand of divine machinery, which recognizes its own fictionality, da Gama's voyage is furthered by Venus, who sees in the Portuguese many of the qualities of her beloved Romans. The blocking figure is not Juno, but Bacchus, jealous at the thought that his own Indian triumphs will be put in the shade by the Portuguese achievement. Early on, in the second canto, in another rerun of Jupiter's prophecy to Venus of Roman history in *Aeneid* 1, Jupiter reassures Venus with a prophecy of Portuguese successes in the east, climaxing in the promise that their naval triumphs over the heathens of the east will set the seas aflame even more violently than did the battle of Actium, the climax of Roman history as portrayed on the Virgilian Shield of Aeneas at the end of *Aeneid* 8. Virgil's tendentious presentation of Actium as a conflict between the Olympian gods of the west and the monstrous gods of Egypt translated readily into Christianity's long-lived crusading ideology. Camões' Jupiter sees Actium replayed in the far east; geographical proximity made Actium a handy prefiguration of the battle of Lepanto, off the west coast of Greece, in 1571, the decisive Catholic naval victory over the Ottoman Turks.[10]

Following Jupiter's prophecy in Canto 2, Camões continues to track

the Virgilian plot as Jupiter sends down Mercury to ensure that the Portuguese are given a friendly welcome by the king of Melinde, to whom da Gama narrates the history of Portugal and the story of his own journey so far, just as Aeneas tells Dido his story in *Aeneid* 2 and 3. This is a visit to Carthage minus the erotic. In this epic, sexual gratification is not an obstacle to the mission, but a reward. After the Portuguese sailors have reached Calicut and evaded various plots fostered by Bacchus, they sail to an Island of Love where Venus has arranged that the sea-goddess Tethys and the Nereids should bestow their favours on da Gama and the Portuguese. This bower of bliss is also the place for further supernatural revelation, both of cosmic and geographical secrets and of further glorious Portuguese discoveries in the future. This positive realignment of erotic desire and epic goals, in sharp contrast to the disruptive effects of love on the fulfilment of the designs of Fate in the *Aeneid*, is in keeping with a more general tendency in Renaissance epic to harmonize the motivations of love and fame. Partly perhaps in self-exculpation, Camões explains that his sexy episode on the Island of Love is in fact an allegory for the thrill and delight of the sweet honour won by daring action (9.88–95).

Christian reworkings of the Virgilian plot, particularly in the virulent, and prevalent, strain of the 'Satanic epic', inevitably tend to demonize the enemy Other. But modern criticism of Renaissance epic, like twentieth-century criticism of the *Aeneid*, has looked insistently for voices of the defeated, sometimes speaking to the reader in a direct appeal, and sometimes struggling to make themselves heard through the repressive deformations of the epic victor. This kind of criticism has in part developed independently in the work of classicists and early modernists, in both cases dancing to the tune of a turn in twentieth-century literary and cultural studies to the political and ideological (see Chapter 1, pp. 16–18), but there are also examples of the influence of Virgilian on Renaissance studies, and vice versa.

No one has done more to cross-fertilize the two disciplines than David Quint, who in his 1993 *Epic and Empire* discusses the topos of the epic curse, the imprecation of the defeated, which has the power to project into the future a point of view opposed to that of the epic hero. In the *Aeneid* Dido has her revenge on the perfidious – as she sees him – Aeneas with her famous dying curse in which she calls down further suffering and an early death on Aeneas, and eternal enmity between the Carthaginians and the Roman descendants of Aeneas. Dido reaches over the centuries to conjure up Hannibal and the Punic Wars. Her curse is modelled on Polyphemus' prayer to his father Poseidon, after his blind-

ing by Odysseus, that if it is fated that Odysseus should return home, it should be a late and painful return. Some have seen in the Homeric Polyphemus episode a reflection of encounters between early Greek colonists and traders and less civilized peoples in the Mediterranean world.[11] Certainly in the later reception the Cyclops became a figure both for the cannibalistic primitives who infest newly discovered worlds, and for the victims of colonialist oppression.[12] Dido is a much more obvious victim than Polyphemus, and if she finally turns into a threatening monster, this, many readers may feel, is no less than Aeneas deserves. Her demonization at her death, and after (when she will turn into a raging Fury), also comments on the Roman demonization of the historical Carthaginian enemy and the one-eyed Hannibal.

Camões puts his epic curse in the mouth not of a north-African monster, but a monster at the southern tip of the continent. Near the centre of *The Lusiads*, as the Portuguese approach the Cape of Good Hope, they encounter the terrifying apparition of Adamastor, a dark cloud that materializes into the features of an evil-looking giant (5.37 ff.). Adamastor is the personification of the Cape, and he is also a monstrous likeness of the negroes, initially welcoming but soon turning hostile, who threaten the Portuguese in the preceding episode. He is a descendant of the Homeric and Virgilian Polyphemus, and thus another example of the easy identification of hostile natives with the classical Cyclopes; the honey-gathering Hottentot in the previous episode is described as 'more savage than the brutish Polyphemus' (5.28). Virgilian, rather than Homeric, is the merging of an anthropomorphic monster into a feature of the landscape, following the imagistic equation in *Aeneid* 3 of Polyphemus with the volcano Etna.

This embodiment of the natural and human dangers of the Cape promises to avenge himself on the presumptuous boldness of the Portuguese sea-journey into undiscovered waters, violating the secrets of nature. He prophesies a series of shipwrecks and sufferings on land that will afflict future Portuguese expeditions. In response to da Gama's question as to who he is, Adamastor replies that he was one of the Giants, sons of Earth, who warred against Jupiter. Adamastor joined in the war as the only way to realize his love for the sea-goddess Thetis. Tricked by Thetis, he tried to escape from his shame by searching out another world. There, after the defeat and punishment of his brothers, he was metamorphosed into the Cape, for ever encircled by the waters of Thetis and for ever frustrated of his desire. Camões is also highly Virgilian in building into his historical epic allusion to Gigantomachy, the myth of the war between the gods and giants (see Chapter 5, p. 98).

Another example of the epic curse occurs in the Harpies episode in Book 3 of the *Aeneid*, in a contamination of material from the *Argo* legend with the matter of the *Odyssey*. In a strange episode of innocence and guilt the Trojans come to what seems the peaceable landscape of the islands of the Strophades, where happy herds of cows and goats graze at will, a quasi-Golden Age scene, which the Trojans violate by slaughtering animals for food. It turns out that these are the herds of the Harpies, who attack and pollute the Trojan feast (Fig. 14). The Harpy Celaeno, foreshadowing Dido's curse in Book 4, predicts that although the Trojans will reach the promised land of Italy and found a city, it will only be after fierce hunger has forced them to eat their tables, a dire threat which is fulfilled in comic mode when they ravenously eat a kind of pizza base for their first, vegetarian, meal on reaching Latium. The Trojans' unwitting violation, on the Strophades, of what belongs to another can be read as a reflection or prefiguration of the damage, albeit unintentional, that their coming brings to the human inhabitants of first Carthage and then Latium.

Virgil's Harpies episode is the basis for the first encounter of Columbus with the New World in the earliest extensive neo-Latin verse account of Columbus' voyage, in the third book of Girolamo Fracastoro's *Syphilis* (1530), a didactic poem on the disease to which it gave its name.[13] The poem combines medical description and theory with mythological and historical narrative, in a mixture of didactic and epic which is itself highly Virgilian. The story of the hunter Ilceus who is inflicted with syphilis after unwittingly killing a stag sacred to Diana, and who undertakes a descent to the Underworld in search of springs of quicksilver, is an aetiological tale giving an origin for the toxic mercury cure for syphilis. It is modelled on the epic-style narrative of Aristaeus at the end of the fourth *Georgic*, the explanation for the ox-sacrifice (*bugonia*) by which Aristaeus restores his bees after they have been wiped out by plague. Ilceus' descent also alludes to Aeneas' descent to the Underworld in *Aeneid* 6, itself an epic adventure with strong didactic elements.

Book 3 of the *Syphilis* tells of the discovery in the New World of the cure for syphilis of the guaiacum tree (a hardwood genus whose species include the national plants of Jamaica and the Bahamas), in a layered narrative that imposes a pattern of rash presumption followed by punishment and then redemption on both the natives of Hispaniola and the Spanish newcomers. In verses that allude both to the Trojans' first sighting of Italy in Book 3 of the *Aeneid* and to their arrival in Latium at the mouth of the Tiber in Book 7, Fracastoro's Columbus reaches Hispaniola, to find an idyllic landscape where gaily coloured parrots fly about. The Europeans immediately

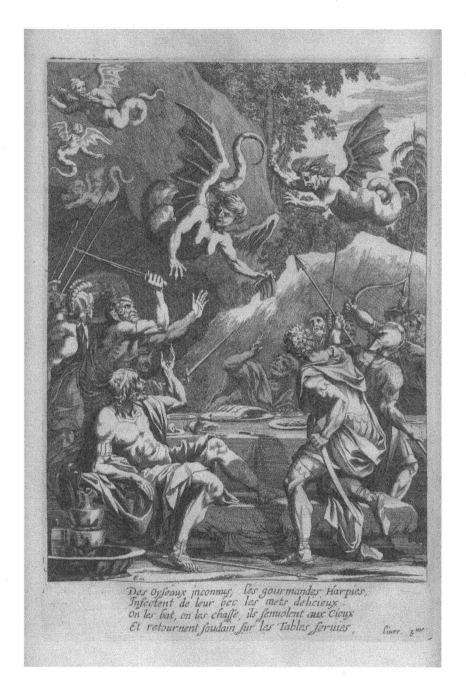

Des Oyseaux inconnus; les gourmandes Harpies,
Infectent de leur bec les mets delicieux :
On les bat, on les chasse, ils s'envolent aux Cieux
Et retournent soudain sur les Tables servies.

Liure 3.me

Fig. 14. The Harpies attack the Trojans. Engraving by François Chauveau, from
Michel de Marolles, *Les Oeuvres de Virgile traduites en prose* (Paris, 1649).

shatter the peace with gunpowder, often presented as a Hellish inven-
tion in Renaissance epic, shooting and killing large numbers of the birds.
One of them escapes and, perching on a crag, tells the attackers that they
violate birds sacred to the sun, and utters a dire warning that imitates
Celaeno's prophecy in *Aeneid* 3: the Europeans will not found cities and
introduce Christianity to the New World until they have suffered terribly
at sea and in battle, and been inflicted with the plague of syphilis. Their
tribulations will include 'Cyclopes', another reference to the cannibalistic
Caribs; in this context Fracastoro archly footnotes the ultimate source for
the epic curse in the Cyclops Polyphemus' imprecation against Odysseus.

This is followed by the emergence from the woods of the black natives,
and the friendly reception of Columbus by their king, in a scene modelled
on the reception of Aeneas by the Arcadian king Evander, on the site of
the future Rome, in *Aeneid* 8. That meeting will have as a tragic conse-
quence the death in battle of Evander's son Pallas. The possibility that
European–Amerindian relations may not always be cordial is hinted at in
Fracastoro's focus on the colourful and variegated garb of both 'kings', the
native ruler and Columbus, as if they were two human parrots – joined in
friendship now, but for how long? It happens to be the day of an annual
ritual in which sufferers from syphilis are healed with lustrations and a
branch of guaiacum. The native king explains the origin of the ritual,
narrating the story of the ancestral sin of the shepherd Syphilus who in
a time of drought denied the divinity of the Sun and instead worshipped
the human king. Divine punishment followed in the form of syphilis,
until the nymph Ammerice pronounced that in response to the sacrifice
of a black cow Juno will make a tree grow from which will come salvation.
This is a second version of Virgil's Aristaeus epyllion, with overtones of a
Christian doctrine of salvation, and perhaps containing historical Chris-
tian allegory: Syphilus has been seen as a figure for Luther, challenging
the Roman Catholic Church.

The *Syphilis* is a good example of the vitality and utility of Virgil's
poetry at a turning-point in modernity. Fracastoro finds in it a useful tool
with which to think about the discovery of a new world and new peoples;
the beginnings of western colonialist imperialism; cultural and moral
responses to a major event in the natural world, the appearance of syphi-
lis, a disease that was to embed itself in European consciousness for the
next four centuries; and possibly also to think about the upheavals in reli-
gion caused by the Reformation. The Harpy-parrots episode is a shocking
example (at least to modern sensibilities) of the wanton violence inflicted
on the New World by its European discoverers, who do not even have the

Trojans' excuse of hunger in slaughtering the cattle of the Harpies, even if the weight of allegory and aetiology in the following episode detracts from a genuine sympathy with the human inhabitants of Hispaniola. But at least the natives are given a voice, of a kind, just as the peoples and their leaders whom Aeneas meets and fights in Latium are also allowed a point of view, which many modern readers find more sympathetic than that of Aeneas himself.

A more extensive, and overtly sympathetic, portrayal of a native people who opposed the European colonist is found in Alonso de Ercilla's *La Araucana*, on the wars of 1553–9 against the Araucanian (Mapuche) Indians, in which the author himself had fought (written and published in three parts, 1569, 1578, 1589).[14] Regarded as the best Spanish historical epic, its narrative of the freedom-loving and fiercely resistant Indians has made it central to the national culture of Chile, and it has been the subject of a number of anti-imperialist readings, or at least readings for 'further voices'. David Quint structures his discussion according to the superimposed models of Virgil's *Aeneid*, an epic of empire, and Lucan's *Civil War*, the narrative of the destruction of the Roman Republic. The *Aeneid* is the template for a plot of imperial conquest, the *Civil War* for the celebration of, and lament for, Araucanian resistance to Spanish imperialism. Quint shows how Ercilla used publication by instalments to suspend Virgilian closure, in a way that exploits the narrative aimlessness of both Lucan's *Civil War* and the Italian romance. Thus the first part ends (where the *Aeneid* began) with a storm at sea, which Aeolus, the Homeric and Virgilian king of the winds, is powerless to control, and which is still raging at the beginning of the second part. The second part, like the last book of the *Aeneid*, concludes with a duel, here between two Indian heroes, Rengo and Tucapel, but the last canto ends with a fatal blow about to descend – which, at the beginning of the third part, turns out not to have been fatal. This is a trick learned from the interruption of a narrative at a moment of greatest suspense in Ariosto's *Orlando Furioso*. Craig Kallendorf, on the other hand, reads *La Araucana* as a commentary on the ideological tensions within the *Aeneid* itself, and focuses, for example, on the conflict between reason and anger in both poems. Ercilla's sympathetic interest in the emotional states of Indian women is indebted to a reading of Virgil's Dido. But Ercilla also takes issue with Virgil when telling the story of the Indian wife Lauca, wounded in the battle in which her newly wed husband was killed, who begs to die too, but is healed and sent back to her people. The narrator is reminded of Dido, whose true story, of fidelity until death to her first husband, he tells at length (Cantos 32–3), correcting Virgil's

slanderous version of Dido's passion for Aeneas (see Chapter 3, p. 53).[15]

More complex still is an assessment of the relationship between the Old and New Worlds in what some claim to be the most Virgilian of Shakespeare's plays, *The Tempest*. This is one of the few Shakespearean plays for whose plot there is no single obvious model in an earlier text, and in an effort to fill that vacuum a number of critics have argued that the *Aeneid* underpins the play. These days the 'brave new world' of Prospero's island is often read through the lens of early modern voyages of discovery and colonization to the New World of the Americas, a fashion reinforced by later twentieth-century ideological and post colonialist readings of Shakespeare. New World readings of *The Tempest* tend to refer to details in a plethora of early modern accounts of discovery and settlement,[16] but it is worth asking how far the play can be understood as a New World reading of the *Aeneid* itself, comparable to the texts examined hitherto in this chapter.[17]

A number of obvious allusions to the *Aeneid* punctuate *The Tempest*, but what they all add up to is rather puzzling. One answer would be that they are incidental, and that, familiar as Shakespeare clearly was with Virgil, like any Renaissance grammar-school boy, he does not respond as profoundly to Virgil as he does to Ovid.[18] *The Tempest*, like the *Aeneid*, opens with a storm that drives a ship off course, in the case of the Trojans away from their journey to Italy and on to the shores of north Africa, in the case of Alonso and his men in the course of a journey from north Africa to Italy (Naples). In both Virgil and Shakespeare the literal storm also functions as a symbol for turbulence on the psychological and political levels. Ferdinand's greeting of Miranda (I.ii.489–90): 'Most sure, the goddess | On whom these airs attend' translates Aeneas' address to the first person he meets on the shores of Carthage, his mother Venus in disguise, *Aeneid* 1.328 *o, dea certe*, a passage that was often used in contexts alluding explicitly or implicitly to Queen Elizabeth (see Chapter 3, pp. 60–2). Most puzzling is the business about 'widow Dido' between Adrian, Gonzalo, Antonio and Sebastian (II.i.62–83), which plays with the two versions of Dido, chaste and unchaste, and which obtrusively prompts the reader to think about both the similarity and dissimilarity between the Virgilian and Shakespearean texts. Thus Adrian corrects Gonzalo: 'She [Dido] was of Carthage, not of Tunis', where Alonso's daughter had been married to the king of Tunis: true, but the modern Tunis is very close to the site of ancient Carthage. How should we gauge the distance between the Virgilian and Shakespearean plots? Ariel's entrance as a Harpy to make the banquet disappear at III.iii.64 ff. is based on the Harpies episode

in *Aeneid* 3, adapted in the New World narrative of Fracastoro's *Syphilis*; and there are Virgilian elements in the masque in IV.i.

The Tempest's Virgilian plot is that of an exile, Prospero, who finally achieves a homecoming, but in his case to his original home in Milan, rather than a new home in Italy, as in Aeneas' case. The role of Aeneas is divided between Prospero and Ferdinand, whose love for Miranda, with their subsequent wedding, blessed by the masque of Iris, Ceres and Juno, is a happier version of the doomed love-affair of Dido and Aeneas, solemnized in the cave in a demonic and elemental parody of a wedding overseen by Juno (*Aen.* 4.165–8). The marriage of the daughter of the rightful duke of Milan to the son of the king of Naples avoids the problems that arise when the ancestor of the Romans is entangled with the foreign Other in the person of African Dido.

At the same time Prospero's island opens a space on to a strange and non-European world, the New World to which specific allusion is made by Ariel's reference to 'the still-vexed Bermudas' (I.ii.267), and by the name of Caliban's god Setebos, a Patagonian deity. Caliban's name is an easy anagram of 'can[n]ibal'. Gonzalo's designs for 'the plantation of this isle' (II.i.131–57) draws on Montaigne's provocative description of prelapsarian savages in his essay 'Of the Cannibals', and envisages a Golden Age dispensation. Cannibalism and utopianism are constant features of early modern images of New World landscapes and societies,[19] foreshadowed in the combination of the idyllic and the Hellish in Virgil's Latium, the Trojans' 'new world' (see p. 152 above). Prospero's enslavement of Caliban (and Ariel) has been extensively analysed for what it may reflect of relations between European colonizers and the native peoples they encountered in the New World. In Virgilian terms, Caliban is yet another descendant of Polyphemus in *Aeneid* 3, a frequent model in New World narratives for hostile, and especially cannibalistic, natives. The only profit he has drawn from Prospero's teaching him language, and the only way he can get back at his master, is in 'know[ing] how to curse' (I.ii.423–4): the vengeance of the Odyssean Polyphemus, whose curse is an immediate model for the defeated Dido's curse against Aeneas.

If we follow the narrative logic of landfall after a Virgilian storm and the other allusions to the story of Dido and Aeneas in the play, Prospero's Mediterranean isle is a version of Carthage, rather than a place on the other side of the Atlantic in the New World. Shakespeare superimposes different geographical frames on one another, in awareness of how the Virgilian narrative of Aeneas' wanderings in a Mediterranean world familiar to readers and audiences of both Virgil's and Shakespeare's

time can be projected on to stranger and remoter topographies. Virgil already achieves this in *Aeneid* 3 by exploiting Sicily's traditional status as a home of wonders, and making the Roman province into something of a big game reserve for primitive monsters. In early modern New World rewritings of the *Aeneid* the 'western land', Hesperia, is no longer the by now very familiar Italy, but unknown lands in a much more distant west. Prospero's island is both somewhere in the middle of the Mediterranean, where feuding Europeans work out their differences; somewhere on the more distant, and non-Christian, shore of north Africa; and somewhere in the Americas, Virginia perhaps or Patagonia. Individual perspective and genealogy help to link these disparate locations. The one occurrence of the phrase 'new world' in the play is in Miranda's famous exclamation (V.i.205–6) 'How beauteous mankind is! O brave new world | That has such people in't!' Prospero replies to her, ''Tis new to thee.' To Miranda the world is new because she sees it populated for the first time by human beings other than herself and her father (and Ferdinand), while to Prospero this is a tiresomely familiar crowd. ''Tis new to thee' might also be taken as a comment on the way in which familiar places and texts, such as the *Aeneid*, can be made to embody visions of new lands and new peoples.

The most novel, the most alien, character in the play, Caliban, is not in fact an indigenous cannibal, but the son of an emigrant from Algiers, a place on the same north African coast as Carthage and Tunis. His mother, the witch Sycorax, has elements of the classical witches Medea and Circe, who are also among the models for Virgil's Dido. Is the north African Sycorax herself perhaps an incarnation of Dido, who on her abandonment by Aeneas turns first into fearsome witch and, on her death, into vengeful Fury? Was she pregnant with Caliban by Aeneas? Critics note that Sycorax' 'history is curiously parallel with' that of Prospero,[20] one of the Aeneas-figures within the main plot of *The Tempest* – as the personal histories of Dido and Aeneas within the *Aeneid* have much in common.

Caliban, whose literary ancestry includes the Virgilian Polyphemus, shares with the latter's model, the Odyssean Cyclops, the distinction of having been adopted as a self-image by black writers protesting at their disenfranchisement and demonization by their former colonialist masters, at the same time as they assert their own independence, commenting on the inhibitions created by the imposition of a language not their own, for example in Aimé Césaire's Black Theatre adaptation of *The Tempest* (*La Tempête*, 1969).[21]

The providential plot of the *Aeneid* held a lasting appeal for the Protestant settlers and colonists of North America.[22] John Smith's *A Map of*

Virginia (1612) includes a brief history, 'The Proceedings of the English Colony in Virginia', divided into 12 chapters like a prose *Aeneid*, in which Smith brings to unknown shores a divinely guided people, and confronts a Turnus-like enemy in the person of Powhatan.[23] In their wars with the natives the settlers saw themselves as a chosen people unjustly attacked. *New-Englands Tears* (London, 1676) by Benjamin Tompson, the first North American poet born in America, is a series of verse episodes on King Philip's War that ornaments its narrative with references to the *Aeneid*, and identifies the Native Americans as 'Rutilians', the people of Aeneas' enemy Turnus. Tompson supplied prefatory poems for Cotton Mather's *Magnalia Christi Americana* (1702), 'perhaps the supreme achievement of American Puritan literature'.[24] Subtitled 'The Ecclesiastical History of New England', it is a prose epic on the religious history of Massachusetts which alludes repeatedly both to the *Aeneid* and to the great Protestant reworking of the classical epic tradition, Milton's *Paradise Lost*. The first sentence of the Introduction outlines the plot of a providentially guided flight from Europe to a land in the west, bringing religion to a new homeland:

> I write the wonders of the Christian religion, flying from the depravations of Europe, to the American Strand; and, assisted by the Holy Author of that Religion, I [...] report the wonderful displays of His infinite Power, Wisdom, Goodness, and Faithfulness, wherewith His Divine Providence hath irradiated an Indian Wilderness.

The next sentence turns from the introduction of gods (*Aen.* 1.6) to Aeneas' other main purpose, foundation, with 'the first settlement of colonies'; not the least important foundation for Mather is that of Harvard College. The motto on the title-page of Book 1 of *Magnalia* revises the last line of the proem to the *Aeneid* (1.33): 'So great a labour it was to found a people for Christ' (*Tantae Molis erat, pro CHRISTO* [instead of *Romanam*] *condere Gentem*). The Virgilian subtext also rises to the surface in Mather's first Latin quotation in the main text: 'The reader will doubtless desire to know, what it was that *tot Volvere casus Insignes Pietate Viros, tot adire Labores, Impulerit*' ('drove men outstanding in piety to go through so many misfortunes, to confront so many labours', adapting *Aen.* 1.9–11). The answer is the faith of the Protestants, the collective hero (plural *uiros*, not singular *uirum*), the 'Blessed Remnant' fleeing from 'Satan's world'. As in many other examples of the Christianized *Aeneid*, the goddess who persecutes Aeneas, Juno, has metamorphosed into Satan.

The history of the theocracy's victories over Satan, in this prose exem-
plar of the 'Satanic epic', comes to a climax in the last book of the *Magna-
lia* on *Ecclesiarum Praelia* 'Battles of the Churches', culminating in the
greatest 'temptation', the Indian wars. Biblical and Virgilian allusions
continue to converge. Phips' victory over the Indian king Philip is a repe-
tition of the Israelites' entry into the promised land, but *Arma uirosque
cano* is the Virgilian heading for this last book of warfare, the Virgilian-
biblical battles with which the true Church consolidates its advance into
the New Jerusalem.

The Virgilian mission of foundation, and Aeneas' core value of *pietas*,
retain their relevance as American history moves towards the Revolu-
tion and the foundation of the Republic. In 1760 George Washington
purchased for his mantelpiece 'A Group of Aeneas carrying his Father
out of Troy, with four statues, *viz.* his Father Anchises, his wife Creusa
and his son, Ascanius, neatly finished and bronzed with copper'.[25] In
a poem 'Addressed to General Washington in the year 1777', after the
battles of Trenton and Princeton, Annis Boudon Stockton, wife of one of
the signatories to the Declaration of Independence, compares Washing-
ton to Aeneas:

> Not good Aeneas who his father bore,
> And all his household gods from ruined Troy,
> Was more the founder of the Latian realm,
> Than thou the basis of this mighty fabric
> Now rising to my view, of arms, or arts;
> The seat of glory in the western world.[26]

'The seat of glory in the western world' is the subject of Joel Barlow's
epic poem *The Vision of Columbus* (1787), revised and expanded as the
ten-book *Columbiad* (1807, and subsequent editions).[27] In its day it was a
bestseller, but also attracted adverse criticism. Epic in nineteenth-century
America mutated into new forms in verse and prose, and in retrospect it
is easy, perhaps too easy, to dismiss *The Columbiad* as a dinosaur of literary
history. The Virgilian template is signalled in the opening lines: 'I sing the
Mariner who first unfurl'd | An eastern banner o'er the western world, |
And taught mankind where future empires lay | In these fair confines of
descending day.' Barlow also locates himself within the earlier tradition
of New World epic: the first two lines allude to a reference to Ercilla's
La Araucana in William Hayley's *An Essay on Epic Poetry* (1782) (*Epis-
tle* 3.241–2), 'In scenes of savage war when Spain unfurl'd | Her bloody

banners o'er the western world'. Columbus' imperialism, by contrast, will be more peaceful. Barlow places at the head of *The Columbiad* the stanza on the fame of Columbus' voyage from Canto 15 of Tasso's *Gerusalemme Liberata* (see above, p. 151).

We first come upon Columbus, discoverer of the western world, during his imprisonment after his third voyage. The form of the poem is a series of visions of the future history of the Americas, vouchsafed to him by an angel in *The Vision*, replaced in *The Columbiad* by 'Hesper', the personification of Hesperia, the land of the west. The ultimate models for this panorama of futurity are the Virgilian Parade of Heroes and the Shield of Aeneas, partly mediated through the imitations of those Virgilian passages by Milton on the Hill of Vision from which the archangel Michael shows Adam the future history of the world in *Paradise Lost* 11, and by Camões, on the mountain top from which the sea-goddess Tethys shows Vasco da Gama a panorama of the universe and the earth in the last book of *The Lusiads*. Not the least of the Virgilian qualities of *The Columbiad* is its ambition to sum up a long previous epic tradition.

The vision compensates Columbus for his personal loss of liberty with the glorious prospect of the triumph of Freedom in America. Freedom succeeds to Despotism in the moral world, as Order succeeds to Chaos in the physical world, a very American take on the Virgilian equation of *cosmos* and *imperium*, the natural and the political orders. On the Virgilian Shield of Aeneas 'the sons of Aeneas [the Romans] rushed into battle in defence of liberty' (8.648), but Republican liberty is subordinate to praise of the one great man Aeneas in the *Aeneid*. In his Preface Barlow criticizes Virgil for writing and feeling 'like a subject, not like a citizen. The real design of his poem was to increase the veneration of the people for a master, whoever he might be, and to encourage like Homer the great system of military depredation.' Virgil's *pax Augusta* is very different from the celestial and cosmic peace celebrated in the Hymn at the beginning of *Columbiad* 8, after three books narrating the revolutionary wars.

For Columbus the vision is also a mental journey from exile to the fully developed potential of the New World homeland. In chains, and debarred from the pleasant lands that he has discovered, he re-experiences the Miltonic Satan's loss of Heaven and Adam's loss of Eden (1.89–96):

Land of delights! ah dear delusive coast,
To these fond aged eyes for ever lost!
No more thy flowery vales I travel o'er,
For me thy mountains rear the head no more,

For me thy rocks no sparkling gems unfold,
Nor streams luxuriant wear their paths in gold;
From realms of promised peace for ever borne,
I hail mute anguish, and in secret mourn.

But like the exiled Aeneas Columbus is promised the glorious future of a 'fame to come' (*Aen.* 6.889, summing up the Parade of Heroes), although, again like Aeneas, long after his own lifetime (1.165–70): 'Now raise thy sorrow'd soul to views more bright, | The vision'd ages rushing on thy sight; | Worlds beyond worlds shall bring to light their stores, | Time, nature, science blend their utmost powers, | To show, concentred in one blaze of fame, | The ungather'd glories that await thy name.' Hesper goes on to make explicit not the Virgilian, but the biblical, analogy, of Moses' sighting from Pisgah's height of the promised land of Canaan, which he will not enter himself.

Barlow turns Virgilian prophecy into a hymn to progress, with a concluding utopian vision of a world congress of the nations assembled to establish the political harmony of all mankind, as the symbols of political and religious oppression are thrown away. Earlier, after the conclusion of the War of Independence, Barlow warns his fellow-countrymen of the evil of slavery, through the person of Atlas, the guardian genius of Africa, who denounces to Hesper the crimes of the western continent (8.189–304). Atlas, a relative both of Virgil's man-mountain Atlas in *Aeneid* 4 and of Camões' Adamastor, threatens America with a convulsive geological catastrophe should she continue to 'hold inthrall'd the millions of my race'.

The catastrophe turned out to be not a natural disaster, but the convulsion of civil war. Post-bellum receptions of the Virgilian plot offer less optimistic views of 'Aeneas in America', particularly on the part of the Southern Agrarian writers who lamented the loss of traditional values in the industrialization and urbanization led by the northern states after the Civil War.[28] This group of writers were attracted by the values of the *Eclogues* and *Georgics*. They also redistributed the roles of the Greco-Trojan myth, seeing the 'Northerners as the upstart Greeks, Southerners as the older, more civilized Trojans'.[29] In 'Aeneas at Washington' Allen Tate imagines an Aeneas who has fled to a 'new world' that turns out to be America. But the lost 'glowing fields of Troy' merge into the 'thickening Blue Grass' of the southern states. In the new nations' capital this Aeneas remains in exile:

I stood in the rain, far from home at nightfall
By the Potomac, the great Dome lit the water,
The city my blood had built I knew no more [...]

Stuck in the wet mire
Four thousand leagues from the ninth buried city
I thought of Troy, what we had built her for.

At the beginning of the poem 'I myself saw furious with blood | Neop-
tolemus [...] Priam | cut down, his filth drenching the holy fires', a close
adaptation of the Virgilian eyewitness account of the death of Priam in
Aeneid 2. This 'I' melts into the first person of a modern who has survived
the horrors of the American Civil War, coinciding with a reading of the
Virgilian sack of Troy as a figure for the civil wars that destroyed the
Roman Republic, and out of which were salvaged the foundations for the
Augustan principate. In Aeneas' next words we hear the tones of a South-
ern gentleman: 'In that extremity I bore me well, | A true gentleman,
valorous in arms, | Disinterested and honourable.' For this Aeneas it is
now too late for anything other than a dispassionate detachment: 'I see
all things apart, the towers that men | Contrive I too contrived long, long
ago. | Now I demand little.'

In 'The Mediterranean', written a little earlier (1932), Tate plays the
part of the American abroad. The subject is a picnic in a secluded bay in
Provence, reached by boat, in which the 'feasters' repeat the experience
of the Trojans on reaching Latium and fulfilling the Harpies' curse by
eating the bread 'platters' of their meal: 'and in our secret need | Devoured
the very plates Aeneas bore'. On holiday in Europe, Tate and his fellow-
Americans can enjoy the fantasy of 'tast[ing] the famous age | Eternal here
yet hidden from our eyes', a mythical moment that has not yet unfolded
all the history prophetically contained within it. In answer to the question
'What country shall we conquer', the reply is given in the last five lines:

Now, from the Gates of Hercules we flood

Westward, westward till the barbarous brine
Whelms us to the tired land where tasseling corn,
Fat beans, grapes sweeter than muscadine
Rot on the vine: in that land were we born.

That the momentary contentment of the picnic is not lastingly fulfilled in the 'promised land' of the last stanza is suggested by the epigraph to the poem, *Quem das finem, rex magne, dolorum?* 'Great king, what end do you grant to our woes?', a slight adaptation (*dolorum* for *laborum* 'labours') of Venus' anxious question to Jupiter after the storm in *Aeneid* 1 (241). Even after the westward continuation of Aeneas' journey and fated mission to America, the question remains to be asked.

8

PARODY AND BURLESQUE

From its beginnings the seriousness of epic, at the summit of the hierarchy of genres, is open to comic undercutting. The *Iliad* itself already contains moments of humour that provide relief from the heroic matter of the war at Troy.[1] In Book 2 the misshapen Thersites aims at provoking laughter with his ridicule and criticism of King Agamemnon, and is himself the object of laughter when he is unceremoniously put in his place by Odysseus. Thersites is the mouthpiece for a poetry of blame rather than praise, attempting to set himself up as a satirical critic.[2] In another example, at *Iliad* 23.784 the Achaeans laugh when, during the foot-race, the lesser Ajax slips in the dung excreted by cattle sacrificed at the funeral of Patroclus. The humour here may be felt to be in place, in that the games provide the heroes with an opportunity for competitive display without the life-and-death consequences of contest on the battlefield. The Homeric gods, notoriously, often behave in a less than dignified manner, in what has been called a 'sublime frivolity' ('ein erhabener Unernst'), most (in)famously in the story of the 'unquenchable laughter' (*Odyssey* 8.326) aroused in the gods who come to stare at the adulterous Ares and Aphrodite trapped *in flagrante* by the fine-spun chains of Aphrodite's husband, Hephaestus.

A long line of parodies of epic begins with the *Margites* (seventh/ sixth century BC), whose eponymous hero was a moron who did not know whether his mother or his father had given birth to him, and who did not know what to do on his wedding night. Food as well as sex is a natural subject of parody, as in the *Attic Dinner* by Matron (fourth century BC), a poem which began with a variation of the first line of the *Odyssey*, 'Tell me, Muse, of the many nourishing dinners' (*polutropha* instead of *polutropon* 'of many wiles', the epithet of Odysseus). The only fully preserved Homeric parody is the *Batrachomyomachia*, 'The Battle of the Frogs and Mice' (of disputed date), whose humour – and pathos – derive from applying the grand topics of epic warfare to these small creatures, 'imitating the

deeds of the earthborn Giants', as the proem puts it.

The contrast between small and large is a recurrent tactic in Virgil's anthropomorphizing treatment in the fourth *Georgic* of the bees, whose society is in parts an image of an idealized community of Romans. There is a touch of humour in the simile that likens the Stakhanovite bees, busy at their honey-making, to the gigantic Cyclopes labouring in their forge at the production of Jupiter's thunderbolts, 'if one may compare small things to great' (*Geo.* 4.176 *si parua licet componere magnis*). The battle of the bees (*Georgics* 4.67–87) is a set-piece of mock epic, great motions which can easily be quelled by the beekeeper by throwing a handful of dust. In that conclusion it is not difficult to read a lesson about the vanity of human epic ambitions and achievements ('as flies to wanton boys').

In the *Aeneid* itself Virgil mostly adheres to a Hellenistic sense of decorum in avoiding the moments of humour in the Homeric poems. Virgil's gods do not forget their dignity to the extent that Homer's gods do. The one time when Virgil repeats a Homeric earthiness is in the imitation in *Aeneid* 5 of the Iliadic foot-race, when Nisus slips and falls in blood and dung left from the sacrifice of cattle, prompting Aeneas to laugh when he appears after the race, 'his face and limbs disfigured with moist dung' (*Aen.* 5.357–8). But given the history of Homeric parody, it was to be expected that the *Aeneid* would quickly generate a parodic tradition of its own, in keeping with earlier Roman exercises in epic parody. The second-century BC satirist Lucilius parodies a council of gods in Ennius' Roman historical epic, the *Annals*. In *Satires* 2.5 Horace continues Odysseus' conversation, in the land of the dead in *Odyssey* 11, with the shade of the seer Teiresias with the latter's advice on how to get rich in Ithaca by legacy-hunting (a notorious practice in the Rome of Horace's day). Lucilius established the hexameter, the metre of epic, as the standard metre of Roman satire, and this shared metre allows satire to slip easily into parody of its grander relative, epic, notably in the satires of Juvenal.

The tenacity of the tradition of Virgilian parody over the centuries is in itself a mark of the success of the poem. As recent studies have shown, parody, and related forms such as burlesque and travesty, are not a simple matter of disrespect, of 'making fun of', putting a moustache on the Mona Lisa, but a 'combination of respectful homage and ironically thumbed nose'.[3] Parody relies for its effects on the reader's knowledge of the text being parodied, and the more well read, and retentive of our reading, that we are, the more we will enjoy the experience of reading parodic texts, as we pat ourselves on the back for our skill as readers in recognizing the parodist's skill. Parody is a marked form of intertextuality.

Parody works at various levels of audience and reading skills. There is a simple humour in the take-off of Virgil found in a Pompeiian graffito in a fuller's establishment, evidence of the widespread recognizability of at least the opening words of the *Aeneid*: *fullones ululamque cano, non arma uirumque* 'I sing of fullers and a screech-owl, not "arms and the man"' (the owl is the bird of Minerva, patron goddess of the college of dyers of Pompeii).[4] The graffitist was perhaps puncturing the self-importance of the commercial middle class of the town.

In the case of Ovid we are dealing with a far more sophisticated dialogue between a parodist and his readers. *Arma*, the first word of the *Aeneid*, is also the first word of Ovid's *Amores*, as the love-poet gives a fictional account of how he set out to write martial epic, until Cupid intervened and stole a 'foot', so that Ovid is forced to limp in erotic elegiac couplets (alternating lines of six and five feet), rather than march in continuous hexameters. This jokey beginning at once establishes a relationship with, and sets a distance from, the *Aeneid*. Virgil's epic continues as a presence in the background throughout the *Amores*, for example in the second poem which stages a triumph of Cupid, who is asked at the end to follow the example of his relative Augustus and protect those whom he has defeated. Augustus is the 'relative' of Cupid because his ancestor Aeneas, son of Venus, was Cupid's brother, a love-elegist's perspective on the divine ancestry of the Julian family celebrated in Virgil's recent epic.

Ovid's most extensive intertextual engagement with the *Aeneid* is in his own long hexameter poem, the *Metamorphoses*. Homage and irony are both present in Ovid's very intricate and witty dealings with the instant classic that the *Aeneid* had become on Virgil's death, and parody is a term appropriate in some instances: for example the substitution for the doomed gay lovers Nisus and Euryalus, in *Aeneid* 9, of the doomed heterosexual couple of beautiful centaurs, equally devoted in their love, who are killed in the battle of Lapiths and Centaurs in *Metamorphoses* 12; or the reduction of the difficulty of returning from the Underworld to a long uphill slog, eased by conversation with the Sibyl who tells Aeneas about her erotic history (*Met.* 14.120–55). When Ovid tells us that the Trojans arrive at a place on the coast of Italy 'that did not yet have the name of Aeneas' nurse [Caieta]' (*Met.* 14.157), this is a humorous and mock-pedantic correction of Virgil who gives the place the name 'Caieta' at exactly the same point in the narrative (*Aen.* 6.900), *before* the death of the nurse and Aeneas' naming of the place in her memory.[5]

Typical of Ovid's dealings with the *Aeneid* is a tendency to emphasize and expand the erotic aspects of Virgil's epic. After all, as Ovid says in

defence to Augustus of his own erotic poetry, 'no part from the whole body of the *Aeneid* is read more than the story of the love [of Dido and Aeneas] joined in an illegitimate union' (*Tristia* 2.535–6). A parodic sequel to the Dido and Aeneas story is told in the elegiac *Fasti* (3.545–656): after Dido's death her sister Anna flees from Carthage to escape the invading Iarbas, Dido's jilted suitor, and undergoes exilic wanderings and misfortunes curiously similar to those of the Virgilian Aeneas. Eventually she arrives in Latium where she is welcomed, out of gratitude to her sister Dido, by Aeneas, who presents her to his Italian wife Lavinia. The blushing Virgilian maiden has turned into a monster of erotic suspicion. Lavinia conceals her murderous jealousy of Anna, until the bloodstained ghost of Dido appears to Anna and tells her to flee – as the ghost of Hector told Aeneas to flee on the night of the sack of Troy in *Aeneid* 2. Anna jumps out of the window and runs to the river Numicius, in which she hides and becomes the river-nymph Anna Perenna. Anna shares an ending with Aeneas, who will also disappear in the Numicius and become a god. This is a tissue of Virgilian *déja-vu*s that casts a bad light on Lavinia, and takes Virgilian plot-line and teleology down a siding.

In the Anna Perenna story Ovid plays on a generic instability within Virgil's own narrative of Dido and Aeneas, where the world of epic heroes collides with the private passions of love elegy. Parodic effects are also created in the prose narratives of the Latin novels of Petronius and Apuleius, in which epic grandeur is brought down to earth in episodes of low realism. The fairy tale of Cupid and Psyche in Apuleius' *Golden Ass* alternates between the register of lofty epic and scandalous tales of sexual misdemeanour of a kind at home in comedy and elegy. The role of the Virgilian Juno persecuting her human enemy Aeneas is played by a very bourgeois Venus, who takes out her indignation at the shame brought on her household by her son Cupid's infatuation with Psyche, by persecuting the hapless mortal girl.[6] In Petronius' racy story of the Widow of Ephesus (*Satyricon* 110–12) the soldier and the widow's maid quote lines from Anna's speech persuading Dido to yield to her love for Aeneas, in order to persuade the widow to abandon her grief-stricken devotion to the corpse of her husband and to have sex with the soldier.[7] Like Odysseus and Aeneas, the anti-hero of the *Satyricon*, Encolpius, is persecuted by the anger of a god, in this instance the ithyphallic Priapus who has cursed Encolpius with impotence. At one point Encolpius berates his wilting penis, whose lack of response is conveyed by a Virgilian pastiche in which erotic parody tips over into obscene *double-entendre*, with the citation of the lines in which, at a moment of high pathos, the shade of Dido refuses

to respond to Aeneas in the Underworld (*Satyricon* 132.11): 'she/it stayed there turned away from me with eyes fixed on the ground, and her/its face was no more moved by the speech I had begun than are bending willows or poppies on drooping necks.'

These three lines stitch together two lines from *Aeneid* 6 (469–70) with half-lines from other Virgilian passages (*Ecl.* 5.16 and *Aen.* 9.436). It is in fact an early example of the cento, that exercise in making a patchwork of Virgilian fragments mean something completely different from their meaning in their original context, which enjoyed great popularity from late antiquity down to the Renaissance (see Chapter 1, pp. 10–11). The best known of the ancient pagan centos is the *Cento nuptialis* 'Nuptial Cento' by Ausonius (*c.* 310–94), which describes the various stages of the wedding ceremony, concluding with the wedding night. In a prose preface Ausonius self-deprecatingly introduces the *Cento* as a trifling little work, and he apologizes for 'disgracing the dignity of Virgil's poetry with such a facetious subject-matter', but what was he to do when the emperor himself had commanded it? The final section, the 'Deflowering', begins thus (101–9: the Virgilian sources are given on the right, *A.* = *Aeneid*, *G.*= *Georgics*, *E.* = *Eclogues*):

Postquam congressi sola sub nocte per umbram	*A.* 11.631, 4.55
et mentem Venus ipsa dedit, noua proelia temptant.	*G.* 3.267, *A.* 3.240
tollit se arrectum, conantem plurima frustra	*A.* 10.892, 9.398
occupat os faciemque, pedem pede feruidus urget.	*A.* 10.699, 12.748
perfidus alta petens ramum, qui ueste latebat,	*A.* 7.362, 6.406
sanguineis ebuli bacis minioque rubentem	*E.* 10.27
nudato capite et pedibus per mutua nexis,	*A.* 12.312, 7.66
monstrum horrendum, informe, ingens, cui lumen ademptum,	*A.* 3.658 (Polyphemus)
eripit a femore et trepidanti feruidus instat.	*A.* 10.788

After they had come together in night's solitary darkness, and Venus herself gave them energy, they start on new battles. He raises himself erect, and though she struggles much in vain, he takes possession of her mouth and face, and in his ardour presses foot on foot. Treacherously seeking the depths, he snatches from his thigh the rod hiding beneath his clothes, crimsoned with blood-red elder-berries and with vermilion, baring its head, and with feet mutually entwined – a terrible monster, hideous, huge, and eyeless – and eagerly presses on her, anxious.

The remaining 32 lines of 'Deflowering' include fragments from Virgil's description of the Underworld, and from a variety of scenes of battle, exploiting the frequent association of sexual penetration and defloration with military assault and wounding.

In the sixteenth century Lelio Capilupi perpetrated a number of erotic and obscene Virgilian centos, including 'On the life of monks' (*De vita monachorum*, 1543), on the solitary habits of monks ('often with their hand they fill their cells with liquid nectar' = *Aen.* 10.620 and *Geo.* 4.164) and the miraculous pregnancies of nuns, and the *Gallus* (also 1543), which tells of the happy sequel, in the form of a graphic scene of sexual intercourse, to the story in Virgil's tenth *Eclogue* of the elegiac poet Gallus abandoned by his girlfriend.[8]

The mysterious solemnity of the Virgilian Underworld made it a prime target for the parodist or satirist. The otherworld is already the setting for one of the most extensive and sophisticated parodic texts in Greek literature, Aristophanes' *Frogs*, in which Herakles goes down to the Underworld to stage a poetic contest between the shades of Aeschylus and Euripides. A late example of the tradition of comic Underworlds is Offenbach's *opera bouffe Orpheus in the Underworld* (1858), a satire on Gluck's *Orfeo ed Euridice*, and hence indirectly a spoof on the Virgilian story of Orpheus in the Underworld in *Georgics* 4. A lengthy recapitulation of the Virgilian Orpheus and Eurydice is included in the description of a journey through the Underworld by the ghost of a gnat in the *Culex*, a mock-heroic epyllion which in antiquity and down to the eighteenth century was held to be an early work of Virgil himself, but which is now recognized as a post-Virgilian concoction drawing on elements of all three of Virgil's major works, the *Eclogues*, *Georgics* and *Aeneid*.[9] The *Culex* is another example of mock epic which gives a heroic role to very small creatures: the gnat has saved a sleeping shepherd from being killed by a monstrous snake by biting the shepherd, who unthinkingly swats the gnat on awakening, before killing the snake. While the shepherd lives to go on enjoying his bucolic idyll, the dead gnat is condemned to travel through a very epic Underworld, as its ghost relates in a dream to the shepherd, who then erects a cenotaph for the gnat in gratitude.

Edmund Spenser's *Complaints* (1591) includes 'Virgil's Gnat', an amplified translation of the *Culex*, which reinforces the mock-heroic ethos of the original and gives the gnat a typically Spenserian concern for vanity and mutability. Spenser's *Complaints* also includes an original essay in the genre of insect mock-epic, the *Muiopotmos, or The Fate of the Butterflie*, which tells of the snaring of the beautiful butterfly Clarion by a malignant

spider. The epyllion starts off in the highest epic vein: 'I sing of deadly dolorous debate, | Stirred up through wrathful Nemesis' despite, | Betwixt two mighty ones of great estate, | Drawn into arms, and proof of mortal fight.' The description of the gay Clarion is indebted both to the *Culex* and to Virgil's bees in *Georgics* 4, but for the themes of art and metamorphosis Spenser goes rather to Ovid's *Metamorphoses*.[10]

A later example of a clash between insects, this time in a mock-epic prose satire, is the encounter of the spider, representative of the moderns, and the bee, representative of the ancients, in Jonathan Swift's *Battle of the Books* (1704: in full *A Full and True Account of the Battle fought Last Friday between the Ancient and the Modern Books in St James's Library*). The *Battle of the Books* also includes an encounter between Virgil himself, who appears on horseback 'in shining armour, completely fitted to his body', and an opponent in armour too big for him, who turns out to be Dryden. In an allusion to the Homeric Glaukos' misjudgement in exchanging his golden armour for the bronze armour of Diomedes (*Iliad* 6.232–6), Swift's Virgil, in a moment of diffidence, exchanges his golden armour for the rusty iron armour of Dryden, followed by an exchange of horses. But Dryden 'was afraid, and utterly unable to mount'. This is Swift's satirical comment on the pretensions of Dryden's translation of Virgil to the grandeur of the original.

Plato reports the notion that in the Underworld sinners were plunged in mud; in Aristophanes' parodic *katabasis* this becomes mud and shit (*Frogs* 145–6). Mud and shit pervade the last poem of Ben Jonson's *Epigrams*, 'The Voyage Itself', in which Jonson narrates a journey through an 'underworld' in the mode of sustained scatology, 'the brave adventure of two wights' who undertake a journey in a water-taxi along Fleet Ditch in London, the cloacal underside of the city, starting from Bridewell, here labelled 'Avernus', the entry to the Underworld near Cumae. Jonson tells 'how | Sans help of sibyl or a golden bough | Or magic sacrifice, they passed along' (47–9): the denial of the supernatural aids to Aeneas' descent emphasizes that this is a real-life journey, not a fiction. Allusion to Aeneas' journey to the Underworld is particularly clear 'In the first jaws' (61: cf. *Aen.* 273 *primisque in faucibus Orci*), where the two intrepid adventurers pass 'Between two walls, where on one side, to scar men | Were seen your ugly centaurs ye call car-men, | Gorgonian scolds and harpies; on the other | Hung stench, diseases, and old filth, their mother, | With famine, wants and sorrows many a dozen' (67–71), alluding to the mythological monsters and personifications of evils that Aeneas encounters at the entrance to the Underworld.[11]

The middle of the seventeenth century saw a Europe-wide fashion for travesties of the *Aeneid*, beginning with the Italian *L'Eneide travestita* ('The *Aeneid* in disguise', 1634), in *ottava rima* (the metre of Ariosto's *Orlando Furioso* and Tasso's *Gerusalemme Liberata*), by Giambattista Lalli, the author of a number of burlesque poems and a great admirer of Torquato Tasso. In his 'Letter to the Reader' Lalli presents his work as homage to Virgil: since 'Virgil's admirable poem has already been translated into the Tuscan tongue, partly in ottava rima and partly in blank verse, I thought it would be an injustice to so distinguished a poem not to translate it also into a pleasingly humorous style ('dilettevole stile giocoso'), so that it should enjoy a more universal appreciation.' Lalli self-deprecatingly apologizes for 'dressing up ('travestir') in poor and coarse rags that incomparable author already clad in gold'.[12]

Lalli was followed in France by the hugely successful *Le Virgile travesty en vers burlesques* by Paul Scarron, published in instalments, reaching as far as *Aeneid* 8, from 1648 to 1653.[13] The author of a standard nineteenth-century study of Scarron observes that Lalli lowered the *Aeneid* by only a couple of notes, while Scarron composed it several octaves lower,[14] in a work in which, according to the seventeenth-century critic Nicolas Boileau, 'Parnassus spoke the language of Les Halles', and 'Dido and Aeneas spoke like fishwives and porters'.[15] The metre is the octosyllable, rather than the more epic alexandrine. In contrast to Lalli, Scarron frequently intrudes his own first person. Typical of his authorial intervention is his variation on the legend that the Dido's Tyrian refugees dug up the head of a horse when they arrived at the site of Carthage (*Aen.* 1.442–5): 'When they arrived in Libya, at the back of this wood they found, in some nasty hole, the head and neck of an ass. If great Virgil's work is to be taken as gospel truth, you will find that I have erred in putting an ass in place of a horse. But, on the word of a burlesque poet, I have read in an Arab book, whose name I can't remember, that it was the head of an ass's foal.' Anachronisms abound, contaminating the heroic past with the mundanities of the present day. Scarron keeps close to the Virgilian text, but frequently expands, sometimes with long lists of realistic detail: thus, for example, the 705 lines of *Aeneid* 4 balloon to 2,972 lines in *Virgile travesty*.

The publication and popular success of Scarron's anarchic *Virgile travesty* coincided with the insurrectionary movement known as the Fronde, which arose from opposition by the Parisian Parliament and the territorial nobles to the policies of Cardinal Mazarin, Chief Minister during the regency of Anne of Austria, mother of Louis XIV, a child of five

at the time of the death of Louis XIII in 1643. It is tempting to see a connection between the spirit of the English Restoration and the success of the English imitation of Scarron, the *Scarronides* ('son of Scarron'), by Charles Cotton, a travesty of *Aeneid* 1 and 4 (1664, 1665). Cotton was among other things a friend of Izaak Walton and author of a supplement to *The Compleat Angler*, and a translator of Montaigne's *Essays*. Samuel Pepys collected a copy of Book 1 on the day that it was licensed, and found it 'extraordinary good'. *Scarronides* went through numerous editions, and spawned copy-cat travesties of other books of the *Aeneid*. Together with Samuel Butler's contemporary *Hudibras* (1663–78) it set a fashion in England for burlesque poetry. Compared with Scarron, Cotton makes a further descent into the scatological and sexual. The tone of Cotton's travesty is set from the beginning:

> I sing the man, (read it who list,
> A Trojan true as ever pissed)
> Who from Troy Town, by wind and weather
> To Italy, (and God knows whither)
> Was packed, and wracked, and lost, and tossed,
> And bounced from pillar to post.
> Long wandered he through thick and thin;
> Half roasted now; now wet to th' skin;
> By sea and land; by day and night;
> Forced (as 'tis said) by the god's spite:
> Although the wiser sort suppose
> 'Twas by an old grudge of Juno's,
> A murrain curry all cursed wives!

Aeolus lets out the winds of the storm by farting. 'Whom Jove observing to be so stern, | In the wise conduct of his postern, | He made him king of all the puffers' (1.93–5). When Aeneas meets his mother in disguise, 'So smug she was, and so arrayed, | He took his mother for a maid: | A great mistake in her, whose bum | So oft had been god Mars his drum' (1.617–20). Venus tells Aeneas the story of Dido's coming to Carthage, 'Where now she lives a housewife wary, | Has her ground stocked, and keeps a dairy' (1.707–8). Aeneas' gifts to Dido include 'a fair great ruff | Made of a pure and costly stuff | To wear about her highness' neck; | Like Mistress Cokaine's in the Peak' (1.1199–1202; Cotton's cousin Sir Aston Cokaine was a neighbour in the Peak District). The infatuated Dido is on heat for Aeneas: in her prayers 'Juno had most veneration, | As she was the queen of copulation' (4.145–6; Juno is the Roman god of marriage). Dido's

consultation of priests and prophets is all in vain: 'Or what do prophecies avail | When women have a whisk i' th' tail? | Dido for love in woeful wise, | Bubbles, and boils, and broils, and fries.' The royal hunt becomes a squirrel hunt, and (4.435–44):

> The cave so darksome was, that I do
> Think Joan had been as good as Dido:
> But so it was, in that hole they
> Grew intimate as one may say:
> The queen was blithe, as bird in tree,
> And billed as wantonly, whilst he
> By hindlock seizing fast occasion,
> Slipped into Dido's conversation:
> And in that very place and season.
> 'Tis thought Aeneas did her reason.

The scatological resurfaces when Mercury comes down to Carthage, flying faster than 'arrows loosed from Grub-Street bow | In Finsbury' (4.617–18), and finds Aeneas 'building for the queen a jakes' (4.660). Dido's priestess-enchantress becomes a hideous shriveled hag, a close relative of the witches in Macbeth, and perhaps a model for the Beldame sorceress in Nahum Tate's libretto for Purcell's *Dido and Aeneas*, which certainly has its moments of travesty-like humour, and a moment of sexual *double-entendre* when Aeneas enters during the hunt, brandishing his weapon: 'Behold upon my bending spear | A monster's head stands bleeding.'[16] Cotton's abject witch is also a self-parody of the poet of burlesque travesty: 'This witch a ribble row rehearses, | Of scurvy names in scurvy verses, | Which by the manner of her mouthing, | Was certainly burlesque, or nothing' (4.1355–8). The tragic climax of the story, Dido's suicide, is reduced to farce. Dido takes 30 lines weighing up methods of killing herself, before resolving to use a rope, rather than the more heroic Virgilian sword (4.1665–74):

> In mind she weighed, as she sat crying,
> What kind of death was best to die in.
> Poison she thought would not be quick,
> And which was worse, would make her sick.
> That being therefore waived, she thought,
> That neatly cutting her own throat,
> Might serve to do the business for her,
> But that she thought upon with horror,
> Because 'twould hurt her; neither could
> She well endure to see her blood.

Cotton ends, as he began, with piss: her household are alerted to her death-throes when she pisses herself as she hangs (4.1805–10):

A yellow aromatic matter
Dropped from her heels, commixed with water,
Which sinking through the chamber-floor,
Set all the house in sad uproar.
All at the first that they amiss thought,
Was that her Grace had missed the piss-pot.

The realist detail frequent in the travesty pushes epic in the direction of the novel, and Scarron's other works include the *Roman comique*. Epic was the main genre for fictional narrative in antiquity; epic parody, as we have seen, features prominently in those ancient prose fictions to which modern scholars give the label 'the ancient novel', and epic parody is also an important element in the development of the early modern novel, in the English tradition notably in the novels of Henry Fielding, who also wrote a verse parody of the *Aeneid*, the political satire the *Vernon-iad* (1741). In the Preface to *Joseph Andrews* Fielding asserts 'Now a comic Romance is a comic Epic-Poem in Prose.' The description of Joseph's cudgel (Bk 3 ch. 6) is modelled on the descriptions of the Shield of Achilles in *Iliad* 18 and of the arms of Aeneas in *Aeneid* 8. A wider set of structural parallels with the *Aeneid* is found in *Amelia*, which explores Virgilian themes of honour and love. Amelia's husband Booth abandons her to follow his regiment to Gibraltar, in accordance with the dictates of honour, so repeating Aeneas' abandonment of Dido. After Booth recognizes the values of Christianity, Amelia is able to avert a duel between him and Colonel James, so replacing the heroic ending of the *Aeneid*, the duel of Aeneas and Turnus, with a Christian ending. Booth finally abandons the military life in order to live happily ever after with his family.[17]

Where the travesties of Lalli, Scarron and Cotton use low language to describe the actions of great persons, the heroic cast of the *Aeneid*, Fielding applies epic images and themes to his less than heroic characters. To distinguish these two kinds of disjunction between high and low, the term 'mock heroic' is conveniently used for the inverse of travesty, namely the use of lofty language for low objects, as in the case of the *Batrachomyomachia* or the *Culex*.[18] The classic French mock-heroic poem is Nicolas Boileau's *Le Lutrin* 'The Lectern' (1674–83), which tells of a quarrel between the treasurer and the precentor of the Sainte-Chapelle in Paris over the installation by the treasurer of a lectern that blocked the precentor's view of the choir.[19] A number of translations gave it wide currency in

England. It starts in a free adaptation of the Virgilian 'Arms and the man', together with a glance at the quarrel between Agamemnon and Achilles that begins the *Iliad*. Below I give the translation of John Ozell (1708); the original French is even closer to the Virgilian original, reproducing the structure of seven lines of plot summary followed by four lines of address to the Muse, asking why Juno was angry with Aeneas.

> Arms and the priest I sing, whose martial soul
> No toil could terrify, no fear control;
> Active it urged his outward man to dare
> The numerous hazards of a pious war:
> Nor did th' immortal prelate's labours cease,
> Till victory had crowned 'em with success;
> Till his gay eyes sparkling with fluid fire,
> Beheld the desk reflourish in the choir.
> In vain the chanter and the chapter strove;
> Twice they essayed the fatal desk to move:
> As oft the prelate with unwearied pain,
> Fixed it to his proud rival's seat again.
> Muse, let the holy warrior's rage be sung;
> Why sacred minds infernal furies stung:
> What spark inflamed the zealous rival's heat,
> How heavenly breasts with human passions beat.

'How heavenly breasts with human passions beat' (in French 'Tant de fiel entre-t-il dans l'âme des dévots!') transforms *Aeneid* 1.11 *tantaene animis caelestibus irae?* 'Are heavenly spirits [the gods] possessed of such anger?' (which appears as the Latin motto on the title-page of Ozell's translation) into a question about the ill temper of men of the cloth. The action is set in motion by the intervention of the Fury Discord, enraged by the tranquillity of life in the Sainte-Chapelle, a reworking of the intervention of the angry Juno and her agent, the Fury Allecto, in the *Aeneid*.

John Dryden was a great admirer of Boileau. His description of Boileau's method can be applied to Dryden's own practice in his satirical works:

He writes [*Le Lutrin*] in the French heroic verse, and calls it an heroic poem; his subject is trivial, but his verse is noble. I doubt not but he had Virgil in his eye, for we find many admirable imitations of him, and some parodies [...] And, as Virgil in his fourth Georgic, of the Bees, perpetually raises the lowness of his subject, by the loftiness of his words, and ennobles it by comparisons drawn from empires, and from monarchs

[...] we see Boileau pursuing him in the same flights, and scarcely yielding
to his master. This, I think [...] to be the most beautiful and noble kind
of satire. Here is the majesty of the heroic, finely mixed with the venom
of the other; and raising the delight which otherwise would be flat and
vulgar, by the sublimity of expression.[20]

With *Mac Flecknoe* (i.e. 'son of Flecknoe', *c.* 1676) Dryden achieved 'the
first great English mock-heroic poem'.[21] It takes the central Virgilian
themes of succession and empire, and applies them to the Irish writer
Flecknoe's anointing of Thomas Shadwell as his successor in the empire of
poetic nonsense and dullness. At the coronation Shadwell is the Ascanius
to Flecknoe's Aeneas (108–11):

> At his right hand our young Ascanius sate,
> Rome's other hope, and pillar of the state.
> His brows thick fogs, instead of glories, grace,
> And lambent dullness played around his face.

The first couplet alludes to the appearance of Ascanius by his father's side
at *Aeneid* 12.168, *magnae spes altera Romae* 'great Rome's second hope'; the
second couplet parodies the harmless flame that licks (*lambere*) round
Ascanius' head at *Aeneid* 2.682–4, an omen of predestination and future
greatness amidst the flames that are destroying Troy. Shadwell's succes-
sion to Flecknoe is an inert replacement of like with like (15 'Shadwell
alone my perfect image bears'); at the end 'The mantle fell to the young
prophet's part, | With double portion of his father's art': more of the same,
and very little art, if we remember Flecknoe's own question (176) 'What
share have we in nature, or in art?' By contrast, Dryden's witty and artful
diversion of the matter of the *Aeneid* to very different ends marks him as a
creative poetic successor of Virgil.

Alexander Pope took on the mantle of *Mac Flecknoe* in *The Dunciad*,
a complex work with a complex history of composition which, in its final
four-book version of 1743, satirizes the anointing by the goddess Dulness
of Colley Cibber as poet laureate.[22] According to the mock-pedantic
annotation by 'Scriblerus' in the 1729 *Variorum* edition, 'the Action of the
Dunciad is the Removal of the Imperial Seat of Dulness from the City
to the polite world; as that of the Aeneid is the Removal of the empire
of Troy to Latium.' Ultimately Virgilian in its combination of the cosmic
and the historical is the setting of 'the human drama, absurd and miser-
able as it is, against the "huge scenic background of the stars"'.[23] But this
is an epic which ends with the equation not of cosmos and empire, but

of chaos and empire, in the Miltonic strains of the ending of the 1743 *Dunciad* (4.653–6):

> Lo! thy dread empire, Chaos! is restored;
> Light dies before thy uncreating word;
> Thy hand, great Anarch! lets the curtain fall,
> And universal darkness buries all.

Chaos, not Troy, resurgent. *The Dunciad* is a *summa* of previous epic and mock epic tradition, with a number of set-piece Virgilian imitations. At the beginning Cibber, in a writer's despair, lights a sacrificial bonfire of his works: the model of the sack of Troy in *Aeneid* 2 is made explicit when (1.255–6) 'Tears gushed again, as from pale Priam's eyes | When the last blaze sent Ilion to the skies.' The goddess Dulness extinguishes the pyre; out of destruction will come a bright future for Cibber, succeeding Laurence Eusden as poet laureate, 291–2: 'All hail! and hail again, | My son: the promised land expects thy reign', combining the Virgilian plot of the promise of a future kingdom with the witches' salutation of Macbeth. In Book 2 his coronation is celebrated with games for booksellers, poets and critics, parodying the games in *Iliad* 23 and *Aeneid* 5. Pursuing the phantom of a poet created by Dulness, the bookseller Edmund Curl slips in a pool of urine (representing the 'piss' brought to his shop in the form of purloined material). Curl's prayer mounts to the lavatory throne of Jove, who uses such petitions as toilet paper, and Cloacina, the goddess of sewers, favours Curl by lending him fresh vigour from the 'ordure's sympathetic force'. Instead of an archery contest, a contest as to who can piss higher decides the prize of a woman. The Fleet-ditch is the setting for more mud and shit in an event for 'party-writers', who delight in flinging dirt, a contest in diving into the Fleet stream, won by Smedley, rising from the depths 'in majesty of mud' (2.326).

Book 3 takes the sleeping Cibber, 'on fancy's easy wings' and led by 'a slip-shod sibyl', to the Elysian shade, another underworld of literary making and literary memory where 'poetic souls' are dipped in the Lethe of dullness and then rush to take on new bodies, the calf-skin of new books. Playing the part of the shade of Anchises, the ghost of the writer Elkanah Settle unfolds to Cibber a vast panorama of past and future, combining the Virgilian Parade of Heroes in *Aeneid* 6 with Michael's revelation to Adam of the future history of the world in *Paradise Lost* 11. Settle reaches the climax of his parade of heroes announcing Cibber as the new Augustus, combining (predictably) *Aeneid* 6.791 ff. (*hic uir, hic est*)

with echoes of the fourth *Eclogue*, 3.319–20 'This, this is he, foretold by ancient rhymes: | Th' Augustus born to bring Saturnian times.' But the reader knows from Pope's opening address to Swift that this will be (1.28) 'a new Saturnian age of lead' (in alchemy Saturn is lead).

In the German-speaking world great success was enjoyed by *Virgils Aeneis, travestirt*, by the Austrian enlightenment writer Aloys Blumauer (1755–98), of which Books 1 to 4 were published in 1784, with further instalments in 1785 and 1788.[24] Blumauer's is a travesty with a message: its obsessive satire on Roman Catholicism is in keeping with the anticlerical reformism of the Hapsburg emperor Joseph II. Aeneas is the founder not just of Rome, but of its degenerate heir the Vatican. The pious credulity of Virgil's Trojans is redirected against Christian superstition: a hermit from Argos tells the Trojans that the wooden horse was built in payment of a vow to St George, and that anyone who refuses to believe its sanctity will be excommunicated. There is much anachronism: Aeneas goes to a coffee-house in Carthage and reads a newspaper report of his escape from Troy, reworking the Virgilian episode in which Aeneas sees scenes from the Trojan War in a temple of Juno. Dido reads Goethe's *The Sorrows of Young Werther*. There is much eating and drinking – Elysium is a Land of Cockaigne where Aeneas finds champagne, sekt and mead foaming in the waterfalls, and cakes, marzipan and doughnuts growing on the trees – and much scatological humour. Dido's infatuation for Aeneas is reduced to a list of physical symptoms: (4.16) 'The poor woman had a constant itching through all her members, now in the stomach, now in the throat. She ran about incessantly like a foal tormented by the stinging of nasty gadflies.' Blumauer had perhaps read Cotton's *Scarronides*, in which Dido's lust is compared to a heifer who 'doth itch, | With gad-breeze [gadfly] sticking in her breech' (*Scarronides* 4.181–2: behind both passages lies Virgil's own mock-epic description of a gadfly at *Georgics* 3.146–53). There are also travesties of Virgil in Russian, Hungarian and French-Belgian, and Ivan Kotlyarevsky's travesty the *Eneida* (1798, 1842) was the first work written wholly in Ukrainian, and marks Kotlyarevsky as the father of Ukrainian literature.[25] The Trojans become Ukrainian Cossacks, who wander the world after the destruction by the Russians of their historic stronghold, the Zaporizhian Sich.

The most famous mock-heroic of the Romantic period in England, Byron's *Don Juan*, sends up its own pretensions to stand in the central line of the classical epic tradition near the end of the first Canto (1.200):

> My poem's epic, and is meant to be
> Divided in twelve books: each book containing,
> With love, and war, a heavy gale at sea,
> A list of ships, and captains, and kings reigning,
> New characters; the episodes are three:
> A panoramic view of hell's in training,
> After the style of Virgil and of Homer,
> So that my name of Epic's no misnomer.

'Twelve books', 'love and war', 'a heavy gale at sea', 'a panoramic view of hell' are all features of the *Aeneid*, but also of other epics. *Paradise Lost* has 12 books; the combination of love and war is even more prominent in the Renaissance epics and romances of Pulci, Ariosto, Tasso and Spenser than in the *Aeneid*; the epic storm and a description of the Underworld is borrowed by Virgil from Homer, whose poems are a more frequent presence in *Don Juan* than is the *Aeneid*.[26] But Virgilian parody could be put to pointed topical use in the late Georgian and Regency period, as in two cartoons by James Gillray, 'Dido forsaken' (21 May 1787), which shows the Prince of Wales abandoning Maria Fitzherbert; and 'Dido in despair' (6 February 1801), which shows Lady Hamilton distraught as Nelson sets sail to fight the Frenchman (Plate 5).

Byron's allusivity and mockery in *Don Juan* play over a wide range of European and English literature, with an attenuated acknowledgement of the centrality of the *Aeneid* in those traditions, and the same may be said of the last major outcrop in English poetry of the mock-heroic tradition, T.S. Eliot's *The Waste Land* (1922),[27] for all that Eliot also made the last significant attempt in English letters to re-instate Virgil at the heart of the western tradition. In *The Waste Land* Shakespeare has become the gravitational centre for allusive evocations of the high style.

9

ART AND LANDSCAPE

W hen, in the Renaissance, artists turned from their nearly exclusive focus on sacred subjects to secular subjects, the *Aeneid*, as the central non-biblical narrative text of western literature, naturally became the source for innumerable artistic representations, above all in painting, but also in sculpture, as well as in the minor arts: prints, maiolica, *cassoni* (Italian wedding chests), metal plaquettes.[1] As a secular source for artistic images the *Aeneid* is second only to Ovid's *Metamorphoses*, which with its greater variety of mythological stories can justly claim the title of 'painters' bible'. From the later sixteenth century on these two long narrative poems from antiquity were joined, as favourite textual sources for painted images, by two Renaissance romance epics, each heavily indebted to both Virgil and Ovid, Ariosto's *Orlando Furioso* and Torquato Tasso's *Gerusalemme Liberata*.

A few images of episodes from the *Aeneid* survive from antiquity. There is only one Pompeiian painting that certainly illustrates an episode in the *Aeneid*, the doctor Iapyx attempting to heal Aeneas' arrow-wound (*Aen.* 12.383–429) (Fig. 15).[2] Unseen by the human actors, Venus appears in the background bringing the herb from Crete that will magically heal the wound. Scenes of the story of Dido and Aeneas appear on a mosaic floor from the Roman villa at Low Ham in Somerset, England (*c.* AD 350), from the Trojans' sailing to Carthage to Dido abandoned, with a much reproduced panel showing a fully clothed Aeneas embracing a naked Dido in the countryside.[3]

The earliest surviving book illustrations of the *Aeneid* date from just a few decades after the Low Ham mosaic. We have far older manuscripts of Virgil than for almost any other ancient author, and the oldest, the so-called *Virgilius Vaticanus* of about 400 AD, contains 41 images from the *Aeneid*, still within the illusionistic conventions of classical art (Figs. 16, 17). The illustrations in the later, probably mid-sixth-century, *Virgilius Romanus* are already recognizably more 'medieval' in their flattened perspec-

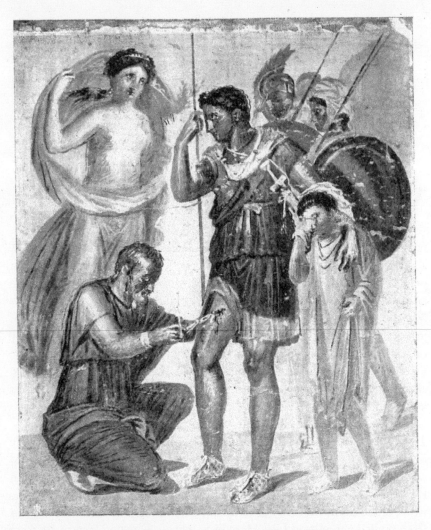

Fig. 15. Aeneas and Iapyx, Pompeii, Casa di Sirico.

tive and simplification of line.[4] After these precious survivals there are a
handful of illustrated Virgil manuscripts from the ninth to the twelfth
centuries, before the more numerous illustrations of the thirteenth and
fourteenth centuries, which, however, more often accompany vernacular
versions, in verse and prose, of the story of the *Aeneid.*[5] Some fifteenth-
century manuscripts of Virgil contain lavish illustrations, notably those
attributed to Apollonio di Giovanni in a manuscript in Florence (Flor.
Bibl. Riccard. MS 492). Apollonio is also known for his Virgilian scenes

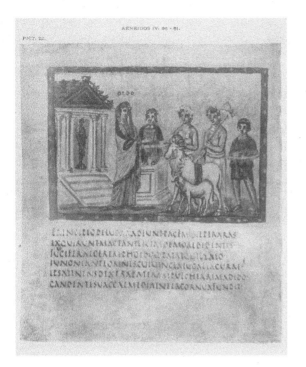

Fig. 16. Dido offers a sacrifice, from the Vergilius Vaticanus.

Fig. 17. Aeneas and Achates approach the Sibyl in front of the temple of Apollo, from the Vergilius Vaticanus.

on Renaissance *cassoni*, wedding chests, that provide an early vehicle for the display of paintings illustrating classical myth and legend.[6]

Turning to the printed book, an exhaustive handbook of illustrated editions of Virgil's works from 1502 to 1840 lists over 550 editions and translations with one or more woodcuts and engravings (if only on the title-page).[7] One of the earliest has been called 'one of the most wonderful illustrated books ever produced', a 1502 Strasbourg Virgil whose production was overseen by the humanist Sebastian Brant, author of the satirical *Ship of Fools*. Brant's Virgil contains 214 woodcuts, whose blocks were re-used in later editions of Virgil, and whose designs provided models for images in other media, including maiolica and painting (Fig. 2). Brant claims in an epigram at the end of his edition that, while others may expound Virgil in eloquent speech and teach him to schoolboys, he, Brant, wanted to use rustic pictures to publish him for the unlearned and country-dwellers, rather like the *Biblia Pauperum*, 'Bible of the Poor', picture Bibles designed to teach the illiterate. The architectural settings and the clothes of the Brant woodcuts are still fully medieval; the final encounter in the *Aeneid* between Aeneas and Turnus is set within a fenced-off area as for an early modern duel. Very different are the classicizing scenes in seventeenth-century editions, such as those by François Chauveau for the French translation of Virgil by Michel de Marolles (1649) (Figs. 1, 5, 14), and those by Franz Cleyn for the English translation by John Ogilby (1654) (Figs. 4, 18), reused in Dryden's 1697 translation of *The Works of Virgil*. A more rococo air is found in the illustrations by Giuseppe Zocchi for a 1760 edition of the blank-verse translation of the *Aeneid* by Annibal Caro (1507–66), the best of the Italian translators (Figs. 13, 19). The artistic idiom has become neoclassical in the etchings by Bartolomeo Pinelli in the Italian translation by Clemente Bondi (1811) (Figs. 6, 11).

Turning to painting, the *Aeneid* is the subject of a number of pictorial cycles, mostly in Italy. The only cycle to assign a separate painting to each of the 12 books of the *Aeneid* is that by Nicolò dell'Abate for the Castle of Scandiano in Reggio Emilia (*c.* 1540). Each painting uses the technique of continuous narrative, in which several episodes from a single book are depicted, distributed around a landscape. The Wooden Horse in the panel for *Aeneid* 2 is based on woodcuts in the 1502 Brant Virgil. Virgilian cycles may serve various intellectual and ideological agendas. The Scandiano scenes from the *Aeneid* were part of a larger scheme which included battle scenes *all'antica* in the dado beneath the *Aeneid* frescoes, and sixteenth-century figures in landscapes in the lunettes above, while from the octagonal panel in the ceiling members of the Boiardo family, owners of the

castle, look down. It has been suggested that the battle scenes allude to the tradition of conflicts between Umbrians and Tuscans in Emilia before the coming of Aeneas: 'the lord and lady of Scandiano, eminent on the contemporary scene, are rooted in time reaching, through the glorious episodes of the *Aeneid*, into a history more ancient than Rome's.'[8] The *Aeneid* roots Virgil's contemporary Rome and its ruler Augustus in a glamorous legendary past; patrons of art in post-antique centuries seek to legitimize and glamorize their own pretensions with the legend and history contained in the *Aeneid*. Attempts have also been made to link some aspects of the Scandiano cycle to the most famous Boiardo, Matteo Maria (1440/1–94), author of the romance *Orlando Innamorato*.

One of the grandest of the cycles is the Gallery of Aeneas in the Palazzo Pamphilj, on the Piazza Navona in Rome (1651–54), decorated for Pope Innocent X Pamphili.[9] Its ceiling bears frescoes of scenes from the *Aeneid* by the great baroque painter Pietro da Cortona, reaching from the storm in Book 1 to the death of Turnus in Book 12. In a context of papal display, the frescoes advertise the fact that the Rome whose foundation followed from the struggles and victory of Aeneas now rules a spiritual rather than a temporal empire. In an elegiac poem on the origins of Christianity, Innocent's predecessor Urban VIII (Maffeo Barberini) had presented Aeneas as a prefiguration of the pope, the Pontifex Romanus, picking up on the emphasis that Virgil does indeed lay on Aeneas' priestly role in the *Aeneid*, foreshadowing the *pontifex* 'high priest' of pagan Rome. The link between Virgil's legendary narrative and Christianity is made in other ways. In one of da Cortona's many visual allusions, the pose of Neptune, stretching out his arm to calm the storm in *Aeneid* 1, evokes that of God in Michelangelo's Creation of Adam (Plate 6). It has further been suggested that the head of Neptune bears a resemblance to the bronze bust of Innocent X by Algardi. Even without that it is an easy step to see in the scene of the calming of the storm, as often in representations of this subject, a political application of the programmatic scene of order restored from disorder at the beginning of the *Aeneid* (see Chapter 5, pp. 96–8). More particularly Innocent had been involved in the negotiations that brought to an end the Thirty Years' War in 1648. Another personal allusion is the prominence given to Venus' doves, for the Pamphili coat of arms bore a dove with an olive branch in its beak, below three fleurs de lis. The olive is associated with Minerva, and the lily with Juno, together with Venus the three goddesses set at odds with each other through the Judgement of Paris. On the Pamphili coat of arms the symbols of the three goddesses are harmoniously united; the *Aeneid* tells of a hostility between Venus,

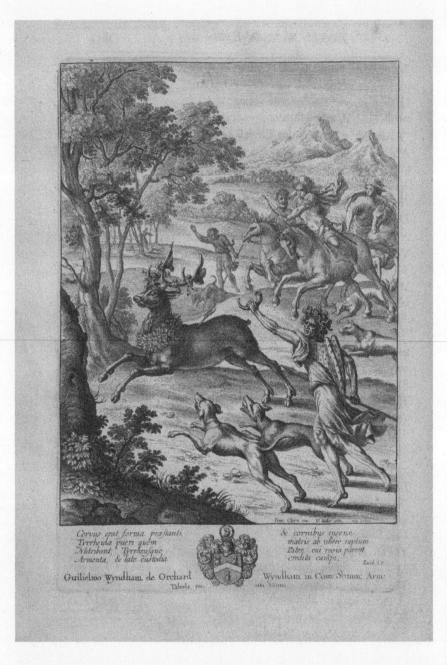

Fig. 18. Ascanius shoots Sylvia's stag. Engraving after drawing by Franz Cleyn, in *The Works of Publius Virgilius Maro*, translated by John Ogilby (London, 1654).

Fig. 19. Dido and Aeneas in the cave. Engraving by Giuseppe Zocchi, in
L'Eneide di Virgilio del commendatore Annibale Caro (Paris, 1760).

mother of Aeneas, and Juno, persecutor of Aeneas, which will be resolved by the end of the poem.

Far lighter in tone are the frescoes by G.B. Tiepolo in the Villa Valmarana near Vicenza (1757).[10] The Stanza dell'Eneide is one of four rooms, the other three being decorated with scenes from Homer's *Iliad*, Ariosto's *Orlando Furioso* and Tasso's *Gerusalemme Liberata*, prompting comparisons between the ancient and modern epics of a kind found in early modern literary-critical discussions of the epic poem. Tiepolo's figures appear as if on stage, a painterly recreation of the operatic world of Metastasio, whose libretto on Dido was set to music by many composers in the eighteenth century (see Chapter 3, pp. 75–6). In the scene of 'Aeneas presenting Cupid in the guise of Ascanius to Dido' Tiepolo improvises on the text of *Aeneid* 1 (Plate 7). To show us that this is Cupid, the figure of Ascanius, who appears reluctant to come forward in the presence of the regal figure of Dido, still wears the god of love's wings. Aeneas leans towards the welcoming queen, motivated by a father's love. The introduction made in this scene of *pietas* will lead to a very different, and disastrous, kind of love once the disguised Cupid begins to work on Dido.

The story of Dido is one of the most frequently represented in painting, as it is also a favourite subject for theatre and opera.[11] In the Palazzo Pamphilj in Rome the Dido and Aeneas story is reserved for separate treatment in the frescoes by Francesco Allegrini (*c.* 1653) in the Sala di Enea e Didone, the bedroom of the Pope (and latterly of the Brazilian Ambassador to Rome), built actually inside the church of Sant' Agnese in Agone. The scenes on the four sides of the ceiling show the history of Dido ending with her suicide. Opposite the prelate's bed is the most intimate of the scenes, Dido and Aeneas in the cave, but in the central panel at the top of the ceiling Jupiter appears, looking rather like the Christian God, sending down Mercury to recall Aeneas to his mission, reminding the occupant of the bed of his Christian duties.

Single paintings from the story of Dido focus mostly on the erotic and pathetic aspects, with the largest number devoted to the death of Dido. She appears either as a single figure, as in examples by Rubens (in the Louvre) or Andrea Sacchi (Caen, Musée des Beaux-Arts), focusing on the private emotions of the despairing queen in an image that contrasts soft female flesh and cold hard steel, as in that other popular subject of female suicide, the death of Lucretia; or else surrounded by her bereft sister and members of her court, as in the important treatment by Guercino (1629, in the Galleria Spada, Rome), commissioned for another woman called to rule after the death of her husband, Marie de' Medici.

The subject of the death of Dido was the battleground for an artistic challenge to Sir Joshua Reynolds, President of the Royal Academy, by the Romantic Swiss artist Henri Fuseli, at the Royal Academy exhibition of 1781 in the newly opened Somerset House. Fuseli chose to hang his own phantasmagorically sublime version opposite Reynolds' emotional but conventionally classical composition (Plates 8, 9).[12] The death of Dido had recently been chosen as a subject for the history painting prize for Royal Academy students, and Reynolds painted his version as a pedagogical showpiece. The distraught figure of Anna echoes the pose of the Virgin Mary at the deposition of Christ. Fuseli arranges his composition vertically, and Dido's outstretched limp arms are reminiscent of nothing so much as the Crucifixion.

From the many other works of art based on scenes from the *Aeneid* I focus now on a selection of subjects that have proved particularly popular with artists over the centuries. I start at the beginning of the poem, with the opening narrative sequence of the unleashing of the storm-winds by Aeolus at the request of Juno, and the calming of the storm by Neptune, this latter often in a political allegory of good government, as in paintings by Rubens (see Chapter 5, pp. 97–8) and Pietro da Cortona (see p. 193 above).

Juno's visit to Aeolus in *Aeneid* 1 is balanced in Book 8 by the visit of the goddess who opposes Juno, Venus, to another divinity with control over vast elemental energy, her husband Vulcan. Venus uses her erotic charms to seduce Vulcan into agreeing to make a new set of arms for Aeneas, which he does when he descends after their love-making to the subterranean forge of the Cyclopes (*Aen.* 8.370–453). Artists select from, or combine, several stages in the narrative. The appearance of Venus before Vulcan produces a contrast between the voluptuous white flesh of the goddess of love and the knotted and muscular body of her ugly craftsman husband, whose job is to make the weapons of war, so producing also a contrast between Venus and the world of Mars, to which artists have often been attracted. Venus often appears in the forge of Vulcan itself, conflating the two stages in the Virgilian narrative, and licensed by Virgil's model in Homer's *Iliad* for the episode, Thetis' visit to the forge of Hephaestus (the Greek name for Vulcan) to ask for a new set of arms for her son Achilles. The making of the arms allows for the depiction of muscular bodies in vigorous action, in a variety of poses, sometimes with chiaroscuro effects of the flames of the forge in a dark smithy. The French rococo painter François Boucher painted a number of versions of Venus asking Vulcan for the arms that verge on soft porn (Plate 10); admittedly

Virgil's description of Venus and Vulcan's love-making is the closest thing to explicit sex in the *Aeneid*.[13] The bringing of the arms by Venus to Aeneas in a sacred grove at the end of *Aeneid* 8 is also a favourite subject for artists.

Two of the most famous images associated with the *Aeneid* frame the narrative of the sack of Troy in *Aeneid* 2. At the beginning a family unit is wiped out when two monstrous serpents emerge from the sea to kill the Trojan priest Laocoon and his sons, apparently a sign that Troy and its future generations are doomed. At the end of the book three genera-tions of a family survive to start the search for a new Troy as Aeneas makes his way from the burning city carrying his father Anchises, who bears the Trojan *penates*, and leading his own son Ascanius by the hand. There are many pre-Virgilian images of Aeneas and Anchises fleeing from Troy, but it is now forever associated with Virgil's account of the story, as it perhaps already was in the statuary group of the subject that occu-pied a prominent position in the Forum of Augustus, dedicated in 2 BC, the most elaborate monument of Augustus' Rome and whose iconogra-phy has much in common with central themes of the *Aeneid*. The statues themselves are lost, but copies in painting and relief sculpture survive from antiquity, as does also a comic version in which the three humans are replaced by the figures of apes with dangling phalli:[14] it was already a cliché to be parodied. It is the subject of Bernini's earliest large-scale sculpture, in the Borghese Gallery in Rome, an exercise in accommodat-ing the three figures within a narrow marble block and in the contras-tive depiction of the three ages of man (Fig. 20).[15] The face of Aeneas recalls that of Michelangelo's *Risen Christ*, suggesting perhaps an analogy between Aeneas as the saviour of the Trojan people and Christ as Saviour, and looking forward to the 'resurrection' of Troy in new city-foundations in Italy. In Rome Bernini was preceded by Raphael's painting of 'The Fire in the Borgo' in the Stanza dell'Incendio in the Vatican, which includes on the left a man escaping with an old man on his shoulders, accompanied by a boy, a clear 'quotation' of the Virgilian subject (Fig. 21). The fresco depicts the miraculous halting of a fire in a district of Rome near St Peter's by Pope Leo IV in 847, and the visual allusion to the *Aeneid* suggests an analogy between the roles of Aeneas and the Pope as city-founders and city-preservers, and perhaps also between Aeneas and Raphael, energetic in supplying Rome with new, classicizing, works of art, as restorers of destroyed cities.

The only surviving ancient representation of the death of Laocoon is the statuary group in the Hellenistic baroque style unearthed in Rome in 1506 (Fig. 22). It was instantly acclaimed as a masterpiece of ancient

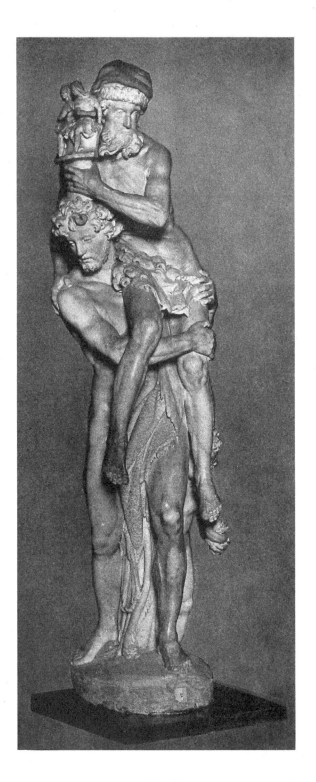

Fig. 20. Bernini
*Aeneas and
Anchises*, from R.
Norton, *Bernini
and Other Studies
in the History of Art*
(New York, 1914).

Fig. 21. Raphael, *The Fire in the Borgo*, Stanza dell'Incendio, Vatican.

art, the subject of many poems, and the model for countless later works of sculpture and painting.[16] An engraving of the group by Marcantonio Raimondi is labelled 'as in the second book of Virgil's *Aeneid*', but both its date and its relationship to Virgil's account of the death of Laocoon are much disputed – did Virgil know of it when writing his verbal *tour de force*, or is it an early illustration of, or homage to, the *Aeneid*? Allusions to the group are frequent in post-antique depictions of the Virgilian scene, and a comparison between the sculpture and Virgil's narrative is the starting point for a seminal eighteenth-century work on the difference between visual and verbal arts, Lessing's *Laocoon: An Essay upon the Limits of Painting and Poetry* (1766). Like the group of Aeneas fleeing from Troy with his father and son, the over-exposure of the Laocoon group has spawned numerous parodies, for example a *Punch* cartoon of 1909 showing John Bull struggling in the coils of excessive rates for telegraphic cables (Fig. 23).

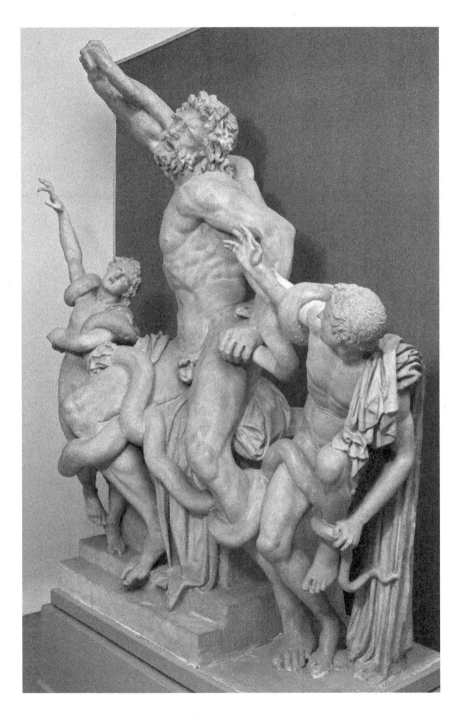

Fig. 22. The death of Laocoon.

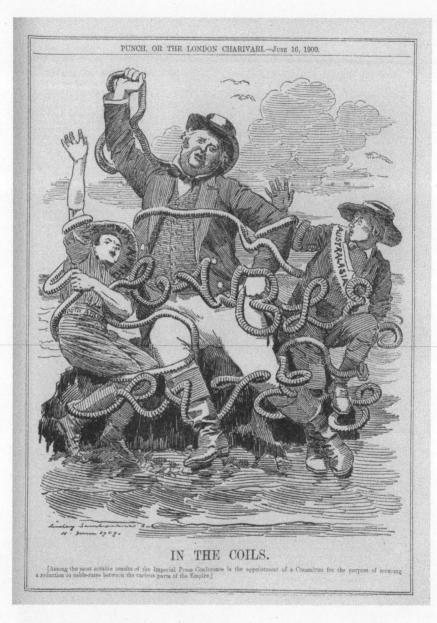

IN THE COILS.

[Among the most notable results of the Imperial Press Conference is the appointment of a Committee for the purpose of secur-ing a reduction in cable-rates between the various parts of the Empire.]

Fig. 23. 'In the coils', cartoon from *Punch*, 16 June 1909, 425.

The *Aeneid* and landscape

Perhaps the most distinctive contribution of Virgil as an inspiration for visual artists has been in the depiction of landscapes.[17] All three works of Virgil are set in landscapes charged with meaning and memory. The pastoral landscapes of the *Eclogues* are places of utopian contentment and abundance, but also of lost happiness. In the *Georgics* the busy countryside of the farmer is set within a wider panorama of man's imprint on Italy, and beyond that of semi-fantastic places in distant parts of the world. In the *Aeneid* the Trojans make landfall on the shore of north Africa in a numinous but also ominous harbour in a landscape. Aeneas proceeds to meet his mother in the first of a number of dark woods in the poem that foreshadow the fully symbolic dark woods of Dante and the Renaissance romance, before making his way to the magnificent cityscape under construction in the newly founded Carthage, the fresh dawn of a city with a long history, but a history that from Virgil's reader's perspective is now in the past, its palaces and towers razed to the ground by the Romans after the Third Carthaginian War in 146 BC.

Landscape and cityscape interact in suggestive ways in the Italy of the second half of the *Aeneid*. When the Trojans arrive at the mouth of the Tiber they find an idyllic, prelapsarian landscape; soon they travel to the temple-palace of King Latinus with its statue-gallery of ancestors and spoils of past wars. The stage on which is played out the action of the *Aeneid* is notable for the depth of its historical memory: this is the story of the remote legendary origins of Virgil's Rome, but that legendary past opens out on to remoter times still. The site of Rome in *Aeneid* 8, ruled over by the Arcadian king Evander, is a rural, quasi-pastoral, place, in the sharpest contrast to the temples of marble and gold of Augustus' day, but already it contains the ruins of earlier cities, the settlements of Janus and Saturn, 'memorials of men of old' (*Aen.* 8.356). Part of the charm and fascination for Virgil's first readers will have been the defamiliarization of very familiar Italian and Roman landscapes, placed in another time and seen through the eyes of exiles from another country.[18]

Landscape is already an important feature in the earliest of the cycles of paintings based on the *Aeneid*, that by Dosso Dossi for the 'Camerino d'alabastro' in the Ducal Palace at Ferrara (*c.* 1520), of which only three panels survive. In 'The entrance of Aeneas into the Elysian Fields' Aeneas and the Sibyl cross a bridge, past a rocky arch leading presumably to Tartarus, to emerge from the shadows into an idyllic landscape punctuated by occasional clumps of trees, in which the blessed converse

on the grass or dance. Landscape also plays a major part in the paintings at Scandiano, an early work by Niccolò dell'Abate who went on to become a leading painter at the French court at Fontainebleau, known for his mythological subjects in a landscape which would inspire Claude Lorraine and Nicolas Poussin.

A particularly atmospheric Virgilian landscape by Poussin is the *Landscape with Hercules and Cacus* (*c.* 1660) (Plate 11).[19] The subject is Hercules' killing of the monstrous Cacus, the story told by Evander to Aeneas on the site of Rome in *Aeneid* 8. The gigantic figures of the victorious Hercules and the slain Cacus, on the craggy Aventine where Cacus had his cave, echo Poussin's *Landscape with Polyphemus*, where the Cyclops towers on top of Etna (Fig. 13): there was a time when the site of Rome itself was infested by a man-eating monster. The parallels within the *Aeneid* between Polyphemus in Book 3 and Cacus in Book 8 are very clear.

Claude painted six scenes from the *Aeneid* in the last ten years of his life, works in which the landscape rather than the figures establish a mood.[20] *Coast Scene of Delos with Aeneas* (1672) depicts a stage on the Trojans' wanderings from Troy to Italy, drawing on both *Aeneid* 3 and Ovid's retelling of the Virgilian story in *Metamorphoses* 13. From Ovid comes the detail of the king of Delos pointing out to Aeneas the two trees to which Latona clung while giving birth to her twins Apollo and Diana. This natural memorial to a long-distant event in the history of the gods is balanced by a man-made architectural monument, the Temple of Apollo, anachronistically modelled on the Pantheon in Rome, one of the great buildings of the city which will be founded and ruled by the descendants of Aeneas. In *The Landing of Aeneas at Pallanteum* (the name of Evander's settlement on the site of the future Rome) (1675) Aeneas arrives in a pastoral landscape but already massive buildings rise out of the woods, including the Pantheon (Plate 12). On the other side of the Tiber are the ruins of the earlier cities, and in the background is the Ponte Rotto or 'Broken Bridge', the ancient *Pons Aemilius* which crosses the Tiber below the Tiber-island, in ruins by the seventeenth century. The anachronistic palimpsest that results from this superimposition within the landscape of different times in the history of Rome is in itself highly Virgilian.

In Pallanteum the idyll still holds, just, but Aeneas has come upstream from the mouth of the Tiber because war has already broken out in Latium in the previous book, 7. The immediate *casus belli* is shown in Claude's last painting, *Ascanius shooting the Stag of Sylvia* (1682) (Fig. 24). In a densely wooded, and slightly ominous, landscape, nature is taking over another ruined building, a great temple. The peace of Italy will soon be shattered

Fig. 24. Claude Lorraine, *Landscape with Ascanius shooting the Stag of Sylvia.*

when the infuriated Italian country-folk rush to arms to take revenge after Ascanius shoots a stag that he does not know to be the pet-stag of the shepherd's daughter Sylvia. Sylvia's name means 'girl of the woods': this is the point in *Aeneid* 7 when a landscape bearing the generic markers of pastoral is invaded by epic warfare. The wind that bends the trees on the left of the canvas is a harbinger of the whirlwind of war that will soon engulf Latium.

Claude's landscapes were especially popular in England, and their combination of trees, lawns and bodies of water inspired the creation of real landscapes in the shape of the eighteenth-century English landscape garden. More particular Virgilian references punctuate one of the grandest of these gardens at Stourhead in Wiltshire, created by the banker Henry Hoare in the mid-eighteenth century.[21] There is a major visual similarity between Claude's *Coast Scene of Delos with Aeneas* and the first vista seen by the visitor to the Stourhead garden, with a bridge to the left and a replica of the Pantheon across the lake to the right. The inscription over the first classical temple, *procul, o procul este profani* 'Keep away, keep

away, you that are uninitiated', are the words addressed by the Sibyl to Aeneas before they enter the Underworld in *Aeneid* 6. Over the entrance to the grotto was once an inscription referring to the Nymphs' cave in the Carthaginian harbour (*Aen.* 1.167–8), the first and one of the most haunting landscape descriptions in the *Aeneid*, and one of the models for Satan's first sight of the wooded mound topped by the Garden of Eden in Milton's *Paradise Lost* (4.131 ff.). Less high-minded activities in another of the great eighteenth-century landscape gardens are suggested by 'Dido's Cave', a classical garden seat at Stowe, probably built to a design by Sir John Vanbrugh for a 'garden of love', around 1720. A mural inside shows Dido and Aeneas surrounded by torch-holding Cupids. In his poem 'Stowe' of 1732 Gilbert West, nephew of Lord Cobham who laid out the gardens, tells how the vicar of Stowe was so taken by the charms of a young woman on a swing that he chased her through the gardens until he came upon her in Dido's Cave. Unlike Aeneas he did the honourable thing and is reported to have later married the girl.

Claude is also a major inspiration for the landscapes of J.M.W. Turner, who painted 11 canvases based on subjects from the *Aeneid*. Turner's last four exhibited paintings (1850) were all on incidents in the story of Dido and Aeneas, with lines attached from Turner's own poem 'Fallacies of Hope'.[22] He made two versions of Aeneas and the Sibyl at Lake Avernus. The first (*c.* 1798) was based on a drawing by the owner of Stourhead, Sir Richard Colt Hoare; the second (1814–15) hung in the cabinet room at Stourhead alongside another mythological Italian subject, *Lake Nemi with Diana and Callisto* by Richard Wilson, a founding father of British landscape painting, influenced himself by Claude and in turn an important influence on Turner. Italianate landscapes with Virgilian themes were thus visible inside and outside the house. In another Virgilian subject, *Dido and Aeneas* (1814), the small figures of the couple are on a bridge looking down on the classical cityscape of Carthage, superimposed on what is recognizably the riverscape of the Thames seen from Richmond Hill, another subject of Turner's. This is a double vision in space and time that magnifies the effect of the Virgilian superimposition in the *Aeneid* of places seen at different times of their history. Turner practised poetry as well as painting, and in a draft of a poem on Dido and Aeneas located their love-making in Alexander Pope's grotto at Twickenham, on the Thames close to Richmond.

The scenes of the Trojan War viewed by Aeneas in the Temple of Juno in *Aeneid* 1 are an ironic foreshadowing of the ultimate destruction of another great Mediterranean city, Carthage, as a result of the enmity with

Rome that will result from Dido's dying curse on the unfaithful Aeneas. Furthermore the sack of Troy might also raise thoughts about the perishability of Rome itself.[23] Consciously or not, Turner hints at a similar analogy between ancient and more recent history in the paired canvases of *Dido building Carthage; or the rise of the Carthaginian Empire* (1815) (Plate 13) and *The Decline of the Carthaginian Empire* (1817) (Plate 14). The composition of both is closely modelled on Claude's *Seaport with the Embarkation of the Queen of Sheba*, and in his will Turner asked that his two paintings should be hung in the National Gallery beside Claude's *Seaport*. In the first painting the sun is rising, in the second it is setting. They were painted at the end of the Napoleonic Wars: Turner saw in the fall of Napoleon an example of the inevitable rise and fall of great empires, which also contained a warning for the maritime empire of Britain. These are not the only nineteenth-century British paintings to suggest an analogy between Carthage and Britain: in Samuel Austin's *The Arrival of Aeneas at the Court of Dido Queen of Carthage* (1826, Walker Art Gallery, Liverpool), Liverpool's new classical buildings are part of the Carthaginian cityscape.[24] The grand vision of the cycle of empires in Turner's rise and fall of Carthage paintings is the vision of the *Aeneid*, whose larger temporal sweep takes in the destruction of Troy to be followed by the foundation and rise of Rome, whose empire is won to the cost of the Greek cities which had been victorious over Troy.

Turner's visions of imperial rise and decline impressed the imagination of Thomas Cole (1801–48), the English-born American artist who founded the Hudson River School of painting. Cole's most ambitious work is the five canvases of *The Course of Empire* ('The Savage State', 'The Arcadian, or Pastoral State', 'The Consummation of Empire', 'Destruction', 'Desolation').[25] History progresses through a series of visual allusions, all superimposed on the same topography. The wilderness and its inhabitants of 'The Savage State' are those of North America before the white man. In 'The Arcadian State' we are in a landscape by Claude or Poussin. 'The Consummation of Empire' shows a city redolent of imperial Rome – or of the grandiose classical buildings of nineteenth-century Washington DC (Plate 15). The harbour is reminiscent of Claude's *Seaport* or Turner's Carthage. 'Destruction' puts us in mind of Turner's storm scenes or of John Martin's apocalyptic biblical scenes. As a whole Cole's *The Course of Empire* reflects contemporary American idealization of pastoralism, and anxieties that empire would lead to excess and decay. Cole's nineteenth-century biographer described *The Course of Empire* as 'a grand epic poem, with a nation for its hero, and a series of national actions and events for

his achievement'.[26] The latent Virgilian vision of the course of empire, mediated to Cole through Turner, was not the first or last time that the plot of the *Aeneid* informed American conceptions of the destiny of their young nation.

NOTES

Chapter 1. Introduction

1. Eliot (1957), 68.
2. From the Constitution of the Society, reproduced in Blandford (1993), 90.
3. On the reception of Virgil in the first half of the twentieth century see Ziolkowski (1993), 17–26, on the bimillennial celebrations.
4. See Burrow (2004).
5. Ziolkowski and Putnam (2008), 744–50.
6. Hardie and Moore (2010), 4–7.
7. The phrase of Theodorakopoulos (1997), 156.
8. The *Life* of Donatus is conveniently available in English translation in Camps (1969), Appendix I. There is an excellent survey of the life and career of Virgil by Don and Peta Fowler in the *Oxford Classical Dictionary*, under 'Virgil'.
9. The great work on Virgil's imitation of Homer is Knauer (1964a); for an English summary of his main conclusions see Knauer (1964b), 61–84.
10. Macrobius, *Saturnalia* 1.24.11.
11. Hardie (1993).
12. Ricks (2002), 12.
13. Comparetti (1997), 28–9.
14. Suetonius, *De Grammaticis et Rhetoribus* 16.3.
15. See Wallace (2010); Tudeau-Clayton (1998), Ch. 2.
16. Comparetti (1997), 32.
17. An excellent impression of the range of Virgilian commentary down to the Renaissance, with ample exemplification, is given by Ziolkowski and Putnam (2008), 623–824. For antiquity and the Middle Ages see Comparetti (1997), Chs 5 and 6; Baswell (1995). Wilson-Okamura (2010) uses the commentary tradition to build a picture of how Virgil was read in the Renaissance.
18. The other is the *Virgilian Interpretations* by Tiberius Claudius Donatus (late fourth to early fifth century; not to be confused with Aelius Donatus), a paraphrase of the *Aeneid* focusing on Virgil's rhetorical skill in what is interpreted as an epic of sustained praise.
19. Title-page of *Virgilius cum commentariis quinque* (Lyon: Jacobus Sacon, 1499), reproduced in Wallace (2010), 62.

20. See Comparetti (1997), 63–9; Ziolkowski and Putnam (2008), 636–41.

21. Trapp (1984).

22. Ziolkowski and Putnam (2008), 829–30; Ekbom (2013); Loane (1928); van der Horst (1998).

23. McGill (2005); Rondholz (2012); Ziolkowski and Putnam (2008), 471–85.

24. On the Homer–Virgil comparison see Wilson-Okamura (2010), 124–42.

25. Simonsuri (1979); Caldwell (2008). On changing views of Virgil see Williams (1969); Selden (2006).

26. *Plain Truth, or Downright Dunstable: a Poem* (London, 1740): for this and other citations in the paragraph see T.W. Harrison (1967). See also Weinbrot (1978).

27. Upton (1746), 134.

28. Warton (1763), Vol. i, vi–vii.

29. Atherton (2006).

30. Hegel (1983–85), Vol. ii, 402.

31. English translation as Heinze (1993).

32. Graves (1962), an expansion of one of Graves' 1961 lectures as Oxford Professor of Poetry.

33. On Atlas as an emblem of the Virgilian sublime see Hardie (2009), 79–89.

34. This passage is not cited by Burke as an example of the sublime, but a number of passages from the *Aeneid* are.

35. As argued by Harrison (1967), 81–91.

36. Warton (1763), postscript to Vol. iv, 305–6.

37. For a fuller survey see Vance (1984).

38. Blair (1793), Vol. i, 447.

39. Shairp (1881), 188.

40. 'The modern element in literature', inaugural lecture as Oxford Professor of Poetry, 1857.

41. For a recent survey see Wharton (2008).

42. Watson (1986), 115.

43. For an excellent detailed survey of the landmarks and tendencies in twentieth-century criticism and scholarship on the *Aeneid* see S.J. Harrison, 'Some views of the *Aeneid* in the twentieth century', in Harrison (1990), 1–20.

44. Parry (1963).

45. Trapp (1718–20), Vol. ii, 880.

46. Clausen (1964).

47. Kallendorf (2007a).

48. Thomas (2001).

49. Eloy (1990).

50. Higgins (2009).

51. Cox (2011).

Chapter 2. Underworlds

1. Clark (1979), 13–16 'Near Eastern descents'.
2. Meres, Francis, *Palladis Tamia*, in Smith (1904), Vol. ii, 317–18. On the history of literary metempsychosis see Gillespie (2010).
3. Hardie (1993), 103–5; Kofler (2003), Ch. 4 'Ennius in der Unterwelt'.
4. Most (1992).
5. Particularly influential is Feeney (1986).
6. Hardie (1990).
7. Feldherr (1999).
8. The crossroads leading to places of damnation and places of bliss is Orphic-Pythagorean doctrine: Plato, *Gorgias* 524A.
9. On the consequences for imperial Roman epic see Hardie (1993), Ch. 3 'Heaven and Hell'.
10. Fabbri (1918); Hammond (1933).
11. The *Alexandreis* is accessible in a translation by Townsend (1996). The *Alexandreis* is one of three major twelfth-century works that rework the Underworld of the ancient Virgilian tradition, together with Bernardus Silvestris' *Cosmographia* and Alan of Lille's *Anticlaudianus*: see Korte (2008).
12. For an extended study of the afterlives of Virgil's *Fama* see Hardie (2012a).
13. See Feeney (1993), 241–8; Hardie (2002), 231–6.
14. See Hardie (2012a), 596–7.
15. On ghosts and intertextuality see Burrow (forthcoming).
16. Eduard Norden (1899) showed that Anchises' praise of Augustus at *Aen.* 6.791–805 is modelled on lost Alexander panegyric.
17. Hardie (1993).
18. There is an annotated translation by Bergin and Wilson (1977); for discussion see Bernardo (1962); Marchesi (2009).
19. *Africa* 9.179 'he was a shade' *umbra fuit*: cf. Dante, *Inferno* 1.66–7 '"Whatever you be, whether a shade or, for sure, a man." He replied: "Not a man; I was a man once"' ('Qual che tu sia, od ombra od uomo certo.' | Risposemi: 'Non uomo; uomo già fui').
20. On the 'necromantic metaphor' at the heart of the Renaissance's sense of itself as the revival of antiquity see Greene (1982).
21. See Hinds (2004).
22. Comparetti (1997), Part II; Spargo (1934).
23. In the *Image du Monde* (1245): see Comparetti (1997), 312–13.
24. Laird (2001), 50.
25. Comparetti (1997), 92–3.
26. Wiseman (1992).
27. Comparetti (1997), Ch. 8; Baswell (1995), Ch. 3 'Spiritual allegory, platonizing cosmology, and the Boethian *Aeneid* in medieval England'; 91–101 'Late Antique Virgilianism and medieval modes of allegorical interpretation'.
28. See Wilson-Okamura (2010), 157–8.
29. Kallendorf (1989), Ch. 6 'Dante and the Virgil criticism of Cristoforo

Landino'; Wilson-Okamura (2010), Index s.v. 'Landino'.

30. See Courcelle (1995a) for copious illustration of the response of the Church Fathers to the several parts of the Virgilian Underworld, from the third to the sixth centuries.

31. See Courcelle (1995b).

32. Courcelle (1995a), 52–3; Wilson-Okamura (2010), 173–8 'Purgatory'.

33. Norden (1957), 5–10; Courcelle (1995b), 65, revises this conclusion, with reference to the *Vision of St. Paul*.

34. From the very extensive bibliography on Dante and Virgil a few items: Comparetti (1997), Ch. 14; Jacoff and Schnapp (1991); Brownlee (1993), Ch. 9.

35. On this episode see Hawkins (1991); Jacoff (1991).

36. Edited by Thurn (1995); commentary by Thurn (2002).

37. Noted by Stephen J. Harrison (2008), 115.

38. Fowler (2009), 244.

39. Reeves (1989).

40. On modern descents see Pike (1997); Platthaus (2004); Falconer (2005).

41. 'A short account of psycho-analysis', *Standard Edition [...] of Sigmund Freud*, Vol. 19 (1923), 191, discussed by Oliensis (2009), 127–9.

42. Timpanaro (1976), 29–61.

43. See Cox (1999), 132–58; Duffy (1990), 36–8.

44. Butor (1964), 256.

45. See Putnam (2012).

Chapter 3. 'La donna è mobile': Versions of Dido

1. General books on the reception of Dido: Burden (1998); Bono and Tessitore (1998); Martin (1990); Kailuweit (2005).

2. Hinds (1993).

3. On the traditions about Dido see Pease (1935), 14–22.

4. Desmond (1994), 24–33, 55–73.

5. Lord (1969).

6. Kallendorf (1989), Ch. 3 'Boccaccio's two Didos'.

7. See Hardie (forthcoming).

8. Pascal (1917).

9. O'Hara (1996), 110–11.

10. See Baccar (1990).

11. Translations by Melvin Dixon, in Senghor (1991). See Cailler (2007).

12. On similarities between Virgil's Dido and Aeneas and Plutarch's Antony and Cleopatra (Shakespeare's main source) see Pelling (1988), 17–18.

13. Desmond (1994), Ch. 2 'Dido as *libido*: from Augustine to Dante'.

14. Warner (2005), Ch. 1 'Petrarch's *culpa* and the allegory of the *Africa*'; Ch. 2 'Renaissance allegories of the *Aeneid*: the doctrine of the two Venuses and the epic of the two cities'; Kallendorf (1989), 28–9, 48–9.

15. Hall (2008), Ch. 14 'Sex and sexuality'.

16. Watkins (1995); Hardie (2010).
17. See Pugh (2005), 58–66.
18. See Williams (2006); Weber (1999).
19. Binns (1971); Roberts-Baytop (1974). On Gager's *Dido* and the Sieve portrait see Purkiss (1998).
20. Camden (1615), i, 494
21. Desmond (1994), Ch. 6 'Christine de Pizan's feminist self-fashioning and the invention of Dido'.
22. Marshall (2011).
23. See Semrau (1930), 63–6.
24. This is the ingenious argument of Tschiedel (2010).
25. Transl. in Ahern (1988).
26. Cox (2011), Ch. 12. Another supplement of Lavinia's story is Claudio R. Salvucci's *The Laviniad: An Epic Poem* (1994). A modern novel which practises greater violence on Virgil's plot in order to allow a female character a central role is the *Creusid* by the leading Hungarian woman novelist Magda Szabó (2009), in which Creusa, Aeneas' first wife, does not die in the flight from Troy, but instead kills Aeneas outside the gate of the city before he can kill her, to become another female leader of a refugee people, impersonating her husband in the journey to Italy.
27. See Green (2009).
28. See Porter (1993), 112.
29. Transl. Yunck (1974); see Cormier (1973); Mora-Lebrun (1994); Singerman (1986), 80–98 on the love of Eneas and Lavine; Baswell (1995), Ch. 5 'The Romance *Aeneid*'; Wilson-Okamura (2010), 233–9.
30. Wilson-Okamura (2010), 239–47.
31. Bennett (2002).
32. Dynastic romance: Fichter (1982); the reconciliation of honour and love is a central theme of Burrow (1993).
33. From the large bibliography on the *House of Fame* see Baswell (1995), Ch. 6 'Writing the reading of Virgil: Chaucerian authorities in the *House of Fame* and *The Legend of Good Women*'.
34. Waddell (1932), xxiii.
35. Dronke (1992).
36. Ziolkowski (1993), 95–8.
37. Semrau (1930), 18–36; Glei (2000).
38. For lists see Martin (1990, xi–xxv; Semrau (1930), 93–4. On the Italian tradition see Lucas (1987); Herrick (1965). On the French tradition see White (1975) and the chapters by Lazard, Ducos and Fabre in Martin (1990). On the German tradition see Semrau (1930).
39. Page numbers are as in Balmas (1968).
40. Howe (1994) has a long and informative introduction.
41. For a survey of approaches see Deats (2004).
42. Ziosi (2012).

43. On Virgil and Purcell's *Dido and Aeneas* see Harris (1987); Paulsen, 'Henry Purcells Oper "Dido and Aeneas",' in Binder (2000), Ch. 7; Fisk and Munns (2002).

44. On Virgil and *Les Troyens* see Cairns (1988); Fitzgerald (2004); Bowersock (2009); Pillinger (2010).

45. See Heller (1998).

46. Semrau (1930), Ch. V.

47. Néraudau (1990), 299–306.

48. See Paratore (1973).

49. Vance (2000), 221.

Chapter 4. The Many Faces of Aeneas

1. Mackie (1988); Schauer (2007).

2. Heinze (1993), 223.

3. Stahl (1981).

4. Griffin (1993).

5. *Discourse on Epick Poetry.*

6. Werner (2002).

7. This is the suggestion of E.L. Harrison (2006).

8. Stanford (1954), Ch. 9 'Ulysses among Alexandrians and Stoics'.

9. See Starr (1992); for a selection of Tiberius Donatus see Ziolkowski and Putnam (2008), 644–9.

10. See Kallendorf (1989); see also Wilson-Okamura (2010), 208–12 'The ideal man theory'; Morton (2000), Introduction.

11. Cited by Brower (1940), 120.

12. See Hammond (1999), Ch. 4 'The epic of exile'.

13. For a survey see Garrison (1992), Ch. 6 'War: Turnus and *pietas* in the later Renaissance'.

14. Fowler (2000).

15. 'Repressed remorse' is the phrase of Colin Burrow (1993), 57; the history of pity and compassion in epic and romance, with a particular focus on the evolutions of Virgilian *pietas*, is at the heart of Burrow's book. On Virgil's *pietas* and the later history of the word see also Henry (1873–89), i, 175–87; Garrison (1992).

16. Morton (2000), Ch. 6 'Turnus the bold and Aeneas the pious'.

17. See Seem (1990).

18. Vegio (2004). On supplements to the *Aeneid* in general see Oertel (2001), 1–18.

19. Kallendorf (1989), Ch. 5.

20. Also reworking the antithesis in Aeneas' address to Ascanius at 12.435–6 '*disce, puer, uirtutem ex me uerumque laborem, | fortunam ex aliis.*'

21. Cairns (1989), esp. Chs 1–3.

22. Heinze (1993), 227

23. Hardie (1986), 326.

24. Comparetti (1997), 107–15; Kallendorf (1989), 175 n. 14.
25. Galinsky (1972), Ch. 5 'Herakles among the philosophers and Alexandrians'.
26. On the tenacity of allegorization see Borris (2000). On medieval allegorization of the *Aeneid* see Baswell (1995), Chs 3–4; on Renaissance allegorical epic see Aguzzi (1971); Treip (1994).
27. Kallendorf (1989), Ch. 6; Allen (1970), 142–54; Murrin (1980), Ch. 2.
28. See Kallendorf (1989), 160–5.
29. Paduano (2008).
30. Donatus, *Life of Virgil*, 39; the gesture has been often repeated through history with or without conscious imitation of Virgil: see Krevans (2010).
31. Kofler (2003); Deremetz (1995), Ch. 6 '*Heros cunctans*', on the hesitating Aeneas as a reflection of the hesitations of the poet himself in the face of his poetic task.
32. Cox (1999), 38–56; Ziolkowski (1993), 203–22.
33. Putnam (1965), 41–8.

Chapter 5. Empire and Nation

1. For the comparison between the historical allegory of the *Aeneid* and biblical typology see Gransden (1973/74).
2. Ziolkowski (1993), 12–17.
3. Thomas (2001), 1–7.
4. See Haan (1992, 1993); Hardie (2012a), 429–38.
5. Martin (1972); Brower (2010).
6. See Stechow (1968), 47, 58 for pagan/Christian interferences in Rubens.
7. Gevaerts (1641).
8. Hardie (1986), Chs 3 and 4.
9. *Ibid.*, Ch. 8.
10. von Albrecht (1964), 143.
11. Ware (2012).
12. *Ibid.*, 128–41.
13. Rees (2004), 39–40.
14. Curtius (1953), 29, 384.
15. Ziolkowski and Putnam (2008), 96–100; Holtz (1997).
16. Godman (1987), 74–6; see also Tanner (1993), Ch. 3.
17. See Zwierlein (1973).
18. See Yates (1975), 9–11.
19. The classic study is Yates (1975). On the Hapsburg tradition see Tanner (1993).
20. Strong (1973), 79.
21. Joachim Meister, *De Rodolpho Habspurgico* (Görlitz, 1576): see Römer (2001).
22. Parry (1981), 17.
23. Gwynne (2012).
24. Yates (1975), 29–87 'Queen Elizabeth I as Astraea'.
25. See Parry (1981), 1–21; Erskine-Hill (1983), 123–9.

26. Dekker (1953–61), ii, 298.
27. Stephen Harrison (1604).
28. Jonson (1925–52), vii, 100.
29. See Erskine-Hill (1983), 106.
30. Ogilby (1662); see Erskine-Hill (1983), 216–19.
31. Hammond (1999); Erskine-Hill (1983), Ch. 8 'Dryden and the Augustan idea'.
32. Hammond (1999), 92–105.
33. Vance (2000), 216–17.
34. Recorded by Camden, *Britain* (1610), 80; revived by Edmund Bolton in *London, King Charles, His Augusta* (1648).
35. Audra and Williams (1961), 132.
36. O'Brien (2002).
37. Tennyson and Virgilian imperialism: Vance (1997), 149–53 'Virgil and Tennyson'; and also Vasunia (2009), 100 ff.
38. Markley (2004), 8.
39. Vance (1997), 151–2.
40. Anzinger (2010).
41. See Barchiesi (2006), xxxvii.
42. The phrase *urbs aeterna* itself is first attested at Tibullus 2.5.23.
43. Feeney (1993), 155.
44. O'Hara (1990), 132–51.
45. Bawcutt (1976), 109.
46. Neander (1768).
47. Hammond (1999), 126–38 on *The Hind and the Panther*; Ch. 4 on Dryden's response 'to several kinds of tragic loss and alienation' in his translation of the *Aeneid*.
48. I am indebted to Mark Heerink for help with the interpretation of *Gijsbreght*. See van der Paardt (1987).
49. In general see Erskine (2001).
50. Beaune (1982); Tanner (1993), Ch. 5 'Mythic genealogy'; Hay (1957), 48–9.
51. Huppert (1965).
52. Laumonier (1983); see also Yates (1975), 130–3, on the connections between the *Franciade* and Ronsard's programme for the entry of Charles IX with his new queen, Elizabeth of Austria, from a house also of Trojan descent.
53. Tatlock (1950); Heninger (1962); Waswo (1988).
54. Vance (2000), 221–2; Fisk and Munns (2002).
55. O'Brien (2002), 283.
56. Spencer (1952).
57. J.C. Scaliger, *Poematia* (Lyons, 1546), 382.
58. Ed. Manetti (1978).

Chapter 6. *Imperium sine fine*. The *Aeneid* and Christianity

1. Comparetti (1997), 313–14.
2. Ziolkowski and Putnam (2008), 856–7 (Alexander Neckam); Spargo (1934), 117.
3. Paschoud (1967), 178–87, 224–7; McShane (1979), 61–8.
4. Ziolkowski and Putnam (2008), 487–503; Comparetti (1997), 99–103.
5. For a judicious sifting of the evidence see Nisbet (1978).
6. Roberts (1985); Green (2006); Herzog (1975). For a survey of biblical epic down to the Renaissance see Lewalski (1966), Ch. 3.
7. For an account of the treatment of Virgilian fame in Christian epic see Hardie (2012a), Ch. 11 'Christian conversions of *fama*'.
8. Pollmann (2004); Buchheit (1988); Roger Green (1995).
9. Galinsky (1972), 202–6.
10. *Virgilii Evangelisantis Christiados Libri XIII. Inflante Alexandro Rosaeo Aberdonense* (London, 1638), an expansion of *Virgilius Evangelisans* (London, 1634).
11. Döpp (2000).
12. There is a rich bibliography on Augustine and Virgil: important contributions include Hagendahl (1967), 444–59 on Virgil in the *City of God*; MacCormack (1998); O'Donnell (1980); Gillian Clark (2004).
13. On Virgil in the *Confessions* see also Bennett (1988); O'Meara (1963), 252–61.
14. O'Meara (1963), 260, for the suggestion that Augustine here thinks of the Virgilian underworld.
15. This problem and the solutions found for it are the subject of Gregory (2006).
16. Ulysses: Stanford (1954); Hercules: Galinsky (1972).
17. Steadman (1967).
18. Cairns (1989), 31–8; see also McGushin (1964).
19. Hardie (1986), 280–1, 374.
20. The phrase is Roberts' (2004), 57.
21. See Quint (1983), Ch. 3 'Sannazaro: from Orpheus to Proteus'; Hardie (2013).
22. Auerbach (1965), Ch. 1 '*Sermo humilis*'.
23. Milton and Virgil: start from Blessington (1979) and Martindale (1986); see also Gransden (1984); Putnam (2006). On the generic encyclopedism of *Paradise Lost* see Lewalski (1985).
24. In Fracastoro, *Opera Omnia* (Venice, 1555).
25. Greene (1982).
26. Hardie (2012b).
27. Quoted by Haecker (1931), 86.
28. For detailed discussion of the topics in these paragraphs see Ziolkowski (1993), esp. Ch. 1; 48–51 on Haecker; 76–89 on 'The German millennialists', and the scholarly and more popular revival of interest in the Fourth *Eclogue* in Germany in the years around 1930.

29. In Eliot (1957).
30. Galinsky (1972), Ch. 5 'Herakles among the philosophers and Alexandrians'.
31. 'Vergil and the Christian world', in Eliot (1957), 135–48.
32. Lützeler (1976), 204–5.
33. Snell (1953), 301.
34. Klingner (1965), 297–8.
35. For what follows see Hardie (2000).
36. Fränkel (1945), 163.
37. Ziolkowski (2005), 118–21 on Horia; 125–9 on Malouf.

Chapter 7. The *Aeneid* and New Worlds

1. See Jones (1964), esp. Chs 1 and 2; Elliott (1970), 24–6 on the importance of the classical tradition.
2. See Clay (1992).
3. For a detailed study of the source and meaning(s) of the motto see Rosenthal (1971).
4. Jones (1964), Ch. 1 'The image of the New World' (Utopian); Ch. 2 'The anti-image' (devils and cannibals).
5. In the translation of Richard Eden (1555).
6. Gambara's epic is edited by Gagliardi (1993). For a survey of Columbus epics see Hofmann (1994).
7. Cañizares-Esguerra (2006).
8. Laird (2010).
9. On New World themes in *Paradise Lost* see Evans (1996); Quint (1993), 253–6 on Satan as a New World explorer.
10. Quint (1993), 49 'Appendix 2. Lepanto and Actium'. For a selection of neo-Latin poems on Lepanto see Wright, Spence, Lemons (2014).
11. See Dougherty (2001), index s.v. 'Cyclopes'.
12. See Hall (2008), Ch. 7.
13. Quint (1993), 126–7; Hardie (2004).
14. Davis (2000); Quint (1993), 157–85; Kallendorf (2007a), 77–102; Galperin (2009).
15. On Dido in Spanish literature see Lida de Malkiel (1974).
16. Valuable for its detailed comparisons with voyagers' accounts is Frey (1979).
17. For a reading that does aim to show that 'the Virgilian material merges with the colonial discursive context', in a search for 'the voice of the colonial Other' speaking within an imperialist and colonialist Virgilian framework, see Kallendorf (2007a), 102–26, with extensive bibliography of earlier discussions of the *Aeneid* as source for *The Tempest*; note in particular Hamilton (1990); see also Wilson-Okamura (2003).
18. This is the conclusion of Martindale (2004), 89 'Shakespeare is not usefully to be described as a Virgilian poet.'
19. Orgel (1987), 33.
20. *Ibid.*, 19.

21. Kallendorf (2007a), 125; Bruner (1976).
22. See Shields (2001); Reinhold (1984).
23. Jones (1964), 238.
24. Bercovitsch (1966), 337.
25. Cited by Shields (2001), 188.
26. Cited by Shields (2001), 190.
27. See McWilliams (1989).
28. See Ziolkowski (1993), Ch. 5 'Virgil in the New World'.
29. Allen Tate, obituary for William Faulkner, cited by Ziolkowski (1993), 173.

Chapter 8. Parody and Burlesque

1. See Acosta-Hughes in Acosta-Hughes et al. (2011), 7–8. On laughter in Homer see Halliwell (2008), Ch. 2.
2. Rosen (2007), Ch. 3 on Thersites and the ancient traditions of satire.
3. Hutcheon (1985), 33; another influential account is Rose (1993); see also Goldhill (1991), Ch. 3.
4. Gigante (1984), 83–4.
5. On this and other aspects of Ovid's imitation of Virgil in his 'little *Aeneid*' in *Metamorphoses* 13 and 14 see Hinds (1998), 104–22.
6. On allusions to Virgil in Apuleius' *Golden Ass* see Harrison (1997).
7. Siewert (2007).
8. Tucker (2009); Glei (2006).
9. Most (1987).
10. Text and comment on 'Virgil's Gnat' and 'Muiopotmos' in McCabe (1999).
11. McRae (1998).
12. von Stackelberg (1982).
13. Modern edition: Serroy (1988); see H.G. Hall (1967); Flamarion (1990).
14. Morillot (1888), cited by von Stackelberg (1982), 236.
15. Nicolas Boileau-Despreaux, 'Au Lecteur', prefixed to the first edition of *Le Lutrin* (1674).
16. Pinnock (1998).
17. See Mace (1996).
18. Parker (2012); Rawson (2010); see also Bond (1932).
19. Translated by Ozell (1711–12).
20. *A Discourse concerning the Original and Progress of Satire*, quoted in Brower (1940), 131.
21. Parker (2012), 335.
22. Brower (1959), Ch. 10 'The intellectual scene: the tradition of Pope'; Robertson (2009), Ch. 3 'Pope's *Dunciad* and its successors'; Jones (1968).
23. Brower (1959), 342.
24. Robertson (2009), Ch. 8 'Heroes in their underclothes: Blumauer's travesty of the *Aeneid*.'
25. Cadot (1999).
26. See Robertson (2009), 331–7 'Byron and Homer'.
27. Rawson (2010), 187–90.

Chapter 9. Art and Landscape

1. The fullest collection of materials on Virgil in art is in the catalogue of an exhibition held in Rome on the bimillennium of Virgil's death, Fagiolo (1981). For briefer surveys see Llewellyn (1984); Liversidge (1997). See also Bardon (1950).
2. From the Casa di Sirico (VII 1, 25.47; Naples, Mus. Naz. inv. nr. 9009).
3. Toynbee (1964), 241–6.
4. Vatican Virgil: Wright (1993); Roman Virgil: Wright (2001). See also Cameron (2011), 706–12 'Illuminated manuscripts'.
5. Ziolkowski and Putnam (2008), 433–4; 438–46 'Illuminated *Aeneid*, 800–1500'; Courcelle and Courcelle (1984).
6. Callmann (1974).
7. Suerbaum (2008). On particular sets of illustrations see Leach (1982) (Brant and Dryden); Kallendorf (2001).
8. Langmuir (1976), 157.
9. Fagiolo (1981), 161–71; Preimesberger (1976); Rowland (2010).
10. See Levey (1957).
11. See Hano (1990); Montagu (1998).
12. Postle (1995), 187–92; Brenneman (1999).
13. Brunel (1986).
14. *Lexicon Iconographicum Mythologiae Classicae*, 'Aineias' 99.
15. Hibbard (1990), 34–8.
16. See Most (2010); Settis (1999).
17. McKay (1969).
18. On landscape in the *Aeneid* there is much sensitive discussion in Jenkyns (1998).
19. Rosenberg and Christiansen (2008), 109–10.
20. Langdon (1989), 148–50.
21. Woodbridge (1970); timely scepticism as to the extent of the Virgilian programme at Stourhead in Kelsall (1983).
22. Finley (1999), 61–81.
23. Barchiesi (1999).
24. Vance (2000), 217 n. 9.
25. Powell (1990), 62–71.
26. Noble (1853), 168.

BIBLIOGRAPHY

Those who wish to explore further will find rich materials in Farrell and Putnam (2010), and, for the first 1,500 years of Virgil's influence, in Ziolkowski and Putnam (2008). The six large and copiously illustrated volumes of the *Enciclopedia Virgiliana* (Rome 1984–91) include detailed entries on many aspects of the reception of the *Aeneid*, as does *The Virgil Encyclopedia* (eds R.F. Thomas and J.M. Ziolkowski) (Wiley-Blackwell, 2014).

Acosta-Hughes, Benjamin, et al. (eds) (2011) *Homère revisité: parodie et humour dans les réécritures homériques*. Besançon

Aguzzi, Danilo L. (1971) *Allegory in the Heroic Poetry of the Renaissance*. Ann Arbor

Ahern, M. (ed.) (1988) *A Rosario Castellanos Reader*. Austin

Ahl, Frederick (transl.) (2007) *Virgil. Aeneid*. Oxford

Allen, Don C. (1970) *Mysteriously Meant: The Rediscovery of Pagan Symbolism and Allegorical Interpretation in the Renaissance*. Baltimore

Anzinger, Silke (2010) 'Von Troja nach Gondor. Tolkiens "The Lord of the Rings" als Epos in vergilischer Tradition', in Burkard, Schauer and Wiener (2010), 363–401

Atherton, Geoffrey (2006) *The Decline and Fall of Virgil in Eighteenth-Century Germany. The Repressed Muse*. Rochester, NY, and Woodbridge

Audra, E. and Aubrey Williams (eds) (1961) *Alexander Pope. Pastoral Poetry and An Essay on Criticism*. London and New Haven

Auerbach, Erich (1965) *Literary Language and its Public in Late Latin Antiquity and the Middle Ages*, transl. R. Mannheim. London

Baccar, Alya (1990) 'Survie d'Elissa-Didon dans la Tunisie contemporaine', in Martin (1990), 241–9

Balmas, E. (ed.) (1968) *Etienne Jodelle. Œuvres completes*, Vol. ii, *Le poète dramatique. Le poète satirique*. Paris

Barchiesi, Alessandro (1999) 'Representations of suffering and interpretation in the *Aeneid*', in P. Hardie (ed.) *Virgil. Critical Assessments of Classical Authors* (New York and London, 1999), Vol. iii, 324–44

—— (2006) 'Introduzione' to *Publio Virgilio Marone. Eneide*. Milan

Barchiesi, M. (1981) 'I moderni alla ricerca di Enea', in *I moderni alla ricerca di Enea*. Rome: 11–46

Bardon, H. (1950) 'L'*Énéide* et l'art, XVIe–XVIIIe siècles', *Gazette des Beaux-Arts*, 77–98

Baswell, Christopher (1995) *Virgil in Medieval England. Figuring the Aeneid from the Twelfth Century to Chaucer.* Cambridge

Bawcutt, Priscilla (1976) *Gavin Douglas: A Critical Study.* Edinburgh

Beaune, Collette (1982) 'L'utilisation politique du mythe des origines troyennes en France à la fin du moyen age', in *Lectures médiévales de Virgile* (1982)

Bennett, Camille (1988) 'The conversion of Vergil: the *Aeneid* in Augustine's *Confessions*', *Revue des Études augustiniennes* xxxiv, 47–69

Bennett, Philip (2002) 'La femme, l'amour, le pouvoir: Henri Plantagenêt et le *Roman d'Eneas*', in D. Buschinger (ed.) *Autour d'Aliénor d'Aquitaine*, *Médiévales* xxii, 20–7

Bercovitsch, Sacvan (1966) 'New England epic: Cotton Mather's *Magnalia Christi Americana*', *English Literary History* xxxiii, 337–50

Bergin, T.S. and A.S. Wilson (1977) *Petrarch's Africa.* New Haven and London

Bernard, J.D. (ed.) (1986) *Vergil at 2000: Commemorative Essays on the Poet and His Influence.* New York

Bernardo, Aldo (1962) *Petrarch, Scipio and the 'Africa'. The Birth of Humanism's Dream.* Baltimore

Binder, Gerhard (ed.) (2000) *Dido und Aeneas: Vergils Dido-Drama und Aspekte seiner Rezeption* (rev. ed.). Trier

Binns, J.W. (ed. and transl.) (1971) 'William Gager's *Dido*', *Humanistica Lovaniensia* xxix, 167–254

Blair, Hugh (1793) *Lectures on Rhetoric and Belles Lettres*, 2 vols. London

Blandford, D.W. (1993) *Pentekontaetia. The Virgil Society 1943–1993.* London

Blessington, F.C. (1979) *Paradise Lost and the Classical Epic.* Boston, London and Henley

Bond, Richmond P. (1932) *English Burlesque Poetry 1700–1750.* Cambridge, MA

Bono, Paola and M. Vittoria Tessitore (1998) *Il mito di Didone. Avventure di una regina tra secoli e culture.* Milan

Borris, Kenneth (2000) *Allegory and Epic in English Renaissance Literature. Heroic Form in Sidney, Spenser, and Milton.* Cambridge

Bowersock, Glen W. (2009) 'Berlioz, Virgil, and Rome', in *From Gibbon to Auden: Essays on the Classical Tradition.* Oxford: 89–97

Brenneman, David A. (1999) 'Self-promotion and the sublime: Fuseli's "Dido on the funeral pyre"', *Huntington Library Quarterly* lxii, 68–87

Broch, Hermann (1946) *The Death of Virgil*, transl. J.S. Untermeyer. London

Brower, Reuben (1940) 'Dryden's epic manner and Virgil', *PMLA* lv, 119–38

—— (1959) *Alexander Pope: The Poetry of Allusion.* Oxford

—— (2010) 'Visual and verbal translation of myth. Neptune in Vergil, Rubens, and Dryden', in Farrell and Putnam (2010), 270–89

Brownlee, Kevin (1993) 'Dante and the classical poets', in R. Jacoff (ed.) *The Cambridge Companion to Dante.* Cambridge: Ch. 9

Brunel, George (1986) *Boucher.* London

Bruner, Charlotte H. (1976) 'The meaning of Caliban in Black literature today',
 Comparative Literature Studies xiii, 240–53
Buchheit, Vinzenz (1988) 'Vergildeutung im *Cento* Probae', *Grazer Beiträge* xv,
 161–76
Burden, Michael (1998) *A Woman Scorn'd. Responses to the Dido Myth.* London
Burkard, T., M. Schauer and C. Wiener (eds) (2010) *Vestigia Vergiliana. Vergil-
 Rezeption in der Neuzeit.* Berlin and New York
Burrow, Colin (1993) *Epic Romance: Homer to Milton.* Oxford
—— (1997) 'Virgil in English translation', in Martindale (1997), Ch. 2
—— (2004) 'English Renaissance readers and the *Appendix Vergiliana*',
 Proceedings of the Virgil Society xxvi, 1–16
—— (forthcoming), *Metaphors of Imitation* (Blackwell's Lectures)
Butor, Michel (1964) *Essais sur les modernes.* Paris
Cadot, Michel (1990) 'Énée et Didon à la mode d'Autriche, d'Ukraine et de
 Belgique', in Martin (1990), 209–20
Cailler, B. (2007) *Carthage ou la flame du brasier. Mémoire et échos chez Virgile,
 Senghor, Mellah, Ghachem, Augustin, Ammi, Broch et Glissant.* Amsterdam
 and New York
Cain, Tom (ed.) (1995) *Ben Jonson. Poetaster.* Manchester
Cairns, David (1988) 'Berlioz and Virgil', in Ian Kemp (ed.) *Hector Berlioz: Les
 Troyens.* Cambridge: 76–88
Cairns, Francis (1989) *Virgil's Augustan Epic.* Cambridge
Caldwell, Tanya M. (2008) *Virgil Made English: The Decline of Classical Authority.*
 New York
Callmann, Ellen (1974) *Apollonio di Giovanni.* Oxford
Camden, William (1615) *Annales Rerum Anglicarum et Hibernicarum, Regnante
 Elizabetha.* London
Cameron, Alan (2011) *The Last Pagans of Rome.* Oxford
Camps, W.A. (1969) *An Introduction to Virgil's Aeneid.* Oxford
Cañizares-Esguerra, J. (2006) *Puritan Conquistadors: Iberianizing the Atlantic,
 1550–1700.* Stanford
Cardwell, R.A. and J. Hamilton (eds) (1986) *Virgil in a Cultural Tradition.*
 Nottingham
Chevallier, R. (ed.) (1978) *Présence de Virgile: Actes du Colloque des 9, 11 et 12
 décembre 1976.* Paris
Clark, Gillian (2004) 'City of God(s): Virgil and Augustine', *Proceedings of the
 Virgil Society* xxv, 83–94
Clark, Raymond J. (1979) *Catabasis. Vergil and the Wisdom-Tradition.* Amsterdam
Clausen, Wendell (1964) 'An interpretation of the *Aeneid*', *Harvard Studies in
 Classical Philology* lxviii, 139–47
Clay, Diskin (1992) 'Columbus' Senecan prophecy', *American Journal of Philology*
 cxiii, 617–20
Comparetti, Domenico (1997) *Vergil in the Middle Ages*, transl. E.F.M. Benecke,
 with a new introduction by J.M. Ziolkowski. Princeton

Cormier, Raymond J. (1973) *One Heart One Mind: The Rebirth of Virgil's Hero in Medieval French Literature*. University, Mississippi

Courcelle, Pierre (1984) *Lecteurs païens et lecteurs chrétiens de l'Énéide*, Vol. i, *Les témoignages littéraires*. Paris

—— (1995a) 'Les pères de l'église devant les enfers virgiliens', *Annales d'histoire doctrinale et littéraire du moyen-age* xxx, 5–74

—— (1995b) 'Interprétations néo-platonisantes du livre VI de l'*Énéide*', in W.K.C. Guthrie (ed.) *Recherches sur la tradition platonicienne*. Geneva: 93–136

—— and J. Courcelle (1984) *Lecteurs païens et lecteurs chrétiens de l'Énéide*, Vol. ii, *Les manuscrits illustrés de l'Énéide du dixième au quinzième siècle*. Paris

Cox, Fiona (1999) *Aeneas takes the Metro. The Presence of Virgil in Twentieth-Century French Literature*. Oxford

—— (2011) *Sibylline Sisters. Virgil's Presence in Contemporary Women's Writing*. Oxford

Curtius, Ernst. R. (1953) *European Literature and the Latin Middle Ages*, transl. Willard R. Trask. London

Davis, Elizabeth B. (2000) *Myth and Identity in the Epic of Imperial Spain*. Columbia, MO

Deats, Sara M. (2004) '*Dido, Queen of Carthage* and *The Massacre of Paris*', in P. Cheney (ed.) *The Cambridge Companion to Christopher Marlowe*. Cambridge: 193–206

Dekker, Thomas (1953–61) *The Dramatic Works*, ed. F. Bowers, 4 vols. Cambridge

Deremetz, Alain (1995) *Le Miroir des Muses. Poétiques de la réflexivité à Rome*. Lille

Desmond, M. (1994) *Reading Dido: Gender, Textuality, and the Medieval 'Aeneid'*. Minneapolis

Döpp, S. (2000) '*Virgilius Evangelisans*: zu Praefatio und Prooemium von Alexander Ross' *Christias*', *Nachrichten der Akademie der Wissenschaften in Göttingen 1. Philologisch-historisch Klasse* vi, 257–99

Dougherty, Carol (2001) *The Raft of Odysseus. The Ethnographic Imagination of Homer's Odyssey*. Oxford

Dronke, P. (1992) 'Dido's lament: from medieval Latin lyric to Chaucer', in Dronke, *Intellectuals and Poets in Medieval Europe*. Rome: 431–56

Dudley, D.R. (ed.) (1969) *Virgil*. London

Duffy, Jean H. (1990) *Butor. La Modification*. London

Eden, Richard (1555) *The Decades of the Newe Worlde or West India*. London

Ekbom, Moa (2013) *The Sortes Vergilianae. A Philological Study*. Uppsala

Eliot, T.S. (ed.) (1954) *Literary Essays of Ezra Pound*. London

—— (1957) *On Poetry and Poets*. London

Elliott, John H. (1970) *The Old World and the New. 1492–1650*. Cambridge

Eloy, Michel (1990) 'Énée et Didon à l'écran et dans la bande dessinée des années 50 et 60', in Martin (1990), 289–97

Erskine, Andrew (2001) *Troy between Greece and Rome. Local Tradition and Imperial Power*. Oxford

Erskine-Hill, Howard (1983) *The Augustan Idea in English Literature*. London

Evans, J. Martin (1996) *Milton's Imperial Epic: Paradise Lost and the Discourse of Imperialism*. Ithaca and London

Fabbri, Paolo (1918) 'Il genio del male nella poesia di Claudiano', *Athenaeum* vi, 48–61

Fagiolo, M. (1981) *Virgilio nell'arte e nella cultura Europea. Catalogo della mostra*. Rome

Falconer, Rachel (2005) *Hell in Contemporary Literature: Western Descent Narratives since 1945*. Edinburgh

Farrell, Joseph and Michael C.J. Putnam (eds) (2010) *A Companion to Vergil's Aeneid and its Tradition*. Chichester and Malden, MA

Feeney, Denis C. (1986) 'History and revelation in Vergil's underworld', *Proceedings of the Cambridge Philological Society* xxxii, 1–24

——— (1993) *The Gods in Epic: Poets and Critics of the Classical Tradition*. Oxford

Feldherr, Andrew (1999) 'Putting Dido on the map: genre and geography in Vergil's Underworld', *Arethusa* xxxii, 85–122

Fichter, Andrew (1982) *Poets Historical: Dynastic Epic in the Renaissance*. New Haven and London

Finley, Gerald (1999) *Angel in the Sun. Turner's Vision of History*. Montreal & Kingston, London, Ithaca

Fisk, Deborah P. and Jessica Munns (2002) '"Clamorous with war and teeming with empire": Purcell and Tate's *Dido and Aeneas*', *Eighteenth-Century Life* xxvi, 23–44

Fitzgerald, William (2004) '*Fatalis machina*: Berlioz's *Les Troyens*', *Materiali e Discussioni* lii, 199–210

Flamarion, E. (1990) 'Énée et Didon travesties par Furetière (*Le livre quatrième contenant les amours d'Énée et Didon ou l'Énéide travestie*, 1648) et Scarron (*Virgile travesti* 1648–53)', in Martin (1990), 117–28

Fowler, Don (2000) 'Epic in the middle of the wood: *mise en abyme* in the Nisus and Euryalus episode', in A. Sharrock and H. Morales (eds) *Intratextuality: Greek and Roman Textual Relations*. Oxford: 89–113

Fowler, Rowena (2009) '"Purple shining lilies": imagining the *Aeneid* in contemporary poetry', in S.J. Harrison (ed.) *Living Classics. Greece and Rome in Contemporary Poetry in English*. Oxford: 238–54

Fränkel, Hermann (1945) *Ovid: A Poet between Two Worlds*. Berkeley

Franklin, J.L., Jr (1997) 'Vergil at Pompeii: a teacher's aid', *Classical Journal* xcii, 175–84

Frey, Charles (1979) '*The Tempest* and the New World', *Shakespeare Quarterly* xxx, 29–41

Gagliardi, Cristina (ed.) (1993) *Lorenzo Gambara. De Navigatione Christophori Columbi*. Rome

Galinsky, G.K. (1972) *The Herakles Theme. The Adaptations of the Hero in Literature from Homer to the Twentieth Century*. Oxford

Galperin, Karina (2009) 'The Dido episode in Ercilla's *La Araucana* and the critique of empire', *Hispanic Review* lxxvii, 31–67

Garrison, James D. (1992) *Pietas from Vergil to Dryden*. University Park, Pennsylvania

Gevaerts (Gevartius), Jean Gaspard (1641) *Pompa Introitus Honori Serenissimi Principis Ferdinandi Austriaci Hispaniarum Infantis [...]* Antwerp

Gigante, Marcello (1984) *Virgilio e la Campania*. Naples

—— (ed.) (1986) *La fortuna di Virgilio*. Naples

Gillespie, Stuart (2010) 'Literary afterlives: metempsychosis from Ennius to Jorge Luis Borges', in Hardie and Moore (2010), 209–25

Glei, Reinhold F. (2000) 'Neulateinische Dramatisierungen der Aeneis – ein Überblick', in Binder (2000), Ch. 4

—— (2006) 'Vergil am Zeug flicken. Centonische Schreibstrategien und die Centones ex Virgilio des Lelio Capilupi', in R. Glei and R. Seidel (eds) *'Parodia' und Parodie: Aspekte intertextuellen Schreibens in der lateinischen Literatur der frühen Neuzeit*. Tübingen: 287–320

Godman, Peter (1987) *Poets and Emperors. Frankish Politics and Carolingian Poetry*. Oxford

Goldhill, Simon (1991) *The Poet's Voice. Essays on Poetics and Greek Literature*. Cambridge

Gransden, K.W. (1973/74) 'Typology, symbolism and allegory in the *Aeneid*', *Proceedings of the Virgil Society* xiii, 14–27

—— (1984) '*Paradise Lost* and the *Aeneid*', in Martindale (1984), 95–116

—— (ed.) (1996) *Virgil in English*. Harmondsworth

Graver, Bruce E. (1986) 'Wordsworth and the language of epic: the translation of the *Aeneid*', *Studies in Philology* lxxxiii, 261–85

Graves, Robert (1962) 'The Virgil cult', *Virginia Quarterly Rev.* xxxviii, 13–35

Green, Mandy (2009) *Milton's Ovidian Eve*. Farnham

Green, Roger P.H. (1995) 'Proba's *cento*: its date, purpose and reception', *Classical Quarterly* xlv, 551–63

—— (2006) *Latin Epics of the New Testament: Juvencus, Sedulius, Arator*. Oxford

Greene, Thomas M. (1982) *The Light in Troy. Imitation and Discovery in Renaissance Poetry*. New Haven and London

Gregory, Tobias (2006) *From Many Gods to One. Divine Action in Renaissance Epic*. Chicago and London

Griffin, Alan (1993) 'Pius Aeneas or Aeneas the wimp?', *Akroterion* xxxviii, 81–5

Gwynne, Paul (2012) *Poets and Princes: the Panegyric Poetry of Johannes Michael Nagonius*. Brepols

Haan, Estelle (1992, 1993) 'Milton's *In quintum Novembris* and the Anglo-Latin gunpowder epic,' *Humanistica Lovaniensia* xli, 221–95; xlii, 368–402

Haecker, Theodor (1931) *Vergil: Vater des Abendlands*. Munich; transl. A.W. Wheen, *Virgil: Father of the West* (New York, 1934)

Hagendahl, H. (1967) *Augustine and the Latin Classics*, 2 vols. Goteborg

Hall, Edith (2008) *The Return of Ulysses. A Cultural History of Homer's Odyssey*. London and New York

Hall, H.G. (1967) 'Scarron and the travesty of Virgil', *Yale French Studies* xxxviii, 115–27

Halliwell, Stephen (2008) *Greek Laughter. A Study of Cultural Psychology from Homer to Early Christianity*. Cambridge

Hamilton, Donna B. (1990) *Virgil and The Tempest: The Politics of Imitation*. Columbus, OH

Hammond, Mason (1933) '*Concilia deorum* from Homer through Milton', *Studies in Philology* xxx, 1–16

Hammond, Paul (1999) *Dryden and the Traces of Classical Rome*. Oxford

Hano, Michael (1990) 'Inventaire des peintures consacrées à l'épisode de Didon et d'Énée', in Martin (1990), xxvii–xxxi

Hardie, Philip (1986) *Virgil's Aeneid: Cosmos and Imperium*. Oxford

—— (1990) 'Ovid's Theban history: the first anti-*Aeneid*?', *Classical Quarterly* xl, 224–35

—— (1993) *The Epic Successors of Virgil: A Study in the Dynamics of a Tradition*. Cambridge

—— (2000) 'Ovid: a poet of transition?' (The Fourteenth Todd Memorial Lecture). Sydney: 11–23

—— (2002) *Ovid's Poetics of Illusion*. Cambridge

—— (2004) 'Virgilian imperialism, original sin, and Fracastoro's *Syphilis*', in M. Gale (ed.) *Latin Epic and Didactic Poetry*. Swansea: 223–34

—— (2009) *Lucretian Receptions. History, the Sublime, Knowledge*. Cambridge

—— (2010) 'Spenser's Virgil: *The Faerie Queene* and the *Aeneid*', in Farrell and Putnam (2010), 173–85

—— (2012a) *Rumour and Renown: Representations of Fama in Western Literature*. Cambridge

—— (2012b) 'Abraham Cowley's *Davideis*', in L. Houghton and G. Manuwald (eds) *Neo-Latin Poetry in the British Isles*. Bristol: 69–86

—— (2013) 'Shepherds' songs: generic variation in Renaissance Latin epic', in T.D. Papanghelis, S.J. Harrison and S. Frangoulidis (eds) *Generic Interfaces in Latin Literature*. Berlin and Boston: 193–202

—— (forthcoming) *Dido and Lucretia, Proceedings of the Virgil Society*

—— and Helen Moore (eds) (2010) *Classical Literary Careers and their Reception*. Oxford

Harris, Ellen T. (1987) *Henry Purcell's Dido and Aeneas*. Oxford

Harrison, E.L. (2006) 'Vergil's Aeneas and Yeats's anecdote', *Classical Quarterly* lvi, 630–1

Harrison, Stephen (1604) *The Arch's of Triumph Erected in Honour of the High and Mighty Prince James I*. London

Harrison, Stephen J. (ed.) (1990) *Oxford Readings in Vergil's Aeneid*. Oxford

—— (1997) 'From epic to novel: Apuleius as reader of Vergil', *Materiali e Discussioni* xxxix, 53–74

—— (2008) 'Virgilian contexts', in L. Hardwick and C. Stray (eds) *A Companion to Classical Receptions*. Malden, MA, and Oxford: 113–26

Harrison, T.W. (1967) 'English Virgil: the *Aeneid* in the XVIII century', *Philologica Pragensia* x, 1–11, 80–91

——— (1969) 'Dryden's *Aeneid*', in B. King (ed.) *Dryden's Mind and Art.* Edinburgh: 143–6

Hawkins, Peter S. (1991) 'Dido, Beatrice, and the signs of ancient love' in Jacoff and Schnapp (1991), 113–30

Hay, Denys (1957) *Europe: the Emergence of an Idea.* Edinburgh

Hegel, G.W.F. (1983–85) *Vorlesungen über die Philosophie der Religion*, ed. W. Jaeschke, 3 vols. Hamburg

Heinze, Richard (1993) *Virgil's Epic Technique*, transl. H. and D. Harvey and F. Robertson. London

Heller, W. (1998) '"O castita bugiarda": Cavalli's *Didone* and the question of chastity', in Burden (1998), 169–225

Heninger, S.K. (1962) 'The Tudor myth of Troy-novant', *South Atlantic Quarterly* lxi, 378–87

Henry, James (1873–89) *Aeneidea, or Critical, Exegetical, and Aesthetical Remarks on the Aeneis*, 4 vols. London and Dublin

Herrick, M.T. (1965) *Italian Tragedy in the Renaissance.* Urbana

Herzog, R. (1975) *Die Bibelepik der lateinischen Spätantike: Formengeschichte einer erbaulichen Gattung.* Munich

Hibbard, Howard (1990) *Bernini.* London

Higgins, Charlotte (2009) 'Battlestar Galactica revealed as the new Virgil's Aeneid', *Guardian*, 24 February

Hinds, Stephen (1993) 'Medea in Ovid: scenes from the life of an intertextual heroine', *Materiali e Discussioni* xxx, 9–47

——— (1998) *Allusion and Intertext. Dynamics of Appropriation in Roman Poetry.* Cambridge

——— (2004) 'Petrarch, Cicero, Virgil: virtual community in *Familiares* 24,4', *Materiali e Discussioni* lii, 157–75

Hofmann, Heinz (1994) '*Adveniat tandem Typhis qui detegat orbes*: Columbus in neo-Latin epic poetry (16th–18th centuries)', in W. Haase and M. Reinhold (eds) *The Classical Tradition and the Americas.* Berlin, Vol. i, 420–656

Holtz, L. (1997) 'Alcuin et la réception de Virgile du temps de Charlemagne', in H. Schefers (ed.) *Einhard: Studien zu Leben und Werk.* Darmstadt: 67–80

Howe, Alan (ed.) (1994) *Alexandre Hardy. Didon se sacrifiant. Tragédie.* Geneva

Hulubei, A. (1931) 'Virgile en France au XVIe siècle', *Revue du seizième siècle* xviii, 1–77

Huppert, George (1965) 'The Trojan Franks and their critics', *Studies in the Renaissance* xii, 227–41

Hutcheon, Linda (1985) *A Theory of Parody.* New York and London

Jacoff, Rachel (1991) 'Intertextualities in Arcadia: *Purgatorio* 30.49–51', in Jacoff and Schnapp (1991), 131–44

——— and Jeffrey T. Schnapp (eds) (1991) *The Poetry of Allusion: Virgil and Ovid in Dante's Commedia.* Stanford

Jenkyns, Richard (1998) *Virgil's Experience. Nature and History; Times, Names, and Places.* Oxford

Johnson, W.R. (2004) 'Robert Lowell's American Aeneas', *Materiali e Discussioni* lii, 227–39

Jones, Howard M. (1964) *O Strange New World*. New York

Jones, J. W. (1961) 'Allegorical interpretation in Servius', *Classical Journal* lvi, 217–26

Jonson, Ben (1925–52) *The Works*, eds C.H. Herford and P. and E. Simpson, 11 vols. Oxford

Kailuweit, Thomas (2005) *Dido - Didon - Didone: eine Kommentierte Bibliographie zum Dido-Mythos in Literatur und Musik*. Frankfurt and New York

Kallendorf, Craig (1989) *In Praise of Aeneas: Virgil and Epideictic Rhetoric in the Early Italian Renaissance*. Hanover, NH, and London

—— (2001) 'The *Aeneid* transformed: illustration as interpretation from the Renaissance to the present', in S. Spence (ed.) *Poets and Critics Read Virgil*. New Haven: 121–48

—— (2007a) *The Other Virgil. Pessimistic Readings of the Aeneid in Early Modern Culture*. Oxford

—— (2007b) *The Virgilian Tradition. Book History and the History of Reading in Early Modern Europe*. Aldershot

Kelsall, Malcolm (1983) 'The iconography of Stourhead', *Journal of the Warburg and Courtauld Institutes* xlvi, 133–43

Kiernan, Victor (1982) 'Tennyson, King Arthur, and imperialism', in R. Samuel and G.S. Jones (eds) *Culture, Ideology and Politics: Essays for Eric Hobsbawm*. London: 126–48

Klecker, E. (1994) *Dichtung über Dichtung. Homer und Vergil in lateinischen Gedichten italienischer Humanisten des 15. und 16. Jahrhunderts*. Vienna

Klingner, Friedrich (1965) *Römische Geisteswelt*, 5th edn. Munich

Knauer, Georg (1964a) *Die Aeneis und Homer*. Göttingen

—— (1964b) 'Vergil's *Aeneid* and Homer', *Greek Roman and Byzantine Studies* v, 61–84

Kofler, Wolfgang (2003) *Aeneas und Vergil. Untersuchungen zur poetologischen Dimension der Aeneis*. Heidelberg

Korte, Petra (2008) 'Christlicher Hades und vergilisches Fegefeuer', *Frühchristliche Studien* xlii, 271–306

Krevans, Nita (2010) 'Bookburning and the poetic deathbed: the legacy of Virgil', in Hardie and Moore (2010), 197–208

Laird, Andrew (2001) 'The poetics and afterlife of Virgil's descent to the underworld: Servius, Dante, Fulgentius, and the *Culex*', *Proceedings of the Virgil Society* xxiv, 49–80

—— (2010) 'The *Aeneid* from the Aztecs to the Dark Virgin: Vergil, native tradition and Latin poetry in colonial Mexico', in Farrell and Putnam (2010), 217–233

Langdon, Helen (1989) *Claude Lorrain*. London

Langmuir, Erika (1976) '*Arma virumque*: Nicolò dell'Abate's *Aeneid* gabinetto for Scandiano', *Journal of the Warburg and Courtauld Institutes* xxxix, 151–70

Laumonier, Paul (ed.) (1983) *Pierre de Ronsard. La Franciade*. Paris

Leach, E.W. (1982) 'Illustration as interpretation in Brant's and Dryden's editions of Vergil', in S. Hindman (ed.) *The Early Illustrated Book: Essays in Honor of Lesssing J. Rosenwald*. Washington: 175–210

Lectures médiévales de Virgile (1982) (Actes du colloque organisé par l'École française de Rome, Rome, 25–28 octobre 1982). Rome

Levey, Michael (1957) 'Tiepolo's treatment of classical story at Villa Valmarana: a study in eighteenth-century iconography and aesthetics', *Journal of the Warburg and Courtauld Institutes* xx, 298–317

Lewalski, Barbara (1966) *Milton's Brief Epic. The Genre, Meaning, and Art of Paradise Regained*. Providence, RI, and London

—— (1985) *Paradise Lost and the Rhetoric of Literary Forms*. Princeton

Lida de Malkiel, M. (1974) *Dido en la literatura española: su retrato y defensa*. London

Liversidge, M.J.H. (1997) 'Virgil in art', in Martindale (1997), 91–103

Llewellyn, Nigel (1984) 'Virgil and the visual arts', in Martindale (1984), 117–40

Loane, Helen A. (1928) 'The Sortes Vergilianae', *Classical Weekly* xxi, 185–9

Lord, M.L. (1969) 'Dido as an example of chastity: the influence of example literature', *Harvard Library Bulletin* xvii, 22–44

Lucas, C. (1987) '*Didon*. Trois réécritures tragiques du livre IV de l'*Énéide* dans le théâtre italien du XVIe siècle', in G. Mazzacurati and M. Plaisance (eds) *Scritture di scritture. Testi, generi, modelli nel Rinascimento*. Rome: 557–604

Lupher, D.A. (2003) *Romans in a New World: Classical Models in Sixteenth-Century Spanish America*. Ann Arbor

Lützeler, P.M. (ed.) (1976) *Materialien zu Hermann Broch 'Der Tod des Vergil'*. Frankfurt

McCabe, Richard A. (ed.) (1999) *Edmund Spenser. The Shorter Poems*. London

MacCormack, Sabine (1998) *The Shadows of Poetry: Vergil in the Mind of Augustine*. Berkeley

Mace, Nancy A. (1996) *Henry Fielding's Novels and the Classical Tradition*. Newark, DE, and London

McGill, Scott (2005) *Virgil Recomposed. The Mythological and Secular Centos in Antiquity*. New York

McGushin, P. (1964) 'Virgil and the spirit of endurance', *American Journal of Philology* lxxxv, 225–53

McKay, Alexander G. (1969) 'Virgilian landscape into art: Poussin, Claude and Turner', in Dudley (1969), 139–60

Mackie, C. J. (1988) *The Characterisation of Aeneas*. Edinburgh

McRae, Andrew (1998) ' "On the Famous Voyage": Ben Jonson and civic space', *Early Modern Literary Studies* Special Issue iii, 1–31

McShane, Philip A. (1979) *La Romanitas et le Pape Léon le Grand*. Tournai and Montreal

McWilliams, John P. (1989) *The American Epic: Transforming a Genre 1770–1860*. Cambridge

Manetti, A. (ed.) (1978) *G. M. Filelfo. Amyris*. Bologna

Marchesi, Simone (2009) 'Petrarch's philological epic (*Africa*)', in V. Kirkham and A. Maggi (eds) *Petrarch. A Critical Guide to the Complete Works.* Chicago and London: 113–30

Markley, A.A. (2004) *Stateliest Measures: Tennyson and the Literature of Greece and Rome*. Toronto

Marshall, Sharon M. (2011) *The Aeneid and the Illusory Authoress: Truth, Fiction and Feminism in Hélisenne de Crenne's Eneydes*. PhD Exeter

Martin, John R. (1972) *The Decorations for the Pompa Introitus Ferdinandi*. London

Martin, René (ed.) (1990) *Énée et Didon: naissance, fonctionnement et survie d'un mythe*. Paris

Martindale, Charles (ed.) (1984) *Virgil and his Influence. Bimillennial Studies.* Bristol

—— (1986) *John Milton and the Transformation of Ancient Epic*. London and Sydney

—— (ed.) (1997) *The Cambridge Companion to Virgil*. Cambridge

—— (2004) 'Shakespeare and Virgil', in C. Martindale and A.B. Taylor (eds) *Shakespeare and the Classics*. Cambridge: 89–106

Montagu, Jennifer (1998) '"Ut poesis pictura?" Dido and the artists', in Burden (1998), 131–49

Mora-Lebrun, Francine (1994) *L'Énéide médiévale et la naissance du romain*. Paris

Morillot, Paul (1888) *Scarron et le genre burlesque*. Paris

Morton, Richard (2000) *John Dryden's Aeneas: A Hero in Enlightenment Mode*. Victoria, BC

Most, Glenn (1987) 'The "Virgilian" *Culex*', in M. Whitby, P. Hardie and M. Whitby (eds) *Homo Viator. Classical Essays for John Bramble*. Bristol: 199–209

—— (1992) 'Il poeta nell'Ade: catabasi epica e teoria dell'epos tra Omero e Virgilio,' *Studi italiani di filologia classica* iii:10, 1014–26

—— (2010) 'Laocoons', in Farrell and Putnam (2010), 325–40

Murrin, Michael (1980) *The Allegorical Epic: Essays in its Rise and Decline*. Chicago

Neander, L.B. (1768) *Supplementum ad Lib. VI Aeneid de Festis Imperii RomanoGermanici et Aug. Gente Austriaca*. Vienna

Néraudau, Jean-Pierre (1990) 'Énée et Didon dans l'opéra des XVIIe et XVIIIe siècles', in Martin (1990), 299–306

Nisbet, R.G.M. (1978) 'Virgil's fourth *Eclogue*: easterners and westerners', *Bull. Inst. Class. Studies* xxv, 59–78

Nitchie, Elizabeth (1919) *Vergil and the English Poets*. New York

Noble, Louis Legrand (1853) *The Life and Works of Thomas Cole* (repr. Cambridge, MA, 1964)

Norden, Eduard (1899) 'Ein Panegyricus auf Augustus in Vergils Aeneis', *Rheinisches Museum* liv, 466–82

—— (1957) *Aeneis Buch VI*, 4th edn. Stuttgart

O'Brien, Karen (2002) 'Poetry against empire: Milton to Shelley', *Proceedings of the British Academy* cxvii, 269–96

O'Donnell, James J. (1980) 'Augustine's classical readings', *Recherches Augustiniennes* xv, 144–75

Oertel, Hans-Ludwig (2001) *Die Aeneissupplemente des Jan van Foreest und des C. Simonet de Villeneuve.* Hildesheim, Zurich and New York

Ogilby, John (1662) *The Entertainment of His Most Excellent Majestie Charles II, in his passage through the City of London to his coronation.* London

O'Hara, James J. (1990) *Death and the Optimistic Prophecy in Virgil's Aeneid.* Princeton

—— (1996) *True Names: Vergil and the Alexandrian Tradition of Etymological Wordplay.* Ann Arbor

Oliensis, Ellen (2009) *Freud's Rome. Psychoanalysis and Latin Poetry.* Cambridge

O'Meara, John (1963) 'Augustine the artist and the *Aeneid*', in *Mélanges offerts à Mlle Chr. Mohrmann.* Utrecht

Orgel, Stephen (ed.) (1987) *William Shakespeare. The Tempest.* Oxford and New York

Ozell, N. (1711–12) *The Works of Monsieur Boileau. Made English from the last Paris Edition,* 2 vols. London

Paduano, Guido (2008) *La nascita dell'eroe. Achille, Odisseo, Enea: le origini della cultura occidentale.* Milan

Paratore, E. (1973) 'L' "Andromaque" del Racine e la "Didone abbandonata" del Metastasio', in *Scritti in onore di Luigi Ronga.* Milan: 515–47

Parker, Fred, (2012) 'Travesty and mock-heroic', in D. Hopkins and C. Martindale (eds) *The Oxford History of Classical Reception in English Literature,* Vol. iii. Oxford: 323–59

Parry, Adam (1963) 'The two voices of Virgil's *Aeneid*', *Arion* ii/4, 66–80

Parry, Graham (1981) *The Golden Age Restor'd. The Culture of the Stuart Court, 1603–42.* Manchester

Pascal, C. (1917) 'Didone nella letteratura latina di Africa', *Athenaeum* v, 285–93

Paschoud, François (1967) *Roma Aeterna. Études sur le patriotisme romain dans l'occident latin à l'époque des grandes invasions.* Neuchâtel

Pease, A.S. (ed.) (1935) *Virgil. Aeneidos Liber Quartus.* Cambridge, MA

Pelling, Christopher B.R. (ed.) (1988) *Plutarch. Life of Antony.* Cambridge

Pike, David L. (1997) *Passage through Hell. Modernist Descents, Medieval Underworlds.* Ithaca and London

Pillinger, Emily (2010) 'Translating classical visions in Berlioz's *Les Troyens*', *Arion* xviii.2, 65–104

Pinnock, Andrew (1998) 'Book IV in plain brown wrappers: translations and travesties of Dido', in Burden (1998), 249–71

Platthaus, Isabel (2004) *Höllenfahrten. Die epische katábasis und die Unterwelten der Moderne.* Munich

Poinsotte, J.-M. (1990) 'L'image de Didon dans l'antiquité tardive', in Martin (1990), 43–54

Pollmann, Karla (2004) 'Sex and salvation in the Vergilian *Cento* of the fourth century', in Rees (2004), 79–96

Porter, William (1993) *Reading the Classics and Paradise Lost*. Lincoln, NE

Postle, Martin (1995) *Sir Joshua Reynolds: the Subject Pictures*. Cambridge

Powell, Earl A. (1990) *Thomas Cole*. New York

Preimesberger, R. (1976) '*Pontifex Romanus per Aeneam praedesignatus*. Die Galleria Pamphily und ihre Fresken', *Römisches Jahrbuch für Kunstgeschichte* xvi, 221–87

Pugh, Syrithe (2005) *Spenser and Ovid*. Aldershot

Purkiss, Diane (1998) 'The Queen on stage: Marlowe's *Dido, Queen of Carthage* and the representation of Elizabeth I', in Burden (1998), 151–67

Putnam, Michael C.J. (1965) *The Poetry of the Aeneid: Four Studies in Imaginative Unity and Design*. Cambridge, MA, and London

—— (2006) 'The *Aeneid* and *Paradise Lost*: ends and conclusions', *Literary Imagination* viii, 387–410

—— (2012) 'Virgil and Heaney: "Route 110"', *Arion* xix, 79–107

Quint, David (1983) *Origin and Originality in Renaissance Literature: Versions of the Source*. New Haven and London

—— (1993) *Epic and Empire: Politics and Generic Form from Virgil to Milton*. Princeton

Rawson, Claude (2010) 'Mock-heroic and English poetry', in C. Bates (ed.) *The Cambridge Companion to Epic*. Cambridge: 167–92

Rees, Roger (ed.) (2004) *Romane memento: Vergil in the Fourth Century*. London

Reeves, G. (1989) *T.S. Eliot: a Virgilian Poet*. London

Reinhold, Meyer (1984) 'Vergil in the American experience', in *Classica Americana: The Greek and Roman Heritage in the United States*. Detroit: 221–49

Ricks, Christopher (2002) *Allusion to the Poets*. Oxford

Roberts, Michael (1985) *Biblical Epic and Rhetorical Paraphrase in Late Antiquity*. Liverpool

—— (2004) 'Vergil and the Gospels: the *Evangeliorum libri IV* of Juvencus', in Rees (2004), 47–61

Roberts-Baytop, A. (1974) *Dido, Queen of Infinite Literary Variety: The English Renaissance, Borrowings and Influences*. Salzburg

Robertson, Ritchie (2009) *Mock-Epic Poetry from Pope to Heine*. Oxford

Römer, Franz (2001) 'Aeneas Habsburgus. Rudolf I in einer epischen Darstellung des 16. Jahrhunderts', *Wiener Studien* cxiv, 709–24

Rondholz, Anke (2012) *The Versatile Needle. Hosidius Geta's Cento 'Medea' and its Tradition*. Berlin and Boston

Rose, Margaret A. (1993) *Parody: Ancient, Modern, and Post-Modern*. Cambridge

Rosen, Ralph (2007) *Making Mockery: The Poetics of Ancient Satire*. Oxford

Rosenberg, Pierre and Keith Christiansen (eds) (2008) *Poussin and Nature: Arcadian Visions*. New Haven and London

Rosenthal, Earl (1971) 'Plus ultra, non plus ultra, and the columnar device of Emperor Charles V', *Journal of the Warburg and Courtauld Institutes* xxxiv, 204–28

Rowland, Ingrid (2010) 'Vergil and the Pamphili family in Piazza Navona, Rome', in Farrell and Putnam (2010), 253–69

Salvucci, Claudio R. (1994) *The Laviniad: An Epic Poem*. Bristol, PA

Schauer, Markus (2007) *Aeneas dux in Vergils Aeneis: eine literarische Fiktion in augusteischer Zeit*. Munich

Seem, L.S. (1990) 'The limits of chivalry: Tasso and the end of the *Aeneid*', *Comp. Lit.* xlii, 116–25

Selden, Daniel L. (2006) 'Vergil and the Satanic *cogito*', *Literary Imagination* viii/3, 1–45

Semrau, E. (1930) *Dido in der deutschen Dichtung*. Berlin

Senghor, Léopold Sédar (1991) *The Collected Poetry*, transl. M. Dixon. Charlottesville and London

Serroy, J. (ed.) (1988) *Scarron. Le Virgile travesti*. Paris

Settis, Salvatore (1999) *Laocoonte, fama e stile*. Rome

Shairp, John Campbell (1881) *Aspects of Poetry*. Oxford

Shields, John C. (2001) *The American Aeneas. Classical Origins of the American Self*. Knoxville

Siewert, Walter (2007) '"Witwe von Ephesos" als Vergil-Parodie', *Altsprachliche Unterricht* i/2, 20–6

Simonsuri, Kirsti (1979) *Homer's Original Genius: Eighteenth-Century Notions of the Early Greek Epic (1688–1798)*. Cambridge

Singerman, J.E. (1986) *Under Clouds of Poetry: French and English Reworkings of the Aeneid 1160–1530*. New York

Smith, G. Gregory, (ed.) (1904) *Elizabethan Critical Essays*, 2 vols. Oxford

Snell, Bruno (1953) *The Discovery of the Mind*, transl. T.G. Rosenmeyer. Oxford

Sowerby, Robin (2006) *The Augustan Art of Poetry. Augustan Translation of the Classics*. Oxford

—— (ed.) (2010) *Early Augustan Virgil: Translations by Denham, Godolphin, and Waller*. Lewisburg

Spargo, John W. (1934) *Virgil the Necromancer: Studies in Virgilian Legends*. Cambridge, MA

Spencer, Terence (1952) 'Turks and Trojans in the Renaissance', *Modern Language Review* xlvii, 330–3

Stahl, Hans-Peter (1981) 'Aeneas: an "unheroic hero"?', *Arethusa* xiv, 157–77

Stanford, W.B. (1954) *The Ulysses Theme*. Oxford

Starr, R.J. (1992) 'An epic of praise: Tiberius Claudius Donatus and Vergil's *Aeneid*', *Classical Antiquity* xi, 159–74

Steadman, John M. (1967) *Milton and the Renaissance Hero*. Oxford

Stechow, W. (1968) *Rubens and the Classical Tradition*. Cambridge, MA

Strong, Roy (1973) *Splendour at Court: Renaissance Spectacle and Illusion*. London

Suerbaum, Werner (1981) *Vergils Aeneis, Beiträge zu ihrer Rezeption in Gegenwart und Geschichte*. Bamberg

—— (2008) *Handbuch der illustrierten Vergil-Ausgaben 1502–1840*. Hildesheim, Zurich and New York

Sullivan, Francis A., SJ (1959) 'The spiritual itinerary of Virgil's Aeneas', *American Journal of Philology* lxxx, 150–61

Szabó, Magda (2009) *L'Instant: la Créuside*, transl. C. Philippe. Mayenne

Tanner, Marie (1993) *The Last Descendant of Aeneas. The Hapsburgs and the Mythic Image of the Emperor*. New Haven and London

Tatlock, J.S.P. (1950) *The Legendary History of Britain: Geoffrey of Monmouth's Historia Regum Britanniae and its Early Vernacular Versions*. Berkeley

Theodorakopoulos, Elena (1997) 'Closure: the book of Virgil', in Martindale (1997), Ch. 11

Thomas, Richard F. (2001) *Virgil and the Augustan Reception*. Cambridge

Thurn, Nikolaus (1995) *Ugolino Verino Carlias. Ein Epos des 15. Jahrhunderts erstmal herausgegen*. Munich

—— (2002) *Kommentar zur Carlias des Ugolino Verino*. Munich

Timpanaro, Sebastiano (1976) *The Freudian Slip: Psychoanalysis and Textual Criticism*, transl. K. Soper. London

Townsend, David (transl.) (1996) *The Alexandreis of Walter of Châtillon. A Twelfth-Century Epic*. Philadelphia

Toynbee, Jocelyn M.C. (1964) *Art in Britain under the Romans*. Oxford

Trapp, J.B. (1984) 'The grave of Virgil', *Journal of the Warburg and Courtauld Institutes* xlvii, 1–31

Trapp, Joseph (1718–20) *The Aeneis of Virgil Translated into Blank Verse*, 2 vols. London

Treip, Mindele A. (1994) *Allegorical Poetics and the Epic. The Renaissance Tradition to Paradise Lost*. Lexington, KY

Tschiedel, Hans J. (2010) 'Der *Dido* von Charlotte von Stein', in Burkard, Schauer and Wiener (2010), 299–313

Tucker, George H. (2009) 'Érotisme, parodie, et l'art du centon dans le *Gallus* (1543; *Centones ex Virgilio*, 1555) de Lelio Capilupi', in D. Sacré and J. Papy (eds) *Syntagmatia: Essays on Neo-Latin Literature in Honour of Monique Mund*. Leuven: 329–43

Tudeau-Clayton, Margaret (1998) *Jonson, Shakespeare & Early Modern Virgil*. Cambridge

Turner, Frank (1993) 'Virgil in Victorian classical contexts', in *Contesting Cultural Authority: Essays in Victorian Intellectual Life*. Cambridge: 284–321

Upton, John (1746) *Critical Observations on Shakespeare*. London

Usher, Phillip J. and Isabelle Fernbach (eds) (2012) *Virgilian Identities in the French Renaissance*. Cambridge

van der Horst, P.W. (1998) '*Sortes:* sacred books as instant oracles', in L.V. Rutgers (ed.) *The Use of Sacred Books in the Ancient World*. Leuven: 143–73

van der Paardt, R.Th. (1987) 'Vondels *Gijsbreght* en de Aeneis', *Hermeneus* lix, 244–50

Vance, Norman (1984) 'Virgil and the nineteenth century', in Martindale (1984), 169–92

—— (1997) *The Victorians and Ancient Rome*. Oxford

—— (2000) 'Imperial Rome and Britain's language of empire, 1600–1837', *History of European Ideas* xxvi, 211–24

Vasunia, Phiroze (2009) 'Virgil and the British Empire, 1760–1880', in D. Kelly (ed.) *Lineages of Empire: the Historical Roots of British Imperial Thought*. Oxford: 83–116

Vegio, Maffeo (2004) *Short Epics*, ed. and transl. M.C.J. Putnam. Cambridge, MA, and London

von Albrecht, Michael (1964) *Silius Italicus: Freiheit und Gebundenheit römischer Epik*. Amsterdam

von Stackelberg, J. (1982) 'Vergil, Lalli, Scarron. Ein Ausschnitt aus der Geschichte der Parodie', *Arcadia* xvii, 225–44

Waddell, Helen (1932) *The Wandering Scholars*, 6th edn. London

Wallace, Andrew (2010) *Virgil's Schoolboys. The Poetics of Pedagogy in Renaissance England*. Oxford

Ware, Catherine (2012) *Claudian and the Roman Epic Tradition*. Cambridge

Warner, J.C. (2005) *The Augustinian Epic, Petrarch to Milton*. Ann Arbor

Warton, Joseph (1763) *The Works of Virgil in English Verse*. London

Waswo, Richard (1988) 'The history that literature makes', *New Literary History* xix, 541–64

Watkins, J. (1995) *The Specter of Dido. Spenser and Virgilian Epic*. New Haven and London

Watson, Elizabeth P. (1986) 'Virgil and T.S. Eliot', in Cardwell and Hamilton (1986), 115–33

Weber, Clifford (1999) 'Intimations of Dido and Cleopatra in some contemporary portrayals of Elizabeth I', *Studies in Philology* xcvi, 127–43

Weinbrot, Howard (1978) *Augustus Caesar in 'Augustan' England: The Decline of a Classical Norm*. Princeton

Werner, Shirley (2002) '"Frigid indifference" or "soaked through and through with feeling"?', in W.S. Anderson and L.N. Quartarone (eds) *Approaches to Teaching Vergil's Aeneid*. New York: 60–8

Wharton, David (2008) '*Sunt lacrimae rerum*: an exploration in meaning', *Classical Journal* ciii, 259–79

White, Monique C.B. (1975) *The Dido Fable in French Tragedy: 1560–1693*. Ann Arbor

Williams, Deanne (2006) 'Dido, Queen of England', *English Literary History* lxxiii, 31–59

Williams, R.D. (1969) 'Changing attitudes to Virgil: a study in the history of taste from Dryden to Tennyson', in Dudley (1969), 119–38

Wilson-Okamura, David S. (2003) 'Virgilian models of colonization in Shakespeare's *Tempest*', *English Literary History* lxx, 709–37

—— (2010) *Virgil in the Renaissance*. Cambridge

Wiseman, T.P. (1992) 'Talking to Virgil', in *Talking to Virgil. A Miscellany*. Exeter: 171–209

Woodbridge, K. (1970) *Landscape and Antiquity: Aspects of English Culture at Stourhead 1718–1838*. Oxford

Wright, D.H. (1993) *The Vatican Virgil: A Masterpiece of Late Antique Art*. Berkeley

—— (2001) *The Roman Vergil and the Origins of Medieval Book Design*. British Library

Wright, E.R., S. Spence and A. Lemons (eds) (2014) *The Battle of Lepanto*. Cambridge, Mass.

Yates, Frances (1975) *Astraea. The Imperial Theme in the Sixteenth Century*. London and Boston

Yunck, John A. (transl.) (1974) *Eneas: A Twelfth-Century French Romance*. New York

Ziolkowski, Jan M. and Michael C.J. Putnam (eds) (2008) *The Virgilian Tradition: The First Fifteen Hundred Years*. New Haven and London

Ziolkowski, Theodore (1993) *Virgil and the Moderns*. Princeton

—— (2005) *Ovid and the Moderns*. Ithaca and London

Ziosi, Antonio (2012) *Didone regina di Cartagine di Christopher Marlowe: Metamorfosi virgiliane nel Cinquecento*. Rome

Zwierlein, Otto (1973) 'Karolus Magnus – alter Aeneas', in A. Onnerfors, J. Rathofer and F. Wagner (eds) *Literatur und Sprache im europäischen Mittelalter: Festschrift für Karl Langosch zum 70. Geburtstag*. Darmstadt: 44–52

INDEX